AMERICAN ART MUSEUMS

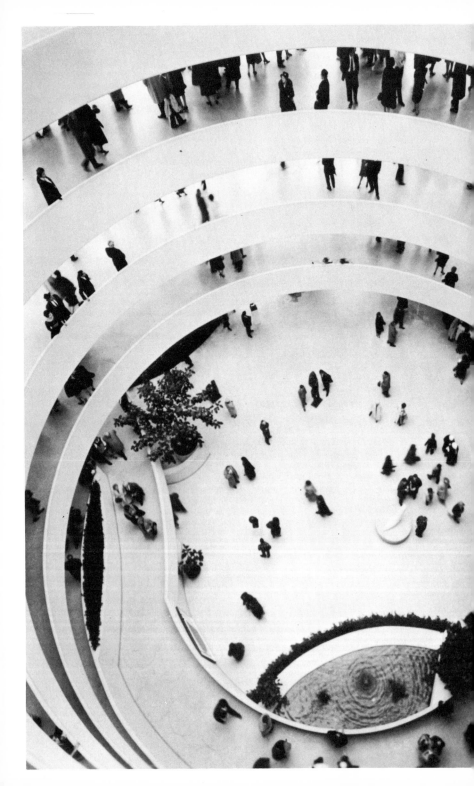

AMERICAN ART MUSEUMS

An Introduction to Looking

THIRD EDITION, EXPANDED

Eloise Spaeth

HARPER & ROW, PUBLISHERS

1817

NEW YORK, EVANSTON
SAN FRANCISCO
LONDON

As this book went to press, closings were announced by the following museums:

Allen Memorial Art Museum, Oberlin, Ohio
Closed through 1976.

Philadelphia Museum of Art, Philadelphia, Pennsylvania
Closed until April 1976.

Museum of Art: Rhode Island School of Design, Providence, Rhode Island
Closed until Fall 1976.

The St. Louis Art Museum, St. Louis, Missouri
Closed until late Fall 1976.

AMERICAN ART MUSEUMS: AN INTRODUCTION TO LOOKING (Third Edition, Expanded). Copyright © 1960, 1969, 1975 by Eloise Spaeth. All rights reserved. Printed in the United States of America. No part of this book may be used or reproduced in any manner whatsoever without written permission except in the case of brief quotations embodied in critical articles and reviews. For information address Harper & Row, Publishers, Inc., 10 East 53rd Street, New York, N.Y. 10022. Published simultaneously in Canada by Fitzhenry & Whiteside Limited, Toronto.

Designed by Lydia Link

Library of Congress Cataloging in Publication Data

Spaeth, Eloise.
American art museums.
Bibliography: p.
Includes index.
1. Art—United States—Galleries and museums.
2. Art dealers—United States—Directories. I. Title.
N510.S6 1975 708'.13 74-1857
ISBN 0-06-013978-1

75 76 77 78 79 10 9 8 7 6 5 4 3 2 1

CONTENTS

Foreword

This book is not meant to be a definitive guide, but rather an introduction to looking. Although the space is limited I have tried to cover all the major museums and as many as possible minor-major art museums. In selecting, I have frequently had to be somewhat arbitrary in my choices. The emphasis, but for a few exceptions, is on the *general* art museum; a few, not falling within this category, have been included because geographically they are near a particular museum under discussion or are in an area where general museums are few and far between (see Cody, Wyoming).

In choosing university and college museums, I have given preference to those which have their own museum buildings and which act as community museums as well. The winnowing has been difficult, since practically every university has or is building a museum or an art center on campus. The largest metropolitan museums are given a description too brief in relation to their importance, on the assumption that everyone knows where they are. Moreover, their sales desks have catalogs and literature on their collections in abundance. Tours and docents (museum jargon for lecture-guides) are plentiful.

In a few lines, I have tried to capture the quality, character and mood of the museums listed. Each has its own. In some I have singled out specific works of art; sometimes the works chosen are the museum showpieces, sometimes the choice has been my own. The works discussed belong to the permanent collections. However, it is advisable to request a floor plan when visiting a particular institution, for frequently museum directors rearrange the collections and what is here today is elsewhere tomorrow.

Museum libraries are listed, but frequently they are open to the qualified scholar only—or are reference libraries. Practically none are circulating libraries.

The titles of works of art, the spelling of artists' names (whether to or not to *c* Memlin*c*), and all attributions follow museum labels.

How Museums Came to Be

The American art museum as a public and formal institution is of fairly recent vintage, but over the last century the United States has managed to gather together some of the world's great art treasures. More important, we have created a climate where the arts, both visual and performing, are as much a part of the scene in the average-size city—say, Jacksonville, Florida, or Flint, Michigan—as the local bowling alleys. Today, no self-respecting municipality would be caught without an art center, whether manned by a professional staff or held together by a group of volunteers. However, this proliferation of museums did not happen overnight.

The Charleston South Carolina Library Society, formed in 1773, was the first group to establish a museum. Although the stress was on history, china, bits of jewelry, miniatures and portraits were also on display.

After the Revolution, a number of historical societies were formed, from Georgia to Vermont, to preserve and keep up to date the story of the new country. Grim portraits of civic and political leaders, on the whole of more historical than artistic interest, hung beside maps, land grants and firearms. Although Colonial America had been too busy making history to think much about art, painters found patrons and painting began to improve. Master craftsmen who decorated Colonial carriages and furniture were soon testing their skills on canvas.

In Philadelphia, about 1783, Charles Willson Peale, the saddler's apprentice who became a painter, held exhibitions at his home. His artist son Rembrandt Peale erected in Baltimore a building designed specifically as an art museum. Although the Pennsylvania Academy of the Fine Arts had been established in Philadelphia, Peale's museum holds the honor of being the first building in America to house only works of art.

At the same time, other institutions were struggling to estab-

lish and maintain themselves. The National Academy of Design opened in New York in 1826, with Samuel F. B. Morse (the inventor of the telegraph, who was also a painter) as its first president. The Boston Athenaeum, a library since 1807, began to show paintings. Actually Harvard College had been the pioneer: in 1760 Harvard established a "Museum Room" which was the beginning of its university collection. In 1811 James Bowdoin bequeathed a collection of European paintings to the college named for his father, thus creating the oldest American college art collection. Yale purchased John Trumbull's paintings of the American Revolution, opening its Trumbull Gallery in 1832. In 1844 the Wadsworth Atheneum, in Hartford, Connecticut, opened its new picture gallery with some 80 paintings.

It was, however, the avid private collectors of the mid-century who hastened the emergence of the museum as a separate entity. In those days making the Grand Tour of Europe was *de rigueur* for young men of wealth before they settled down. Often, from these travels, they brought home paintings of quality. James Jackson Jarves, the most astute of the lot, came back with a magnificent group of 13th to 17th century Italian paintings, 119 in all. Most of them are now at the Yale University Art Gallery. Men like William Walters of Baltimore, the first of our great collectors to become involved in Oriental art, and William Corcoran, the Washington banker, set the pattern for the Morgans, Fricks and Mellons of later years.

The tradition of the millionaire patron of the arts carried into the 20th century. Such men as the Wideners, the Morgans, Johnson, Frick, Bache, Freer, Lehman, Havemeyer, Huntington and later the Mellons, Kress, Hanna, Dale, the Rockefellers, Guggenheim and Hirshhorn have given and are giving America priceless examples from almost every known civilization. Whatever their motives—pride, generosity, love of the beautiful, vanity—every citizen in the United States has the privilege of seeing these collections in public museums. Surprises are everywhere.

While the chief purpose of a museum is still to collect, preserve and exhibit works of art, the modern concept goes far beyond such a definition. Many changes have taken place through the years. Some institutions feel that they must involve themselves more deeply with the broad local community and even use the museum as a platform for advanced social views. Others feel just

as strongly that active engagement toward these ends should not take place in a museum. But certainly the base of museum involvement has broadened tremendously in the last ten years. The educational programs that even the smallest art centers have supported have borne fruit. Could José Rivera's abstract steel sculpture have been placed on a mall in Lansing, Michigan, or Picasso's 100-foot *Bust of a Woman* have risen on a Tampa, Florida, university campus even 20 years ago? A recent survey undertaken by the National Endowment for the Arts shows that 92 percent of the museums surveyed see their function as primarily educational (these figures include all museums, not just art museums). Seventeen percent think museums should encourage social change. But most of us still go to museums to see great works of art, to try to understand other cultures through their arts and artifacts or to keep abreast of the art movements in our time. We go to look.

An Introduction to Looking

Unless one is at the Hermitage Museum in Leningrad and a future visit seems unlikely, it is wiser in large museums to restrict oneself to digestible-sized areas.

As you go from gallery to gallery, continents and centuries are bridged. Standing before the elegant statue of an *Athenian Youth* in New York's Metropolitan Museum, you are on the Acropolis, the smell of olive blossoms and thyme in the air, a witness of immortality. Nearby is the life of the Nile: Pharaohs build the pyramids and artists hammer out gold necklaces as dynasty succeeds dynasty. In another museum we step into our own historical past. Tea is dumped in Boston Harbor and a wilderness is cleared; *Paul Revere, Silversmith*, painted by John Singleton Copley, in the Boston Museum of Fine Arts, is Longfellow's Paul Revere who spread the word to every Middlesex village and farm.

Or perhaps we are taken with the extravagances of the French courts, with porcelains and bric-a-brac and painters like Boucher and Fragonard giving evidence of refined abandon in the reigns of the worldly kings named Louis. Or maybe we fear the tyranny of tradition and gravitate to the contemporary galleries, where we are challenged by current audacities. From a confusion of remembered shapes and colors, somehow a small Vermeer painting or a giant Lehmbruck sculpture will force its way to the conscious surface of our minds, refusing to be obscured.

Whatever our interest or curiosity, we go back to what has touched us most, to communicate with what has delighted or moved us. Works of art seldom yield their mysteries at a first glance.

E.S.

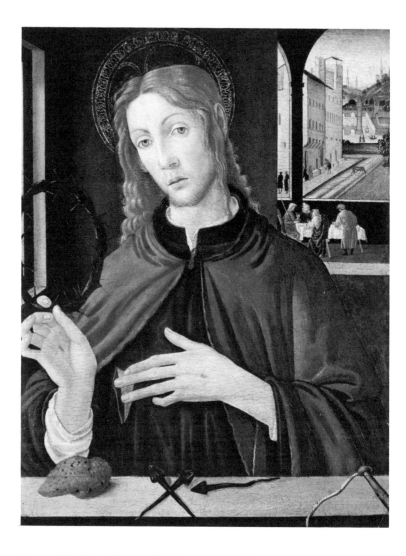

Jacopo del Sellaio: Christ and the Instruments of the Passion
(Birmingham Museum of Art, Birmingham, Ala.
Samuel H. Kress Collection)

ALABAMA

BIRMINGHAM MUSEUM OF ART
2000 8th Avenue, Birmingham, Alabama

Hours: Mon.–Sat. 10–5; Thurs. 10–9; Sun. 2–6
Closed: Jan. 1, Dec. 25

The Birmingham Art Society, formed in 1908, hung its exhibits for years wherever sympathy and space allowed. Finally, in 1951 the society took a giant step forward. The board of trustees changed its name, hired a professional director plus curators, and set about forming a collection. In 1959 the museum moved to its new home, the Oscar Wells Memorial Building. The small but imposing structure incorporated technical devices that though common practice today were quite advanced at the time: a television system that permits live broadcasts, zoned temperature controls, closed loading docks, and the latest lighting ploys in the 15 galleries that fan out from a two-storied court. In early 1974 a large wing opened, allowing space for much of the collection previously not on view and for changing exhibitions.

Emphasis has been placed on the general art museum concept. The Kress collection encompasses the major schools of Italian painting from the 13th to late 18th centuries. One beauty is *Christ and the Instruments of the Passion* by Jacopo del Sellaio, a pupil of Fra Filippo Lippi; another, Perugino's unfinished *Portrait of St. Bartholomew*. An unusual Kress gift is a panel by an unknown Flemish painter depicting the battle of Pavia (1525), in which the French were defeated and Francis I captured. A rare group of Palestinian artifacts and sculpture stretches from Paleolithic objects to Byzantine pottery. The Far East section holds ancient Japanese and Chinese pottery as well as modern ceramics and

1

textiles. Pre-Columbian art includes outstanding examples of Chimu gold. Artifacts of American Indian culture include fine material of the Northwest Coast and the Plains. The Moundsville Indian cultures of western Georgia and eastern Alabama, which flourished from A.D. 1200 to 1500, are shown in examples of pipes, pots, beads and animals.

The decorative arts section is extensive: the Wedgwood collection alone has 1,500 pieces from before 1830, including two Portland vases. The English silver collection holds important examples by Hester Bateman and Paul de Lamerie. There are varied surprises—top Remington bronzes; a small atypical Fragonard, *St. Peter Denying the Lord.*

One lonely, huge Frank Stella represents today's painting, but with nine new galleries opening it is hoped that the "now" painters will join Stella. Meanwhile scholarly exhibitions with good catalogs, such as the recent Veronese exhibition, the first one ever devoted to this master and his followers in America, are held.

MOBILE

THE MOBILE MUSEUM OF FINE ARTS

Langan Park, Mobile, Alabama

Hours: Mon.–Sat. 10–5; Sun. 12–5
Closed: Major holidays

That as old a city as Mobile did not feel the lack of an art museum is explained by the fact that the historic house has such significance in the area. However, in 1964 citizens and city commissioners joined in forming the present museum. A smart building housing one large gallery with an atrium rests on the rolling lawns of Langan Park. A two-story wing, in the style of the present galleries, has moved off the drawing board.

A serious attempt is being made to form a good collection. Emphasis at present is on the 19th century. Two recent acquisitions are Renoir's *Still Life—Roses* and Tissot's *The Goose Girl.* A 300 percent increase in gallery attendance in its short life attests to both the museum's liveliness and Mobile's need.

ARIZONA

THE PHOENIX ART MUSEUM

1626 North Central Avenue, Phoenix, Arizona

Hours: Tues.–Sat. 10–5; Sun. 1–5; Wed. 10–9
Closed: Major holidays

The Phoenix Museum has set itself the task of developing an encyclopedic museum. The director modestly admits that a number of volumes are still missing. But a beginning has been made in Medieval, Renaissance and Baroque art, and a new gallery shows the 19th century Europeans. The Oriental section, once a rather large deposit of varied objects, has been redefined and set in a quiet gallery; rare Chinese ivories from the Sir Victor Sassoon Collection are in a room of small objects. A print and drawing gallery has been added. Contemporary artists share large flexible space: Trova, Pomodoro, Stella, and Diebenkorn come to mind. As in every southwestern museum obeisance is made to Central and South America: a Mexican Colonial drawing room; works by Tamayo, Merida, Rivera, Cuevas, etc.; stunning Peruvian silver. A large relief in bronze by Mexico's popular sculptor Zuniga enhances the entrance.

The museum is part of a pleasant complex with theater and library all sharing a courtyard with verdant planting, splashing fountains and occasionally the museum's six Jacob Epsteins.

And how did all this come about? As usual through the efforts of a group of women. As John Mason Brown so neatly phrased it: "Women are the Typhoid Marys of American culture." In 1915 a determined handful of Phoenix Woman's Club members decided the calendar art exhibited at the state fair needed upgrading and

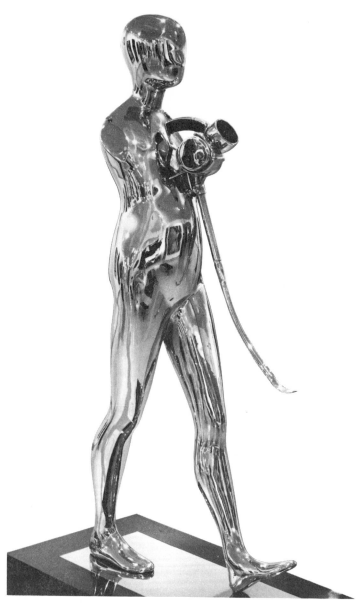

Ernest Trova: Walking Man (Phoenix Art Museum, Phoenix, Ariz.)

encouraged regional artists to show their work at the fair. One member, Mrs. Dwight Heard, formed the Phoenix Art Association in 1925 and arranged for the gift to the city of the land where the fine arts project has finally materialized.

TEMPE

ARIZONA STATE COLLEGE

Tempe, Arizona

Hours: Mon.–Fri. 10–5; Sun. 1–5
Closed: National holidays

Only a half hour from downtown Phoenix, the collection at Arizona State is well worth a visit. Walk down a pleasant mall lined with trees and miscellaneous architecture to Matthews Center, where three galleries are allotted to the collection, the basis of which is the Oliver James bequest. The paintings, many of which hung in the James home, are mostly small in scale and demonstrate what love and a discerning eye can achieve. Eakins, Homer, Ryder, Sheeler, Kuhn, Stuart Davis and Shahn are shown at their small, succinct best. One gallery gives us splendid Americana, including an almost life-sized lawn figure in iron of George Washington, a Roman toga draped incongruously over his general's uniform.

The museum's director claims that Arizona State's historical survey of American art is the largest in scope, if not in numbers, west of the Mississippi, and states unequivocally that its American pottery collection, dating from 1780 to today's funk art, is the top. The print collection is exhaustive: 32 Dürers, 27 Rembrandts, 100 Hogarths and 60 Whistlers are but samplings. The Arizona State College collection deserves a better home. Some of these prints should find wall space.

TUCSON ART MUSEUM

325 West Franklin Street, Tucson, Arizona

Hours: Tues.–Sat. 10–5; Sun. 1–5
Closed: Mon., major holidays

Formed in 1924, the Tucson Fine Arts Association for years led a pillar-to-post existence, including being harbored in the basement of the Chamber of Commerce building.

In 1955 the association acquired its present quarters, the former home of a distinguished judge, and a new name—the Tucson Art Center. The collection's holdings are mainly in Pre-Columbian, Spanish Colonial and art of the American West.

The ambitious aim of the center was to embrace most of man's aesthetic experience, and in preparation for this boundless venture, the museum, as it is now designated, is embarking on one of the most exacting projects in the country. A city block, including four historic adobe houses, has been given to the museum by the city under urban renewal.

Architect William Wilde has artfully designed a new building that will rest in the center of, and be compatible with, a complex which was a part of the Presidio of Old Tucson. One adobe house will be turned back into a typical house of the period. Two others will be used for art classes and related purposes. Century-old trees planted on the Presidio grounds will shade patios and a sculpture court. Inside the museum late 20th century planning prevails. The ceiling height of galleries varies, and an ingenious employment of ramps allows for maximum flow and viewing. By keeping the museum's roofline low architectural harmony between Tucson's past and present has been handsomely achieved.

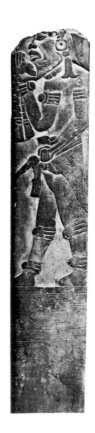

Stela, Carved Siltstone, Mexico, A.D. 800
(Tucson Art Center, Tucson, Ariz.)

UNIVERSITY OF ARIZONA ART MUSEUM

Olive Road and Speedway, Tucson, Arizona

Hours: Mon.–Sat. 10–5; Sun. 2–5
Closed: Jan. 1, Dec. 25

Set on one of Tucson's main thoroughfares, this campus museum is easily accessible to outside visitors as well as students.

Although the museum has a creditable Old Master collection, including a Hispanic-Flemish retablo of 26 panels attributed to Fernando Gallego, the heart of the collection is 20th century art. The size and range is extensive and includes Pollock, Stamos, Gorky, Tobey, Kline and de Kooning's smashing *Women Ochre*. Miró, Appel, Léger and Mathieu are but a few of the Europeans.

A strong sculpture section is in the making, encompassing such monumental pieces as Archipenko's *Torso in Space*, Maillol's *Flore Nue* and Henry Moore's *Girl Seated Against a Square Wall*. The Moore is an edition of two, the other belonging to the sculptor's daughter. Fortified by the Edward Joseph Gallagher III and the C. Leonard Pfeiffer collections, the gallery, though stopping short of the most experimental movements, has come to be an important center for contemporary art. In-depth exhibitions of such masters as Henry Moore, John Marin and Walt Kuhn are held during the winter season.

Henry Moore: Girl Seated Against a Square Wall (University of Arizona Museum, Tucson, Ariz. The Gallagher Memorial Collection)

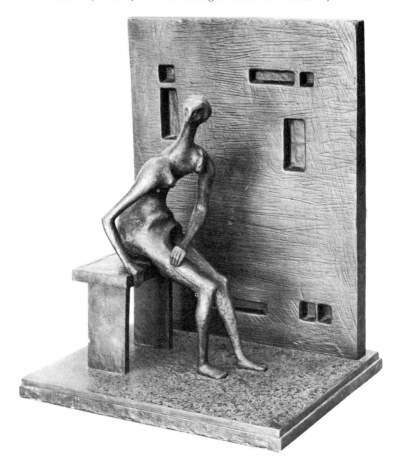

ARKANSAS

THE ARKANSAS ART CENTER

MacArthur Park, Little Rock, Arkansas

Hours: Mon–Sat. 10–5; Sun. 12–5

Although Little Rock's public cultural beginnings were tentative, a fine arts club that began slowly in 1914 gradually became a small museum. Its present activities as the Arkansas Arts Center more than compensate for the laggard years. Theater, dance, music, art exhibitions, a school of art and drama, keep the center about the most active place in Arkansas. An artmobile goes out to those who cannot come to the galleries. The late former Governor Winthrop Rockefeller and Mrs. Rockefeller, the David Rockefellers and the Barton Foundation made the artmobile possible. It takes both works from the permanent collection and special exhibits through the countryside.

The center's main interest in collecting is in prints, drawings and watercolors. Recent acquisitions include 114 watercolors of Robert Andrew Parker's *How to Kill* series. Andrew Wyeth's *Snowflakes* is also an important addition, as is a René Magritte drawing, done as a frontispiece for the catalog when the center reviewed the work of this well-known Belgium Surrealist. Probably the best known of the Old Master drawings is Francesco Bassano's *Adoration of the Shepherds*.

Eighteenth and 19th century Americans include John Hesselius, Gilbert Stuart, Asher B. Durand and Thomas Moran. The 20th century non-American paintings that are popular are Odilon Redon's six-foot *Andromeda*, who is chained to a rock waiting deliverance from the monster by Perseus, and Diego Rivera's

Two Women. The latter is a fascinating painting done in 1913–1914 in Europe and showing the influence of the Cubist movement on his work, an influence he was to reject on his return to Mexico.

The contemporary collection, spurred on by the Delta Art Exhibition, which shows the work of artists from the entire Mississippi Delta area, continues to expand. The exhibition gathered from a seven-state area is juried by leading museum men in the contemporary field in the United States.

Interior View (University Art Museum, University of California at Berkeley, Berkeley, Calif.)

CALIFORNIA

UNIVERSITY OF CALIFORNIA AT BERKELEY: THE UNIVERSITY ART MUSEUM

2626 Bancroft Way, Berkeley, California

Hours: Wed.–Sun. 11–6; Thurs. 11–9
Closed: Mon., Tues., July 4, Sept. 3, Nov. 22, 23, Dec. 24, 25, 31,
Jan. 1, Feb. 18, March 25, May 27

The façade of this sculptured building by architects Ciampi, Jorasch and Wagner of San Francisco presents a series of mesalike stacked concrete formations. The result is impressively stern. So is the huge Calder stabile anchored at the entrance. Architectural historian Spiro Kostof describes the spectacular interior and boldly cantilevered galleries as a series of five trays that fan out in a 90-degree angle, stepping down as they do so. Ramps lead from the lobby to these and to higher galleries which are circumscribed by a pleated glass wall. More natural light is filtered through skylights and floor-to-ceiling windows. Highly original monster-sized ceramic chairs and benches by Stephen de Staebler enliven the entrance hall. An outside ramp leads one from various levels to a sculpture garden where a gleaming Pomodoro along with a Voulkos and a Liberman can be seen. One enters the theater in the evening through this garden. The Pacific Film Archives is housed in the museum and is one of four such centers in the country.

Although the collection covers most periods in the history of art, much emphasis is placed on the contemporary. Hans Hofmann's splendid gift, shortly before he died, of 45 of his important works makes a fine rallying point. The gesture, which included a princely sum for housing the paintings, was made because friends at the university arranged for him to leave Nazi Germany to teach at Berkeley.

Some other artists shown in handsome examples are Sam Francis, Ad Reinhardt, Willem de Kooning, Adolph Gottlieb, Mark Rothko, Francis Bacon, Helen Frankenthaler, Clyfford Still, Mark Tobey, Nancy Grossman and David Smith. In fact Berkeley has the most distinguished representation of the New York School west of Chicago, only a part of which can be on view at any one time. California artists include Bruce Conner, William T. Wiley, Harold Paris and William Allen. The museum has acquired major Baroque paintings by Rubens, Carracciolo, Savoldo and Carlone, and some fine 19th century works by Medardo Rosso, Blakelock, Bierstadt and Ensor. The Oriental stress is on Chinese and Japanese painting.

A working arrangement with the Lowie Museum of Anthropology across the street allows the museum to have antiquities and primitive works of the highest order from the Lowie collection on view in its galleries.

LA JOLLA

LA JOLLA MUSEUM OF CONTEMPORARY ART

700 Prospect Street, La Jolla, California

Hours: Tues.–Fri. 10–5; Sat., Sun. 12:30–5; Wed. 7 P.M.–10 P.M. Closed: Mon., Jan. 1, Dec. 25

Very little, if anything, is left of the Ellen Browning Scripps house that in 1941 became the home of La Jolla's first art center. A series of additions has more than doubled its space, including a luxurious auditorium joined to the original building by a sculpture garden and a large open gallery. A wing with the most distracting view along the southern California coastline plunges down the hill at the rear. While there is a general collection and holdings in Oceanic, African and Pre-Columbian art, the emphasis and the major portion of the work is 20th century. For many years La

Jolla was the only major community providing adequate coverage of the various trends in 20th century art, including the most experimental. A few examples in the permanent collection are Billy Al Bengston, John Altoon, Robert Irwin, Theodore Stamos, José de Rivera, Peter Alexander, Milton Avery and Thomas Downing. German Expressionist Ernst Ludwig Kirchner's vivid *Portrait of Max Liebermann,* father of Secessionism, counterpoints his splendid 1905 *Portrait of the Artist with Nude Model.* A gift brought 70 oils and watercolors by John Marin and Marsden Hartley to La Jolla.

The print collection begins with 17th century European etchings and engravings and ranges to a group of more than 400 lithographs from the Tamarind Workshop. Tamarind was founded to provide facilities for artists to work with master printers in much the same manner as Lautrec and Picasso worked in Paris in print *ateliers.*

While exhibiting all major trends, it is La Jolla's aim to provide a platform for the emerging artist as well as to be the mecca for the avant-garde in the area.

Carl André: 36 Pieces of Magnesium and Zinc (La Jolla Museum of Contemporary Art, La Jolla, Calif.)

LOS ANGELES

LOS ANGELES COUNTY MUSEUM OF ART

5905 Wilshire Boulevard, Los Angeles, California

Hours: Tues.–Fri. 10–5; Sat., Sun. 10–6
Closed: Mon., major holidays
Restaurant

The best thing to report about an art museum, aside from the quality of its collection, is its functionalism. The Los Angeles County Museum of Art definitely has both. A person wishing to see a current exhibition goes directly to the Hammer Wing Gallery. For the permanent collection, he proceeds to the Ahmanson. For a concert or lecture, he steps from the Norton Simon Sculpture Plaza to the Leo S. Bing Center.

Set on broad and busy Wilshire Boulevard, on the edge of Hancock Park, the museum, designed by William L. Pereira & Associates, consists of three pavilions covered with split-faced Cappalino marble tiles and surrounded by colonnades of slender columns arranged around a large central plaza. On pleasant weekends the plaza becomes an impromptu platform for the performing arts. A group of mimes may occupy one space, a string band another, while a lone guitarist sends forth his plaintive chant across the way. Encircling the museum is a sculpture garden containing heroic works by some of the world's leading sculptors.

While many gifts have enriched the museum since it began in 1911 as a section of the Los Angeles County Museum of History, Science and Art, it was William Randolph Hearst who, with his gargantuan appetite for collecting, raised it in the 1940s to a first-class power. At the height of his buying, Hearst's acquisitions represented a quarter of the sales of art objects in the world; warehouses bulged; his agents ranged from Tucumcari to Tibet. That he was an indiscriminate buyer of art (a misconception fostered by the story of his ordering his agents to get him a rare piece which he already possessed but had forgotten) is disproved here. Outstanding Hearstian treasures in residence are in the field of Hispano-Moresco pottery, silver, Gothic tapestries and English furniture. But Greek, Etruscan, Hellenistic and Roman sculptures and a large group of Greek pottery are not to be ignored.

The galleries circle a spacious four-storied skylighted court. The first-floor galleries contain the antiquities, Pre-Columbian and African collections. One cannot state with certainty where any given work will be in a museum, as incoming directors and curators are naturally prone to change—to want their individual stamp on installations. But the five stupendous Assyrian Assur-Nasir-pol reliefs will probably always remain in the first-level galleries. Classical, Oriental, Pre-Columbian and African works are also here. The purchase of the Nasli and Alice Heeramaneck distinguished Indian collection put the museum's East Indian group on a par with the collections of Boston, Cleveland and Kansas City. On display in the new Nepal and Tibet Gallery is a large selection of *tanka* (religious theme) paintings also from the Heeramaneck collection.

Decorative arts, aside from the Ancient and Classical, begin with the Gothic. Great tapestries, Oriental porcelains once in the J. P. Morgan collection, and top examples of Renaissance, Baroque and Rococo furniture are here. Recently many Nepalese fabrics and artifacts have been added.

Also among early masters represented are Giovanni Bellini, Bernardo Daddi, two extraordinary Masolino panels and a complete set of altarpiece panels by Luini. Two remarkable small, early paintings not to be missed are Hans Holbein the Younger's *Portrait of a Woman* and Petrus Christus's *Portrait of a Man*. Holbein, a German, spent many years in England, his last six in the pay of the court of Henry VIII. Here, as in his royal portraits of Henry's unfortunate queens, Jane Seymour, Anne of Cleves and Catherine Howard (as well as Christina of Denmark, who had the wit to decline his hand), Holbein painted without embellishment exactly what he saw, a vital, petulant young woman. In Petrus Christus's portrait the sitter shows a grave, enigmatic dignity, his face modeled as though it were sculpture.

Among the 19th and 20th century Europeans are a great Cézanne, *Still Life with Cherries and Peaches*, and Degas's *The Bellini Sisters*. Another portrait of them hangs in the Wadsworth Atheneum in Hartford. Other French treasures are provided by Gauguin and Matisse, and several Picassos, including the stunning *Courtesan with Collar*, painted when he was only twenty-three. Rouault's *Samson Turning the Millstone* is one of his first paintings done for a Prix de Rome competition (he did not win). When all the German Expressionist paintings are up the impact

Rembrandt van Rijn: Portrait of
Marten Looten (Los Angeles
County Museum of Art,
Los Angeles, Calif. Gift of
J. Paul Getty)

Fra Bartolommeo: Holy Family
(Los Angeles County Museum
of Art, Los Angeles, Calif. Gift
of the Ahmanson Foundation)

Uttar Pradesh, Kanauj, 6th-7th
century: Uma-Mahesvara (Los
Angeles County Museum of Art,
Los Angeles, Calif. Museum
Associates Purchase)

is terrific. A gift of 29 sculptures by Rodin further strengthens the 19th century group. *Monument to Balzac* stands at the museum entrance while *Eve, Crouching Woman, The Shade* and others are in the sculpture garden.

The strength of the American section is in its mid-19th and early 20th century holdings. Recent acquisitions are a major landscape by Jasper Francis Cropsey, Copley's *Portrait of Hugh Montgomerie, 12th Earl of Eglinton*, Gilbert Stuart's *Portrait of Richard 4th Viscount Barrington*, George Caleb Bingham's *A View of a Lake in the Mountains*, George Inness's *In the Hackensack Valley (Green Landscape)*, Winslow Homer's *After the Hunt*, Childe Hassam's *The Spanish Stairs* and Thomas Eakins's *The Wrestlers.*

The textile and costume section contains a research center used by appointment by hundreds every year. The conservation center is one of the most important on the coast. One massive spectrometer that analyzes materials in a work of art is the same machine that analyzes the findings on the moon.

The permanent collection of contemporary art may be seen in the upper level of the Hammer wing. Here one sees favorite sons Sam Francis and Richard Diebenkorn along with fine examples of most of America's leading artists. Los Angeles is a city of burgeoning and generous collectors, especially in the field of 20th century art. In 1931 when the art museum was still a part of the Science and History Museum, the William Preston Harrisons began collecting important European and American paintings with the express purpose of leaving them to the museum. Others, such as the George De Sylvias, followed. If today's collectors continue the tradition, the museum will soon be one of the richest in the country.

UNIVERSITY OF CALIFORNIA AT LOS ANGELES: FREDERICK S. WIGHT GALLERIES

405 Hilgard Avenue, Los Angeles, California

Hours: Tues.–Fri. 11–5; Sun. 1–5
Closed: Mon., Sat.

As with many university art galleries, the emphasis here is on a fine, scholarly, in-depth exhibition program rather than on building a permanent collection, although in contemporary sculpture

the museum seems to be leading the way in southern California. The Franklin D. Murphy Sculpture Garden is a tribute to the university's chancellor emeritus, who was a guiding spirit in its creation. Dr. Murphy, who believes that students should live in intimate contact with great works of art, is never happier than when he passes one of them curled up with a book within the convolutions of a Zajac sculpture. Concrete bays for sitting, reading, lolling or study are set within the garden, usually with sculpture as the focal point. The four large bronze Matisse figure reliefs placed against the pink brick of the walls at the gallery entrance are referred to irreverently by the students as "The Backs."

Set among eucalyptus, jacaranda and pine trees or bedded down on a brick terrace are 47 monumental pieces by artists of such stature as David Smith, Calder, Lipchitz, Laurent, Hepworth, Chadwick, Consagra, Rosenthal, Archipenko, Henry Moore, Noguchi, Voulkos, Rickey, Maillol, Rodin and Arp, as well as one of Duchamp-Villon's few casts of *Horse in Motion* and five heads of Matisse's *Jeanette* series. Outside of the Museum of Modern Art sculpture garden in New York and the Hirshhorn Museum in Washington, I know of no better place to view important sculpture than the plaza and gardens of the University of California at Los Angeles.

The Frederick S. Wight Galleries, remodeled and renamed for the university's longtime director and teacher, more than doubled its exhibition space. Examples from three collections that are

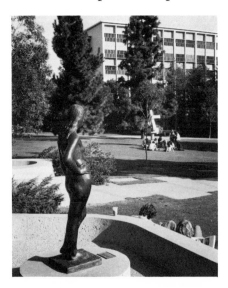

Gerhard Marcks: Freya (Frederick S. Wight Galleries, UCLA, Los Angeles, Calif. Gift of the UCLA Art Council in honor of Franklin D. Murphy)

always on view are the Sir Henry Welcome Collection of African art, the George Kennedy Collection of Oceanic art, and the Wood Collection of Pre-Columbian.

The collection of 19th and 20th century paintings contains examples by well-known Californians such as Lebrun and Oliviera and some good German Expressionist canvases, including Kirchner's last painting, found on his easel before he died.

The print galleries which run down the entire side of the second-floor wing are built primarily on material from the Grunwald Graphic Arts Foundation and contain prints ranging from the 15th century to today. Among them are Old Masters, a Japanese group—largely Hiroshige—and Matisse holdings that are second only to the Museum of Modern Art. Major strength lies in the Japanese wood block prints, the German Expressionists and the French Impressionists. The Renoir group contains all of the artist's print output but one and is on long-term loan and available to students. A set of Tamarind's annual prints was purchased so the cabinet has the whole history of this fine workshop. For specialists in design, there's the ornament collection, including rare pattern and design sketchbooks by such masters as Chippendale and Sheraton.

MALIBU BEACH

THE J. PAUL GETTY MUSEUM

17985 Pacific Coast Highway, Malibu Beach, California

Hours: Wed.–Sat. 10–5; Sun. 12–5
Closed: Mon., Tues., major holidays

In a former lemon grove high on a hill overlooking the Pacific, J. Paul Getty has built himself a museum. This is no ordinary museum but the re-creation of the Roman Villa dei Papyri at Herculaneum, near Pompeii. Built in the 1st century B.C., it was destroyed by the eruption of Vesuvius in A.D. 79. A detailed plan of the villa was drawn when subterranean excavations were made at Herculaneum in the 18th century. The plan is now in the Naples museum along with much of the sculpture found at the site. A

staggering enterprise, which must be seen to be believed, the museum opened in 1974 after three years of building on a 10-acre site adjacent to the old Getty mansion.

One enters through the 320-foot-long peristyle garden, which is surrounded by colonnaded walks. The four statues of the Seasons which grace the pool running almost the length of the garden are duplicates of the originals which were moved from the Herculaneum site to the Naples museum. All the verdant planting, flowers, herbs and shrubs, are those typical of a Roman villa in southern Italy at the time. One must constantly keep in mind that this level (not the lower floor of conservation studio, library and services, or the second floor of painting galleries) is as absolute a re-creation to scale as possible while allowing for minor adjustments in the name of museology. This can be seen in the use of old marble, ancient wall and floor mosaics and the carefully copied frescoes. Our faith in the American workman is restored, for the intricately patterned mosaic and marble floors were reconstructed by them and the plaster medallions in the ceilings were done by local artisans. Perhaps only in southern California with its elaborate movie sets could such artisans be found.

The duplicated frescoes along the atrium walls were done by Garth Benton, nephew of artist Thomas Hart Benton. At the apex of the atrium and the entrance to the museum is a two-storied enclosed peristyle holding one of the greatest treasures, the life-sized *Lansdowne Herakles*. The image of Herakles was discovered in the Villa of Hadrian at Tivoli. More than 30 copies have been associated with it. How the first Marquis of Lansdowne got the statue out of Italy is still conjecture. It remained in his sumptuous Adam house in Berkeley Square, London, until 1930 and in the Lansdowne estate until 1951 when Mr. Getty purchased it. (Get the scholarly pamphlet by Seymour Howard on the sculpture.)

The series of elaborate galleries that fan out from here are certainly environmentally appropriate to the Getty collection of Greek and Roman antiquities which range from 6th century B.C. to 8th century A.D. The works, which also include the *Mazarin Venus* (a Hellenic piece once owned by Cardinal Mazarin) and an Amazon head from the Temple of Hera in Argos, are beautifully and economically placed. One gallery holds three standing Greek figures and recessed cases with fragments and small objects; another, in Pompeian red, contains ten noble Roman busts. If the

colors seem loud, one must remember that this is the way the Romans liked them—loud.

An inner garden court open to the sky relieves the monotony of marble. One gallery off this court contains two stunning mosaics. One, *The Bear Hunt*, third century, is thought to be North African; the other, *Orpheus*, was found along with many other mosaics in southern France near Vienne in 1899. Don't miss the small collection of Etruscan objects, or the dramatic Greco-Roman *Falling Niobid*, or the Cottingham relief, a marvelous Attic piece showing a youth restraining a rearing horse.

On going to the second floor one leaves Herculaneum behind and a series of period rooms and painting galleries takes over. The opulence of marble is replaced by the elegance of silk damask, with each gallery wall a different color. The scope of the paintings is western European from the 14th into (but barely) the 20th century. A few highlights are *Coronation of the Virgin*, a polyptych by the 15th century Florentine Cenni de Francesco, Poussin's *St.*

Lansdowne Herakles
(The J. Paul Getty Museum, Malibu, Calif.)

John Baptizing the People, works by Lorenzo Lotto, Paolo Veronese, Giovanni Lanfranco and what is becoming the small star attraction, *Four Studies of a Negro's Head.* Though attributed to Rubens, many scholars feel it is from Van Dyck's hand.

The decorative arts section has been greatly expanded and features French furniture of the late 17th and 18th centuries, many pieces from royal collections, as well as silver, ceramics, tapestries and Oriental carpets. In many instances the furniture and *objets d'art* outshine the paintings. The collection of French furniture from the beginning of Louis IV's reign until the French Revolution must surely be one of the best in the country. It includes documented pieces by such craftsmen as Jean-Henri Riesener, Giles Joubert, Charles Cressent, Bernard van Risenburgh and Adrien Delorme. The early Italian paintings are set against rich red. The different schools—Tuscan, Sienese, Florentine—hang in their own bays. The Dutch and Flemish rooms adjoin. One large gallery hung in dark green damask holds enormous 17th and 18th century Baroque paintings, another the tapestry collection.

A tenuous step is made into the 20th century with works by Degas, Renoir, Utrillo, Bonnard. The rich fare upstairs is relieved by terraces where one can step from the somber past into the California sun. One looks over the long atrium; another winds down to a lower terrace which holds the museum's indoor-outdoor dining pavilion.

Static though this collection may appear to be, it is constantly being reappraised and refined. It's been a long time since Mr. Getty began rather haphazardly (did J. Paul Getty ever do anything haphazardly?) placing Greek torsos in his house on the hilltop. As his interest and knowledge of the arts increased so did the quality. The recent purchase of Georges de la Tour's *The Beggar's Brawl* is a case in point, as is Van Dyck's *Portrait of a Member of the Pallavicini Family.*

Anachronistic as it seems to re-create Herculaneum on a hill in California, attendance has been so heavy that, in spite of a large underground parking garage, the museum has been forced to close weekends. This will be rectified but in the meantime call before making the trek to Malibu. The wealth of antiquities, to say nothing of the important works of art Mr. Getty has lately been acquiring, which presumably will eventually come here, make the new J. Paul Getty Museum a major West Coast art institution.

OAKLAND

OAKLAND ART MUSEUM

1000 Oak Street, Oakland, California

Hours: Tues.–Sat. 10–5; Fri. 10–10
Closed: Mon., major holidays
Restaurant

Occupying a seven-acre site in downtown Oakland overlooking Lake Merritt, this museum designed by Kevin, Roche and John Dinkaloo Associates is one of the most satisfying art complexes in the United States. The three major museums for art, history and science are linked in one brilliant concept of connecting gardens, sometimes depressed below ground level, all enclosed by galleries and arcades. The roof of one gallery becomes the garden terrace leading into another. The interests of the three units flow into each other ideologically as well as physically, for the overall aim is to present the comprehensive story of the arts, the cultural history and the natural sciences of California and to show their interrelation. No fewer than 14 sculpture courts, both large and intimate, encircle the art museum. There the work of such artists as Peter Voulkos, Robert Howard, Roger Bolomey, and the Rodin of California, Arthur Putnam, are shown. The large central gallery is devoted to California art; its core is the Kahn Collection of 19th century art, which consists of works either by California artists or on California subjects.

In the first (blessedly carpeted) galleries one is introduced to early documented California material, including a fine genre portrait of the Davidson family. Mrs. Davidson was a Peralta. The

Richard Diebenkorn: Figure on a Porch (Oakland Art Museum, Oakland, Calif.)

site the museum stands on was a land grant of the Peralta family.

Because of California's Spanish Colonial and Last Frontier history, plus her flamboyant gold rush days, the museum is rich in visual documents. Among a dozen Bierstadts is a view of Oakland, along with four of Arthur B. Davies local views. One area is devoted to the grandiose Victorian period. *Yosemite 1876, Valley*, commissioned by Leland Stanford from William Keith, hung in the Stanford home. The marble sculpture *California Venus*, by Rupert Schmidt, is the West's answer to Hiram Powers (see Cincinnati Art Museum).

But the Oakland Museum also moves along with today's trends. Early works by California artists Diebenkorn, Park, Still, Bishop and Oliviera are here along with Ron Davies, John McLaughlin, Roy de Forest, Bruce Conner, Wayne Thiebaud and Larry Bell. The development of California crafts is well documented, especially from the time of Arthur Matthews, painter, craftsman and head of the California School of Design. A feature here is a multimedia center frequently showing films commissioned by the museum and relating either to current exhibits or Bay Area art and architecture.

The centrally located, well-named Great Hall is used for important changing exhibitions. Do not leave the complex without a visit to the lively History Museum, where you can tie in all the works of art you have seen with the memorabilia of different periods in California's history. The pleasant restaurant looks out over what must be one of the most verdant and well-cared-for museum gardens in the country.

PASADENA

THE PASADENA MUSEUM OF ART
411 W. Colorado Blvd., Pasadena, California

Hours: Tues.–Sat. 10–5; Sun. 12–5
Closed: Mon., major holidays

The former Pasadena Museum of Modern Art has its admirers and its detractors, as is usually true of any strong architectural

statement. I am one of its admirers. The building is in the shape of an undulating letter "H." Its white and tobacco-brown exterior is done in a glazed ceramic brick developed by Edith Heath, a leading American potter, and the whole is bedded in a platform of green grass. The impressive oval entrance gallery is the crossbar of the H. From it one views Pasadena's skyline or the long reflecting pool and sculpture garden on the opposite side.

The structure, designed by Ladd & Kelsey of Pasadena, was conceived to implement the museum's policy of showing 20th century art, its origins and the movements germane to it. As this book goes to press, all this has been changed. The term "modern" has been dropped from the museum's title and word has it that only about 25 percent of the museum space will be used for Pasadena's present collection, which includes top examples of Oldenburg, Kelly, Lichtenstein, Stella, Flavin, Judd, Johns, Noland and Nevelson. The museum's board has been reorganized. The Norton Simon Inc. Museum of Art, and The Harry G. Steele Foundation, long a patron of the museum, are assuming the continuance of the museum and of what amounts to its rebirth. The majority of the works of art shown will be from the Simon foundations.

Frans Hals: Portrait of a Man
(Norton Simon, Inc. Museum
of Art, Pasadena, Calif.)

Brancusi: Head of a Woman
(The Norton Simon Founda-
tion, Pasadena, Calif.)

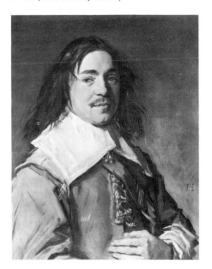

Mme. Galka E. Scheyer's historic *Blue Four* collection will remain. This is a remarkably integrated and distinguished group of works by Feininger, Kandinsky, Jawlensky, and Klee, artists who worked together in Germany before and between the world wars. The Klee and Jawlensky holdings are among the nation's finest. Of interest are Klee's comments on the problem of naming the group for an American showing. They were, he insisted, bound together only in friendship, but if they were to send work to a new country they should have a catch name; however, in no case was it to end in "isms" or "ists." Because of the association with an earlier group in Munich who founded the Blue Riders, Madame Scheyer called Klee and his three friends the Blue Four. Pasadena has an enviable assemblage of Klee's work—41 in all.

Norton Simon, a self-made man, was an early mastermind of the conglomerate. His foundations' holdings of major works of art are probably the most extensive in private hands in the country. So vast is the collection that even with the showing in Pasadena on a more or less permanent basis of many of Simon's works of art, the lending policy to other institutions will not be curtailed. The range of the collection is from antiquities to the present with emphasis on works from pre-Renaissance Europe.

It is probable that major works such as the two 15th century panels *Saints Benedict and Apollonis* and *Saints Paul and Fredoano* and the 14th century altarpiece by the Paduan painter Guariento di Arpo will be on view in Pasadena. The latter, titled *The Infancy of Christ and the Passion*, is a series of 24 panels set in a single frame, not the easiest work to move about. But don't take anything for granted. Simon's whole object seems to be to keep the collection as fluid as possible. He conceives of it as, to use Malraux's phrase, "a museum without walls," a collection of movable masterpieces. So it is obviously impossible to say at this time what will or will not be in Pasadena. Perhaps surprise will be one of the museum's delights. Now, one can only marvel at the richness of the collection, whether it be the Old Master group, the Impressionists, the cache of Picassos or the truly staggering group of 19th and 20th century monumental sculpture.

As the reorganization and remodelling of the building (to adapt to the new collections) may take some time, it would be wise to call before making the trip to Pasadena.

SACRAMENTO

E. B. CROCKER ART GALLERY

216 O Street, Sacramento, California

Hours: Tues. 2–10; Wed.–Sun. 10–5
Closed: Mon., major holidays

The E. B. Crocker Art Gallery is the only one in the United States originally designed to hold a ballroom, a billiard room, two bowling alleys and a roller skating rink. Those were Crocker's stipulations when in 1870 he retired from the practice of law and commissioned Seth Abson to erect an entertainment center and art gallery next to his home. Designed in the style of a 16th century Italian villa, the building with its richly carved and elaborately tiled interior remains much the same today. With the years facilities and wings of a more modern nature have been added.

Shortly after commissioning the art gallery, Crocker and his family went to Europe, but because his trip coincided with the Franco-Prussian War, they settled in Germany. Art dealers aware of Crocker's wish to form a collection were soon bringing him paintings from all over Europe. Five years later, when he died, the museum was filled with more than 700 works of art, many of them naturally by German artists. In 1885 the museum was given to the city by Crocker's widow.

Directors through the years have succeeded in weeding out much of the inevitable dross that comes with such impulsive gathering. Some fine Dutch and Flemish masters remain: Jan de Heem, Jan van Goyen, David Teniers, Philip Wouwerman. And there is a beautiful 15th century panel painting of *St. Bernard of Clairvaux Receiving the Stigmata from the Virgin.* However, the strength of the collection lies in the remarkable print and drawing section: Dürer, Rembrandt, Fragonard and David are a few of the artists represented by important drawings. A group of Babylon clay tablets which date from before the first millennium B.C. starts the antiquities section, which includes Greek vases, Roman glass and, jumping a continent, ceramic art of Pre-Columbian America.

The Oriental collection's *pièce de résistance* is in its large and distinguished assemblage of Korean pottery. The contemporary

Francisco de Goya: The Marquis de Sofraga (Fine Arts Gallery of San Diego, San Diego, Calif.)

Mattia: Prince Augusto Chigi (Fine Arts Gallery of San Diego, San Diego, Calif.)

Francisco de Zurbarán: Agnus Dei (Fine Arts Gallery of San Diego, San Diego, Calif.)

section received new impetus with the formation, in 1959, of the Crocker Art Gallery Association. The Mexican Rufino Tamayo's brilliant painting *Laughing Woman* proclaims the museum's intention of collecting 20th century masters on an international scale. A regular schedule of special exhibitions is maintained, and a variety of other programs is offered, including concerts, films and lectures. Wayne Thiebaud, Joseph Raffael and William Wiley make up a part of the lively group who live or teach in Sacramento.

SAN DIEGO

FINE ARTS GALLERY OF SAN DIEGO
Balboa Park, San Diego, California

Hours: Tues.–Sat. 10–5; Sun. 12:30–5
Closed: Mon., major holidays
Library (open to members and qualified students)

For San Diego's International Exposition in honor of the opening of the Panama Canal in 1915, architect Bertram G. Goodhue designed a Spanish town of cloisters, towers and palaces around a great plaza. When the fair ended, the public demanded that the whole complex, done in the ornate plateresque style of the 17th century, remain in the park. In 1926, through the generosity of Mrs. Amelia C. Bridges, a Fine Arts Gallery created in the same style opened in Balboa Park.

Spanish art is a high point here, with the Venetian, Renaissance and Baroque schools next in importance—all based on gifts of three post-Victorian maidens, the Misses Putnam, recluses who lived in an Italian villa surrounded by ten-foot-high wrought-iron fences. Even their sorties to the museum were made after hours. On a trip to Russia with their father they began collecting icons. These are housed, together with other Putnam Foundation pictures, in the Timken Gallery adjacent to the Fine Arts Gallery. When Mrs. Bridges died two of the Putnam sisters, Miss Anne and Miss Amy, assumed support of the Fine Arts Gallery. In

1966 a wing was added and in 1974 another projected. This is an orderly museum: the schools of painting are arranged chronologically—the Flemish, the Dutch, Spanish, French, and Italian. One of the Italian Gallery's high points is *Portrait of Gentile Bellini* by his brother Giovanni Bellini. Veronese, Ricci and Tiepolo, with his *Flight into Egypt*, are also here. A favorite in the Spanish Gallery is Alonzo Sanchez Coello's *Portrait of a Spanish Infante*. He may be seven, but he looks like a wise, shrewd old bishop.

The American section, a late bloomer, includes 19th and 20th century paintings, among them one of Eastman Johnson's best, *The Drummer Boy*, and canvases by most of the Eight. Twentieth century Europeans Braque, Helion and Matisse make a good showing.

The Asian collection is beautifully set around a small inner court; examples of Chinese, Japanese, Indian and Persian works are shown.

The Fine Arts Gallery leaves to its neighbor La Jolla the task of showing the more advanced or experimental forms of paintings, but its handsome sculpture garden steps right along with Niki de Saint Phalle, Joan Miró, David Smith, Marino Marini, Henry Moore and Barbara Hepworth.

TIMKEN GALLERY

Hours: Tues.–Sat. 10–4:30; Sun. 1:30–4:30
Closed: Mon., Sept.

The adjacent, small, elegant structure, the Timken Gallery, has been built exclusively for Putnam Foundation paintings. Some of the fine canvases in the Timken are Hieronymus Bosch's *Christ Taken in Captivity*, Goya's brilliant *Portrait of Marquis de Sofraga*, painted in 1798 at the peak of the artist's career; Francisco de Zurbarán's *St. Jerome* and a delightful atypical little *Agnus Dei;* El Greco's *The Penitent St. Peter*, and Juan Sanchez Cotán's *Quince, Cabbage, Melon and Cucumber*, which makes brilliant mathematical use of objects to create light and shadow.

One cannot praise this little jewel box of a museum too highly. Paintings of unique distinction have been gathered from all over the world because of one attribute: quality. Agnes Mongan, past

curator and director of the Fogg Art Museum in Cambridge, has this to say in the foreword to the catalog which she and her sister. Elizabeth Mongan, compiled: "The large Flemish panel by Petrus Christus journeyed across, or more probably around, Europe to Sicily long before it crossed the Atlantic. The Hals *Portrait of a Man* once hung in Budapest; the Cuyp *Landscape with a Milkmaid* in Russia; the Ribera *Wise Man* probably in Genoa; and the Boltraffio in Broomhall, the country seat of Lord Elgin of the marbles. The beautiful Cotán is perhaps unique among the paintings of its school in having been in the United States for more than a century.

"The Western Hemisphere was less than a dream when four of the Italian pictures were painted: the great 14th century Florentine *Dossal*, the Giotto *Eternal Father*, the Luca di Tommé *Trinity*, and the Niccolo di Buonaccorso *Madonna of Humility*."

The Timken Foundation of Canton, Ohio, which is primarily responsible for the building, is carrying out an old tradition of supporting the arts, for Mrs. Bridges, who in 1925 made possible the Fine Arts Gallery, was a Timken.

SAN FRANCISCO

CALIFORNIA PALACE OF THE LEGION OF HONOR
Lincoln Park, San Francisco, California

Hours: Daily 10–5; holidays 1–5
Restaurant

For years San Francisco was that rare phenomenon among American cities—a three-art-museum town. Each museum had its distinctive character, yet they were alike in that each started under the aegis of an important San Francisco name. The Spreckels built the Legion of Honor; M. H. de Young sired the museum that bears his name; the Crocker family had always given its support to the San Francisco Museum of Art. There was feuding and fighting and even gunplay among the three tycoons who helped shape the dapple-gray city. Today, the stories amuse—the monuments endure.

Two of the monuments, the de Young and the Legion of Honor, have been fused. While maintaining their separate identities they are now administered by one director. The Legion, almost exclusively dedicated to French art, has incorporated into its collections top French pieces from the de Young, such as de La Tour's atypical *Peasant Woman* and *Peasant Man.* The Legion's fine American paintings went to Golden Gate Park.

The museum occupies a spectacular site. Its broad front lawn, sweeping downhill, looks north across the harbor to the Golden Gate Bridge, east to the beauty of the city, while below it is a cool forest of plane trees.

When Mr. and Mrs. Adolph Spreckels gave the building to the city, they asked permission from the French government to copy the Paris Palace of the Legion of Honor, formerly the Palais de Salm, where Mme. de Staël held her famous salon. It is in the French classical style which developed in the time of Louis XVI.

Auguste Rodin aided Mrs. Spreckels in selecting many of his works which are now in the central sculpture court. *The Burghers of Calais* is an original bronze. An early marble piece was done when Rodin was only twenty-one. The powerful *St. John the Baptist* is an example of his mature style.

It would be difficult to find a comparable collection of 18th century French furniture in all America. Much of it came from Collis Huntington's house at 57th Street and Fifth Avenue, New York City, where Tiffany's now stands. Collis's son Archer in-

French Tapestry: Scene from the Apocalypse (California Palace of the Legion of Honor, San Francisco, Calif.)

School of Fontainebleau, Master of Flora: The Triumph of Flora (California Palace of the Legion of Honor, San Francisco, Calif.)

herited the house on the condition that he live in it, but, preferring California, he let it go to Yale and gave the furniture to the museum.

Fragonard's *Self-Portrait* shows him, benign and small, painting at a desk—an intense and intimate little canvas, free of the frivolity of the court of his patron, Mme. du Barry. Carle Van Loo's four paintings of the Muses—music, painting, sculpture and architecture—were commissioned by Mme. de Pompadour for her charming Château de Bellevue. La Pompadour, who collected châteaux and pavilions the way other royal mistresses collected jewelry, lavished her not inconsiderable talents on Bellevue. The paintings in time passed into the Rothschild collection in Vienna and were confiscated by the Nazis during World War II. Thomas Howe, longtime director of the museum, first saw them in the salt mines in Alt-Aussee, Austria, where the Nazis had secreted them, when he was deputy chief, Monuments, Fine Arts Section, for the U.S. Forces. Returned to the Rothschilds, they were later consigned to New York dealers, where Mr. Howe saw his official sticker still on them. He decided then and there that the Fates meant them for the Legion of Honor.

Largillière, with his *Portrait of the Marquis de Montespan*, Nattier, Boucher, Oudry, Le Nain, Corot, Manet, Monet and

Renoir are all seen in top form. A recent acquisition is *The Triumph of Flora*, surely one of the most delectable nudes in French painting. The attribution given is School of Fontainebleau, Master of Flora mid-16th century). Another rare French treasure is a superb Louis XVI salon from the Hôtel d'Humières, Paris. For some years it graced the town house of the late Otto Kahn, and then, as often happened, it became the property of Lord Duveen. The museum's brochure on the subject makes fascinating reading.

Medieval and Renaissance art have their own newly remodeled galleries with travertine floors and oak-paneled platforms and walls. A gift of furniture, metalwork, sculpture and outstanding tapestries from the Paul Fagan Collection is incorporated into this suite of three handsome rooms. Among the tapestries is the renowned series *The Apocalypse*, woven for Louis I, Duke of Anjou. The series is the oldest major French work in tapestry which has endured, dating from 1375 to 1380.

Several galleries are devoted to changing exhibitions. Part of the decorative arts collection is beautifully installed on the lower floor. The Achenback Foundation for Graphic Arts has assembled the most complete print and drawing section west of Chicago's Art Institute. Open to qualified students is work of all periods and nationalities. Spacious new galleries hold changing exhibitions in graphic art, and the conservation department, concerned solely with works on paper, is one of the few in the country working specifically with this medium.

M. H. DE YOUNG MEMORIAL MUSEUM

Golden Gate Park, San Francisco, California

Hours: Daily 10–5
Library

When the California Midwinter Exposition closed in 1895, all its buildings were junked except for the Japanese tea garden, the Fine and Decorative Arts Building, and the heavily ornamented "Royal Pavilion." Through the efforts of a group of San Franciscans, led by M. H. de Young, owner and editor of the *Chronicle,* a museum was established in the latter two buildings. De Young

had flair and a gift for showmanship (he and his brother bought 80,000 lots in Los Angeles for $10,000 and gave one away to anyone who bought a ticket to their theater, the Alcatraz). His first purchases for the new museum were from what was nearest at hand—the material that foreign governments had displayed at the fair. This ran to Sèvres and Royal Worcester porcelains, Greek vases and some fine primitive carvings, the best coming out from the South Sea Islands at the time.

In a grove of cypress and linden trees, its grounds heavy with flowers that form Matisse patterns, the museum has undergone many changes. Today it is a thoroughly pleasant building with spacious galleries and two verdant garden courts. The entrance opens into the William Randolph Hearst Memorial Court, its walls covered with what must be the largest Flemish Gothic tapestries in existence. The Hearst Collection leads directly into the Kress Collection, exhibited in three specially designed galleries. Here are Spanish, Dutch, French and Italian masters, such as Fra Angelico, Titian and Pieter de Hooch, and an El Greco of the city's own patron St. Francis. Other distinguished works are El Greco's *St. John the Baptist*, Rubens's *Tribute Money* and Dieric Bouts's small panel painting *Virgin and Child*. For *Christ Appears to Mary Magdalen after His Resurrection*, Rubens executed the figures, while Jan Brueghel the Elder painted the encompassing, frosty, blue-green landscape.

The Wespien Room, one of a series of important interiors, came from the palatial residence of the Lord Mayor of Aachen. Built in 1735, most of the palace was destroyed by bombs in the last war. A Spanish room has a 15th century Mudéjar ceiling; there's an original oak and paneled Elizabethan room. An elaborately carved French Rococo room from a château near Rouen leads into a Louis XVI Parisian room. These delightful French rooms look out into a formal garden. Each gallery is integrated with the decorative arts and paintings of the period.

Many of the paintings in the American section are top examples of their period. I think of Frederick E. Church's *Rainy Season in the Tropics*, William Harnett's *After the Hunt* and Alexander Pope's *The Trumpeter Swan*. We move from the earliest painting in the museum, attributed to Joseph Badger (1708–1765), on through John S. Copley and Gilbert Stuart to John Vanderlyn (the last of the Neo-Classicists and the first American painter to study

Dieric Bouts: Virgin and Child (M. H. de Young Memorial Museum,
San Francisco, Calif.)

in Paris), through the grandiose Hudson River School, the American Impressionists and the Eight. The cutoff date is the advent of the Abstract Expressionists. A sister museum, the San Francisco Museum of Art, carries on from there.

A new series of galleries showing various cultures of Meso-America and Africa have been installed along with works of the Northwest Coast Indians. Many of the sculptures and artifacts were purchased by Mr. de Young when they were exhibited by the various countries at the 1895 Exposition, thus putting the museum in the avant-garde in a field that is being so rapaciously collected today.

CENTER OF ASIAN ART AND CULTURE: THE AVERY BRUNDAGE COLLECTON

The Avery Brundage Collection adds another dimension to Asian art on the West Coast. Formed by Avery Brundage, longtime president of the International Olympic Committee, the center is an independent institution with its own staff and budget though housed in a wing of the de Young Museum. Brundage encountered the arts of the Orient at the first major Chinese art exhibition held outside Asia (Royal Academy, London, 1935). It was first-sight love and led to a passion to possess. The setting for the treasures is austere in its simplicity; a large window at the end of one of the galleries opens onto the trees and the old Japanese tea garden. The Chinese section makes up about one-half of the group; the ceramics alone range from Neolithic times to the present day. The 700 pieces of jade span 3,000 years of history. History is again the motif as Buddhism is traced in stone and bronze. The principal paintings are mainly Japanese, screens of the Muromachi, Momoyama and Edo periods, and Kamakura scrolls. Japanese sculptures, including five of the 6th century Haniwa period, are of wood, terra cotta, bronze and dry lacquer. Temple sculpture, steles and bronzes from India, Thailand and Korea fill out this rich pattern. Only about one-fifth of the center's collection can be on display at any given time.

SAN FRANCISCO MUSEUM OF ART

Van Ness Avenue at McAllister Street, San Francisco, California

Hours: Tues.–Fri. 10–10; Sat., Sun. 10–5
Closed: Mon., major holidays

In describing the basis for the collection I can do no better than to quote from a former director, Gerald Nordland: "The collection is drawn almost entirely from the 20th century. Two great works by pivotal masters, the 1895–98 Picasso's *Street Scene* and the 1898 Matisse's *Corsican Landscape* begin the chronology. Fauvism is represented by Matisse's *Girl with the Green Eyes*. Cubism may be studied through works by Braque, Picasso, Léger, Lipchitz. Surrealism, German Expressionism, the School of Paris and the American School from Marin, O'Keeffe, Dove, Lachaise and Stuart Davis to the Abstract Expressionists are documented."

The museum traces its origins to 1870 and the San Francisco Art Association (now the San Francisco Art Institute). In 1921 the group was incorporated as a museum independent of the association. In 1933 it moved into the new War Memorial building and under the guidance of its first director, Dr. Grace L. McCann Morley, established its direction—that of working for the acceptance of the new in 20th century art.

That the San Francisco Museum ever survived its setting is in itself an achievement. Housed by sufferance for years on part of the fourth floor of this overly imposing building, the valiant group has progressed to the point where its exhibition space occupies the entire floor. A broad red carpet leads one from sidewalk to elevator. The young gravitate here, whether to watch their children crawl through the convoluted loops of Peter Voulkos's huge sculpture at the entrance or to sit holding hands through one of Don Hallock's Videola sessions. Hallock uses electronic images thrown on a moving circular surface and combined with sound. The music may range from his own compositions to a Scarlatti sonata. The broad, high-ceilinged galleries are hospitable to even the largest of contemporary paintings. Its wide corridors are ideal for print, drawing and photographic exhibitions. Approximately half the space is used for the permanent collection and the rest for frequently challenging temporary exhibitions.

Besides the important painters of the different movements

Yves Tanguy: Hidden Motives
(San Francisco Museum of Art,
San Francisco, Calif.)

mentioned, the museum owns examples by Motherwell (with three works), Olitski, Oliviera, Hockney, Rauschenberg, Johns, Frankenthaler, de Kooning, Vicente, Gene Davis and many other established artists. More and more the museum is becoming the place to see important Bay Area artists, such as William Wiley, Robert Arneson, Bruce Conner and William Allen, and sculptors Richard Shaw, John Mason, Peter Voulkos and Bob Hudson. The San Francisco Museum of Art, together with the Berkeley museum, is at the heart of the experimental movement and takes leadership among the West Coast avant-garde.

SAN MARINO

HENRY E. HUNTINGTON LIBRARY AND ART GALLERY

1151 Oxford Road, San Marino, California

Hours: Tues.–Sun. 1–4:30
Closed: Mon., major holidays, Oct.

The botanist, the art connoisseur and the bibliophile all have special pleasures awaiting them at San Marino. Before he set about amassing his truly straggering collection of 18th century art, Henry

E. Huntington built his library, which contains one of America's great collections of British books. Oldest of all manuscripts here is the Latin Bible, 1077, belonging to Gundulf, Bishop of Rochester, England. Psalters, Books of Hours, the Ellesmere Chaucer, the Gutenberg Bible, Shakespeare's First Folio—the list overwhelms.

An important side to the library not seen by the public is its working Research Institute, dedicated to the study of Anglo-American civilization from the 16th century to the history of the American West. Work is carried on here by as many as 50 to 70 scholars at any given time.

The fabulous gardens—with five acres of camellias, with rare Oriental plants, and the largest selection of desert greenery outside the desert—were originally designed to woo Huntington's bride away from the East Coast. The Japanese garden contains a Samurai's dwelling of the 16th century replete with furniture and *objets d'art* of the period. From all over the world, Huntington brought strange and wonderful trees to shade and decorate the grounds of his San Marino ranch, on which he built in 1910 an English manor house. (This was a period when American millionaires tended to erect Renaissance *palazzi* on the Wabash and French *châteaux* on the prairies.) The public rooms of the mansion remain much as they were.

In 1913, by marrying his Uncle Collis's widow, Arabella, Henry Huntington consolidated the vast real estate and railroad fortune which Collis had established and Henry, as his West Coast manager, had rapaciously expanded. That avid and astute dealer Sir Joseph Duveen had already guided Mrs. Collis Huntington into the rarefied world of Rembrandt, Velásquez, Hals and Bellini. Indeed, the Metropolitan's prized *Aristotle Contemplating the Bust of Homer* was once in Arabella Huntington's collection. She bequeathed it to her son, Archer P. Huntington, who sold it back to Duveen.

When Arabella married her nephew-in-law, budding collector Henry, the 18th century interiors were soon filled with paintings, sculpture, furniture and *objets d'art*, some French, but most of them English. Henry Huntington's penchant for English portraiture coincided, happily for him, with a time when taxes and death duties were forcing the British aristocracy to dispose of their more valuable ancestral portraits. Duveen provided Huntington with one of the best collections of Gainsboroughs now under

one roof. Indeed, although other dealers were used, Henry relied most on the ubiquitous Duveen, who was aiding Henry Clay Frick and other millionaires in building their collections. The year he died, 1927, three years after his wife's death, Huntington purchased Sir Thomas Lawrence's delightful *Pinkie*. In the main gallery, the only addition to the house except for the service wing, hang the unreproducible original *Pinkie* and Gainsborough's *Blue Boy*, perhaps the most reproduced painting of the last century.

Blue Boy was delivered from the Duke of Westminster via Duveen for what then was the considerable sum of approximately $600,000. Later Gainsborough's *The Cottage Door* and Reynolds's masterpiece, *Sarah Siddons as the Tragic Muse*, came from Westminster through Duveen to Huntington. Duveen got *Pinkie* (Elizabeth Barrett Browning's aunt) at auction for $377,000. He offered it first to Andrew Mellon, on the principle that he must keep all his millionaires equally happy, but Mellon balked at the price. The next day he telephoned Huntington, and *Pinkie* went to Cali-

Thomas Gainsborough: Blue Boy (Henry E. Huntington Library and Art Gallery, San Marino, Calif.)

Jean Antoine Houdon: Portrait of a Lady (Henry E. Huntington Library and Art Gallery, San Marino, Calif.)

fornia. Another stunning acquisition was Gainsborough's portrait of his friend *Karl Friederich Abel*, court musician to Queen Charlotte. The high period in British portraiture, 1770 to 1795, is breathtakingly and comprehensively covered in a single gallery which focuses on Reynolds and Gainsborough. Only two canvases in the room, Henry Raeburn's *Master William Blair* and a Constable landscape, do not fall into this period. The dining room holds canvases by Kellner, Hogarth and Romney, and a stunning marble fireplace, circa 1755.

Huntington's first purchases from Duveen were the incomparable Boucher tapestries, *The Noble Pastoral*, woven in Beauvais. The Savonnerie carpets were part of a series woven for the Palais du Louvre.

While the heart of the collection is in the paintings, other rarities abound, such as the Renaissance bronzes in the small gallery to the left of the entrance and the miniatures, including one of Charles I by John Haskins. A recent acquisition is the *Shield of Achilles* modeled by John Flaxman, a leading English sculptor, and one of four cast in 1821. This one was done for the Duke of York and follows closely the account given by Homer.

When Arabella died in 1924, Huntington added a memorial wing to the library. It is fitting that the 15th and 16th century paintings, the Sèvres porcelains and most of the French sculpture is here. Mrs. Huntington's taste was the more catholic and her interests deeper. The Houdons fascinate. *Portrait of a Lady* is a tour de force in marble. In *Sabine*, Houdon makes unbelievably whimsical use of marble to portray his piquant daughter. The sculpture collection concentrates on Giovanni da Bologna, Falconet, Clodion, Houdon and the work of sculptors from the ateliers of these masters. In the Renaissance room, the Rogier van der Weyden *Madonna and Child* stands out among 12 other Madonnas of the same luxuriant period.

John Russell Pope, architect of the National Gallery of Art, was commissioned by Henry Huntington to create a mausoleum for his wife and himself. Deep in an orange grove, there they lie now, like a Medici couple, not far from the main house in which they amassed their treasures. They left behind them a handsome endowment to protect their monuments from almost any conceivable disaster.

SANTA BARBARA

SANTA BARBARA MUSEUM OF ART

1130 State Street, Santa Barbara, California

Hours: Tues.–Sat. 11–5; Sun. 12–5
Closed: Mon., national holidays

A United States post office in the Spanish Colonial style was re-modeled by Chicago's famous architect David Adler in 1939 to house Santa Barbara's burgeoning art collection. In a cool white court, one step from the busy street, are important Greek and Roman antiquities ranging from the 6th century B.C. to the second century A.D., many from the Wright Ludington Collection.

Old Master paintings include *A Franciscan Monk*, by the 17th century Spanish painter Francisco de Zurbarán, and *The Holy Family*, by Pieter de Witte. The English group holds a portrait of painter Thomas Gainsborough. Attributed to William Hoare, it was probably done to mark Gainsborough's admission into the Royal Academy.

The Oriental and Indian sections have their own tranquil galleries. Only a small part of the rare group of musical instruments can be on display at one time. Visitors are invited to play the sturdier instruments such as drums and gongs.

Primitive cultures are shown with some emphasis on Mexico's state of Guerrero. The fine African collection was gathered long before the current rage for it started.

A splendid drawing collection starts with the Renaissance and continues into the 17th and 18th centuries. Watercolors and drawings by Marin, Demuth, Miró, Picasso, Matisse and Degas have come from Santa Barbaran Wright Ludington's distinguished collection.

The museum has been a pioneer in the development of American art on the West Coast. The Preston Morton wing, built in 1961, houses this rich lode, which begins with Benjamin West and includes Copley's portrait of *General Joshua Winslow* and goes through the Hudson River School, with an important Frederick Church, to the school of the Eight. Mrs. Sterling Morton's gift in 1960, which doubled in distinguished representation 18th and

19th century paintings, has outstanding early examples of such 20th century masters as Weber, Hopper, Albers, Kuniyoshi, Sheeler and Kuhn. The museum also attunes its exhibitions and purchases to the young activists on the art scene.

The most popular painting in the museum is *The Buffalo Hunter* (circa 1830), by an unknown American who had the ability to combine the drama of his subject matter with rhythmic lines and an architectural sense of space. A strong document from our colorful past, the *Hunter* still roams the plains from one western exhibition to another.

The changing exhibition program is as active as any on this lively coast. Plans are being drawn for a three-story wing which will include a rooftop sculpture garden and restaurant. One's eye will range from Rodin and Rickey to the sculptured mountain range behind Santa Barbara.

George Wesley Bellows: Steaming Streets (Santa Barbara Museum of Art, Santa Barbara, Calif. Preston Morton Collection)

STANFORD

STANFORD UNIVERSITY: UNIVERSITY MUSEUM OF ART
Stanford, California

Hours: Tues.–Sat. 10–5; Sun. 1–5

Governor and Mrs. Leland Stanford conceived the idea of a museum as a memorial to their only son, who, though barely sixteen when he died, had a predilection for collecting works of art. While they were developing these plans the thought of a university took shape; thus the museum is probably the only one in the world to have sired a university.

The oldest art museum in the West (1891), the building was badly damaged and much of its collection destroyed during the 1906 earthquake. Today the collections are housed in the Stanford University Museum of Art and the Thomas Welton Stanford Art Gallery, built in 1917. The latter is used throughout the school year for changing and loan exhibitions. The scope is Ancient and Classical, Asian, European and American. The Egyptian material runs Pre-Dynastic to Saitic and is choice partly because the Stanfords were members of the Egyptian Exploration Fund, a society formed to finance excavations in Egypt, the findings to be distributed to subscribers. Part of Boston's Egyptian treasures also came through this fund. Many of these works are handsomely installed in the recently opened Rotunda Gallery.

Impatient to stock their museum, the Stanfords purchased outright some distinguished collections. In 1896 the Metropolitan Museum obligingly sold them about half of its Cesnola group of Cypriot antiquities. The Baron Ikeda Collection endowed them with Chinese and Japanese ceramics, paintings and Japanese lacquers. The McAdams group of American Mound relics was also acquired.

Since those early days many gifts and purchases have enhanced the Asian collection. Eleven rare Chinese paintings from the collection of Dr. Victoria Contag have been acquired. They include hangings, hand scrolls and albums, and range through the Ming (1368–1644) and Ch'ing (1644–1912) dynasties. They were brought

together in Shanghai before the Communist takeover in 1944. The Chinese jade collection should be studied.

European painting starts with 14th century Italy and is rather rich in 17th and 18th century Italian furniture and paintings. Two Longhis present charming and vivid views of Venice. Guardi's *Landscape with Ruins*, the Magnasco and the Zuccarelli should also be noted, as well as the genre paintings of 17th century Flanders. Although the collection contains earlier works, such as the Annibale Carracci drawing, watercolors, drawings and prints from the 18th to 20th centuries are being emphasized. A Rodin room has recently been added; 88 bronzes by the French 19th century sculptor came as a gift plus works in plaster, clay and ceramics, drawings and personal memorabilia and such important works as *Walking Man, The Kiss* and *Naked Balzac*. The donor is B. Gerald Cantor, for whom the gallery is named.

The California Room, a mixture of art and mementos, holds a model of the Governor Stanford, California's first locomotive, brought around the Horn and assembled in San Francisco. Used as a work engine on the building of the Central Pacific Railroad, from which most of the Leland Stanford wealth derived, it is but fitting that it should be honored by the university its labors helped to create.

Théodore Géricault: The Black Standard Bearer (Stanford University Museum of Art, the Committee for Art at Stanford and the Mortimer C. Leventritt Fund, Stanford, Calif.)

COLORADO

COLORADO SPRINGS FINE ARTS CENTER AND TAYLOR MUSEUM

30 West Dale Street, Colorado Springs, Colorado

Hours: Mon.–Sat. 10–5; Sun. 1:30–5
Closed: Mon. from Sept. to June
Library

A remarkable woman, Mrs. Alice Bemis Taylor infused the Arts Center with her own taste. Mrs. Taylor was interested in American Indians and got permission to visit the storage rooms of the Grand Canyon Hopi House belonging to Fred Harvey, whose restaurants and souvenir shops punctuated the Santa Fe Railroad lines. Harvey—in spite of his souvenir counters—was an astute collector. Mrs. Taylor was so impressed by what she saw that she bought many of his finest things and shipped them home to Colorado, without a thought of what she was letting herself in for. Today her artifacts of the Navaho, Hopi and Northwest Indians, and the Spanish Colonial art with which she later became enamored, form an important part of the museum.

The exact date when the Spanish Franciscan friars left Mexico to work among the Indians in what is now our Southwest is not known, but there is evidence of their work as early as 1610.

The missionaries were versatile, making pulpits, altar rails and tabernacles and carving religious statues, some crude, some marked by considerable skill. The first paintings were on animal hides. Later ones on wooden panels show a definite Spanish or Mexican Baroque style. During all of this time the friars were teaching the Spaniards and the Indians to carve statues for their

47

Jose Rafael Aragon: San Ramon Nonato, Bulto (Colorado Springs Fine Arts Center, Colorado Springs, Colo.)

homes and more ambitious figures for their churches. As was the tradition in Spain, many of the bultos (figures carved in the round) were dressed in actual clothing made of anything from calico to damask, though occasionally garments were painted on the carvings.

Most retablos (paintings) and bultos were undated and unsigned; the earliest examples, done under the tutelage of the friars, are delicately carved, the expressions on the faces benign. The ones executed by the Penitentes, a semireligious sect, reflect their belief in a God of blood and vengeance and are stark, macabre and chilling. Colorado Springs' examples are among the finest in the country.

The Fine Arts Center, designed by John G. Meem and opened in 1936, is an elegant, clean-lined, functional building; it was the first institution in America to conceive a structure to serve all the arts.

Its theater, completely professional, includes a high loft for building and painting scenery, an elaborate lighting board, dressing rooms—even a Green Room.

In forming the 20th century collection, the original criterion

was to obtain canvases from significant artists who had been associated with the center as teachers. Thus the center not only has Walt Kuhn's important *Trio* but also 29 oils comprising his slightly ribald *Imaginary History of the West*. Later, a broad collecting policy was adopted, so that today the collection can be summarized as containing American painting, sculpture, graphics, drawings and decorative arts from pre-historic to contemporary periods.

DENVER

THE DENVER ART MUSEUM

100 West 14th Avenue Parkway, Denver, Colorado

Hours: Tues.–Sat. 9–5; Wed. 6 P.M.–9 P.M.; Sun. 1–5
Closed: Mon., major holidays, Veterans Day
Restaurant

The architecturally striking new Denver Art Museum was opened in October of 1971 on the south side of Denver's Civic Center. Masterminded by architects Gio Ponti of Milan and James Sudler of Denver, the building's six stories rise to the height of a normal ten-story building.

The unique 28-sided building is actually two sets of stacked galleries joined by a central core of lobbies and elevators. Its roof garden furnishes one of the most spectacular mountain views in the West.

Starting in 1893, as the Artists' Club of Denver, when the town was not much more than an overgrown mining center, the Denver Art Museum has evolved into the largest museum between Kansas City and Los Angeles—with world art from nearly every period in history.

Antiquities begin with a head of *Queen Nefertiti* (1365 B.C.). The Oriental galleries are rich in objects from all the Asian countries: the goddess of love, *Lakshmi*, from the great temple complex of Khajuraho is here, as is *Kuan Yin*, goddess of mercy from the T'ang Dynasty—not in her usual heroic size, but delicately carved in small, worldly grace.

H. G. Edgar Dégas: Three Women at the Races (Denver
Art Museum, Denver, Colo.)

Exterior View (Denver Art Museum, Denver, Colo.
Wayne Thom photo)

The Italian Renaissance is portrayed by Pesellino, Carpaccio and Ghirlandaio, and works from the ateliers of da Vinci, Botticelli and Mantegna; the Italian Baroque by Veronese and Tintoretto. Spain and northern Europe are represented by paintings of Murillo, Cranach, Terborch, Rembrandt and many others. Lucas van Leyden's tapestries from the series representing *The Months*, done for Rome's Barberini Palace, were presented by William Averell Harriman to museums at terminal points along his Union Pacific Railroad; Denver's is titled *December*. The museum's extraordinary period rooms include a Spanish Baroque, a 17th century English Tudor room from Bury St. Edmunds and one of the most complete Gothic rooms outside France.

Monet, Pissarro, Sisley and Renoir head the French Impressionists. The Marion Hendrie bequest has given the museum some gems. Miss Hendrie, a birdlike little woman who played a key role in the museum's early development, made important purchases in the 1930s, including Paul Klee's *Palast Teiliveise Zerstört;* a Picasso Cubist period canvas, *Nature Morte;* and a splendid Rouault, *Portrait de Femme.* There are also outstanding examples of Braque, Modigliani, de Staël, Gris and Dubuffet.

Primitive art, including Denver's celebrated North American Indian collection formerly in Chappel House, the museum's first home, has been incorporated into the new museum. The department of New World Art is divided into three distinct areas: Pre-Columbian material, a fine collection of *santeros* (see Santa Fe, Museum of New Mexico) and a recently acquired collection of Spanish Colonial art from Peru, composed of Cuzco paintings and decorative arts. Colonial America ranges from Copley and Benjamin West through the 19th century of Peale, Ryder, Homer and Bierstadt. Rico Lebrun's *Figures on the Cross with Lantern* and the Italian Mirko's strange and vital bronze *Chimera* highlight the contemporary section.

The Neusteter Institute of Fashion, Costume and Textiles was founded in the museum in 1962 to further research and publications, to build a collection and to sponsor exhibits.

Pietro Francavilla: Venus Attended by Nymph and Satyr
(courtesy Wadsworth Atheneum, Hartford, Conn.)

CONNECTICUT

HARTFORD

WADSWORTH ATHENEUM

25 Atheneum Square North, Hartford, Connecticut

Hours: Tues.–Sat. 11–4; Sun. 1–5
Closed: Mon., major holidays

Architecturally, there is a staid sort of madness about this oldest of U.S. museums. (Others, for instance the Peale Museum in Philadelphia, can cite earlier founding, but for continuous operation as a public museum the Atheneum takes the trophy.) The Tudor Gothic building opened in 1844. Later a brick addition that can only be called American Gothic was tacked on the back. Next came the Junius S. Morgan Wing, in the best 1910 public library style. In 1934 the Avery Wing made a simple architectural statement and harmonized the whole. Now, with the new James Lippincott Goodwin Wing, the museum comes full circle. The original Tudor Gothic structure again provides the main entrance.

The statue of Nathan Hale which guarded the entrance is now boldly flanked by sculptures by Robert Morris and Alexander Liberman. A monumental David Smith stands outside the new wing's glass façade. The Alfred E. Burr Memorial Mall, while not belonging to the museum, runs down the side of the Morgan Wing. Its colossal three-story bright red controversial Calder stabile continues, although unintentionally, the museum's sculptural ambience. Some of the city fathers objected strenuously to the abstract sculpture's being placed on the mall.

The entrance foyer simulates in modern terms the original vaulted ceiling, while sculptor George Segal's white plaster man, *Trapeze*, swinging from the rafters, sets the pace of the new gal-

lery, which holds important contemporary works. (A floor plan of the museum is available at the desk and helpful.)

Paintings were hung for public viewing in the old 1807 Atheneum. But the collection was greatly expanded by 86 paintings purchased by the donor of the 1844 building, Daniel Wadsworth, and a group of Hartford citizens. John Trumbull, president of the American Academy of Fine Arts when it was founded in 1836, was Wadsworth's brother-in-law.

Although Sir Thomas Lawrence did two other portraits of the expatriate painter Benjamin West, Hartford's version is the original. In the robes of the Royal Academy's president, West lectures on "The Immutability of Colours." Among other splendid 17th to 19th century American paintings, Ralph Earl's *Portrait of Chief Justice Oliver Ellsworth and His Wife, Abigail Wolcott,* has Ellsworth holding the Bill of Rights, which he helped to write. Through the window is a view of his house, which still stands in Windsor, Connecticut. *Portrait of a Woman Knitting,* once titled *Mrs. Seymour Fort,* is one of the finest Copleys in America. Copley probably painted it after he left permanently for England, but the vigor and forthrightness of his American period is there. Fifteen Thomas Coles highlight the splendid Hudson River School group.

The Morgan Wing still gives shelter to acquisitions of that insatiable but selective collector J. P. Morgan, Sr., son of Junius S. Morgan, merchant of Hartford, later of London, in whose memory the wing was built. Greek, Roman, early Christian and Italian Renaissance bronzes enliven this wing, which also holds the most comprehensive German Meissen collection in this country.

An immensely voluptuous 17th century fountain figure, *Venus Attended by Nymph and Satyr,* by Flemish sculptor Pietro Francavilla, rises in mannered elegance in the stark three-story court of the Avery Wing. The Prince of Wales brought *Venus* from Florence to England in 1750. It was then lost (quite a feat: *Venus* is eight feet tall) and was dug up in a rose garden near Croyden in 1919.

The vagrant *Venus* is a fitting clue to the Atheneum's treasures, since its brilliant director from 1927 to 1944, A. Everett Austin, was strongly biased in favor of Baroque and Rococo art. The rapturous marvels of the Baroque collection owe their presence here to Mr. Austin's use of a bequest from Frank C. Sumner, president of the Hartford Trust. Mr. Sumner, himself a flamboyant figure who rode in a purple Rolls Royce, was never known to buy

a painting or visit a museum, yet his fund is still the major source of the museum's purchase-income today.

Random winners from various galleries: Caravaggio's *Ecstasy of St. Francis;* a dark, glowing *Crucifixion* by Poussin; and Zurbarán's magnificent *St. Serapion*, crucified with ropes for preaching the gospel to the Mohammedans. Rather new to the Spanish gallery is the *Portrait of Don Pedro Arascot* by Francisco Bayen, brother-in-law of Goya. An early Goya and an El Greco hang in the same room. Hartford has the pen-and-ink sketch for *View of the Piazzetta, Venice* by Guardi, as well as the charming painting he made from it. *The Tiger Hunt* by Rubens, a smaller version of the one in the museum of Rennes, France, has the cachet of being entirely by the master. Rembrandt's *The Boy, Turkish Women Bathing* by Delacroix, and *Jane Avril Leaving the Moulin Rouge* by Toulouse-Lautrec also command interest.

Unexpected treasures lie waiting in the mezzanine galleries around the Avery court. There is a whole wall of small French masterpieces: Pissarro's *Portrait of Minette*, Monet's *Beach at Trouville*, Courbet's *A Bay with Cliffs*, Picasso's minute *Nude*, which couldn't be more monumental if it were eight feet square. (The Atheneum held the first museum retrospective of Picasso in the United States in 1934.) The seductive, mad, dreamy and some-

Tony Smith: Amaryllis (courtesy Wadsworth Atheneum, Hartford, Conn.)

Pablo Picasso: The Bather (courtesy Wadsworth Atheneum, Hartford, Conn.)

times mischievous world of Surrealism is evoked by di Chirico, Dali, Max Ernst and others.

An important new installation is in the Garmany Gallery. All the museum's wood panel paintings, plus some sculpture, are here, including works by Lucas Cranach the Elder, Van Orley and Philip Wouwerman. Don't miss the Antwerp Nativity with its delightful Surrealist overtones.

The collections of American and English silver are stunningly shown. The Wallace Nutting Collection is accompanied by a comprehensive display of Connecticut furniture and artifacts. The whole Pilgrim century is involved in a thorough review of our founding fathers' cabinetmakers and artisans. In its new and rather sparse setting, each piece can be studied three-dimensionally.

Space does not allow us to do justice to the total collection, which includes ten important Roman fresco portraits and a wealth of paintings scarcely mentioned.

Every museum has its own personality. Some are bland, many are like nervous fillies, shying, side-stepping, running off in all directions, some are pompous. The Atheneum remains an aristocratic old lady, serene and unruffled amidst the audacities of current trends which she sometimes houses.

NEW BRITAIN

THE NEW BRITAIN MUSEUM OF AMERICAN ART

56 Lexington Street, New Britain, Connecticut

Hours: Tues.–Sat. 1–5
Closed: Mon., Sun., major holidays

On a shady side street in New Britain, this pleasant house with four added modern galleries offers a brief, nicely edited course in American art. It commences with striking Primitive portraitists and includes also Charles Willson Peale, John Trumbull, Benjamin West, Ralph Earl, John Smibert, Gilbert Stuart, Thomas Sully and S. F. B. Morse. A beautiful Thomas Cole, *The Clove, Catskills,* and a Frederick Church, *Haying Near New Haven,* represent the Hudson River School. *View of St. Peter's* is an early major work of landscapist George Inness, and one of five Innesses here. Mary

Cassatt is represented by *First Caress*, and there are three Whistlers and a fine Sargent. The genre work of Eastman Johnson, William Sidney Mount and E. L. Henry and the realism of William Harnett, John Haberle and John Peto are shown in first-rate examples. There are numerous works by Henri, Glackens, Sloan, Luks, Prendergast, Lawson, Shinn, and a fine small Bellows, *The Big Dory*. Of five Andrew Wyeths, *McVey's Barn*, a large egg tempera, is perhaps the most important. Thomas Hart Benton's four murals, *The Arts of Life in America*, sound a nostalgic note. Painted for the Whitney Museum of American Art in 1932 and acquired in 1953 by New Britain, the huge murals permanently installed in the new wing bring into focus the concentration of Benton's work here—his oil sketches for the murals, all of the books he illustrated and 68 of his lithographs. The museum is also building an archives of paintings and drawings that exemplify the work of America's best magazine illustrators of the 20th century. A portion of this famous Sanford Low Collection of American Illustration is usually on exhibit. Such well-known 20th century artists as Hopper, Burchfield, Marin, Marsh and Avery are here, too, and New Britain is taking tentative steps, starting with the Abstract Expressionists, to continue collecting in the contemporary field.

The museum gives guided tours by appointment and also lectures. It has a program of changing exhibitions.

Thomas Hart Benton: Arts of the West (New Britain Museum of American Art, New Britain, Conn.)

NEW HAVEN

YALE CENTER FOR BRITISH ART AND BRITISH STUDIES
Chapel Street at High, New Haven, Connecticut

Directly across from the Yale Art Gallery Paul Mellon's gift to the university of a Center for British Studies has taken shape in another one of architect Louis Kahn's masterful buildings. The structure of concrete and steel with a pewter finish will surround two inner courts, three and four stories high. The painting section concentrates on the British scene rather than the well-known portrait school. Some artists represented are Stubbs, Wright of Derby, Constable, Hogarth, Blake and Turner. All of the paintings not on public exhibition will be hung in space adjacent to exhibition areas and will be readily available to the public. The print room houses approximately 20,000 drawings and prints. Other features: a rare book library of approximately 30,000 volumes; a research library of over 10,000 volumes, with a reading room and photographic archive. An auditorium, seminar rooms and a paper conservation laboratory are included. A unique feature is the space along Chapel Street allotted to commercial shops. This was purposefully arranged with the town fathers so that the commercial traffic flow would not be broken. The life of the center turns inward around the court much as it did in the great medieval learning centers. The collection is the largest assemblage of its kind outside Britain. The center is due to open in 1976.

YALE UNIVERSITY ART GALLERY
1111 Chapel Street, New Haven, Connecticut

Hours: Tues.–Sat. 10–5; Sun. 2–5; Thurs. 6 P.M.–*9* P.M. *(Sept.–May) Closed: Mon., major holidays*

Shortly after the fledgling university in New Haven had been given his name, Elihu Yale presented it with its first work of art, a portrait of the reigning monarch, George I, from the workshop of Sir Godfrey Kneller, England's official court painter. To Kneller is ascribed the dubious practice of "factory painting," in which the

Ridolfo Ghirlandaio (attrib.):
Portrait of a Lady with a Rabbit
(Yale University Art Gallery,
New Haven, Conn. James
Jackson Jarves Collection)

master does the face of the sitter, then passes the canvas, assembly line fashion, to his specialists in hats, hands, or ruffles. (This system is not to be confused with the earlier European custom of apprentice or workshop painting, such as Rubens employed.)

In 1832 Yale purchased John Trumbull's series of paintings of Revolutionary battles, miniatures and portraits, and the John Trumbull Art Gallery became the first college art museum in the country. (James Bowdoin III assembled in 1811 the first college collection, but the paintings were strewn about Bowdoin's campus.) Trumbull, former aide to George Washington, was a diplomat and architect as well as a painter. Its course set, the university has continued through gift and purchase to build one of the top collections in America outside of metropolitan centers. In 1864 Samuel F. B. Morse gave his alma mater a painting by his former teacher, Benjamin West. In 1871 Yale purchased the James Jackson Jarves Collection of 119 early Italian paintings, priceless today. Jarves, scholar and connoisseur, peddled his finds to many museums before they came to rest almost by default at Yale. The collection had served as collateral when Yale loaned Jarves $20,000. After a four-year period, Jarves was unable to pay it back, and Yale bought the collection at auction for $22,000. Among the treasures are Ambrogio Lorenzetti's *St. Martin and the Beggar,* Taddeo Gaddi's *Entombment of Christ* and Ridolfo Ghirlandaio's *Lady with a Rabbit.*

Another important gift was the Société Anonyme Collection. The Société was founded by Katherine Dreier, with the help of artists Marcel Duchamp and Man Ray. A determined spinster from Brooklyn Heights who became an astute and militant patron of the arts, Miss Dreier wished her Société to promote art, not personalities (hence the name). This exposition of various progressive movements in American and European art from 1909 to 1949 includes 169 artists from 23 countries. Emphasis is on the early Russian Constructivists, Dadaists, Surrealists and the German Expressionists. Klee, Miró and Malevich made their bow to America under the Société's auspices; some others in the group are Schwitters, Gorky, Kandinsky, Gabo, Arp, Archipenko, Campendonk, Dove and Mondrian.

The present building is composed of two units, the first a 1928 "Ruskin Gothic" museum, the second a buff brick and glass extension of the parent edifice, adroitly created by architect Louis Kahn. Its interior is admirably adapted to the collection and the varied exhibitions that make up a museum calendar. From the first- and second-floor galleries one looks out on Maillol's *L'Air* and Henry Moore's *Draped Seated Woman* (also in warm weather usually draped with students in rumpled jeans pursuing their homework). Contemporary sculpture plays a strong role both inside and in the garden. Represented by important pieces are Lipchitz, Duchamp-

American Windsor chairs of the 18th and early 19th centuries, Portrait of Roger Sherman by Ralph Earl (Yale University Art Gallery, New Haven, Conn. Gerry Thompson photo)

Villon, Paolozzi, Hadzi, Rosati, Rickey, Ferber, Noguchi, Manzù and Hepworth.

Current exhibitions and the contemporaries are usually on the entrance floor. One second-floor gallery holds a staggering compendium of 19th and 20th century American classics, among them seven Eakinses, including *Girl with Cat—Katherine* and *John Biglen in a Single Scull*, Homer's *Game of Croquet*, Sargent, Bellows and Hopper.

In the main galleries the Aztecs surround Picasso, while Soutine and Francis Bacon hold their own amid the Bambara, Cura and Boga tribes of Africa. Van Gogh's famous *The Night Café* is here, along with *Reclining Young Woman in Spanish Costume* by Manet, both from the distinguished Stephen A. Clark Collection. The third-floor holdings are unbelievably rich in European art: the Jarves and Maitland F. Griggs collections of Italian art and the Rabinowitz group which contains, besides the Italian, northern Renaissance paintings such as Hieronymus Bosch's *Allegory of Intemperance* and Lucas Cranach the Elder's *Crucifixion with the Converted Centurion*.

The Oriental galleries, the Dura-European section (in 1928 Yale cooperated with the French Academy on a dig at this ancient site between Antioch and Damascus), Medieval sculpture and Classical antiquities round out this impressive horde.

One could spend days in these galleries, for the old building opens from the European section into our American past. A pivotal canvas, *Bishop Berkeley and Family*, is by John Smibert, one of the first professional artists to reach our shores. He was brought over by the bishop. Canvases by Benjamin West, Wollaston, Blackburn and Earl, and a great covey of Copleys hang about the walls. In the room of Trumbulls, cornerstone of the Yale Gallery, is Gilbert Stuart's portrait of *Trumbull* and Trumbull's own *George Washington at the Battle of Trenton*, all six feet two inches of him; also Trumbull's tiny oil-on-wood portrait of Ben Franklin in fur cap with spectacles sliding rakishly down his nose.

The superb Garvin Collection of American silver and furniture has been given a bold and exciting new installation. Francis P. Garvin, another loyal alumnus (1897), built through the years a fine American decorative arts collection which came to Yale in 1930. When he died in 1937 his widow continued his work and has made the current installation possible.

The exhibition is designed as a continuing historical promenade from our earliest engravers' tools to Charles Eames's stacked chairs. Surprises are revealed around every corner. At the entrance is a ten-foot, three-dimensional montage of craft tools, photographs, architectural drawings, paintbrushes, indenture papers, and so on. The gamut is run from Copley to the filmmaker D. W. Griffith to Warhol. Seen for the first time is the collection of wrought and cast ironware, 18th century ivory miniatures, 19th and 20th century glass. The unmatched silver collection has its own galleries, one holding a Remington Rand Lektriever with rotating shelves: the viewer pushes a button until the desired objects—whether spoons, tankards or teapots—appear. Five hundred pieces can be viewed by this method. Paintings from the university's collection are used to make a point or complement a period. A wall frieze of Windsor chairs is arranged alongside Ralph Earl's portrait of the statesman Roger Sherman sitting in a Windsor chair. One could go on and on about periods and installation. Suffice it to say that the aim is to show the American arts as creative acts that have been integrated into our daily lives, from a folk carved blanket chest to a Hepplewhite chair, from a Bible box to a whatnot from a New Orleans parlor. It's all here and it's—us.

NEW LONDON

LYMAN ALLYN MUSEUM

100 Mohegan Avenue, New London, Connecticut

Hours: Tues.–Sat. 1–5; Sun. 2–5
Closed: Mon., major holidays

The Lyman Allyn Museum was founded in 1932, a gift to the city by Harriet Allyn in memory of her father, who had been a whaling captain in New London. The imposing Greek-columned exterior whose grounds swept down in a hillside carpet of green was a town landmark. Progress in the form of a new superhighway sheared off most of the green carpet and forced the museum to

Hyacinthe Rigaud: Philip V of
Spain (Lyman Allyn Museum,
New London, Conn.)

undergo major construction. The result is a fine new entrance
accessible both from William Street and the Connecticut College
campus. Perhaps because the museum's original collection was
primarily in the field of the decorative arts, the building was de-
signed to give the feeling of a "house-museum." Through clever
remodeling much more of the collection can be on view yet the
sense of intimate proportion maintained. The first floor holds pe-
riod rooms, mostly of American origin, with much of the glass
collection displayed in window bays, and a gallery for changing
exhibitions.

One upstairs gallery done theatrically but effectively holds a
few Renaissance and Medieval pieces and liturgical objects. The
large painting gallery which includes Thomas Cole's *Mount Etna
from Taormina* is here, as are galleries holding Korean objects and
a small but selective collection of Chinese material.

An especially fine drawing in that section is a highly detailed
one of *Philip V of Spain* by Hyacinthe Rigaud. Done in chalk and
pencil, it is so finished that it is obviously the final sketch for the
identical portrait by Rigaud which is now in the Louvre.

RIDGEFIELD

ALDRICH MUSEUM OF CONTEMPORARY ART
258 Main Street, Ridgefield, Connecticut

Hours: Sat., Sun. 2–5 mid-April to mid-Dec.
Art reference library open Wed.–Fri. 1–4
Group tours by appointment

Again revolution takes place in Ridgefield, where General Benedict Arnold once barricaded Main Street to halt the British. Today the vanguard of modern art takes its stand on that same street—behind the barricades of a white clapboard church façade. Old Hundred was its name to the original tenants, the Old Hundred grocery and hardware store. Built in 1783, it became a home in 1883, a church some time later. Naturally, to create functional and airy galleries required interior changes, but New England still prevails. The original polished oak floors, the economy of color and the severity of line serenely harmonize with the art inside that prim façade. Bauermeister and Bolomey, Paolozzi, Penalba, even Picasso, bloom well in this alien soil.

Larry Aldrich, long known in the worlds of both collecting and couture, is the man responsible for the idea and the accomplishment of this vital little museum. Starting with the French Impressionists more than 25 years ago, then with the bang of the gavel at Parke Bernet divesting himself of Impressionism for the livelier rhythms of Abstract Expressionism, Aldrich moved on into newer art forms. Today his worthy aim is to show the emerging artists especially those with no dealer.

The permanent and expanding collection makes its statement in the flexible galleries of the first two floors. There are landscape and figure paintings by Cicero, Dubuffet, Freilicher, Giacometti, Golub, Oliviera, and Rivers. For he Neo-Dada symbolic image, there are works by Baruchello. Billy Al Bengston, Holden, Indiana, Ostlihn, Trova and Willenbecher. The "optical magicians" Anuszkiewicz, Avedisian, Fukui, Jensen, Kelly, Riley, Sander, Stanczak and Vasarely stir up visual excitement. Recent acquisitions include works by Fletcher Benton, Peter Bradley, Louise Nevelson, Will Barnett, Ludwig Sander and Bernard Rosenthal. There are two major exhibitions each year. From mid-April to Labor Day, "Con-

temporary Reflections" presents the work of new artists who do not have gallery affiliation. From mid-September to mid-December, new acquisitions, gifts, loans and selections from the permanent collection are on view.

A library and reading room on a lower floor leads out to the lawn, a generous carpet for what Mr. Aldrich claims is the only purely nonobjective sculpture garden in the country.

Mr. Aldrich has recently opened the Soho Center for Visual Artists at 110 Prince Street, New York City. It is an art library holding not only books, periodicals and other visual material but works on natural phenomena, space, anything that might serve as basic reference material. Admission is by artist's pass only. This can be obtained by writing to the Ridgefield museum or to the Soho Center. In a newly opened space next door, the New York public can now see work by artists who are invited to show in the Ridgefield "Contemporary Reflections" summer exhibitions. This will be an ongoing program. (The center's hours: Mon.–Thurs. 2–6; Fri. 2–8.)

Sculpture Garden (Aldrich Museum of Contemporary Art, Ridgefield, Conn. Richard di Liberto photo)

Dante Gabriel Rossetti: Veronica Veronese (Delaware Art Museum, Wilmington, Del. Samuel and Mary Bancroft Collection)

DELAWARE

THE WILMINGTON SOCIETY OF THE FINE ARTS, DELAWARE ART MUSEUM

2301 Kentmere Parkway, Wilmington, Delaware

Hours: Mon.–Sat. 10–5; Sun. 2–6
Closed: Major holidays
Library

A completely remodeled interior has given the museum flexibility and enabled it to bring more of the fine American collection to view. Important holdings are examples of Benjamin West, Rembrandt Peale, Church, Inness, Eakins and Luks, Hopper, seven Burchfields, and the largest collection of Andrew Wyeth of any museum in the country. Works by the illustrator and native son Howard Pyle are always on view, along with that of his pupils, including various members of the Wyeth family.

The Samuel Bancroft Collection of Pre-Raphaelite works is the finest in the country. The Fogg in Cambridge has more numerically, but many of them are drawings. In addition to canvases by the major painters in the movement, there is an extensive library on the subject. In fact, the new research library is a major feature of the Art Museum. The bulk of the Howard Pyle and John Sloan material is here also, along with that of Jerome Meyers.

A large center gallery houses changing exhibitions. The contemporary section is being strengthened with works by Karl Knobles, Hyde Solomon, Jack Beale, Paul Jenkins and Leonard DeLonga.

The museum, staidly placed in one of Wilmington's better residential areas, has recently engaged in an urban outreach program. It has opened a downtown gallery at 901 Market Street,

in the Bank of Delaware building (security guaranteed). Banker's hours—10–3:30—are kept. The changing exhibits reflect not only the museum's holdings but topical and practical themes as well.

WINTERTHUR

HENRY FRANCIS DU PONT WINTERTHUR MUSEUM

Kennett Pike, State 52, Winterthur, Delaware

Main museum open by appointment only. Write for information.
South Wing: Mid-April through Oct.: Tues.–Sun. 10–4. Nov. 1–
 mid-April: Tues.–Sat. 10–4
Closed: Mon., major holidays

Winterthur, the home of the du Pont family for generations, was built in 1839 by a son-in-law of Eleuthère Irénée du Pont de Nemours. Winterthur was the Swiss town from which the family had come. In 1867 it was sold to an uncle, Henry du Pont, and remained in the family until 1951 when Henry Francis du Pont turned it into a museum.

Set amid gardens and meadows on a 1,000-acre tract six miles northwest of Wilmington, the house was enlarged gradually through the years. As Henry Francis du Pont's collection of Americana grew into the most magnificent one in America, Winterthur acquired, in 1929, a new wing and interior architecture from old houses as far away as New Hampshire and North Carolina. Paintings, sculpture, furniture and decorative accessories from 1640 to 1840 were assembled in more than 125 period rooms. In the Memorial Library are two portraits of Henry Francis du Pont and a scale model of the house which indicates the changes made in it over the years. Beginning with a Massachusetts room of about 1684, and ending with one of the English period, 1815–1840, Mr. du Pont brought together from Maine to Georgia the finest or most authentic record of the architecture, arts, crafts and decorative arts of the eastern seaboard and incorporated them into the rooms. Not only are there drawing rooms of aristocrats but the shops of the craftsmen in which they were produced, such as the

Dominy Woodworking shop, Main Street, East Hampton (mid-18th to mid-20th century). Both the original workshop and a later clock shop are installed at Winterthur. Paintings play an important part in the historical survey. A pre-Revolutionary Philadelphia room has canvases by well-known 18th century American painters, including a portrait of *Mrs. Wm. Morris* done by Copley in 1772 and a group portrait of the *Gore Children* done when Copley was fifteen. Charles Willson Peale is represented by two portraits of the *Lloyd Family of Maryland.* A beautiful James Peale still life in Winterthur Hall was done when the artist was in his seventy-ninth year, in 1828. Elsewhere in the museum there are works by John Hesselius, John Wollaston and the Hudson River Valley limners, and the important small, full-length portrait of *Washington* painted by John Trumbull for Mrs. Washington in 1790. Of great historical moment is the sketch by Benjamin West of the American commissioners' 1783 meeting in Paris to arrange the peace treaty with Great Britain.

In what is possibly the largest and richest assemblage of American decorative arts in the country, we can see the life and spirit of our forebears—in both elegance and simplicity—through a great collection displayed in a great country house.

The last addition to Winterthur is a handsome library and a conservation wing. Using the latest equipment and techniques, every facet of the American decorative arts and painting and sculpture is studied and preserved. The library is open to scholars studying our decorative arts and their European antecedents. The maximum program called for 150,000 bound volumes (including periodicals), 1,000,000 photographs and 200,000 slides. After five years in the new library the museum has reason to believe it did not overbuild.

Gaston Lachaise: Torso of Elevation (in the collection of
the Corcoran Gallery of Art, Washington, D.C.)

DISTRICT OF COLUMBIA

CORCORAN GALLERY OF ART

17th Street at New York Avenue, N.W., Washington, D.C.

Hours: Tues.–Sun. 11–5
Closed: Mon.

William Wilson Corcoran, founder of the gallery, was born in 1798, reached maturity before Gilbert Stuart and Charles Willson Peale died, and outlived Sully and Neagle. As a banker he was famous for having taken up the entire loan asked for by the U.S. government during the Mexican War of 1847–1848. As a collector he believed in the native art of his time, and in 1858 he commissioned architect James Renwick, best known for St. Patrick's Cathedral in New York, to design a museum. Before the museum could open, the Civil War started and the Quartermaster Corps took over the building.

Corcoran did not get his building back until 1869. The museum opened in 1871 with a gala ball attended by President and Mrs. Grant. "The halls were hung with garlands and cages of singing canaries," reported the Washington *Daily Patriot*. Post-bellum rejoicing gave way to serious business, and Corcoran, whether from prescience or faith, began buying American paintings again. One of his few excursions into alien fields was when, through William Walters of Baltimore, he acquired a cast of every known sculpture by the Frenchman Barye. Three years after Corcoran's death in 1888 the collection was moved into the present building. The old edifice, two blocks away, has been restored and declared a public monument. Housing the decorative arts, it is now called the Renwick Gallery. The Grand Salon has been furnished to reflect the tastes of Corcoran's day, and many of the museum's

grandiose 19th century paintings have been loaned to the Renwick to hang as they did nearly a century ago.

The Corcoran shows some dozen pre-Revolutionary canvases. The earliest by a known artist is *Peter Faneuil* by John Smibert. Copley's *Jacob Fowle* is in the painter's direct, American style. Robert Feke, Christian Gullager and John Wollaston are well represented. The Hudson River School, following the tradition of romantic painting long established in Europe, became the vogue early in the 19th century, and Corcoran collected its painters, chiefly Thomas Cole. The museum is a unique bank of America's past in paintings of the events and people which shaped her. Here are portraits of presidents by Gilbert Stuart and George Healy, and a vital likeness of *Benjamin Franklin* by Joseph Wright; also one of the great documents of the western saga painted by Albert Bierstadt, who left the East to set down the drama enacted on the western plains as the Indian killed the buffalo, and the white man killed the Indian. The *Last of the Buffalo* is a moving report.

One of the most popular paintings in the museum is Samuel F. B. Morse's *The Old House of Representatives*. A drawing hangs beside the painting and serves as a key to the 86 portraits in the glowing, complex composition. Hiram Powers's *The Greek Slave* nostalgically reminds one of the museum's beginnings; the piece (one of six copies) was in Corcoran's home. One of the few nudes Victorian America took to its heart and hearth, it was approved by a committee of Cincinnati clergymen.

The painters who bridge the 19th and 20th centuries are Winslow Homer with his strong *A Light on the Sea;* Eakins, represented by *The Pathetic Song;* John Sloan with *Yeats at Petitpas;* Marsden Hartley with *Berlin Abstractions;* and George Bellows with his appealing *Forty-two Kids.* Mary Cassatt's *Woman with a Dog* was painted in Paris while she was working with the French Impressionists.

In 1928 a new wing was opened to house a bequest by the senator from Montana, William A. Clark. Among its treasures are a large group of Corots and Monticellis and some fine Degas sketches. The stamp of the Corcoran is, nevertheless, indelibly American, continuing its founder's original intention to the present day.

Much of the permanent collection has been rehung in orderly historical fashion in the spacious galleries that formerly housed the Clark holdings exclusively. The large front galleries are used

for contemporary work, whether special exhibits or the gallery's holdings. The Corcoran has always supported Washington artists, such as Sam Gilliam, Howard Mehring, Rockne Krebs, Gene Davis and Anne Truitt, as well as young unknowns. A few of the non-Washingtonians in the collection are Anuszkiewicz, Jenkins, Olitski, Pearlstein, Rothko and Bontecou. The American drawing section ranges from Copley to Calder.

DUMBARTON OAKS COLLECTION

1703 32d Street N.W., Washington, D.C.

Hours: Tues.–Sun. 2–5; gardens daily, 2–5
Closed: Holidays, July–Labor Day
Library

The prim Georgetown brick entrance of Dumbarton Oaks gives no hint of the staggering treasures it holds. The collection was formed through a lifetime of searching by Mr. and Mrs. Robert Woods Bliss and given in 1940 with the library, house and gardens to Harvard University. Dumbarton Oaks is administered by the trustees of the university.

Ivory, 10th Century: The Virgin between John the Baptist and St. Basil (Dumbarton Oaks Collection, Washington, D.C.)

The body of the collection represents the full play of the Byzantine Empire (4th–15th centuries) and the lands adjacent to it. The scale is generally intimate—metalworks, jewelry, enamels, ivories and textiles. Each piece is of the highest quality.

Another facet of the Bliss collecting which the public was generally unaware of was Pre-Columbian art. Although Mr. Bliss purchased a handsome Olmec sculpture in 1912 and added occasionally through the years, the main body of the collection was assembled between 1940 and 1960. Before Mr. Bliss's death in 1962, the collection was given to Dumbarton Oaks, with Philip Johnson designing a setting for it. The building which flows from the main house is a rich, imaginative, small wonderland. A series of glass drums forming small galleries looks outward to the woodland and inward to a simple center fountain—a single cascade of water falling to a slate-edged floor. The inner pillars are of agate marble, the floors a patterned teakwood bound by green Vermont marble. Clear plastic drums or pedestals give even such solid objects as a limestone mask (Teotihuacán, A.D. 300–600) a look of suspension in air. Objects are arranged according to cultures, primarily those of Meso-America, the best known of which are the Aztec, Totonac, Zapotec, Mixtec and Mayan and the Andean area comprising parts of Peru and Bolivia.

The Music Room, a handsome section in the original house, contains an El Greco, *The Visitation;* a late Gothic *Madonna* by the German sculptor Tilman Riemenschneider; Flemish tapestries; Italian and Spanish furniture from the 16th and 17th centuries. In this room in 1944 were held the important political conversations that led to the establishment of the United Nations the following year.

Shang Dynasty: Bronze Vessel in Elephant Form (Freer Gallery of Art, Washington, D.C.)

FREER GALLERY OF ART OF THE SMITHSONIAN INSTITUTION

Mall, South side at 12th Street, S.W., Washington, D.C.

Hours: Daily 10–5:30
Closed: Christmas
Library

No visitor to Washington should miss the Freer Gallery. The simple classic building houses one of the great Oriental collections of the world, as well as a large body of the work of the American artist James McNeill Whistler, and paintings by his contemporaries. The exhibition galleries, all on the main floor, surround an open garden court.

The donor, Charles Lang Freer, spent a considerable part of his adult life studying, traveling and collecting the arts of the Near and Far East. Resigning from the Peninsular Railroad Car Works at forty-four, he dedicated himself to building and refining his collection. He was aided by Ernest Fenollosa, a great Orientalist at both Harvard and the University of Tokyo. The Oriental section includes works of art from the Far East: China, Japan, Tibet, Korea; from Indo-China and India; from the Near East: Iran, Iraq, Asia Minor, Byzantium and Egypt. Every facet is included: sculpture, painting, ceramics, metalwork, lacquer, glass, bronze and jade.

Freer's inclusion of his friend Whistler's work is not incongruous, since Whistler, who was deeply involved with the arts of the Orient, played an important role in forming Freer's taste. The whole span of Whistler's work—oil paintings, watercolors, drawings, etchings and lithographs—is covered here by more than 1,000 objects. The famous Peacock Room, done for the London house of shipowner F. R. Leyland, is installed at the Freer. The room became a cause célèbre, and the stories of Whistler's difficulties with Leyland are legend. The sales desk at the museum supplies a booklet on the subject that is more compelling than a mystery story. A Whistler painting, a portrait known as *Rose and Silver; the Princess from the Land of Porcelain,* hangs in the room. In fact, it was for the setting for this portrait that Whistler was commissioned to alter the room slightly. His audacity led to fights, lawsuits and the mental derangement of the man who had first done

the room for Leyland. Mrs. Gardner, when she was building Boston's Fenway Court, asked her friend Sargent to try to buy the room for her, but it had already passed into Freer's hands.

Mr. Freer's will stipulated that no loans were to be made from or to the museum and that endowment income be used to add works of the highest quality to the Oriental collection only and to carry on research in the civilizations from which the objects were produced. The Freer has a training program for graduate students and plays host to scholars from all over the world.

Where does one begin in this house of treasures? With the blue and white porcelain of the Yüan Dynasty? The celadon from Chekiang Province? The Chinese jades? The great Sasanian pieces which, with those in the Hermitage, are rated the best in the world? Glass from the Mamluk period of Syria, the Chinese figure paintings, the Japanese screen paintings, one of the finest groups to be seen outside Japan? Should one visit the gallery of small, enchanting bronzes or the large gallery of sculpture that makes one light in the head from the sheer beauty of the works?

Only a part of the collections can be on view at any one time, but objects in storage may be seen by appointment.

HIRSHHORN MUSEUM AND SCULPTURE GARDEN: SMITHSONIAN INSTITUTION

Independence Avenue at 8th Street, S.W., Washington, D.C.

Hours: Mon.–Sat. 10–5:30; Sun. 12–5:30. Summer: Mon.–Sat. 10–9; Sun. 12–9
Closed: Dec. 25

The Hirshhorn, newest of Washington's art museums, was created by an act of Congress on November 7, 1966. In accepting Mr. Hirshhorn's collection (with a contribution toward the building) Congress provided a site on the Mall on which to erect the museum. The institution is governed by its own board of trustees under the aegis of the Smithsonian Board of Regents. After eight years of controversy over the name, the site, and the plan, the museum opened to the public in October, 1974. Even the professionals and sophisticates of the art world were not prepared for the sheer quantity of the collection. Of approximately 6,000 objects about 850 were chosen for the inaugural exhibition.

There is a brute force in the exterior architecture by Gordon Bunshaft (of Skidmore, Owings and Merrill), and the high unrelenting wall that surrounds most of the building does nothing to dispel this feeling. Inside, however, the harshness lessens. The cylindrical shape rests on four giant piers that reach out like Gothic arches. The interior wall of the circular building is of glass so that on every gallery level one looks down from the circle within the circle on fountain and sculpture. Daylight is controlled by neutral curtains which act as filters.

The collection ranges from the late 19th century to the present and is arranged chronologically from the lower floor through the

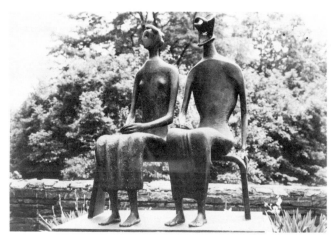

Henry Moore: King and Queen (Hirshhorn Museum and Sculpture Garden, Smithsonian Institution, Washington, D.C.)

View of interior court and fountain (Hirshhorn Museum and Sculpture Garden, Washington, D.C.)

third floor. The top floor is given to offices, conference rooms and endless storage racks. Though not open to the general public the racks are easily accessible to scholars and anyone with a reasonable request.

While the inaugural exhibition is set up in historical sequence this pattern will not be arbitrarily followed. The museum means to be fluid; to collaborate with other museums on exhibits and to show in depth the work of artists in which the museum has great holdings such as David Smith, Henry Moore, de Kooning and Nadleman. While everyone knows of Mr. Hirshhorn's passionate affinity for sculpture, few realize that the sculpture collection starts with antiquities—the Hittites, Etruscans, archaic Greeks—but goes into depth from the mid-19th century to the present. There is also a considerable collection of Benin bronzes. But at present the sculpture shown is of the 19th and 20th centuries. Daumier, Degas, Maillol, Rosso, Brancusi, Gonzalez, Magritte right on through to Pol Bury. Samaras and di Suvero. The painting collection, which has lived much of its life in warehouses awaiting this elegant exposure, is full of surprises and frequently gives an added dimension to artists long taken for granted: Max Weber's cubist period *Bather*, Walt Kuhn's *The Tragic Comedians*, Rockwell Kent's romantic and loosely painted *The Seiners*. There are stunning examples of some of today's artists—Larry Poons, Morris Louis, Helen Frankenthaler, Francis Bacon, Mark Rothko, Ad Reinhardt, Clyfford Still. Sometimes we see a canvas that seems less than a top example of an artist's work, but who knows, there may be ten others to choose from the racks. If, as is occasionally the case, one sees a painting that doesn't seem of museum quality one remembers that this is still a highly personal collection and the donor has the prerogative of hanging an old favorite if he wishes. Few will quarrel with the design of the interior space. Escalators take one swiftly from floor to floor. The painting galleries, unobtrusively carpeted, are around the outer ring of the museum while the inner glass-walled circle with its marble floors is reserved exclusively for sculpture. Occasionally sculpture is placed in the outer circle, sometimes to make a point, sometimes because of an empathy of subject matter: John Flannigan's *Lamb* (Hirshhorn's first purchase) rests before Horace Pippin's *Shepherd in a Field*. A stunning Léger is flanked by two powerful Brancusis. The change of pace between the inner and outer circle is welcome

as are the adroitly placed comfortable chairs.

One can enter the Sculpture Garden through an underground passage or cross Jefferson Drive, which separates the garden from the museum. At one time a bone of contention between Mall purists and the Smithsonian, the entrance problem was solved by sinking the garden so that at no place is the sweepingly beautiful view between the Capitol and the Washington Monument obstructed. The logical approach is from the sculpture court of the museum down the passageway under the street. At the entrance to the garden are two bronze reliefs of Thomas Eakins' *The Opening of the Fight* (The Battle of Trenton) (see Trenton Museum).

Linking the museum with the garden almost as if it were an emblem is a tall and elegant George Rickey, the two great poles so exquisitely balanced that even on a windless day they move gently back and forth like some giant metronome marking the rhythm of life.

In the garden proper, placed about with plenty of surrounding space on the golden pebbles, are the monumental works that people used to journey to the Hirshhorn home in Greenwich, Conn., to see: the abstract but evocative fractured forms of Ipoustéguy's *David and Goliath*, perhaps the most eloquent statement of that theme since Michelangelo; Maillol's standing nude, hands outstretched, palms up, that is, in one word, perfect; Matisse's four heroic-sized studies in bronze of the female back, which, from relief to relief, is transfigured from frail humanity to an immortal and powerful geometry of columns; Picasso's witty and rather endearing *Baby Carriage*, made out of old junk which has been cast into enduring bronze; Moore's majestic *King and Queen*, which even in the bright sun of a Washington autumn look as if they surveyed their desolate realm in some prehistoric winter landscape; Rodin's *Balzac* with its upward thrust of concentrated will like one of the novelist's heroes moving relentlessly up into the Parisian world of sharp practice; and that same sculptor's *Burghers of Calais*, probably the greatest single piece in the whole collection. We hope some day Manzù's *Cardinal* will come into the garden, for rather surprisingly he is lost in the main courtyard.

The begetter of all this bounty immigrated from Latvia with his impoverished family at the age of six in 1905. Self-supporting from the age of twelve, Hirshhorn used $225 in savings to establish himself at seventeen as a curb broker. He made over $100,000

the first year. But it was a plunge in the 1940s and 1950s into uranium mining that rocketed his fortune.

Collecting has obsessed him since the early 1930s. His art buying methods, like his business transactions, are quick and to the point, and woe to the dealer who tries to influence him. His mistakes and triumphs are his own. If he likes an artist his policy is to acquire as many examples as possible of his work or at least to cover many periods of the *oeuvre*. Thus he has more Eakinses than anyone in the country except the Philadelphia Museum, oils plus drawings, sculpture and memorabilia. He has between 50 and 60 Henry Moores and over 40 de Koonings. Hirshhorn feels strongly that Eakins was a bridge to the Eight, and that the group, also known as the "Ashcan School," laid the foundation for 20th century American art. He has covered the school well—a dozen Robert Henris, 13 John Sloans, 9 Lawsons, 24 Arthur B. Davies paintings, etc. Such intensive collecting as 27 Marsden Hartleys and 36 Abraham Walkowitzes, to say nothing of some 200 Louis Eilshemiuses, puts the voracious Hirshhorn in line for the William Randolph Hearst crown, the only difference being that Hirshhorn becomes involved in the artist as an artist while Hearst was involved only with collecting.

With the opening of the museum an exciting, challenging dimension has been added to the Washington contemporary art scene.

MUSEUM OF AFRICAN ART

316–318 A Street, N.E., Washington, D.C.

Hours: Mon.–Fri. 11–5; Sat.–Sun. 12:30–5
Closed: Thanksgiving, Dec. 25

Founded in 1964, the museum occupies the first Washington residence of the great 19th century abolitionist, orator and publisher Frederick Douglass, regarded today as the "father of the civil rights movement." One of Washington's newest museums, it is located on Capitol Hill, just behind the Supreme Court. In 1970 a new wing was added, designed to be compatible with the Victorian style of the original Douglass home. In addition, the museum complex now includes five other town houses as annexes, each

with a different façade to blend in with the residential character of the neighborhood. Space is provided for 12 public galleries; an auditorium gallery in which hundreds of school, civic and church groups each year attend orientation sessions on African art and culture, and a period room re-creating Douglass's original study. Housed also in the complex is the museum's permanent collection of several thousand objects of African art, including 600 works recently bequeathed to it by the late *Life* photographer and Africanist Eliot Elisofon, along with his photo archives of some 50,000 slides, photos and films on African art and environment, the largest such resource in the world.

The museum regularly displays in ongoing rotating exhibitions some 500 objects of African sculpture, including special displays of drums and musical instruments; animals in African art, of particular interest to children; jewelry, weapons, textiles and, in one gallery, African sculpture juxtaposed with examples of modern art which reflect African derivation.

During the summer months a walled garden in the rear creates a harmonious outdoor exhibition space for sturdy figures, wall plaques and elegantly carved houseposts.

The brain child of Warren Robbins, a former State Department and USIA cultural attaché, the museum is necessarily and fittingly related to the heartening American success story of Frederick

Antelope Headdress, Bambara, Mali (Museum of African Art, Eliot Elisofon Archives, Washington, D.C.)

Douglass. Born a slave in Maryland, Douglass, through strength of personality, integrity and intellect, became world renowned as an abolitionist. An adviser to Lincoln, he was thereafter appointed to high office in the administrations of five presidents—Grant through Cleveland. Today the museum in his former home reflects the strong pride he always took in the African antecedents of black Americans.

The museum's companion Frederick Douglass Institute periodically displays its collection of 19th and early 20th century Afro-American artists, including 50 works by Henry O. Tanner, and its historical exhibition "Afro-American Panorama."

NATIONAL COLLECTION OF FINE ARTS

Smithsonian Institution, 8th Street between F and G streets,
 Washington, D.C.

Hours: Daily 10–5:30
Closed: Dec. 25
Tearoom

To most Americans the Smithsonian is a huge octopus whose tentacles reach all about the Mall in Washington and whose innards are dressed in inaugural ball gowns and invigorated by Lindbergh's *Spirit of St. Louis*. If they think of the place in terms of "fine arts" at all, it's in terms of cowboys and Indians. And why not? The Smithsonian's National Collection of Fine Arts owns 445 paintings by George Catlin alone, a stupendous, staccato record of Indian tribes of the Great Plains and the far Northwest. Long housed in a crack of space between totem poles and stuffed elephants at the Museum of Natural History, the collection has at last been moved into a home of its own. The old Patent Office Building, designed in 1836 and one of the most imposing Greek Revival buildings in America, was completely remodeled and provides the new address.

The two-block building was completed in sections, the F Street part in 1842, the East Wing in 1853, the West in 1864. Meanwhile, during the Civil War, its wide corridors were used as a military hospital, and for a while the first Rhode Island Militia was quartered in its halls. The last link around a large

central courtyard, the North Wing was added after the Civil War. Although the interior is Greek Revival, arched and vaulted, clever reconstruction has made some galleries appear intimate, others grandiose.

The library, a vast room of tiered balconies that formerly displayed new inventions, has been left a fetching Victorian architectural tour de force made more fetching by the latest library devices and lights. The Archives of American Art, a national research institute devoted to documenting the history of the visual arts from 1620 to the present by preserving the papers of artists, collectors, curators, dealers and art institutions, shares the library space.

English scientist James Smithson, piqued at being denied a hereditary title because he was the illegitimate son of the first Duke of Northumberland, willed his fortune to a country he had never seen, the United States. An ungracious Congress quibbled. Senator John C. Calhoun declared it, in 1835, "beneath the dignity of the United States to receive presents of this kind from anyone." Only after three years of senatorial wrangling did a clipper ship bearing 105 bags of English gold sovereigns sail into port. Cast into American coins, they produced $508,316.46—a fine sum, indeed, in those days. Smithson's desire was that an institution be formed for the increase and diffusion of knowledge. Congress established that institution in 1846 to, among its aims, collect and show works of art.

The collection gained impetus in 1906 through an important bequest by Harriet Lane Johnston, niece of President James Buchanan.

In 1907 a New York merchant, William T. Evans, donated a long and impressive list of American paintings, among them Winslow Homer's *High Cliff, Coast of Maine*, painted in 1894 and sold to Evans in 1903. Homer had complained to his dealer: "Why do you not sell that *High Cliff* picture? I cannot do better than that. Why should I paint?"

In 1929 a colorful New Yorker, John Gellatly, donated 1,640 objects, from Egyptian mummy masks to European and American paintings, among them 17 canvases by Albert P. Ryder, including *Jonah and the Flying Dutchman*, plus 12 by John Twachtman, 15 by Childe Hassam, 23 by Abbott Thayer.

The first painting acquired is a portrait of Washington's biog-

rapher, François P. G. Guizot, by the painter George P. A. Healy. Another oldster who shared the collection's nomadic existence is a monumental marble, *Dying Tecumseh*. A British brigadier general in the War of 1812 commissioned a popular German-American sculptor, Ferdinand Pettrich, to do the famous Shawnee Indian chief. The estate of the 19th century American sculptor Hiram Powers, as left complete in his Florence studio, has come to the Smithsonian. Many of the Powers sculptures are set in their own charming gallery.

In 1938 Congress passed a bill for the National Collection of Fine Arts (its official name since Andrew Mellon's National Gallery of Art made off with its original name) to be housed in its own building. War and other priorities postponed the realization until 1968. Americans finally have a national museum whose main concern is to collect and exhibit the arts connected with America's heritage. But its activities go far beyond being a showcase. Its lending service places hundreds of works of art in government buildings, the White House included. The "Explore" gallery on the first floor, while officially for children, fascinates adults. An adjacent "Discover" gallery holds various challenging exhibitions, and a Scholars Research Program encourages students in the study of the history of American art.

On entering the museum one feels lifted into noble space. Wide corridor galleries extend the length of the building; a two-storied court faces a large quadrangle enriched by contemporary sculpture. The collection ranges from our earliest painters, John and Gustave Hesselius, Benjamin West and Gilbert Stuart, through the 19th into various trends of 20th century sculpture and painting. Vicente, Gatch, Still, Resnick, Youngerman, Calder, Rickey, Guston and Gottlieb are but a few of the artists represented with important works. Many of the contemporary works are the gift of the S. C. Johnson Collection.

The high point for any visitor must be the historic Lincoln Gallery on the third floor. Here in a room almost 300 feet long with 32 marble pillars supporting an elegant vaulted ceiling, Lincoln's second Inaugural Ball was held just five weeks before he was assassinated.

The great space is adroitly used. One is beckoned in by one of Noguchi's heroic marbles, sometimes flanked by a vibrant Frankenthaler, a Motherwell or a Hofmann. One feels the whole

Robert Rauschenberg: Reservoir
(National Collection of Fine
Arts, Smithsonian Institution,
Washington, D.C.)

Ferdinand F. A. Pettrich: The
Dying Tecumseh (National
Collection of Fine Arts,
Smithsonian Institution,
Washington, D.C.)

sweep of the place. As one proceeds down the long room areas of history, or style, appear: the genre painters summon us; George Catlin and his Indians have their own enclave; we end with the early 18th century. One can reverse these peregrinations by entering through another door that leads directly into the early works, but the main traffic flow leads one into the present. Either way the Lincoln Gallery, summing up as it does the purpose of the collection, is not to be missed.

NATIONAL GALLERY OF ART

Constitution Avenue at 6th Street, N.W., Washington, D.C.

Hours Mon.–Sat. 10–5; Sun. 12–9. April 1–Labor Day: Mon.–Sat. 10–9; Sun. 12–9
Restaurant

In 1937 Andrew Mellon, secretary of the treasury under three presidents, gave to the people of America the Andrew Mellon Collection of works of art and provided for a building worthy of them. No less important than the gift was the structure Mr. Mellon devised for the gift's protection. The National Gallery, though technically a bureau of the governmental Smithsonian Institution, is autonomous and governed by its own board of trustees. The chairman is the chief justice of the United States; other trustees are the secretaries of state and the treasury, the secretary of the Smithsonian, and five citizens who may not be government employees. Thus the highest offices in the nation help guard the gallery.

Mellon's aim was ambitious: to establish the nucleus of a great national collection. He succeeded. There are examples of almost every artist whose influence was felt through seven centuries. His great coup was the purchase in 1930 of 21 masterpieces from the Hermitage in Leningrad. These include Botticelli's *Adoration of the Magi*, Raphael's *Alba Madonna*, Perugino's *Crucifixion*, van Eyck's *Annunciation*, Titian's *Venus with a Mirror*, and works by Van Dyck, Hals and Rembrandt.

Other important collectors took up Mr. Mellon's challenge. When the gallery opened in 1941, the Samuel H. Kress Collection had been added and the Kress Foundation continues to make

Leonardo da Vinci:
Ginevra de' Benci
(National Gallery of Art,
Washington, D.C. Ailsa
Mellon Bruce Fund)

Georges de la Tour:
Repentant Magdalen
(National Gallery of Art,
Washington, D.C. Ailsa
Mellon Bruce Fund)

munificent gifts. Joseph A. Widener's group came next. The superb Lessing Rosenwald Print Collection followed, an anthology of 20,000 prints ranking in quality with the world's greatest. The impressive French 19th and 20th century collection of Chester Dale came together at last in the National Gallery. Cézannes, Monets and Renoirs that many of us grew up with in the Chicago or Philadelphia museums are now in continuous flow at the National Gallery. Twenty-two works of art from the W. Averell Harriman Collection strengthen further the French 19th and 20th century section. Five major Cézannes bring the gallery's total to 18, one of the most important assemblages of Cézanne's work in the world, including the monumental *Portrait of the Artist's Father*. The delightful Picasso *Lady with a Fan* was once in the collection of Gertrude Stein.

The American section contains some early works of great quality. *The Skater* is a masterpiece of Gilbert Stuart's English period. Copley's *Watson and the Shark* was recently acquired from Christ Hospital, London. It had been bequeathed to the hospital by Sir Brook Watson, who commissioned the painting to commemorate either the losing of his leg or the saving of his life (see Detroit). Thomas Cole's second version of the *Voyage of Life Series* (see

Walt Kuhn: The White Clown (National Gallery of Art, Washington, D.C. Gift of the W. Averell Harriman Foundation)

Munson-Williams-Proctor Institute, Utica, New York) has recently come to the National Gallery after hanging in relative obscurity in Cincinnati for a century. From Whistler, Homer and Eakins we move to the American Impressionists and the school of the Eight, and from there to five major paintings by Walt Kuhn. A part of the Harriman bequest, they include *Green Apples and Scoop* and *The White Clown*. With the acquisition of Piet Mondrian's *Lozenges in Red, Yellow and Blue* and a key Picasso Cubist period canvas, *Nude Woman*, the National Gallery moves into the trend-setting world of Contemporary art. From now on the new East Wing will be the backdrop for important contemporary masters.

Jewels of rare value plucked from castle walls or auction blocks continue to enhance the National's holdings. One is *St. George and the Dragon*, a minuscule painting once attributed to Hubert van Eyck but now given to Rogier van der Weyden. A recent major acquisition is Théodore Géricault's *Trumpeters of Napoleon's Imperial Guard*. Mathias Grünewald's small crucifixion was found in the attic of a house in Essen, Germany, in 1922. Surely *Young Girl Reading* is one of Fragonard's most impressive canvases. The diadem seems to have been placed in the National Gallery's crown with the purchase of Leonardo da Vinci's portrait of the pensive but arrogant *Ginevra de' Benci*, the only painting by Leonardo in the western hemisphere. With the purchase of a distinguished Rubens, *Deborah Kip, Wife of Sir Balthasar Gerbier, and Her Children*, the Andrew Mellon acquisition fund closes. How truly fitting and fortunate for the Gallery that Mr. Mellon's children, Paul Mellon and the late Ailsa Mellon Bruce, have carried on the tradition of giving important works of art.

A painting to vie with the sophisticated *Ginevra de' Benci* has recently come to the Gallery through the Ailsa Mellon Bruce Fund. It is Georges de la Tour's *Repentant Magdalen*. These disparate ladies represent the ultimate in quality from both Mellon Funds. The de la Tour, painted between 1738–42, practically disappeared from view in the 18th and 19th centuries. Only in recent decades have the artist's works come to the forefront again. One hesitates to call such a somber and reflective painting dazzling but dazzle it does. Andrew Mellon's daughter and son have also funded expansion, the East Wing, which will house a Center for Advanced Studies in the Visual Arts, and spacious

exhibition galleries to hold the growing collection of 20th century American and Western European art. I. M. Pei fulfilled one of the architectural challenges of the era in designing a building of beauty, excitement and functionalism on an asymmetrical, trapezoidal plot bounded on one side by the Mall and situated on the axis of Constitution and Pennsylvania avenues, the ceremonial route between Capitol and White House.

Aside from the difficult site, there was the further challenge of conformity with surrounding buildings. The cornice line follows those of other structures on Pennsylvania Avenue; the material is the same Tennessee marble as the parent building. A broad tree-lined plaza stretches between the two structures at street level; a long concourse joins them below. Three of the nine stories of the East Wing are below ground. Here light comes from the plaza fountain above, which sends a well of water downward against lighted glass walls. A 700-seat cafeteria and a print and book sales room are here. From the plaza area one enters a great, glass-roofed central courtyard opening to four levels of balconies, bridges and courts. Staircases and hidden escalators take one to three gallery towers which are connected by bridge galleries. The Center for Advanced Studies, a unique complex of photograph archives, art library and scholars' studies, has its own entrance. A charming restaurant on an upper floor overlooking the Mall and a cafeteria on the lower serve both center and galleries.

The Gallery seems to be making a breakthrough in ways other than architectural. In its expanding program it will not only be a center for advanced studies for scholars but will allow the public easier access to works usually reserved for specialists. How this is to be accomplished remains a mystery, but if it succeeds it will be a real innovation in museum practice.

Invaluable for a first visit to this stupendous treasure house is the free booklet of general information available at the sales desk on the ground floor. A separate floor plan, color-keyed by periods, makes it easy to find what is where. Many galleries have free fact sheets of paintings on exhibit. But do not try to see everything on one visit. Three to four tours, one general, the others on specific facets of the collection, are given each day. If you prefer to be on your own, Acoustiguides are available in four languages. On Sunday evenings (except in summer) free concerts are given in the luxuriant Garden Court.

NATIONAL PORTRAIT GALLERY

Smithsonian Institution
F Street at 8th Street, N.W., Washington, D.C.

Hours: Daily 10–5:30
Closed: Dec. 25
Tearoom

In 1857 Congress commissioned G. P. A. Healy to paint a series of presidential portraits for the White House. Intermittently through succeeding decades there was talk of establishing a National Portrait Gallery, but it wasn't until 1962 that through an act of Congress such a collection was established. The gallery was formally opened in 1968 in the historic Patent Office Building (see National Collection of Fine Arts, Washington). Gathered together here for the first time in our history are likenesses of the great, the near-great and the infamous, men and women whose lives and deeds have shaped our country. The Archives of American Art (see National Collection of Fine Arts) has been given space on the ground floor of the Portrait Gallery in which to show through changing exhibitions letters, documents and photos in the collection of archival material.

The collection's concern encompasses all media: painting, sculpture, drawings, prints, miniatures and bas-reliefs. With the exception of daguerreotypes, photography is not included.

Portraits are not admitted to the collection until ten years after the subject's death. However, under special circumstances—such as the gallery's acceptance of Peter Hurd's portrait of President Lyndon B. Johnson which the former president refused—the canvases are held for later addition to the collection. Under this proviso portraits of people still living can be exhibited.

The first floor is used mainly for temporary exhibits. These divide roughly into three areas: theme shows which elaborate on the purpose of the permanent collection, *oeuvre* and iconographic exhibitions. They are all importantly mounted in an ambience subtly suggesting their period.

The earliest likeness, one of Pocahontas done in 1616 by an unknown English painter, shows our Indian maid with an Elizabethan lace ruff around her sweet, inscrutable face. It hangs at the foot of a handsome double staircase leading to the second

William Fisk: George Catlin
(National Portrait Gallery,
Smithsonian Institution,
Washington, D.C.)

floor. Here, from a vestibule dominated by Gilbert Stuart's full-length portrait of George Washington, the presidential corridor extends, showing portraits from Washington to that of Richard Nixon by Norman Rockwell.

Smaller galleries correlate our history and the people who made it. One shows the men and women connected in various capacities with the Civil War. Another exhibits our 19th century writers, philosophers, artists and scientists. In many cases the examples are of distinguished people being painted by distinguished artists such as West, Copley, the Peales. George Catlin did William Clark of the famous Lewis and Clark expedition. It was Clark who gave Catlin clearance to go out and do his paintings of the western Indian tribes. In our own day there is *Henry Miller* by Marino Marini, *Henry Cabot Lodge* by John Singer Sargent, *Tallulah Bankhead* by Augustus John.

Naturally, starting so late in the history of our nation, the gallery has missed many fine historical portraits that long ago found their way into museums and statehouses. However the collection of more than 750 paintings and sculptures assembled since 1962 is nothing short of miraculous. The Portrait Gallery has its own entrance but shares space with the National Collection of Fine Arts and the Archives of American Art. All three organizations are under the aegis of the Smithsonian Institution.

PHILLIPS COLLECTION

1600–1612 21st Street, N.W., Washington, D.C.

Hours: Tues.–Sat. 10–5; Sun. 2–7
Closed: Mon., major holidays

The Phillips Collection is distinctly personal. Even in his under-graduate days at Yale, Duncan Phillips's interest in art ran parallel to his interest in literature. Later he and his wife, painter Marjorié Phillips, decided to form a collection in this rambling, pleasant house where he grew up. It was incorporated as a museum in 1918, 11 years before New York's Museum of Modern Art came into being. Though stressing the contemporary, the collection goes back in a few examples to El Greco and the roots of modern art. The Phillipses continued to live in the house until 1930, when their avidity as collectors finally forced them into another home.

Mr. Phillips has stated his aim succinctly and lucidly: "It is the collection's diversity and its unity as a personal creation which gives to our institution the special character that makes it some-thing of a novelty among the public galleries of the world ... ours is an unorthodox gallery with a way of its own in not segregating periods and nationalities, the better to show the universality of art and the continuities of such ancient seeing habits as realism, ex-pressionism and abstraction."

A new wing of nine galleries has been brought into harmony with the spacious old house. The same "invitation to linger" per-

Pierre Renoir:
Luncheon of the
Boating Party
Phillips Collection,
Washington, D.C.)

Willem de Kooning:
Ashville (Phillips Collec-
tion, Washington, D.C.)

vades. Don't look for historical sequence or "school of" in the installation. You may find a room of smashing Braques, or a Prendergast may hang between a Berthe Morisot and an early Picasso, on the assumption that certain paintings have a natural affinity which is not necessarily intellectual. Two that challenge the imagination are El Greco's and Goya's interpretations of the theme *The Repentant Peter.* They adhere precisely to the subject yet differ utterly in spiritual content. The *Peter* of Goya is an earthy peasant overcome by the enormity of his betrayal, beseeching forgiveness. The *Peter* of El Greco, expressively sorrowful, is already forgiven and lifted into a mystical union with God.

Another fascinating pair, this time by the same artist, van Gogh, are *Entrance to the Public Gardens, Arles,* where trees are softly swirling brush strokes, and *Street Pavers,* whose trees literally writhe their way through the pavement, seeming to be made of sinew rather than wood.

Standing before Thomas Eakins's portrait of the tired, introspective *Miss Van Buren,* one is puzzled that it took this American painter so long to be recognized. Renoir's glowing *Luncheon of the Boating Party* is surely one of the greatest Renoirs extant. The delectable young woman with the poodle in the left foreground became Mme. Renoir shortly after the picture was painted. One could go on isolating masterpieces—Braque's *Philodendron,* the small masterful Degas, *Women Combing Their Hair,* and another little gem, Corot's *Genzano.* But to do this at the Phillips is to court frustration.

Duncan Phillips acquired anywhere from five to twenty examples of the work of many artists, and his collection of Bonnards is

the largest in this country, the first bought 35 years ago before Bonnard was well known here. Some of the Americans represented voluminously are Hartley, Gatch, Burchfield and Knaths. The group of Arthur G. Doves is truly enviable. Mark Rothko has a gallery all to himself; the Phillips was the first museum to purchase a Rothko. De Kooning, Joan Mitchell, Pollock, Guston, Sam Francis, Ben Nicholson, Jack Youngerman and Clyfford Still are represented. Recent acquisitions include Morris Louis, Georges Mathieu, Ken Noland, Adolph Gottlieb, Jack Tworkov, Tony Caro, Frank Stella and several more Karl Knaths.

It is a temptation to go on about the Soutines, Klees, Rouaults, about Weber, Marin and Matisse, about André Derain's *Summer Day*, evoking memories of southern France and almond trees in bloom. In fact, it is a temptation just to stay in the Phillips. Music is almost as much a part of the gallery life as is painting. Every week, except in summer, there are concerts, and many a young composer has had his first hearing in the gallery. A program of activities is available at the desk.

RENWICK GALLERY

Pennsylvania Avenue at 17th St. N.W., Washington, D.C.

Hours: Daily 10–5:30
Closed: Dec. 25

The beautiful Renwick Gallery was designed in 1859 by James Renwick for collector William W. Corcoran. The Civil War interrupted building, and it wasn't until 1874 that Corcoran moved in his collection (see Corcoran Gallery, Washington). From 1899 to 1964 the building was used by the U.S. Court of Claims. The Smithsonian Institution took over in 1966, renamed the building in honor of the architect, and opened it in 1972 as the decorative arts department of the National Collection of Fine Arts. Today it is a showpiece of former grandeur: the great staircase, the Octagon Room, the Grand Salon have been furnished to reflect the taste of the mid-19th century. The rest of the building holds smart, streamlined galleries where special exhibitions on American design and the crafts—both historical and contemporary—are held. One of the galleries displays works from abroad.

Ralph Earl: Portrait of the Vandeleur Family (University of Miami: Lowe Art Museum, Coral Gables, Fla.)

FLORIDA

UNIVERSITY OF MIAMI: THE LOWE ART MUSEUM

3301 Miller Road, Coral Gables, Florida

Hours: Mon.–Fri. 12–5; Sat. 10–5; Sun. 2–5

The Lowe Gallery not only serves a large student body but shares freely its cultural and educational facilities with the whole greater Miami community. The simple, pleasant 1952 building at the edge of the campus will soon have a multilevel addition. A generous grant from Mr. and Mrs. Howard Garfinkle, collectors of American art, has not only made this possible but, for a period of years, the Garfinkles are matching funds for maintenance and operational expenses.

Dr. Virgil Barker, revered historian of American art and author of *American Painting: History and Interpretation*, was the gallery's first director, which accounts for the distinguished and catholic group of American paintings, primitive through contemporary, that the museum owns. With this basis plus the Barton collection of Primitive art, consisting mainly of works of American Indians of the Southwest, the museum plans to strengthen further its American holdings. The Barton collection contains a stunning group of Rio Grande blankets. Spanish colonial weaving was introduced into what is now New Mexico before the mid-17th century. By 1860 weaving had developed into a sophisticated art form. The strong abstract patterns used by both Mexican and Indian bring them very much into today's focus.

Architecturally, the building will take advantage of the unique south Florida environment. The plan allows for a range of avant-garde techniques using various mixed-media methods. While emphasizing American art, the total museum content is not over-

looked. The Kress galleries of Renaissance and Baroque art are always on view. Among the jewels: *Madonna and Child with Donor* by Adriaen Isenbrandt; *Portrait of a Man*, Giovanni Bellini and a small charmer by Francesco Guardi, of that oft-painted church, Santa Maria della Salute, in Venice.

Oriental objects range from T'ang through Ming dynasties. There is a large print collection, also Pre-Columbian works and a salon of young Latin American artists. The new facility allows for the broadening of the fine permanent collection, while further strengthening the American section and making the museum a major research center in American art.

JACKSONVILLE

CUMMER GALLERY OF ART

829 Riverside Avenue, Jacksonville, Florida

Hours: Tues.–Sat. 10–5; Sun. 2–5
Closed: Mon., major holidays
Library

The inviting entrance foyer here, a fetching blend of marble and polished wood, looks directly through a loggia to the St. John's River beyond. The gardens once graced the old Cummer mansion, on whose site the museum was erected in 1961. It is a simple, symmetrical building with galleries flowing around three sides of the central loggia. In this small, orderly museum the historical progression of the art on view starts to the left and brings one eventually back through a room of 20th century paintings. Beginning with an Egyptian head and a Greek kylix, one moves to 15th century paintings. Seek out *Avarice*, a penetrating canvas by Paulus Bor, a little-known master and follower of Rembrandt; the three remarkable portraits by unknown Elizabethans who obviously cleaved to the pattern set by Holbein at the court of Henry VIII; a 16th century Spanish writing desk-chest, embellished with Limoges enamels depicting the life of the Virgin. Other artists and works: Hendrick van Dalen, Anthony Van Dyck, Isaac van Ostade, and Ribera's *St. Peter*, the Bernini marble of *Cardinal Richelieu* and *A Musical Party* by Theodore Rombauts.

Tapestries, furniture and *objets d'art* of corresponding period and place complement sculpture and paintings. Some portraitists are Gilbert Stuart, Benjamin West, John Neagle, John Hoppner and Sir Henry Raeburn. G. P. A. Healy has done a beautiful little portrait of President Andrew Jackson. The 19th century American group has a small but choice Thomas Cole and a dreamy little Martin Heade, *St. John's River*, the same river that laps along the museum's gardens. The group also includes Moran, Bierstadt, Innes and Homer.

No knowing pilgrim leaves the Cummer Gallery without seeing the Ralph H. Wark Collection of Meissen china, the largest group of Meissen tableware in the country and one of the great collections of the world. This collection continues to grow, and five uniquely important miniature Meissen vases have just been added. Mr. Wark and his sister assembled not only this earliest of European china but the first pieces done by its innovator, Johann Friedrich Böttger, the man who discovered the Chinese secret of true porcelain. These unsophisticated early pieces of red sandstone date from 1708 to 1710, the year Böttger produced his first white porcelain. Many exquisite and well-documented examples come from celebrated collections—from the Japanese Imperial Palace, from Elizabeth of Russia's collection in the Hermitage, from Marie, Queen of Hanover. They captivate both aesthetes and students alike.

Gian Lorenzo Bernini: Cardinal Richelieu (Cummer Gallery of Art, Jacksonville, Fla.)

JACKSONVILLE ART MUSEUM

4160 Boulevard Center Drive, Jacksonville, Florida

Hours: Mon.–Fri. 10–5; Thurs. 8 P.M.–10 P.M.; Sat.–Sun. 2–5
Closed: Legal holidays, Aug.
Library

Set in a wide grove of cypress trees one block from a busy thor
oughfare, the Jacksonville Art Museum, a low rectangular build
ing, has recently been added to in an original way. Six platform
galleries cascade down the hillside to a tidewater stream. Rest
areas, where one can enjoy both art and nature, are placed along
the descent. A wide atrium introduces the wing which provides a
spectacular setting for a collection of 470 Chinese porcelains, gift
of land developer Ira Koger. The group is arranged by color
instead of chronologically. Any slight confusion is made up for in
visual impact. The range is 16th to 18th centuries. Some high
lights are a fine Yung Cheng (1723–35) bottle in "mirror" black,
a *wu-tsai* bowl with the reign mark of Chai Ch'ing (1522–66) and
what is considered the star of the collection, a blue and white
Ch'eng Hua stem cup. With a renaissance gesture, Mr. Koger pro
vided funds for the wing (designed by Robert Broward), endowed
the collection and imported a specialist to catalog it. The sculpture
garden has been extended and includes an amphitheater.

With the exception of a small collection of celadon ceramics,
the collection is primarily focused on 20th century, Pre-Colum
bian, and African art, thus complementing Jacksonville's Cummer
Gallery, which covers other areas. Among some of the contem-
porary artists are Forest Meyer, Theodore Stamos, Prescott Smith,
Beverly Pepper and Gene Davis.

A stainless steel, bronze and copper sculpture rises 40 feet in
the sculpture court, as tall as the spindly pines around it. It is the
work of André Bloc, one of the first environmental sculptors.

Begun as a teaching institution, the museum gives instruction
in most art forms, including photography and filmmaking.

MIAMI

MIAMI ART CENTER
7867 North Kendall Drive, Miami, Florida

Hours: Daily 9–5. During an exhibition: Mon.–Fri. 10–4:30; Sat., Sun. 1–6; Mon., Thurs. 7 P.M.–9:30 P.M.
Closed: Major holidays

One hopes that with the gift of a selection from the C. Ruxton Love collection to the Miami Art Center, Miami, the only city in the United States of comparable size without a major art museum will do something about building one. The present staff of the Art Center, which is housed in a small contemporary building, works valiantly at presenting imaginative changing exhibitions to meet the cultural needs of a polyglot population. Exhibitions range from "Things We Use" to "Art of the Asian Mountains."

With the exception of the Love collection of paintings, sculpture and some African material, the holdings are mainly in ceramics and textiles, with a good section of contemporary prints.

PALM BEACH

SOCIETY OF THE FOUR ARTS
Four Arts Plaza, Palm Beach, Florida

Hours: Mon.–Sat. 10–5; Sun. 2–5
Closed: Jan. 1, Dec. 25

The Society of the Four Arts is a beautifully understated cultural complex that really does not fall within the purview of this book.

However, during the long winter and spring season a series of distinguished exhibitions is held in its galleries while a large auditorium accommodates an active program of music, the dance, film and lectures. After the building opened in 1939, the first exhibi-

tion included Rembrandt's *Aristotle Contemplating the Bust o*
Homer, thus setting a tone for quality that has carried into the
present. This Rembrandt, when purchased by the Metropolitan
Museum of Art in 1961, broke all attendance records as the public
queued up to observe Aristotle's contemplation.

A library and intimate gardens that would make a horticul
turalist's pulse race form a part of the complex. Plans are under
way to build a permanent collection limited to 19th and 20th
century art.

ST. PETERSBURG

MUSEUM OF FINE ARTS

255 Beach Drive N., St. Petersburg, Florida

Hours: Tues.–Sat. 10–5; Thurs. 10–9; Sun. 1–5
Closed: Mon., Dec. 25
Library

A newcomer to the art scene, this sprightly museum opened in
1965. The curving entrance façade is classical in design, while the
rear of the building, overlooking Tampa Bay, with its tiled court-
yard and lush planting can only be described as Florida Mediter-
ranean. Although the collection is understandably modest, there
are good beginnings in the arts of the Southeast area and impor-
tant long-term loans of leading French Impressionists Monet,
Renoir and Gauguin. American paintings include one of Thomas
Moran's rare Florida paintings, *St. John's River,* and important
works by Samuel Lovett Waldo, John Frederick Peto, Theodore
Robinson and Georgia O'Keeffe. The 24-foot-high dark marble
entrance hall is elegantly embellished by enormous carved and
gilt twin mirrors from Blenheim Castle. A century ago one of the
Dukes of Marlborough, more interested in agriculture than art,
sold these handsome mantel glasses to raise money for his agrarian
needs. Blenheim Castle now has copies of the mirrors.

Two of the museum's nine galleries are period rooms, Jacobean
and Georgian. One tranquil gallery, a reflecting pool in the midst

Pieter van der Bos: Portrait
of a Young Lady (Museum of
Fine Arts, St. Petersburg,
Fla.)

of the museum's busy life, forms a setting for specimens of Indian,
Southeast Asian and Chinese art, including a full standing chlorite
figure of Vishnu of the Pala Dynasty from the 12th century and an
impressive elaborately carved wood household shrine from the
west of India.

St. Petersburg, a favorite spot for retirement, offers built-in
advantages which the museum's director wisely taps. From talents
in the town he has assembled a volunteer staff on a par with pro-
fessionally staffed museums. Seven retired graduate librarians staff
the museum library. A retired dean of architecture from Pratt In-
stitute has given and maintains his large collection of architectural
slides. The museum thus brings services to its public far beyond
the dream of the average small museum. A 200-seat lecture-theater
is a recent addition.

SARASOTA

JOHN AND MABLE RINGLING MUSEUM OF ART

U.S. Highway 41, Sarasota, Florida

*Hours: Mon.–Fri. 9 A.M.–10 P.M.; Sat. 9–5; Sun., holidays 1–5
Library*

As a young man traveling the circus circuit, John Ringling visited museums and art galleries and began buying the lesser Barbizon painters. On one of his European trips he asked Julius Boehler, an art dealer, to help him pick out statuary for a grandiose real estate venture he planned for Sarasota. From Venice to Naples they went, buying up marble doorways, columns and statues by the dozen. They ordered an 18-foot copy of Michelangelo's *David* cast in bronze. The real estate scheme never saw daylight. The idea of a museum in which to house his treasures did. Ringling commissioned a building in the style of late Italian Renaissance, with wings enclosing a long, formal garden court. *David* stands now between the loggias that parallel the wings.

When Ringling died in 1936, he left the art museum and its collections, 68 acres of exotically landscaped grounds and his palatial residence to Florida. After ten years of litigation, his estate was finally settled and the state was able to accept the donor's gift. A. Everett Austin, Jr., former director of the Wadsworth Atheneum in Hartford, was named director. An authority on Baroque and Rococo art, Austin refined the collection and gave it direction. Today it is one of the few great repositories of Baroque art in the country. The Ringling Museum of the Circus and the 18th century Asolo Theater were also added under Austin's tenure to the Ringling Museum complex.

In one large gallery, the Rubens Room, are four of a series of eleven Rubens "cartoons," designed to be woven into tapestries for the sister of Philip III of Spain. (For any such huge paintings, Rubens made small sketches; then his workshop executed them, and Rubens applied only the finishing touches.) Put up for auction at Christie's in London, they were so massive that there were no takers until the "King of the Big Top," impressed by their

dynamic action, brilliant color and gigantic scale, took them home. They set the Baroque style of much of his collection.

The galleries flow on, each with a background color to set its mood. Gallery 6 introduces the Venetian school with Bassano's *Christ Kneeling in the Garden of Gethsemane* and Veronese's *Rest on the Flight into Egypt*. The latter is an exuberant painting. Above the little family under the palm trees, angels spiral, procuring food and doing the laundry. The concept is naïve, but the richness of the colors and the exotic landscape give sumptuous overtones. Gallery 12 in the south wing is given over to Dutch paintings, among them Rembrandt's *Portrait of a Lady*, de Heem's *Still Life with Parrots,* and one of Hals's most penetrating portraits, a likeness of Pieter Olycan. Just after Ringling unpacked

Cast of Michelangelo's David in the Garden Court
(Ringling Museum of Art, Sarasota, Fla.)

the Hals in his New York office, Lord Duveen saw it. As a dealer, he was piqued that so important a canvas could have left England without his knowledge. He examined the painting, then offered Ringling $300,000 in cash for it—just twice what he had paid. The offer was rejected.

In Gallery 3, opening off the Rubens Room, hangs Rubens's portrait of the Archduke Ferdinand, along with several other works by him. At the time this was painted, Ferdinand had just succeeded his aunt, the Infanta Clara Eugenia, as governor of the Netherlands. (A portrait of her by an unknown Spaniard hangs in the museum.) The Rubens belonged for a time to Sir Joshua Reynolds, and later hung in J. P. Morgan's London house. Another great Rubens in the collection is *The Departure of Lot and His Family from Sodom.*

Even Lord Duveen, with his matchless gift for turning art into gold, was defeated by the size of Gainsborough's largest painting, *General Philip Honywood*, and let Ringling have it at half price. In executing the commission Gainsborough managed to combine the likeness of the pompous general, portrayed with a countenance uncorrupted by thought, with the landscape the artist loved to paint but found slight market for.

Poussin's *Ecstasy of St. Paul* is a little gem. The artist fell in love with this small work and hated to give it up to Dr. Chanteloup, who had commissioned it. He put his patron off by telling him it was not quite finished and, when forced in time to admit that it was, he still insisted it needed "a few caresses." Eighteenth century Venice contributes Canaletto's *View from the Piazzetta* and Tiepolo's *Two Allegorical Figures*, a stunning transferred fresco in grays and gold, probably painted for a Venetian *palazzo*. Though Baroque and Rococo art dominate the Ringling collection, with the opening of additional space art objects of a more general nature are being shown and galleries of contemporary and decorative arts have been added. As a state museum, the Ringling does much to encourage and exhibit Florida artists.

A ceiling painting of the Tiepolo school overlooks the foyer of the enchanting Asolo Theater on the Ringling Museum grounds. Built inside a great castle hall in Asolo, Italy, this is the only 18th century Venetian theater in America. Opera and concerts are given all year round, and a talented repertory company puts on

plays—from Ben Jonson to Samuel Beckett. Wide corridors outside the boxes are hung with 15 rare paintings of Harlequin in his various guises by Giovanni Domenico Ferretti. They were for years in Leopoldskron, Max Reinhardt's Salzburg castle.

The Ringling residence, Ca'd'Zan—Venetian dialect for House of John—is approached by a driveway just north of the museum. The interior shows how the Ringlings lived in the opulent twenties, when they furnished it with objects from all over Europe. The exterior cheerfully mixes the Doge's Palace in Venice with other architectural styles, including a tower similar to the one on the original Madison Square Garden, built by Sanford White and owned by Ringling.

The Ringling Museum of the Circus, on the drive from the museum to the residence, re-creates the nostalgic, magic spell of the sawdust ring, with "Big Top" memorabilia gathered from all over the world: costumes, documents, rare prints, posters, ornate animal cages, circus wagons. With funds appropriated by the Florida legislature in 1973, a new building for this outstanding contribution to circus history is scheduled for completion soon.

Peter Paul Rubens: The Departure of Lot and His Family from Sodom (Ringling Museum of Art, Sarasota, Fla.)

WEST PALM BEACH

THE NORTON GALLERY AND SCHOOL OF ART
1451 South Olive, West Palm Beach, Florida

Hours: Tues.–Fri. 10–5; Sat., Sun., holidays 1–5
Closed: Mon.

Brancusi's *Mlle. Pogany*, her eyes resting on the greensward that sweeps from the museum's door down to Lake Worth, greets one at the entrance to this small, pleasant museum. This particular shining bronze is the last of several versions Brancusi carried from marble to metal.

The donors of the museum, Mr. and Mrs. Ralph Norton of Chicago, living mostly in West Palm Beach, built the present museum and invited the lively Palm Beach Art League to manage the institution. Until his death, Mr. Norton was interested in broadening the range of the collections and spent his later years adding Oriental works of art. The quality of his collecting in this field and the thoughtful purchasing policy since have made the collection one of the most distinguished of small museums in the country and certainly preeminent in the South. As Horace H. F. Jayne in his scholarly new book, *A Handbook of the Chinese Collections*, states: "Eminence is based solely on quality." Because of the Florida climate, Chinese paintings, textiles and lacquerwork have been excluded. The range is Archaic bronzes, Archaic jades, Buddhist sculpture, later jade carvings and ceramics. The gallery holding these treasures is a contemplative oasis set apart from the routine museum flow.

Acquisitions, especially in the painting field, now overflow the original area. A matching wing with interior courtyard, similar to the handsome and much used existing one, is projected.

A print cabinet with works easily accessible has recently been formed. Its holdings, while not large, range from Schöngauer to Warhol.

Among the European masterpieces, the earliest is a strong 13th century Tuscan Madonna in the Byzantine tradition. The greatest treasures are in the French galleries, where there are three Braques, including *The Mantel* and *Still Life with Red Table-*

cloth; three Matisses; Cézanne's *The Artist's Son;* Juan Gris's *Le Journal; Au Café,* which Picasso painted during his first trip to Paris in 1901, and a large 1924 Picasso canvas, *Still Life with Printed Foulard,* a stunning and authoritative work in pinks and browns. Gauguin's *Agony in the Garden* dates from shortly after his stormy and tragic stay with van Gogh. The deeply suffering face of Christ is Gauguin's own.

The American selection is distinguished by paintings by Hopper, Avery, Dove, Brook, Kuniyoshi, Knaths, Marin and Shahn. Walt Kuhn's *Morning,* painted for the famous Armory Show of 1913, is in the style of the Fauves. While most of the strength of the American section lies in the mid-20th century period, the collection is being brought into more contemporary focus.

Georges Braque: The Mantel
(Norton Gallery and School
of Art, West Palm Beach, Fla.)

Reginald Marsh: Lifeguards (Georgia Museum of Art, The University of
Georgia, Athens, Ga. University purchase, 1948)

GEORGIA

UNIVERSITY OF GEORGIA: GEORGIA MUSEUM OF ART

Jackson Street, Athens, Georgia

Hours: Mon.–Fri. 8–5; Sat. 9–12; Sun. 2–5
Closed: Legal and academic holidays

When New York lawyer Alfred Holbrook retired, he settled in Athens, Georgia, with his growing collection of 19th and early 20th century American paintings. The University of Georgia offered a museum. Established in 1948 in the old library, the museum's undistinguished "early post office" style façade is mellowed by its site among the oldest structures on campus.

There is a small Kress study collection, but the principal excitement is American—the Holbrook canvases by George Caleb Bingham, Asher B. Durand, Childe Hassam, John Twachtman, Preston Dickinson, and by each of the Eight, those young rebels who in 1908 refused to go along with the rigidities of the academicians or the dreams of the American Impressionists. Ben Shahn, Charles Burchfield, Milton Avery, Marsden Hartley and Lamar Dodd, longtime head of the University Art Department, punctuate the 20th century story.

The print department, with examples beginning in the 15th century, becomes increasingly important. Two outstanding portfolios are the proof set for Piranesi's *Prison Series* and Estampe Originale—"a comprehensive record of the diverse trends which characterize the art of the 1890s" with work by such artists as Pissarro, Lautrec, and Redon.

Although the building has been astutely remodeled, one hopes that some day this collection will receive housing that will enable

more than token showing—especially since the museum serves both campus and town.

ATLANTA

THE HIGH MUSEUM OF ART

1280 Peachtree Street, N.E., Atlanta, Georgia

Hours: Mon.–Sat. 10–5; Sun. 12–5; Thurs. 10–10 except summer
Library

The Atlanta Memorial Art Center brings together under one roof two theaters, a major concert hall, an art school and library, and the new High Museum of Art. The present museum is a focal point; interconnecting public areas around it include a promenade, a galleria and lounge space. The same address on Peachtree Street is about all that is left of the old High Museum. Early in this century an Atlanta Art Alliance was formed, but not until 1926 when Mrs. Joseph M. High gave her home to the group did it have a permanent address.

Among the Kress collection of Old Masters is an early panel painting, a half-length *St. Catherine of Alexandria*; another panel piece, *St. Vitalis*, may be from the same altarpiece. A favorite is Giovanni Bellini's *Madonna and Child*, painted when the artist was over eighty. Attesting to its universal appeal is the prevalence of early copies of it in European galleries. Tiepolo painted the splendid *Offering by Young Vestal Priestess to Juno Lucina* in rich, dusky colors to enhance the Palazzo Barbaro-Curtis (which served Mrs. Gardner as model for much of her Fenway Court in Boston). The German sculptor Tilman Riemenschneider is represented sparingly in America, but Atlanta has his strong *St. Andrew*. The French group includes Courbet, Corot, Fromentin and the handsome 1903 *House of Parliament* by Monet.

Cherries, Iris and Lupin is the earliest painting in America by the Spaniard Blas de Ledesma. The graphic section, strong and growing, offers Renoir, Goya, Manet, Kollwitz, Lyonel Feininger and Picasso's *Frugal Repast*. An ingenious feature of the gallery, the large print file, allows visitors to slide open the drawers and

study prints which are protected by acetate or glass. The museum's gathering of American paintings is graced by a charming Copley, *Elizabeth Deering Wentworth*, companion in style to the portrait of her sister in the New York Public Library. Charles Willson Peale's portrait of *Senator W. H. Crawford*, a Georgian contender for the presidency in 1824, is from Peale's late period.

Emphasis is on 19th century Americans. Thomas Doughty's *Lake Scene* and a moonlight canvas by Blakelock are favorites. Among 20th century artists are Zorach, Moore, Hopper, Hultberg and Gottlieb.

The McBurney collection sets forth in historical sequence major styles in the decorative arts, 1670–1920.

John Singer Sargent: Portrait of Ralph Curtis on the Beach at Scheveningen (High Museum of Art, Atlanta, Ga.)

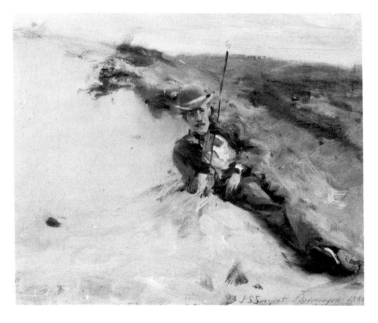

SAVANNAH

TELFAIR ACADEMY OF ARTS AND SCIENCES
121 Barnard Street, Savannah, Georgia

Hours: Mon.–Sat. 10–4:30; Sun. 2–5
Closed: Major holidays, Dec. 24–Jan. 2 (subject to change)

Situated across from Telfair Square, one of those charming green parks that grace downtown Savannah, the museum built by William Jay as a home for the Telfair family in 1818 became, with additions, a public institution. It is now the oldest art museum in the southeastern states and will celebrate its 100th anniversary in 1975.

The dining room and oval-shaped drawing room are furnished with period furniture, much of it belonging to the Telfair family. Colonial and Federal portraits by painters such as John Hesselius, Henry Benbridge, and Samuel F. B. Morse grace the walls. A distinctive feature of the drawing room is two beautifully carved marble mantels signed by John Frazee, the only stone carver to become a member of the National Academy of Design.

In the decorative arts. Telfair Academy houses the largest extant collection of Savannah-made silver, with more than 100 pieces by Frederick Marquand. There is also an exquisite collection of 18th century Chinese export and English hard-paste and soft-paste porcelains.

Newly acquired is a beautiful collection of Savannah costumes with emphasis on 19th century ladies' apparel—wedding dresses, reception dresses, day dresses, mourning dresses, and so on.

The rest of the collection and rotating exhibitions are shown in spacious galleries upstairs and down at the rear. The largest collection in the country of paintings and drawings of the Lebanese poet Kahlil Gibran hangs in an upstairs gallery. The American Impressionists and American Scene painters of the thirties and forties are well represented by such artists as Childe Hassam, John Twachtman, Frederick Frieseke, Robert Henri, George Luks, Ernest Lawson and Arthur Davies. One of George Bellows's best works, *Snow Capped River*, is here.

In the Waring Print Collection is the entire set of prints by Hogarth, 28 Childe Hassams and a complete edition of Holbein's *Dance of Death*.

Another feature of the museum is the classical Sculpture Gallery. It has a white marble floor accentuated by the marble pool mosaic, a recent work by Marjorie Kreilick, in varying shades of gray. The formality is relieved by the movement of the water and the touch of color in the fresh flower grouping at one corner of the pool. Plaster casts of such antiquities as the *Venus de' Medici* and the *Dying Gaul* are sometimes interestingly juxtaposed with the contemporary sculpture and bold forms of modern painting.

The museum owns two handsome 3rd century B.C. capitals dating from Alexander's building spree in Egypt. They were brought across the ocean to Savannah as ballast and dumped on Ballast Island in the Savannah harbor at the end of the trip.

The Owens-Thomas House, an authentically furnished English Regency house at 124 Abercorn Street, is also administered by the museum.

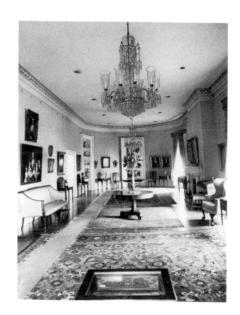

Drawing Room Gallery
(Telfair Academy of Arts and
Sciences, Savannah, Ga.)

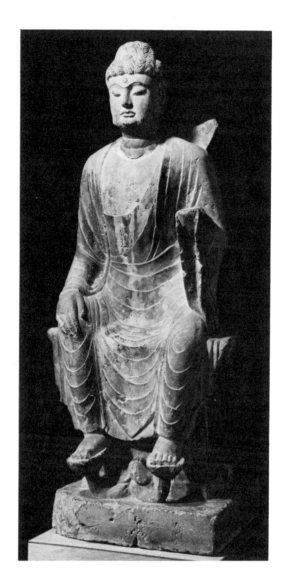

Seated Sakyamuni
Buddha (Honolulu
Academy of Arts,
Honolulu, Hawaii.
Gift of Robert
Allerton, 1959)

HAWAII

HONOLULU ACADEMY OF ARTS

900 South Beretania Street, Honolulu, Hawaii

Hours: Tues.–Sat. 10–4:30; Thurs. 10–9:30; Sun. 3–6
Closed: Mon.
Library

Founded in 1927, the Honolulu Academy is the only general art museum in the Pacific area. Around a Chinese court, galleries present Asian material, and around a Spanish court, Western. Most galleries open onto garden courts so rich with tropical plants that one is torn between staying outside with nature or inside with works of art. The second floor is given over to the contemporaries and to changing exhibitions. But for all the museum's sensible emphasis on balance, it is best known for its Oriental holdings, both qualitatively and quantitatively. Asiatic art covers early China through all its periods in painting, sculpture, and decorative arts; the Buddhist arts of Japan, Momoyama and Edo periods, and a famous group of folding screens from the height of the Classical period. Among the Chinese paintings in the museum is the celebrated ink and brush drawing on paper of geese and rushes referred to as the *One Hundred Geese* scroll, along with works by Hung-jen, Ch'en Hung-shou and others.

The academy also houses one of the world's important groups of Korean ceramics. An extension of the academy known as the Alice Cooke Spalding House provides a gracious setting, amid famous gardens, for Asian decorative arts and a unique Ukiyo-e

Print Center with the extensive James A. Michener Collection of Japanese wood block prints.

The Western section embraces the ancient Mediterranean world, Medieval and Renaissance art, and the Kress Collection of Italian painting. Decorative arts emphasize 18th century England and France.

Later paintings include works by Pissarro, Whistler, Sargent, Eakins, Cassatt, de Chirico, Léger, Braque, Matisse, Picasso, Modigliani and Vlaminck, a splendid Monet, *Water Lilies,* Gauguin's *Two Nudes on a Tahitian Beach* and van Gogh's blazing *Wheatfields.* The modern section is rich with such artists as Karl Knaths, Helen Frankenthaler, Morris Louis, Kenneth Noland, Robert Rauschenberg, Richard Anuszkiewicz, David Smith, Karel Appel and Kenzo Okada. In its changing exhibition program the academy brings to Hawaii a varied art fare from around the world.

ILLINOIS

KRANNERT ART MUSEUM: UNIVERSITY OF ILLINOIS
500 Peabody Drive, Champaign, Illinois

Hours: Mon.–Sat. 9–5; Sun. 2–5

In 1947 the university held its first Biennial Survey of Contemporary American Art. It remains today the oldest in the country and a most distinguished biennial. Not only current trends and leading artists are given a platform, but many young painters are shown and some have made their reputations here. Wisely purchasing from each exhibition, the museum has through the years built up an enviable collection—examples of the highest quality by such artists as Shahn, Rosenthal, Baziotes, Roszak, Lebrun, Jenkins, Motherwell, Morris, Hofmann, Burchfield, Stuart Davis, MacIvor and Knaths. The list is long and impressive.

In 1961 the Krannert Art Museum, a simple, functional, elegant little building, was erected as a gift from Mr. and Mrs. Herman C. Krannert of Indianapolis. Commissioned for the entrance and crowning a long reflecting pool is a large bronze by the sculptor Mirko. It is appropriately entitled *Initiation*. The university's first art gallery opened in 1876, only six years after the university's founding, but it wasn't until 1931 when galleries were installed in the new architectural building that it began a year-round exhibition program.

The works of art in the first gallery, the Trees Gallery (named for Mr. and Mrs. Merle J. Trees of Chicago, who in 1937 began presenting works from their collection on an annual basis), range from the 15th to 19th and 20th century landscape paintings. Through a series of bays, this good but diverse collection is brought into order in a permanent installation. Some high points

are a Frans Hals portrait, *Cornelis Guldewagen, Mayor of Haarlem*, François Clouet's *Madame de Piennes*, Jacob van Ruisdael's *Ford in the Woods*, landscapes by Inness and Blakelock, and *French Farm*, a little gem by Winslow Homer.

The Krannert's aim is to build a good historical collection while continually holding important contemporary exhibitions. As the only general art museum in that vast prairie country of Illinois, except of course for the Chicago Art Institute, the Krannert brings to the student body and the general public exhibitions which are enjoyed by New Yorkers at the Guggenheim, the Whitney and the Museum of Modern Art—sometimes prior to New York openings.

Some late purchases for the museum are Murillo's *Christ after the Flagellation*, a 14th century Sienese panel painting, *St. Catherine of Alexandria, La Famille de Bourbon-Conti* by Nicolas Lancret, *A View on the Stone Estuary* by John Constable, a distinguished Gandharan stele of the 2nd century A.D., Ming porcelains, and the beginning of a Pre-Columbian collection and a collection of Classical art. A huge Mathieu, *Homage to Charlemagne*, usually hangs in the broad stairwell.

A print gallery, decorative arts and minor art galleries, the auditorium and some beautifully recessed cases in which ceramics by major contemporary potters are shown are on the lower floor. The museum follows the same pattern with the crafts as with its painting and sculpture biennials, holding important national craft exhibitions and purchasing top works from them.

Joseph Raffael: Heads, Bird
(Krannert Art Museum,
University of Illinois,
Champaign, Ill.)

CHICAGO

ART INSTITUTE OF CHICAGO

Michigan Avenue at Adams, Chicago, Illinois

Hours: Mon., Tues., Wed., Fri., Sat. 10–5; Sun., holidays 1–6;
 Thurs. 10–8:30
Closed: Dec. 25
Restaurant

The Chicago Academy of Design, established in 1866, was the wellspring of the present institute. Its name change occurred in 1882, and its move to the present Italianate structure was made at the closing of the 1893 World's Columbian Exposition. The building erected to house the fair's Congress of Religions has been home to the Art Institute ever since. Many additions have been made; the latest is the Morton Gallery, which holds the splendid collection of 20th century European art: Modigliani, Marc, Miró, Léger, Delaunay, Giacometti, Balthus, Etienne-Martin and Picasso from 1901 to his great *Nude under a Pine Tree*, done in 1959. Special exhibitions are also held here.

The zest and foresight with which Chicagoans built their city (was it an accident that H. H. Richardson, Louis Sullivan and Frank Lloyd Wright erected some of their earliest monuments here?) was matched in the building of their collections. Mrs. Potter Palmer was purchasing Renoirs in Paris as early as 1892. Only Mrs. Horace Havemeyer in New York, aided by Mary Cassatt, was buying the controversial Impressionists for America at that time. Though Mrs. Palmer was also a friend of Mary Cassatt's, in her purchasing she usually went it alone. In 1889 most collectors were lining their walls with Corot's landscapes; she bought his moving piece *Interrupted Reading*. Another Palmer bequest is an early Monet, *The River*—simply a glorious painting.

The painting section proper starts with 15th century Europeans. Two of the museum's stars are El Greco's *Assumption of the Virgin*, discovered by Mary Cassatt in Spain in 1901 and purchased by the institute in 1906, and the *Ayala Altar*. Dated 1396, this altar, consisting of 16 scenes from the lives of Christ and the Virgin, is one of the most important Iberian works to be

found outside Spain. Other distinguished paintings: *The Life of John the Baptist*, by Giovanni di Paolo, and four large canvases by Giovanni Battista Tiepolo depicting episodes from the story of Rinaldo and Armida. Few museums can boast portraits of the same subject in both babyhood and manhood. Jacques Louis David's stunning *Portrait of the Marquise de Pastoret and Her Son*, a child in a cradle, has been joined recently by *Portrait of the Marquis de Pastoret*, grown to be a handsome if forbidding gentleman.

The museum's truly great group of French 19th century paintings is based on the Mrs. Potter Palmer, Frederick C. Bartlett and L. L. Coburn collections, while the Ryerson and Worcester gifts range from Italian primitives to the 19th century. Two important new works in the extensive collection of earlier European masters are George Braque's *Harbor in Normandy* and René Magritte's *Time Transfixed*. The American painters march straight through from Robert Feke, one of our first native artists, to the latest audacities. There are a number of new acquisitions in the

Georges Seurat: Sunday Afternoon on the Island of La Grande Jatte (courtesy of the Art Institute of Chicago, Chicago, Ill.)

Gustave Caillebotte: Paris, a Rainy Day (courtesy of the Art Institute of Chicago, Chicago, Ill.)

El Greco: The Assumption of the Virgin
(courtesy of the Art Institute of
Chicago, Chicago, Ill.)

area of American art of the 1960s and 1970s. Indeed, there is
scarcely a major contemporary artist, whether working in the
New Realism, Abstraction or any current form, who is not well
represented. California artists are particularly well shown here,
as are those from Chicago.

With the renovation of the painting galleries, small mood
alcoves, sparingly furnished with period pieces of furniture,
sculpture and canvases, have been installed. The print and draw-
ing department is superlative and is alone worth a trip to Chi-
cago. It is constantly being strengthened, not only with major
works but also with sketchbooks and intimate studies. The
Gauguin holdings are the most complete in the world. The Jap-
anese group is second only to Boston's. The collecting of Egyptian
and, to a lesser degree, Classical art was abandoned as Chicago's
famed Oriental Institute took over in those areas (see Oriental
Institute). Numerically, the decorative arts section is strong as
well as being distinguished for the quality of its holdings. One
is introduced to the Oriental and East Indian wing by Kuan-Yin
(Chinese, late Ming), sleeping above the trickling waters of her

fountain bed. The museum also has strong holdings in late Dynasty painting, both the Ming and Ch'ing.

Though as early as 1889 a number of examples of Primitive art drifted into the museum, including important gold pieces from Panama and Colombia, it wasn't until 1952 with the gift of an important group of Melanesian objects that the museum began to work toward a department of Primitive art. Under the directorship of Daniel Catton Rich and Alan Sawyer, a top scholar in the field, the famed Gaffron Collection of Peruvian art was purchased. A gift by Nathan Cummings of Peruvian ceramics brought further enrichment. Today the museum is acknowledged as having one of the finest collections from Peru's ancient civilization in the world. Middle American archaeological findings are well represented, and there is some African art.

For decades the Art Institute has been the nation's "halfway house" in the visual arts, a pleasant stopover on coast-to-coast journeys by plane, train or car. It offers such delights as Seurat's masterpiece, *Sunday Afternoon on the Island of La Grande Jatte* (this perfect painting represents the apex of the Pointillist movement), and what may well become runner-up to the *Grande Jatte* in popularity, Gustave Caillebotte's 7-by-9-foot canvas, *Paris, a Rainy Day*. Painted seven years before the Seurat, the figures in Caillebotte's canvas have the same static monumentality. Other favorites are van Gogh's *Bedroom at Arles*, Toulouse-Lautrec's *At the Moulin Rouge* and Degas's *The Millinery Shop*, to say nothing of 19 Renoirs.

As the gifts pour in, tomorrow's grandchildren may well say —as did Chauncey McCormick, a former president, when asked how the institute could afford such valuable French paintings— "We do not buy them; we inherit them from our grandmothers."

MUSEUM OF CONTEMPORARY ART

237 E. Ontario, Chicago, Illinois

Hours: Mon.–Sat. 10–5; Thurs. 10–8; Sun., holidays 12–5

Chicago's first museum of contemporary art opened in the fall of 1967 in a severe, rectangular, white box, more than half of whose façade is covered by a stunning copper relief sculpture by

the Hungarian-Swiss artist Zoltan Kemeny. An eight-foot moat filled with washed anthracite coal (surely a new use for the ore) separates the museum from the sidewalk. Originally a bakery and recently the home of Playboy Enterprises, the building has 10,000 square feet of unencumbered exhibition space. The interior is white on white—walls, ceilings, floors.

For the present, a permanent collection is in abeyance. The institution came into being as an action museum—ideas in action, objects in action, people in action. Now policy is being changed to allow for retrospective exhibitions and surveys of movements having direct impact on today's new art forms.

UNIVERSITY OF CHICAGO: ORIENTAL INSTITUTE MUSEUM

1155 East 58th Street, Chicago, Illinois

Hours: Tues.–Sun. 10–5
Closed: Mon., major holidays

Since its founding in 1919 by Egyptologist James Henry Breasted, the institute has been sending expeditions forth to excavate in Iran, Iraq, Palestine, Turkey, Egypt and Syria. Although its interest is primarily archaeological, the results displayed are more often than not of deep aesthetic value, whether it's a small Luristan bronze or the colossal portrait of Tutankhamen, Egyptian XVIII Dynasty.

Also of note are the Sumerian sculpture, Palestinian ivories and Assyrian reliefs. Recent additions are objects of all kinds from Nubia, the region above the Aswan Dam in Egypt and the Sudan.

Tell Asmar Sumerian Priest (courtesy of the Oriental Institute, University of Chicago, Chicago, Ill.)

Pablo Picasso: L'Atelier (courtesy of the Indiana University Art Museum, Bloomington, Ind.)

INDIANA

INDIANA UNIVERSITY ART MUSEUM
Fine Arts Building, Bloomington, Indiana

Hours: Tues.–Sat. 9–5
Closed: Mon., Sun., major holidays

The first major acquisition made by the Indiana University Art Department (there was no museum in those early days) was the stunning Stuart Davis *Swing Landscape* assigned to the University in 1941 by the Federal Art Project. Very few pieces were added in the ensuing years, the department being housed in dismantled military camps and little thought being given to the collection and display of art objects. The real growth began with the generosity of James and Marvelle Adams, both alumni of Indiana University. Their first gift was a large terra cotta torso by Maillol in 1955. Perhaps their most important gift is the Vigary reliefs, a series of eight *Scenes from the Life of the Virgin* in brilliantly polychromed high relief, many with intricate architectural backgrounds. Although Vigary was born in France, he arrived in Burgos, Spain, in 1498, in time to introduce to Spanish sculpture the stylistic concepts of the Italian Renaissance. The series is unique in university collections.

Statue of a Youth, a 2nd century Roman marble, sets a tone of quiet elegance in a red marble niche in the entrance stairwell. Warm travertine walls form the backdrop for other Greek and Roman pieces. To the right in a gallery of antiquities, a succinct mini-museum in itself, the pure and sparse display of each piece or fragment induces one to linger and study. The Primitive art, especially its African examples, defies in size most

college collections. The Oriental and Far Eastern section is grow
ing importantly; it includes a superb Haniwa *Horse* (Haniwa
was Japanese funerary genre sculpture, 3rd to 4th century); a
T'ang period glazed *Horse and Rider;* bronze clay and ceramic
works from Thailand and Indian sculpture.

Paintings include a good small group of Renaissance work
from the Kress collection, as well as Turner's *Holvoetsluys* and
Caillebotte's *Riverbank in the Rain* and, coming into the 20th
century, gifts from the distinguished collection of Mr. and Mrs.
Henry R. Hope of Picasso's *L'Atelier,* Jean Dubuffet's *Business
Lunch,* Braque, Rouault and other classic modern artists. In the
modern field works by David Smith, Pomodoro and Vasarely
come to mind.

The large print and drawing section is strong in Renaissance
Baroque and contemporary holdings.

Each departmental art historian acts as a curator within his
specialty in this museum, which reflects largely the creativity of
Dr. Henry Hope, longtime fine arts chairman.

EVANSVILLE

EVANSVILLE MUSEUM OF ARTS AND SCIENCE

411 S. E. Riverside Drive, Evansville, Indiana

Hours: Tues.–Sat. 10–5; Sun. 12–5
Closed: Mon.

The Evansville Museum, a clean-lined contemporary building
on the banks of the Ohio, while not strictly an art museum, has
an active art program and is building a permanent collection.

Representative paintings of the major European schools of
the 17th to the 19th centuries and earlier include works by
Murillo, Romney, Clouet, Pieter Breughel II and Verspronck. A
linenfold-paneled Gothic room holds furniture, tapestries and
other art of the period.

In the contemporary field American art predominates and is
regularly supplemented by purchase awards in two annual shows
at the museum—the Mid-States Art Exhibition and the Mid-

Fernand Léger: Girl with Fruit (Evansville Museum of Arts and Science, Evansville, Ind.)

States Craft Exhibition. Recently a program was initiated to acquire more works by Indiana artists through museum purchases.

Collections and displays also include some Oriental, Egyptian, North and South American Indian, Oceanic and African Negro art.

FORT WAYNE

FORT WAYNE ART MUSEUM

1202 W. Wayne Street, Fort Wayne, Indiana

Hours: Tues., Wed., Thurs., Sun. 1–5; Fri., Sat. 10–5
Closed: Mon.

Although its roots go back to 1886 when both the art school and the Fort Wayne Institute of Arts were founded, the museum proper had its beginnings in 1922. It moved in 1950 to the former William Mossman home on a shady tree-lined street. The Fort Wayne Art Museum, a small institution, follows a historical outline and wisely limits itself to five areas: Egyptian, Greek, Roman, Medieval and 20th century.

Monthly exhibitions, mostly on the contemporary art scene, are shown. The present contemporary holdings emphasize painting, sculpture, prints and drawings by such distinguished Americans as Ivan Albright, George Bellows, Edward Hopper, John Marin and Larry Rivers. Some of the Europeans are Oskar Kokoschka, Maximilien Luce, Emil Nolde, Giuseppe Santomaso and Paul Signac. A new art sales and rental gallery has opened in the carriage house.

INDIANAPOLIS

INDIANAPOLIS MUSEUM OF ART

1200 West 38th Street, Indianapolis, Indiana

Hours: Tues.–Sun. 11–5; Tues. 11–9. Lilly Pavilion: Tues.–Sun. 1–4
Closed: Mon., Dec. 25
Library, restaurant

The new museum designed by Ambrose Richardson, the first pupil of Mies van der Rohe in America, has the blocklike conformation of a Mies structure but without Mies's all-enveloping glass. Wide, paved terraces skirt the center building and the Clowes Wing, the latter to be balanced by another wing as more space is needed. Few, if any, museums in the United States are so felicitously placed. The J. K. Lilly estate, Oldfields, 46 acres along the White River, was given to the museum and has been enlarged by 109 more acres, including a fair-sized lake. Oldfields was laid out in 1914 by the Olmsted brothers, sons of Frederick Law Olmsted, the great landscape architect best known for New York City's Central Park. The grounds have the beauty one has been led to expect only from Charleston and Virginia gardens. Groves of giant beeches, minute flowering orchids, broad lawns and *allées* of trees delight with their ingenious perfection. A canal wanders through the property. Built in 1830 as part of an ambitious project to join Indianapolis with the Great Lakes, it was abandoned when steam engines became numerous.

In 1883 Indianapolis had a well-organized art association pursuing a brisk program. In 1895 a farmer named John Herron, whom no one in local art circles remembered having met, died and left the association a munificent sum. Mystified and annoyed, Herron's relatives battled the will. The art association won out after lengthy litigation.

The fountained, impressive entrance holds a large *LOVE* sculpture by native son Robert Indiana and opens into a spacious wood-paneled and carpeted foyer. To the left the galleries of Oceanic, African and Pre-Columbian art lead into the small Classical section. From here the Oriental section takes over. Owing to the predilection for the Orient of Eli Lilly, patron of the museum, and Wilber Peat, longtime director, the quality of the collection is especially high. Peat, born and raised by missionary parents in China, started working with C. T. Loo, the great dealer of Oriental art, when important Chinese objects were accessible in price. A grant from the National Endowment for the Arts enabled the museum to invite specialists to assess the collection, with the conclusion that for its restricted size Indianapolis has one of the finest collections in America.

Probably the most important event in the history of the museum has been the gift of the Clowes Fund. Housed in a separate but connecting wing, the Clowes Pavilion maintains, in spite of its great bannered Gothic court, the atmosphere of the house-museum. The court is a real tour de force, for the architect has managed to create a Gothic feeling with contemporary overtones. The museum's two 12th century Spanish frescoes look splendid in the stairwell. They are from a series of six, circa 1150, found in the abandoned Chapel of San Baudelio in Berlanga, north of Madrid, and were brought to this country when it was still possible to spirit Spain's national treasures out from under the nose of an indifferent monarchy (see the Cincinnati Art Museum). Dr. G. H. Clowes held the post of research director with Eli Lilly & Co. in Indianapolis from 1921 until his retirement. He started his collecting during the Depression, when Old Masters from European collections began coming on the market. Purchased wisely from established dealers, the works tend to be small but fine examples. Dr. Clowes was not one to be afraid of reattribution, and through the years scholars have been brought in to assess and refine the collection. While some of the museum's

own works are interspersed within the Pavilion, the Clowes imprimatur is everywhere. The pictures span six centuries from the 14th to the end of the 19th. Bellini, Uccello and Bassano are here, as is Caravaggio's *Sleeping Cupid*, long sequestered in a convent in Ireland. Some latter-day Jansenist had overpainted the naked cupid into a Christ child crowned with thorns. Spanish paintings include four El Grecos, Ribera, Velázquez, Murillo and Goya. For me the best of the Dutch is a small Hals, *Self Portrait*, painted about 1650. The Flemish and French paintings are strong, with some portraits of rare excellence by Clouet and Corneille de Lyon.

The museum's own European collection is not to be underestimated. It begins with 13th and 14th century Sienese. The Dutch and Flemish rooms hold big-name painters and lesser but important artists from both schools. Most popular of the museum's several pictures by Turner, England's eminent 19th century painter, is his *The Fifth Plague of Egypt*. Indianapolis also owns a delightful piece of Turner memorabilia, a painted tray. When the artist was illustrating one of Sir Walter Scott's novels, he went to Abbotsford, where Scott entertained him with a lavish picnic. As a souvenir, Turner painted on a coffee tray a charming landscape of the party, with Abbotsford dominating the background. Three rooms of the Clowes Pavilion hold a great gathering of Turner's works which include oils, watercolors, prints and drawings and a library of Turner material, the bulk of which is from the Panzer family of Indianapolis.

Masterpieces in the French 20th century field are Seurat's *Port of Gravelines*, van Gogh's *Landscape at St. Rémy*, Picasso's *Ma Jolie*, Cézanne's *House in Provence* and Paul Gauguin's *Landscape near Arles*. Other enviable holdings are canvases of Matisses and Modigliani, and two Monets.

The American collection, beginning with Benjamin West's happy landscape *Woodcutters in Windsor Park*, is probably strongest in late 19th and early 20th century works. Perhaps John Singleton Copley's best-known canvas, reproduced in many schoolbooks, is *Watson and the Shark* (see National Gallery and Detroit). It was his first effort outside the field of portraiture, done at a time when the grandiose and dramatic canvas was the vogue. The Indianapolis painting shows *His Honor Sir Brook Watson*, decades after his encounter with the shark, dressed in

Sir Joshua Reynolds:
Portrait of Joseph Barretti
(courtesy of the
Indianapolis Museum of
Art, Indianapolis, Ind.
James E. Roberts Fund)

his robes as Lord Mayor of London. Strength lies in the late 19th
century and early to mid-20th century. William Merritt Chase
and Theodore C. Steele, both native sons, are well shown. Chase
moved on to wider fields, but Steele remained in Indianapolis
without the national recognition he obviously deserves. Con-
temporaries include George Ortman, Lee Krasner, Conrad Marca-
Relli, Julian Stanczak and Kenzo Okada, and a delightful small
David Smith whimsically titled *Egyptian Barnyard*. The chang-
ing exhibition galleries are spacious and adaptable.

A short walk through the woods brings one to the Lilly home,
French château in character, which has been turned into the
decorative arts section of the museum. Seventeenth and 18th
century pieces, primarily French, furnish the house. The great
hall contains one of the most striking Nattiers in America, *Mme.
Crozat de Thérèse et sa Fille*. Upstairs are an American country
room, the porcelain collection and a textile study center of more
than 5,000 pieces. Closer to the museum, the house's former
play pavilion has been turned into a charming restaurant.

NOTRE DAME

ART GALLERY: UNIVERSITY OF NOTRE DAME
O'Shaughnessy Hall, Notre Dame, Indiana

Hours: Weekdays 10–5; Sat., Sun. 1–5
Closed: Major holidays

In 1850, eight years after its founding, Notre Dame was given a sizable art collection. Five years later, without benefit of catalog, the art went up in flames. Desultory collecting followed until 1917, when the Braschi group from Rome was purchased. Lately, under an enlightened administration and the scrutiny of eminent scholars, the collection is coming into proper focus. Italian, French, English, Flemish and American paintings feature some exceptional portraits, including one by Bartolomeo Veneto, another by Jean Baptiste Oudry and two by the Dutch Paulus Moreelse which are in the Kress study collection. There are two splendid Nattiers, a Romney, and Sir Peter Lely's *Portrait of Mary II of England* when she was Princess of Orange. Closer to our time is Thomas Eakins's *The Reverend Philip R. McDevitt.* The contemporary section has Georges Mathieu, Laszlo Moholy-

Jean Baptiste Oudry: Hunting Portrait of M. Pouan (Art Gallery, University of Notre Dame, Notre Dame, Ind.)

Nagy, Karel Appel, Adolph Gottlieb, Luis Feito, Isamu Noguchi, Paul Jenkins, Theodoros Stamos, Ben Nicholson, James Brooks, Will Barnet, William Congdon and Joseph Cornell—many of these canvases are from the distinguished G. David Thompson Collection.

A new gallery holds Peruvian textiles and pottery as well as Pre-Columbian sculptures from Costa Rica, Mezcala, Colima and Nayarit. The Eastern sculpture collection with works from Iran, China, India and Thailand is becoming significant.

Easily accessible to students and townspeople, the museum consists of a formal hall holding works by Ivan Mestrovic, long-time artist in residence, and two large galleries. As the collections grow in stature, it is to be hoped that some arrangement can be made to keep more of the permanent holdings on view.

TERRE HAUTE

SHELDON SWOPE ART GALLERY

25 South Seventh Street, Terre Haute, Indiana

Hours: Tues.–Sat. 12–5; Sun. 2–5; Tues. 7 P.M.–9:30 P.M. Closed: Mon., Aug.

No one knows why in 1942 Sheldon Swope left his money to establish an art center, since his interest in the arts seemed to be minimal. But he did, and the unprepossessing entrance on a busy downtown street leads to pleasant, well-lighted, upstairs galleries where unabashed 20th century Realism is the mainstay. Grant Wood's last painting, *Spring in Town*, is here. So is Hopper's *Route Six, Easton* and Burchfield's *Old Houses in Winter*. So are Marsh, Benton and Raphael Soyer. About one-fifth of the collection, which also includes Oriental works, Japanese prints, European painting and 19th century Americans such as Inness, Doughty and Bierstadt, can be shown at one time. One gallery is usually reserved for the contemporaries, among them Leroy Lamis, Paul Jenkins, Andy Warhol, Mark di Suvero and many of Indiana's own, whom the gallery does much to encourage.

Nicholas Marsicano: White Goddess (Davenport Municipal Art Gallery, Davenport, Iowa)

DAVENPORT

DAVENPORT MUNICIPAL ART GALLERY

1737 West Twelfth Street, Davenport, Iowa

Hours: Tues–Sat. 10–4:30; Sun. 1–4:30
Closed: Mon.
Library

From its early beginnings in the twenties as one of the first municipal art galleries in Iowa, the Davenport Municipal Art Gallery was envisioned as part of an eventual master plan to create a community cultural campus. The dream and plan have become, in part, a reality with the construction and opening of a contemporary building in 1963 and an adjacent museum in 1964. In 1967 a Beaux Arts Annex with a fully equipped pottery studio was constructed on the grounds, independent of the main facility. The Wiese Fine Arts Building, newest addition to the Art Gallery, opened in 1972. The permanent collection centers on 19th and 20th century art. Davenport acquired the first significant collection of Haitian art in a public museum.

Of the fine print and drawing section in the making, the Rembrandt prints are the most important, but there is also a good Japanese print group, old and contemporary. Two other treasures make Davenport unique: distinguished Mexican and Spanish colonial painting and a gathering of Grant Wood's art and personal effects that would be the envy of any archivist. Purchased from Wood's sister are paintings, graphics, ink sketches, bas-reliefs and mementos spanning Wood's lifetime, from his silver baby cup to the flag that draped his coffin. Many objects used in his paintings, the sketch box and palette he designed when he was a young man and used until his death, are set in

a special area. A short dividing wall holds a Lucite exhibit case of Wood's sculpture and three-dimensional objects. And here he belongs. For Grant Wood is as much a part of Iowa as the tall corn. Though he fell into a trap of stylization in his landscapes, his satirical *Daughters of the Revolution* (see Cincinnati Art Museum) and the sturdy *American Gothic* may some day stand with the best of our genre painting.

DES MOINES

DES MOINES ART CENTER
Greenwood Park, Des Moines, Iowa

Hours: Tues.–Sat. 11–5; Sun. 12–5; holidays 1–5; Jan. 1,
 Dec. 25, 2–4
Closed: Mon.
Restaurant

Mid-century America experienced the beginning of a fantastic rise in museum attendance, followed by a boom in building that accelerates with every year. Des Moines was one of the first cities in the country to establish the pattern of picking a distinguished architect of national reputation to design its structure. For years, energetic Des Moiners held exhibitions wherever they could find enough wall space and were allowed to drive nails. A gift in 1933 from a local businessman, James D. Edmundson, changed all that. In 1948 a new Des Moines Art Center, one of the most advanced of its time, opened in Greenwood Park. It was designed by the brilliant young architect Eero Saarinen, who went on to build other distinguished structures, including the T.W.A. terminal at New York's Kennedy Airport and the General Motors Center in Warren, Michigan. Some 20 years after the center's opening, a new wing which doubles the space and makes a happy marriage with the Saarinen building was designed by I. M. Pei. A large, enclosed, two-level sculpture court opens to a view of the Greenwood Park Gardens. Connecting galleries on either side join the wing to the present building and enclose a handsome reflecting pool.

The museum's new well-defined policy is to concentrate on contemporary art highlighted by historic examples aesthetically related to the contemporary. Non-American works include Pissarro's splendid *Bouquet of Violets*, Ben Nicholson's *Blue and Lilac*, Kokoschka's *Portrait of Mr. and Mrs. Cowles*, Claude Monet's *Cliffs at Etretat* and one of Rodin's great sculptures from the *Burghers of Calais* series, *Pierre de Wiessant*. In 1884 Rodin did a heroic monument to these burghers, a group of six men who, in the 14th century, offered their lives as forfeit to the king of England in order to save their besieged city. The figures in the finished monument are clothed, but so particular was Rodin about the structure of the body that he always made his life-sized studies, like this one, in the nude. Goya's *Don Manuel Garcia de la Prada*, in yellow satin breeches and blue waistcoat, is an imposing figure, all seven feet of him.

For so young a museum (most of its purchases were made since 1948), the sculpture is impressive. A huge Calder mobile swings from the ceiling of the new wing. Henry Moore, Jean Arp and Henri Laurens are importantly represented.

There is a small antiquities section that includes a beautiful

Edward Hopper: Automat (Des Moines Art Center, Des Moines, Iowa)

Cycladic piece, and collections of Oriental and African art are in the making. But it is in the American section, especially from the early 20th century on, that Des Moines excels. Stanton MacDonald-Wright, John Sloan, George Bellows and Robert Henri are here. Henri's *Ballet Girl in White* is considered one of his best works. Henri was an inspiring teacher in the early part of the century, and his ideas embodied a whole philosophy of art, infuriated academicians and paved the way for the acceptance of modern art. Hopper, Marin, Kuniyoshi, Shahn, Cornell and, into the contemporary field, Jasper Johns, Morris Louis, Noguchi and David Smith are well represented. Certainly with *Automat*, Hopper is at his brooding best.

FORT DODGE

THE BLANDEN MEMORIAL ART GALLERY

920 Third Avenue South, Fort Dodge, Iowa

Hours: Mon.–Fri. 10:30–5; Sat., Sun. 1–5
Closed: Mon., major holidays

An outgrowth of the Fort Dodge Federation of Arts, which was formed in 1922, the Blanden Memorial Art Gallery claims to be the first permanent art facility in the state of Iowa. The neat buff-colored, Neo-Renaissance building houses a small but sophisticated collection of 20th century artists, including Gorky, Beckmann, Klee, Miró, Moore and Marini. In 1951 Dr. Albert C. Barnes gave an oil painting on glass by the European Cubist Louis Marcousis, a painting by Alfred Maurer and seven drawings, including two by his friend William Glackens. According to rumor, this is the only gift the "terrible tempered Dr. Barnes" ever made from his collection to an art institution (see Barnes Foundation, Merion, Pennsylvania).

There is a good group of 19th and 20th century prints and a growing collection of Oriental works, including Japanese prints.

The ongoing program of changing exhibitions concerns itself chiefly with 20th century works.

Marino Marini: Cavalier
(Blanden Art Gallery,
Fort Dodge, Iowa)

IOWA CITY

MUSEUM OF ART: UNIVERSITY OF IOWA

Iowa City, Iowa

Hours: Mon.–Fri. 10:30–5; Sat., Sun. 1–5
Closed: Major holidays

The university's art museum, designed by Harrison and Abromo-witz, opened in 1969. Aside from the exhibition galleries there are lounges, an auditorium, a lending gallery and a large labora-tory for conservation and restoration. More space has recently been added to take care of the increased African collection and the donation of important silver from the 17th and 18th cen-turies and later.

The base of the collection is a gift of Mr. and Mrs. Owen Elliott that comprises a large group of prints, 18th century silver, approximately 60 French paintings from the period after 1904

and a few important Expressionist paintings. Among the latter are landscapes by Munch and Kokoschka, an unusual nude by Franz Marc, a large Lyonel Feininger, early major portraits by Jawlensky and Soutine, Fauve paintings by Vlaminck, and a portrait by Delaunay when he was under Pointillist influence. There are, additionally, canvases by Braque, Juan Gris, Kandinsky, Picasso and Utrillo, di Chirico's *Disquieting Muses,* still lifes by Morandi and Jacques Villon, a Matisse interior with figures and a Breton landscape by Paul Gauguin.

The university's own permanent collection complements that given by the Elliotts, being mainly in the 20th century American field. Among the many fine works are two Jackson Pollocks, including a huge mural painted in 1943, an early Paris landscape by Stuart Davis, a Marsden Hartley of 1915 and the preliminary oil sketch for Jack Levine's *Gangster Funeral,* plus works by Guston, Diebenkorn, Motherwell, Gilliam, Rickey and di Suvero. The collection also includes an important triptych by Max Beckmann.

There are two drawing and print galleries, as printmaking, under the longtime brilliant leadership of Mauricio Lasansky, has long been a high point in the art school's tradition. The collection, aside from the moderns, has a substantial Old Master print group including Dürer, Schöngauer, 25 Rembrandts and a first and third edition of Goya's *Disasters of War*.

Stuart Davis: New York to Paris, No. 1
(University of Iowa Museum of Art,
Iowa City, Iowa)

KANSAS

UNIVERSITY OF KANSAS MUSEUM OF ART
Lawrence, Kansas

Hours: Tues.–Sat. 9–4:45; Sun. 1:30–4:45
Closed: Mon., major holidays

When the university library moved out of its Romanesque Revival building in 1928, the museum rounded up its treasures scattered about the campus and moved in. Gradual reorganization and modernization turned the library's nave and narthex (it was based on a basilica design) into a working museum.

The collections start with the ancient and early Christian world and with some good examples of 4th and 5th century Coptic weaving. Capitals from Languedoc and the Auvergne introduce the Middle Ages. Sculpture plays an important role in the collections. A highlight is a *Madonna and Child* by Tilman Riemenschneider from the distinguished collection of the Prince of Lichtenstein. Two life-size Rococo figures of the brothers Saints Cosmas and Damian are done in polychromed lindenwood. They are attributed to Joseph Götsch. Other wood sculptures are four apostles thought to be French 15th century. The Kress study collection has some interesting Renaissance canvases and a striking 17th century pair of portraits by the Netherlander Nicolaes Maes. There is a good though small decorative arts section.

In the American section is an especially appealing Rembrandt Peale, *Mrs. John Brice and Child,* and three fine Winslow Homer paintings, including his *West Indian Divers,* 1899, as well as important works by West, Copley, Heade, G. L. Brown and others.

Later works include Maillol, Kolbe, Epstein, Dix, Monet, Manet, Rosenquist, Warhol, Judd. Also in the contemporary field, a recent gift (in memory of Gene Swenson, one of the first art critics to write seriously and perceptively of the Pop art movement) is composed of prints, paintings and drawings, including James Rosenquist's handsome *1, 2, 3, Outside*. The institution annually publishes two numbers of *The Register*, a scholarly journal of its holdings.

Tilman Riemenschneider:
Madonna and Child (University
of Kansas Museum of Art,
Lawrence, Kan.)

WICHITA

THE WICHITA ART MUSEUM
619 Stackman Drive, Wichita, Kansas

Hours: Tues.–Fri. 10–3; Sat.–Sun. 1–5
Closed: Mon., major holidays
Library

Although Mrs. Roland P. Murdock was the first professional interior designer in Kansas and traveled about the state lecturing on the importance of aesthetically pleasing homes, she never stressed works of art. However, when she died in 1915, Mrs. Murdock asked in her will that the city build and maintain a museum so that her estate could be used to purchase acquisitions for it. She laid down no limits but did indicate a strong preference for American art. Plans for a handsome building were drawn. The central portion, opened in 1935, has been enlarged several times since. Under the skillful and final authority of Mrs. Murdock's executor, Mrs. Rafael Navas, the collection begun in 1937 was built through the years way beyond the importance of the average small museum's holdings in American art. Though

Ben Shahn: The Blind Botanist
(Wichita Art Museum,
Wichita, Kan.)

broadly based, this is no heterogeneous gathering of big names, but an astutely chosen sampling of every important period in American art, slowly and carefully put together. Although the emphasis is on the contemporaries, two excellent Copleys, *James Otis* and *Mrs. James Otis*, and a Feke testify to our Colonial blossoming. The museum and Mrs. Navas refused to be stampeded by the popularity of "American Scene" collecting in the 1930s, although one of its masters, John Steuart Curry, was a Kansan. Quite properly, though, the fund's first purchase was an important Curry: *Kansas Cornfield*. With giant, shooting stalks of corn whipping in the breeze, it is surely as close to abstraction as that realist ever came. And how many small midwestern museums can boast of a fine Ryder, a Homer (*In the Mowing*), three Eakinses, three Davieses, three Demuths, four Hoppers and three Walt Kuhns?

Seven of the Eight, or Ashcan School, as they were derisively labeled, are represented in Wichita. This group of artists, young at the beginning of the 20th century, rebelled against the slick academic painting of the time. They preferred painting life around them as they saw it: the back alleys, the city tenements, the clotheslines of reality. Beauty lay for them in the ability to catch and hold the mood and meaning of ordinary scenes.

Flannagan, Zorach, Umlauf, Oliver Andrews, De Creeft and Lachaise are shown in notable examples. Indeed, it is impossible to emphasize too strongly the quality of each and every piece in the Roland P. Murdock Collection, the result of a determination to acquire not just the available, but only the finest representation of any artist's work. The fund which gave Wichita such a head start terminated in 1962.

In the meantime the lively Wichita Art Museum Members, Inc., was founded in 1960 for the purpose of extending the services of the museum to the community, and to continue to build the collection in the spirit of the Murdock bequest. Some recent additions have been Robert Salmon, Titian Peale, Benjamin West, John Haberle and contemporaries Nevelson, Lassow, Youngerman, Motherwell, and so on. A collection of the work of Charles M. Russell is now on display in its own gallery. Wichitans are presently planning a total reorganization of the building and the construction of a new wing. Edward Larabee Barnes (*see* Walker Art Center, Minneapolis) of New York City is to be the master architect of the project.

KENTUCKY

J. B. SPEED ART MUSEUM
2035 South Third Street, Louisville, Kentucky

Hours: Tues.–Sat. 10–4; Sun. 2–6
Closed: Mon., major holidays
Library

First and largest art museum in the Blue Grass State, the Speed
conjures up Kentucky's past admirably. Take the whacking
seven-foot-tall *Chief of the Mechanics' Volunteer Fire Brigade of
Louisville,* carved and painted like a cigar store Indian. When
the alarm sounded in the 1800s, the formidable chief was turned
by crank, from his stand atop the firehouse, to point in the
direction of the conflagration. Take John James Audubon, who
began doing portraits to finance his birdwatching, a good deal
of it in Kentucky. Two portrait drawings of *James Berthoud* and
Mrs. James Berthoud by Audubon are here, as well as two oils
of the same subjects, also attributed to the artist. Mrs. Berthoud
is seen in profile at a window which looks out on the site where
J. B. Speed later built a cementworks and part of the fortune
that founded this museum. Matthew Jouett, "Master of the Blue
Grass," and pupil of Gilbert Stuart, is shown by several portraits.
Chester Harding painted the *John Speed Smith Family* during
1819 and 1820 when, at twenty-eight, he stopped in Kentucky
and achieved local fame by doing more than 100 portraits in
six months.

But, for all its Kentuckiana, this is no provincial museum. An
elegant new wing of green Vermont slate winds itself around a
garden court. Its wide entrance gives instantaneous and dramatic
viewing of large contemporary works. This setting has sparked a

Italian, early 16th century: Horse and Rider (J. B. Speed Art Museum, Louisville, Ky.)

new group of collectors who purchase today's art for the museum. A lecture hall and library are also in the wing. Works in the small print and drawing cabinet are frequently changed.

A recent bequest of 50 paintings contains fine examples of Courbet, Monet, Seurat, Degas, Picasso and Cassatt, and an excellent Kokoschka—*Nogent-Sur-Marne Viaduct,* 1932. Other distinguished canvases: Paolo Veronese's *Portrait of a Young Woman Holding a Skull;* Vincenzo Poppa's *St. John the Baptist;* Jacob Jordaens's *Paul and Barnabas at Lystra.* The collective skill of Jan Brueghel the Elder and Hendrick von Balen produced the spirited *A Bacchanale.* There are portraits by Nattier and Largillière and a fine Rubens sketch. Julius Held, art historian, Rubens authority and master sleuth (as all good art historians should be), has identified it as a sketch done for a series of tapestries depicting *The Triumph of the Eucharist,* designed for the Convent of the Descalzas Reales in Madrid. The tapestries left Antwerp for Spain on July 12, 1628, and are still in the convent. Held said of the Louisville sketch, "It betrays the hand of the master in every stroke." Goya's *Fray Joaquin Company, Archbishop of Saragossa* and the polished dome of *Mlle. Pogany* by the 20th century master Brancusi remain favorites. *The Flagellation,* an important Alessandro Algardi, has joined the substantial Italian bronze group.

Hattie Bishop Speed gave the museum to the public in 1925 in memory of her husband. The Preston P. Satterwhite Wing, opened in 1954, holds the donor's collection of art, furniture and *objets d'art* and a superb Elizabethan great hall shipped intact from Devonshire.

An innovation other museums might envy is the establishment of a group of friends, or patrons, or elite corps ... call it what you will. Each pledges $2,000 a year toward the purchase of art. If a Flemish painting is needed, a seminar is given the "friends" during the year on Flemish painting. Then two or three members and the director go to the New York galleries, or paintings are sent to the museum for study. The museum benefits from the friends' money—and the friends, it is hoped, benefit from the seminar and the knowledgeable sharing in building the museum's collection.

NOLITE ME CONSIDERARE QVOD FVSCA SIM QVIA DECOLORAVIT ME SO

17th century Peruvian, School of Cuzco: Lima Madonna
(New Orleans Museum of Art, New Orleans, La.)

LOUISIANA

NEW ORLEANS MUSEUM OF ART

Lelong Avenue at City Park, New Orleans, Louisiana

Hours: Tues.–Sat. 10–5; Sun. 1–6
Closed: Mon., major holidays
Library

With the opening of three new wings in 1971 and increased municipal support, the New Orleans Museum of Art has moved into the mainstream of the cultural life of the country. A gift to the city in 1912 from sugar magnate Isaac Delgado, the beautiful Classical Greek structure designed by Samuel Marx of Chicago was bereft of works of art, endowment or city support. Private collectors rushed to fill the breach—the Morgan Whitneys with their Chinese jades, the Harrod Collection of silver, the Chapman Hymans with Salon and Barbizon paintings. But until World War II the Delgado, as it was then known, remained a provincial museum. A gift of paintings from the Samuel H. Kress Foundation, a series of stimulating temporary exhibitions and the enthusiasm of the staff and trustees elicited from the city fathers a fine new wing and continuing financial support.

An acknowledged cultural gateway to Central and South America, the museum pays its obeisance by frequently hanging on the walls of the beautifully proportioned entrance court its extensive collection of those charming semiprimitive, semisophisticated paintings of the Cuzco and Quito Colonial schools. The museum also has a Pre-Columbian group from the Inca and Mayan cultures. No heterogeneous collection of pots and fragments these, but distinguished sculptures of the Chimu and Mochican cultures of Peru and both early and late classical Mayan periods.

The Samuel H. Kress Collection is set up chronologically, 13th through 18th centuries. Not to be missed is *The Last Supper,* a small Italian Primitive. Scholars do not agree on the painting's origin. Artists painting solely for the medieval Church did not sign their work. Thus, art historians can only surmise through technique and appurtenances in which school to place a picture. Paolo Veronese's *Sacra Conversazione* and Lorenzo Lotto's *Portrait of a Bearded Man* are other distinguished Kress paintings. A fine addition to the Old Master section which contains European paintings from the 15th to 18th centuries is *The Lawyer's Office* by Marinus van Reymerswaele.

Don't miss the elliptical first-floor gallery reserved for Louisiana artists or the new Edgar B. Stern auditorium, where the severity of the hall is tempered by handsome monumental Mayan stele rubbings on the walls. The three-storied Edgar Wisner children's educational wing provides working areas for artists, demonstrating to children a variety of creative techniques ranging from the lost-wax process to pulling a print. The unconventional and colorful children's museum is pure delight.

The balcony, which runs along three sides of the entrance court, is hung with 19th century Louisiana genre paintings. While these artists did not succeed in immortalizing the cotton fields, as George Caleb Bingham immortalized the Missouri River, many are worth more than regional attention. Certainly William A. Walker and Richard Clague belong in the mainstream of genre painting, along with the North's E. L. Henry and William S. Mount.

With the exception of a pair of painted glass doors done by Gauguin in Tahiti, Degas has a gallery of his own. The story goes that Gauguin painted the doors of his house in order to frustrate a curious landlady. Degas's mother was born in New Orleans, and one of his brothers married a New Orleans cousin. During a visit of some months in 1873, he did many portraits of his large family and painted the important *The Cotton Office in New Orleans* to commemorate his trip (it hangs in the Municipal Museum of Pau, in France; a smaller version is at the Fogg Museum at Harvard). Most of the portraits have been lost, but recently when the portrait of Estelle Musson Degas, *Jeune Femme Arrangeant un Bouquet,* came on the market, the then director James Byrnes and the citizens of New Orleans rose to

the challenge and, in a dramatic city-wide drive, raised $190,000 to bring Estelle back home.

The new second-floor wing provides central space for 20th century contemporary works, with surrounding galleries for the Oriental and African collections. A fine example in the latter collection is a 1910 signed piece by Olowe of Ise of the Yoruba tribe, Nigeria. The Billops Glass Collection, one of the most distinguished in the country, starts with the Romans and goes through the 19th century.

Well represented among 20th century artists are Tharrats, Kandinsky, Rouault, Utrillo, Lipchitz, David Hare, Penalba, Vasarely, Ray Parker, Frank Gallo, Frank Stella and Georgia O'Keeffe, with a recent painting, *My Backyard*. There is a good group of Surrealist works—important paintings and sculpture by Max Ernst and Magritte, and paintings by Dorothea Tanning, Kurt Seligman and Roland Penrose (yes, Roland Penrose—collector of and writer on Picasso).

It has been left to tradition-ridden New Orleans to have the first outside laser beam sculpture in the country. Executed by Rockne Krebs, it is titled *Rite de Passage*. It is a complex mechanism of nine colors which lights up the museum façade and charges the sky for miles around. The laser beam sculpture is a gift of the Stern children in honor of their mother, Mrs. Edgar B. Stern, a major benefactor of the museum.

Olowe of Ise: Veranda Post of the Ogoga of Ikere (New Orleans Museum of Art, New Orleans, La.)

Robert Feke: General Samuel Waldo (Bowdoin College Museum of Art, Brunswick, Me.)

MAINE

BOWDOIN COLLEGE MUSEUM OF ART

Walker Art Building, Brunswick, Maine

*Hours: Sept.–June: Mon.–Fri. 10–4; Sat. 10–5; Sun. 2–5. July–
Labor Day: Mon.–Sat. 10–5; 7 P.M.–8:30 P.M.; Sun. 2–5
Closed: Major holidays*

Charles F. McKim of McKim, Mead and White built this museum
in 1894 on one of the most beautiful small campuses in America.
Its elegant little entrance hall has lunette murals of Cox, LaFarge,
Thayer and Vedder. Given in 1811 by founder James Bowdoin
III, this oldest collection of any college group contained 70
paintings, including portraits of Jefferson and Madison by Gilbert
Stuart commissioned by Bowdoin. Among 142 drawings, ap-
praised at the time for $7.50 the lot, are fine specimens of Luca
Cambiaso, Nicholas Poussin and Pieter Brueghel the Elder.

But the fame of the collection rests primarily on portraits of
the Bowdoins themselves, terrific testimonials to a family who
played a strong role in shaping Colonial history. There is no
likeness of Pierre Baudouin, who, fleeing from the Huguenot
persecution in France, established the clan in New England; but
his son James Bowdoin I, who Anglicized the name, was painted
in both youth and maturity by skillful unknowns and also by
Joseph Badger, the house and sign painter who acquired a facility
far beyond likenesses. There are handsome portraits of James
Bowdoin II, one done as a youth by John Smibert, another later
by Robert Feke. Christian Gullager, who did the Salisbury family
in Worcester (see Worcester Art Museum, Mass.), also painted
James II. Robert Feke, portraying James's wife, tried to live
up to her husband's poem to her particular charms—"Her tempt-

155

ing breast the eyes of all command,/And gently rising court the
am'rous hand"—by painting her in what must have been brazen
décolletage for the old New England Puritans. There are many
portraits of collateral Bowdoins, but we will cling to the trunk
of the tree, departing only to mention two: *General Samuel
Waldo*, whose full-length portrait is considered Feke's master-
piece, and Copley's arresting portrait of *Thomas Flucker*, Tory
conspirator married to a Bowdoin. One of the most delectable
portraits of children to be found anywhere is Joseph Black-
burn's of *James Bowdoin III and His Sister Elizabeth*. Gilbert
Stuart did *James Bowdoin III and His Wife*. Mrs. Bowdoin—
young, freshly coiffed and ruffed, and set against a classical
background—is especially appealing. Several years after his death,
James III's widow presented the family portraits to the college.
A scholarly and lively catalog of their history has been done by
Marvin Sadik, former director of the museum. American land-
scapes by George Inness, Thomas Doughty and a little beauty,
Newburyport Marshes, by M. J. Heade have entered the collec-
tion. George Healy's portrait of *Henry W. Longfellow* is one of
three of the poet done by Healy. The Bowdoin portrait, con-
sidered the best, was sought by both Harvard and the Library of
Congress but went to Longfellow's alma mater.

Maine-stater Winslow Homer is well represented. *Fountains at
Night* is an atypical Homer canvas in myriad tones of gray.
Some contemporaries here: Philip Guston, John Grillo, Jack
Tworkov, Franz Kline, Peter Agostini, Reuben Nakian.

Five huge Assyrian reliefs (see Amherst) came to the college
in 1857. Much of its fine Classical Antiquity section is the gift of
Edward Perry Warren, who aided both the Metropolitan and the
Boston Museum in establishing departments of antiquities. The
Salton Renaissance and Baroque medals and plaquettes have
joined the museum.

OGUNQUIT

MUSEUM OF ART OF OGUNQUIT
Shore Road, Ogunquit, Maine

Hours: June 28–Sept. 10, Mon.–Sat. 10:30–5; Sun. 1:30–5

The Ogunquit museum is unusual in that it is strictly a summer museum. However, during that blithe period the place pulsates with all the activity of a city museum. Changing exhibitions are put on, and the permanent collection continues to grow. The building was erected in 1952 in memory of Charles and Adeline Strater of Louisville, Kentucky. Built on a rocky promontory of Narrow Cove, the place has a salty fragrance. Though probably not by design, much of the collection seems indigenous to Maine and the sea—Marsden Hartley's *Lobster Pots and Buoy*, Marin's *Cape Split, Maine*, John Flannagan's *Pelican*. The site on which the museum was built was an artists' preserve for years. Here Walt Kuhn, Kuniyoshi and a host of others used to set up their easels to try to catch that grandeur of cliff and sea peculiar to Maine.

From the center court of the clean-lined little building a glass façade frames the ocean. Sculpture resting out of doors is silhouetted against its blue. Restricted to American art, some of the museum's holdings are in Tobey, Graves, Kuniyoshi, Demuth, Tom Hardy and Walt Kuhn.

PORTLAND

PORTLAND MUSEUM OF ART
111 High Street, Portland, Maine

Hours: Tues.–Sat. 10–5; Sun. 2–5
Closed: Mon., major holidays

The Portland situation is half historic house, half museum. The McLellan-Sweat House, built in 1800, is one of the truly fine

houses of the Federal period. It passed to Colonel Lorenzo de Medici Sweat (yes) in 1880. In 1908 Mrs. Sweat bequeathed the house, and funds to build adjoining galleries, to the Portland Society of Art.

The furnishings have been kept as close to the Federal period as possible. The Gilbert Stuart portrait of General Henry Dearborn is a second version of that at the Chicago Art Institute. One upstairs bedroom has been turned into a showcase for the museum's collection of Portland glass. The glass company flourished 1863–1873, making fine pressed glass in unique patterns (many of which were copied by rivals).

The museum, served by a common entrance with the house (for which there is a $1.00 fee), can only be described as rotunda style. Although space has long been at a premium, the visitor can usually count on seeing some of the particularly interesting 19th century collection. A natural specialty is the school of Portland painters. Their chief mentor as listed in the Portland Directory of 1830 seems to have been "Charles Cadman, fancy painter, rooms Middle Street." For almost a hundred years a group of painters ranging from competent to talented drew their inspiration from the waterfront, the coves, the woods and the streets of Portland. Many of them belong in the mainstream of 19th century painting. The collection also includes pivotal examples of works from the Ashcan School and a rare painting by the eminent photographer Edward Steichen.

The contemporary collection, while small, is strengthened by exhibitions of current modes and a fine 20th century print collection. Do not miss the small house next door. Used as an art school, it is surely the most charming and unique Greek Revival building in New England.

WATERVILLE

COLBY COLLEGE ART MUSEUM
Mayflower Hill, Colby College, Waterville, Maine

Hours: Mon.–Sat. 10–12, 1–5; Sun. 2–5
Closed: Major holidays
Guides provided in summer; apply information center

On the edge of the Colby College campus, the Bixler Art and Music Center houses a new museum with a brisk program. Built to harmonize with the 1959 center, the museum has spacious, adaptable galleries on two levels. Slit windows at strategic corners change the pace of viewing to campus green or campus white.

The entrance gallery, one side of which looks over the Abbott Pattison sculpture court, is dominated by a bold arrangement of Louise Nevelson's black sculpture. Her black and white drawings form a background frieze. Nevelson's total gift to the museum is 20 drawings, 12 sculptures and 4 paintings. Robert Indiana's seven-foot sculpture *ART* arrests one. Other artists represented by important works are Alexander Calder, James Rosati, Abbott Pattison, Lynn Chadwick, Philip Guston, Walt Kuhn, Lee Gatch, Alex Katz, Isamu Noguchi and Chaim Gross.

Presiding over a two-story downstairs gallery is an outsized ship's figurehead of the young Queen Victoria. The adjacent American Heritage Collection of 78 canvases, a 1956 gift to the college, consists primarily of New England Primitives, 1800–1869. Among the museum's estimable Colonial portraitists are John Smibert, Joseph Badger and Joseph Blackburn. John Singleton Copley was twenty-two when he did the *Portrait of Mrs. Metcalf Bowler*. The panels of Mrs. Bowler's living room are now built into the American wing at the Metropolitan. The earliest portrait (1726) is John Watson's portrayal of *William Burnett*, godson of William of Orange, who migrated to the Colonies and became governor of Massachusetts and New Hampshire, which then included Maine.

The 19th century artists Cole, Doughty, Kensett and Inness are shown in good small examples, a blessed relief from their usual outsized canvases. One moves on into rich fare: a Winslow Homer corner, made up of the museum's 14 Homers, leads one

into the John Marin room (one might say, shrine). The works, 25 in all, range from an 1888 watercolor, done when the artist was eighteen, to a 1952 oil painted the year before he died. This thoughtfully selected collection is the gift of Mr. and Mrs. John Marin, Jr.

The American Decorative Arts section is rich in 20th century ceramics and shows some silver and furniture. A group of more than 300 Oriental ceramics, though sparsely shown, is available for study.

While the museum's emphasis is clearly in the American field, there are good examples of 18th century English portraiture and landscapes. Corot, Pissarro, Utrillo, Kirchner and Klee are among the Europeans shown. Classical ceramics and sculpture and Pre-Columbian pieces round out the collection.

John Marin: From Seeing Cape Split (Colby College Art Museum, Waterville, Me.)

MARYLAND

BALTIMORE MUSEUM OF ART
Wyman Park, Baltimore, Maryland

Hours: Tues.–Fri. 11–5; Sat. 10:30–5; Sun. 1–5
Closed: Mon., major holidays
Library, café

Rodin's *The Thinker*, as if he were their talisman, guards the entrance to three museums: Detroit's Institute of Arts, San Francisco's Legion of Honor and the Cleveland Museum. Baltimore's especially beautiful cast in danger of becoming a victim of pollution has been moved inside.

The building, planned around a skylighted garden, is refreshingly simple, and seeing the collections that make up this effective museum is refreshingly easy. The Antioch mosaics (2nd to 6th centuries A.D.), though originally pavements, have been set ingeniously into walls around the court.

Baltimore has received many private collections as gifts, most of which are displayed as units—a provision that can be disadvantageous, but which is minimized here because the collectors were unusually single-minded and each group has its own homogeneity. Thus the museum is really a collection of collections. The areas are American, especially Maryland art, past and present: Old Masters since 1500; the decorative arts since 1500, except when they are amply represented by the neighboring Walters Art Gallery; art of the 20th century and contemporary art; Oriental art; prints and drawings since 1500; sculpture since about 1500; sporting art of the past and present; Pre-Columbian, African and Oceanic art.

A joy of the Epstein Collection is a magnificent northern

John Hesselius: Portrait of Charles Calvert (Baltimore Museum of Art, Baltimore, Md.)

Baroque painting, *Rinaldo and Armida*, by Van Dyck. Voluptu-
ous yet tender, explosively brilliant in color, it was in the col-
lections of Charles I and the Dukes of Newcastle until 1913.
In the same group are a fine Gainsborough from the artist's
Bath period, *Mrs. Charles Tudway*, Frans Hals's *Portrait of a
Young Woman* and Titian's *Portrait of a Bearded Man*. The Euro-
pean tradition carries on in the Mary Frick Jacobs group, includ-
ing Rembrandt's portrait of his son *Titus*; the Frans Hals portrait
of *Dorothea Berck*, who was Mrs. Coymens (Mr. Coymens hangs
several hundred miles north, in the Hartford Atheneum); Nattier's
Barronne Rigoley D'Ogny, and Chardin's *Knucklebones*. Also
Hubert Robert's *The Terrace*, the letters "psl" after the signature
standing for the Prison St. Lazare, where he, as a political pris-
oner, was awaiting execution. Happily for him, and for posterity,
another unfortunate who bore the name Hubert Robert was
executed in his place.

The Maryland wing has all sorts of reminders of the elegance
in which our southern Colonials lived—their furniture, silver and
portraits, including *Portrait of Charles Calvert* with his Negro
slave by John Hesselius, who painted the wealthy Maryland
families, as had his father, Gustavus, before him. There are eight
portraits by the Hesseliuses, mostly of the Calvert family. The
Calverts, it seems, were concerned with preserving their like-
nesses; they also frequently commissioned John Wollaston to
paint them.

The Maryland period rooms start with the early 18th century
and Eltonhead Manor, in Calvert County. Thirteen handsome
pieces of old Baltimore painted furniture have been installed in
the great oval room from Willow Brook House (Baltimore, 1799).
A recent addition is rooms from a typical Baltimore row house.
In the early 19th century architect Robert Mills built 12 row
houses on Calvert Street (we can't seem to lose those Calverts)
called Waterloo Row. These were demolished in 1970 in an
urban renewal plan, but the museum was able to acquire an en-
trance hall, stair hall and double parlor. The comprehensive
Miles White Jr. Collection of American Silver contains examples
of the work of 38 Maryland silversmiths, while the textiles de-
partment's strength in Maryland quilts is newly popular with an
America gone quilt-mad. Maryland's enthusiasm for horses is
expressed in the William Woodward Gallery, decorated as an

Henri Matisse: The Blue Nude (Baltimore Museum of Art, Baltimore, Md.)

18th century drawing room with portraits of all the great race horses, sires and dams of most of today's thoroughbreds.

Few museums in America have as fine a collection of contemporary drawings as is found in Baltimore's Thomas Edward Benesch Memorial Collection. Each work has been chosen with a connoisseur's eye.

Downstairs is the Alan and Janet Wurtzburger Collection of Pre-Columbian, African and Oceanic art. This select grouping is installed so as to give each object its own importance; divided geographically and historically, it provides an invitation to learning.

The reason most of today's collectors travel to Baltimore, it must be admitted, is to see the Cone sisters' collection. These astonishing women, with tastes so far in advance of their time and of the somnolent, polite atmosphere of Baltimore, cherished their purchases in private while they lived and willed them to the city when they died. Dr. Claribel Cone's fierce independence is the key to understanding how she came to buy Matisse's *Blue Nude* of 1907. It took courage for her to enter Johns Hopkins Medical School in 1900, when ladies were supposed to be con-

ent with crocheting doilies, but it took more to buy this canvas,
of such rugged beauty that time and acceptance have in no way
diminished its impact.

The Cones spent a good deal of time in Paris, where their
friend Gertrude Stein introduced them to the young painters.
Matisse became the one whom they collected most avidly. Re-
alizing what an important body of his work they were acquiring,
Matisse let them browse and choose from among his own favor-
tes. The sisters consolidated their friendship with Picasso by
bringing him American comic strips, in which he delighted. The
ladies also bought Delacroix, Corot and a Cézanne, *Mont Ste.
Victoire*, along with Picasso's *Woman with Bangs*, painted in
1902, his *Portrait of Dr. Claribel Cone*, van Gogh's *The Shoes*,
Gauguin's *Woman with Mango* and, of course, the whole rhyth-
mic, colorful chorus of the Matisses.

The Sadie A. May Collection carries on through the Cubists
and Surrealists and shows top examples of Miró, Mondrian,
Delaunay, Léger, Kandinsky and Gris. Three American stunners
are Jackson Pollock's *Water Birds*, Robert Motherwell's 1943
collage *The Joy of Living*, and William Baziotes's *The Drugged
Balloonist*. Unlike those of other Baltimore collectors, Miss May's
collection is catholic and roams in a few but good examples from
the Egyptians, the Greeks and a Renaissance period room, to the
works discussed above.

The Edward Joseph Gallagher Memorial Collection brings
us to the tried and true of our own time: Sheeler, O'Keeffe,
Marin, Stuart Davis, Shahn, Kuniyoshi, Tobey and Kline, to
name but a few. The Alan and Janet Wurtzburger Collection of
sculpture was gathered in their lifetime, but each monumental
piece was chosen with the museum's leafy acreage in mind. De-
ployed about will be Maillol's *Summer*, Moore's *Reclining
Woman*, Zadkine, Wotruba, Lipchitz, Richier, Marcks, Arp, Min-
guzzi, Noguchi, David Smith, Paolozzi, Caro, Giacometti, Du-
champ-Villon, Max Bill and others. The garden is now in the
planning stage.

WALTERS ART GALLERY

600 North Charles, Baltimore, Maryland

Hours: Tues.–Sat. 11–5. Mon., Oct.–May, 1:30–5 and 7:30 P.M.–
9:30 P.M. *Mon., July–Aug. 11–4; Sun., holidays 2–5*
Closed: Major holidays

The long-awaited new wing of the Walters Art Gallery opened
late in 1974. At last literally hundreds of treasures, known and
documented by scholars, are coming out of the storage vaults
for the first time in years to live and breath again in galleries
adroitly designed for their scale. Objects necessarily crowded
together in the older museum, such as the four large wonderfully
carved Roman sarcophagi (A.D. 150–210), are stunningly featured
in the new wing. These were all taken in 1885 from one family
burial ground on Rome's Via Salaria outside the Porta Pia, part
of the Massarenti Collection purchased in 1902 in Rome by Henry
Walters. The 1,540 objects in this collection included Old Master
paintings as well as antiquities. Walters chartered a ship to bring
them all to Baltimore.

The architects of the wing were Shepley, Bulfinch (great-
grandson of Charles Bulfinch, who succeeded Latrobe as archi-
tect of our nation's Capitol), Richardson (grandson of Henry
Hobson Richardson, innovative mid-19th century architect) and
Abbott of Boston. The exterior has the same massive block struc-
ture as the old building, but the interior adapts itself as few new
museums do to the exciting collections. The floor was lowered
in one side of a gallery so that the viewer can look across at the
tapestries as if from a balcony. Concrete sun screens that are
part of the basic structure allow for daylight and just enough
relationship to the outside world. The new wing entrance brings
one immediately on a level with the auditorium. The collections
begin on the next level: Egypt, the Ancient Near East, the
Greeks, Roman, Etruscans. On the floor above we move to the
Walters' famed Byzantine, Islamic and Medieval worlds, in
which, wherever possible, parts of the famed manuscript collec-
tion are integrated. For instance, a gallery-within-a-gallery holds

Ascribed to Pierre Pénicaud: Acrobats
(Walters Art Gallery, Baltimore, Md.)

Islamic manuscripts. Medieval manuscripts are in the Romanesque and Gothic rooms. Access to the original building is simple; a short bridge on each exhibition floor takes one from the old civilizations to the Renaissance and later, works of which are housed in the original structure.

The founder of all this was William Walters, a wealthy Baltimore produce merchant. When the Civil War began, Walters, a Confederate sympathizer in a Union city, took his family to Europe for the duration of the war. Although he had already begun purchasing Maryland painters such as Richard Caton Woodville and had commissioned Alfred Jacob Miller to do 200 watercolors, based on Miller's notebook sketches of his 1830s field trip to the Far West, it was during this sojourn in Europe that Walters began his prodigious buying.

In the Depression that followed the war, William Walters bought up "ribbons of rust" through the South and gradually put together the Atlantic Coast Line Railroad. Meanwhile, wings were built on his house to make room for the crates of art that followed him home. One of his special interests was the work of the French 19th century sculptor Antoine Louis Barye (see Washington, D.C., Corcoran Gallery). The museum has more than 500

Barye sculptures, paintings and drawings, some of which are shown in the new complex. From January to March, Walters opened his collection to the public. Eventually his son Henry built a Florentine *palazzo* on Charles Street which he bequeathed to the city in 1931, together with the collection and stacks of still-crated treasures. Henry Walters, following in his father's footsteps but covering much more ground, collected so unobtrusively, threatening dealers with boycott if they spoke of him, that even today, though the museum is renowned among world scholars, few Americans are aware of its riches. Few collections of world note bear the stamp of the individual preference William Walters and later his son brought to this selection. Even their few idiosyncrasies blend into the whole. Frick and Huntington had their Duveen, Mrs. Gardiner her Berenson, but the Walterses tended their own taste.

It is probably in the Byzantine and Medieval fields, in illuminated manuscripts, small bronzes, enamels and ivories, that the museum is strongest. Its collection of Renaissance enamels is the greatest in the United States. There is an incredible hoard of miniature sculpture from south Russia as well as miniatures and jewelry of Egypt, Rome and Greece. The Renaissance jewelry simply has no equal in America. Other treasured objects are the Sassanian and Islamic metalwork and the Hamad Treasure of Liturgical Silver (Byzantine, 6th century), found near Hamad in northern Syria and the most comprehensive ensemble in existence of early Christian liturgical vessels. A handsome catalog explains terms and uses of the objects. A high point in the Medieval section is a late 15th century Flemish altarpiece, a crowded work of carved oak, polychrome and gilt depicting scenes from the Passion and Resurrection.

Although paintings were of secondary interest to both Walterses, they acquired some fine ones. The inventory includes more than 4,000 works, beginning with Italian gold-ground paintings of such masters as Bartolo di Fredi, Lippo Vanni and Andrea di Bartolo. A fragment of a cross with the weeping Virgin painted on it is ascribed to the Spoletto school (late 12th to early 13th century). It is thought to be the oldest Italian painting in this country. Four early panels were originally part of a predella by Giovanni di Paolo. There is splendor in Fra Filippo Lippi's *Virgin and Child*. For me the slightly offbeat *Madonna and*

Gregorio Schiavone: Madonna and Child (Walters Art Gallery, Baltimore, Md.)

Child by Gregorio Schiavone (School of Padua), with its swags of fruit over the head of the Madonna, is simple enchantment. Another important picture in the collection is Raphael's *Virgin of the Candelabra*. It passed through many hands before it reached Walters in 1910: from the Borghese Palace to Lucian Bonaparte (in 1817 Ingres made a copy of it) to England and finally America, where the last owner mortgaged it to a bank. After a foreclosure the picture came to Walters. A recent acquisition is a small beauty, *Virgin and Child on a Crescent Moon* (Franco-Burgundian, 1415). *Piazza of an Italian City*, by Luciano

da Laurana, is one of three known canvases by this painter (the other two are in Florence and Urbino). The picture is a perfect example of linear perspective—as you walk past it, the broad street is always in focus. The gallery of Dutch and Flemish paintings has an especially fine one by Hugo van der Goes, an artist of the early Renaissance in Flanders, *Portrait of a Donor with St. John.* The 19th century French are well represented with, among others, Delacroix's *Crucifixion,* Ingres's *Odalisque* and Daumier's *Second Class Carriage,* which William Walters commissioned from the artist. Another Ingres, inspired by Titian's *Venus of Urbino* and thought by Ingres scholars to be lost, turned up on the Walters storage racks. Manet, Monet, Sisley and Mary Cassatt are shown in handsome examples. The painting collection stops here and lets the Baltimore Museum of Art carry on into the 20th century.

At last the Chinese porcelains can be seen at their best. Walters indulged his passion for these with so choice a group that a ten-volume work, *Oriental Ceramic Art,* written in 1897 by Stephen W. Bushell, was based primarily on Walters's holdings, and is still a prime reference book. The Oriental Collection is enshrined on the new wing's top exhibition floor.

One of the features in the museum that other institutions could do well to copy is the racks of reference books in different galleries. Comfortable seating areas in the new wing entice one to use them. How good to have this Fort Knox of the art world opened at last and that vast treasury which simply couldn't be shown in the older building on view in such a handsome setting.

MASSACHUSETTS

AMHERST COLLEGE: MUSEUM OF FINE ARTS, MEAD ART BUILDING

Amherst College, Routes 9 and 116, Amherst, Massachusetts

Hours: Labor Day–June 1: Mon.–Fri. 9–5; Sat., Sun. 12–5. Summer: Mon.–Fri. 10–12, 2–4; closed: Sat., Sun., Aug. Closed: Major holidays, academic vacations

Lord Jeffrey Amherst, who saved New England from the French in the Battle of Louisburg (1758) and became governor general of North America, hangs in Gainsboroughian splendor and honor at the Mead Art Gallery (a copy hangs in the National Portrait Gallery in London). The building, erected in 1949 by McKim, Mead and White, was built largely through the generosity of the Mead family. Lecture rooms and a library branch off from the changing exhibitions and the permanent collection in the central section. As with many other campus art museums, only a portion of the permanent holdings can appear at one time. The collection is strong in American art: Copley in portraits of Mr. and Mrs. Benjamin Blackstone, Benjamin West, John Wollaston, Ralph Earl, John Trumbull, Charles Willson Peale and Rembrandt Peale, and Thomas Sully. The Gilbert Stuart holdings number seven, the rarest a portrait of his Irish period, *Robert Shaw Terenure*, ancestor of George Bernard Shaw. The Rotherwas Room (1611) is an outstanding piece of Elizabethan decoration. The house itself existed from 1086 and was mentioned in the Domesday Book of William the Conqueror. When it was dismantled in 1930 Herbert L. Pratt purchased the room and moved it to Glen Cove, Long Island. He gave it to Amherst in 1945.

171

The elaborately carved and richly polychromed mantelpiece is held up by figures of Fortitude, Justice, Prudence and Temperance.

The Nineveh Room contains large reliefs from the palace at Nimrud, capital of the Assyrian empire (9th century B.C.), as well as other antiquities. When Sir Austin Henry Layard, an English archaeologist, dug up pieces, the Reverend Henry Lobdell (Amherst, 1844), a missionary in nearby Mosul, was on hand. Sawed from the face of the huge alabaster blocks they rested on, the reliefs were packed on the backs of camels, who marched 500 miles to the nearest port with their burden. The dig should have been titled "Operation Missionary," because Dartmouth, Middlebury, Bowdoin, Williams, Yale and the University of Vermont all have similar reliefs sent home in the 1850s by alumni missionaries to the Middle East (see S. Lane Faison's *A Guide to Art Museums of New England*). There is a Kress study collection and a decorative arts section quite rich in textiles and American and European furniture. While little of the latter can be on view, it is accessible to anyone interested.

ANDOVER

ADDISON GALLERY OF AMERICAN ART

Phillips Academy, Andover, Massachusetts

Hours: Mon.–Sat. 9–5; Sun. 2:30–5
Closed: Major holidays

If rules were made to be broken, this is the place to break the rules. Our concern is with the community and college art museum, but Phillips Academy is unique among secondary schools in that it established an art museum for its students before such an aid to education was a gleam in many a college president's eye.

A gift of Thomas Cochran, class of 1890, the museum opened in 1931, a tidy package replete with objects of art, maintenance and endowment funds. The permanent collection is exclusively American, but loan exhibitions may and do go far afield. A new

John Singer Sargent: Cypress Trees at San Vigilio
(Addison Gallery of American Art, Andover, Mass.)

building, the Arts and Communications Center, adjoins the museum via the long gallery facing an outdoor sculpture court. Auditorium, studios and workshops are here.

The painting section, recognized as one of the best specialized collections in the country, starts with John Smibert, a Scot who came to New England in 1729. John Singleton Copley is here; so are Benjamin West and many of his pupils—Washington Allston, Gilbert Stuart, John Trumbull and Samuel F. B. Morse, who graduated from Phillips Academy in 1805 at the age of fourteen. There are splendid Hudson River paintings, but it is the holdings of that turn-of-the-century triumvirate Eakins, Homer and Ryder that are most enviable. Homer's *Eight Bells, West Wind* and the early *New England Country School* come to mind.

Others here in fine examples: James McNeill Whistler, Childe Hassam, Maurice Prendergast, George Luks, William Glackens, George Bellows and Edward Hopper. The Addison's spirit of quest and adventure led it to acquire such people as Jackson Pollock, Andrew Wyeth and Charles Sheeler before they attained broad demand and prices beyond most museum budgets.

A selection of furniture, glass and textiles of the Colonial

period is on permanent view, as is a splendid group of models of American sailing ships.

A lively exhibition program is open to students and visitors. Two galleries are devoted to the art of photography. Exhibitions are timely. One project is described thus in the exhibition catalog: "In the merry month of May/ Larry crossed the U.S.A./ Ate McDonalds all the way/ Tells his story day by day." Larry did just that. The result was an exhibition called "One Culture Under God," which consisted of 320 color slides in a two-screen environment, black and whites exhibited in the order in which they were taken and a portfolio of 12 photographic silkscreen prints. While other exhibitions may not be as derring-do, visitors are assured of lively shows plus a fine historical survey of American art.

BOSTON

ISABELLA STEWART GARDNER MUSEUM

280 The Fenway, Boston, Massachusetts

Hours: Sept.–June: Tues. 1–9:30; Wed.–Sun. 1–5:30; closed Mon.,
major holidays. July, Aug.: Tues.–Sat. 1–5:30; closed Sun.,
Mon., July 4

Fenway Court, as Bostonians call it, is as much a triumphal monument to Isabella Stewart Gardner as it is a museum. This remarkable woman, a New Yorker who at twenty married into an old Boston family, alternately shocked and dazzled her adopted city.

Mrs. Gardner began collecting rare editions, but one day Henry James took her to John Singer Sargent's London studio, where she saw his famous *Portrait of Madame X* (now at the Metropolitan). The ebullient Mrs. Gardner put aside the pursuit of first editions for the warmer climes of the visual art world. Trips to European *palazzi* and museums developed the love affair. She made a few intoxicating purchases on her own, one a glorious Vermeer, $6,000 at auction. A couple of bangs of the gavel would bring it down at over a million today. Though she did not realize it at the time, she was bidding against the di-

rectors of the Louvre and the National Gallery, London. In 1894, under the tutelage of Bernhard Berenson, she turned from erratic buying to serious collecting. Berenson, only a few years out of Harvard, was already a brilliant art historian. When he died at ninety-four, in 1959, he was acknowledged a world authority on early Italian and Renaissance art. Although Mrs. Gardner occasionally took fliers on her own and advice from others, his was the genius that guided her picture collecting.

Mrs. Gardner called Rembrandt's *Self Portrait as a Young Man* her cornerstone, because its purchase forced on her the realization that her home could not hold another painting. She also realized that she had a nucleus of works of art so important that they belonged in the public domain. Her original plan was to remodel her Beacon Street address, but because she had strong ideas of what a museum should be she instead designed a house, based on Venetian palaces of the 15th and 16th centuries, large enough to become a museum. Mrs. Gardner was on

The Court, South
(Isabella Stewart Gardner
Museum, Boston,
Mass.)

the job every day, bringing her lunch as the workmen did. She acted, in fact, as master foreman, changing plans (the architect was largely ignored), countermanding, rolling up her sleeves to show a laborer how to get an unorthodox effect she wanted.

For years she had been picking up architectural fragments from all over Europe: capitals, doors, an odd assortment of columns, furniture and fountains. Because of her innate taste and sense of scale, they all fell into place as though plans had been drawn for them.

When Fenway Court was regularly opened to the public after Mrs. Gardner's death, it was still her house—even the varieties of flowers under certain paintings remain essentially the same. Under Zurbarán's *A Doctor of Law* stands a Chinese beaker (Shang, 1200–1100 B.C.) that reiterates the reds and browns of the doctor's robes: a bowl beside is filled with flaming nasturtiums, the color of his great orange collar. The masterful arrangement was originally conceived by Mrs. Gardner.

The front door opens directly into a Spanish gallery designed to set off *El Jaleo, the Spanish Dance*, by Mrs. Gardner's friend John Singer Sargent. The corridor turns into the court, which rises in three tiers of Venetian arches to a skylighted glass roof. Balconied windows look down on a jungle of tropical plants that border a 2nd century Roman mosaic found near the villa of Emperor Augustus's wife Livia. High banks of flowers are a year-long extravaganza of color—chrysanthemums in autumn; a hanging waterfall, stories high, of nasturtiums in spring. An Egyptian hawk rests pertly in the foliage, and a Roman seat has a footstool, daringly compounded by Mrs. Gardner from two Ionic capitals back to back.

In the first gallery of the Italian rooms on the second floor is Piero della Francesca's *Hercules*, his only fresco outside Italy and his only painting of a pagan subject. Masaccio's *Young Man in a Scarlet Turban* is one of the earliest of secular paintings. While it seems strangely flat, it is a strong and penetrating introduction to the portraiture of succeeding generations. Simone Martini's melancholy *Madonna and Child with Four Saints* is the only large and complete altarpiece by the artist outside Italy. In a case with Persian plates and a mélange of objects are two Chinese bronze bears of the Han period. Scholars travel far to see this playful pair.

The Raphael gallery has two paintings by the master, a *Pietà* and his portrait of *Tommaso Inghirami*, painted between 1509 and 1513. A version of the Inghirami portrait is in the Pitti in Florence. In the Inghirami Palace at Volterra is a copy made at the time of the sale (as has often been done by families forced to sell their ancestral paintings) to fill the place left empty by the original.

Music was always a part of the life of the house, and musicales are given frequently in this gallery as they were when Mrs. Gardner entertained. In the Dutch room are two Holbein portraits, four Rembrandts and a beauty of a Rubens, *Portrait of Thomas Howard, Earl of Arundel*—Earl Marshal under Charles I and one of the first great private collectors. Here is the Baroque grandeur of court life, the full armor in smoke grays and blacks dramatizing the noble, intelligent face. Vermeer's *The Concert*, Mrs. Gardner's auction prize, is genre painting at its height, distilled, refined to perfection.

Upstairs in the Titian room is the picture some scholars rate as the finest canvas in America: Titian's *Rape of Europa*. Beside the painting is a small sketch of it by Van Dyck. The Titian hung in Madrid's Royal Palace for a century and a half, and it was there that Rubens did a copy of it. Since Van Dyck never went to Spain, it is presumed that his sketch was done after the Rubens copy. Cellini's bust of a banker and art patron, Bindo Altoviti, for which he was praised by Michelangelo, is in this room, one of the few authentic Cellini bronzes in America. The long gallery is full of memorabilia and treasures such as Botticelli's *Madonna of the Eucharist*, a painting touched with sadness and mysticism. Above the altar, in the chapel at the end of the gallery, is a fine 13th century French window. High Mass is celebrated here by an Anglican priest on Mrs. Gardner's birthday, as provided for in her will.

By the window in the Gothic room is Giotto's *Presentation of the Child Jesus in the Temple*, humane beyond anything his Byzantine predecessors had dreamed of. With splendid disregard for the logic of the time and place, Mrs. Gardner, who delighted in each object she owned for its own sake and mixed at will, hung Sargent's portrait of herself so that it dominates the room. *Portrait of Mrs. Gardner* was considered so outrageous when it was painted (she chose to wear her famous pearls to

John Singer Sargent: Mrs. John L. Gardner
(Isabella Stewart Gardner Museum,
Boston, Mass.)

delineate her tiny waist, instead of around her neck where they belonged) that Mr. Gardner would not allow it to be shown publicly, and only after his death was it hung again.

Fenway Court celebrates the passion, the daring and the taste of Isabella Stewart Gardner and the brilliantly selective eye of Bernhard Berenson. Sir Philip Hendy says in his commendable catalog: "It is probably the finest collection of its compact size in the world."

In her last years Isabella Gardner, obsessed with the importance of perpetuating Fenway Court, is said to have turned miser and put her servants on rations when she wanted to buy a painting. Aline Saarinen recounts in *The Proud Possessors* how Mrs. Gardner used to send her secretary and curator to a corner store each day for an orange. One day, to save himself time, he bought two. "What's the matter?" asked the storekeeper. "The old lady having a party?"

INSTITUTE OF CONTEMPORARY ART

955 Boylston Street, Boston, Massachusetts

Hours: Mon.–Fri. 10–5; Sat. 11–5
Closed: Sun., major holidays

Almost four decades after it was started, the Institute of Contemporary Art is finally entering permanent quarters in a landmark building, a former police station, at the corner of Hereford and Boylston streets. The late 19th century red brick building is an impressive example of Richardsonian Romanesque architecture and was originally designed by Arthur H. Vinal. The façade clearly indicates the influence of Richardson with its Syrian arches on the ground level, the sets of arched windows and the broad gable. The exterior of the building will remain intact, but the interior is being renovated from top to bottom. There will be a French restaurant on the lower level, two floors of exhibition space and members' facilities on the top floor. There are also plans for a sculpture garden. In an adjoining building are the staff offices and the institute's education program, VALUE (Visual Arts Laboratory in the Urban Environment).

The emphasis here is on showing the work of regional artists, often young, little known and without galleries. The ICA acts as catalyst for new artists and new ideas. There is no permanent collection. Exhibitions are programed to involve the public as much as possible, and urban and environmental problems are explored through the use of visual material.

MUSEUM OF FINE ARTS

465 Huntington Avenue, Boston, Massachusetts

Hours: Daily 10–6; Tues., Thurs. to 9 P.M.
Closed: Major holidays
Library, restaurant

On February 4, 1870, the Massachusetts legislature granted a charter and gave a plot of land on what is now Copley Square to a small group of men who wished to form a museum. On the auspicious date of July 4, 1876, an assemblage of paintings and

sculpture from Boston's Athenaeum, engravings from Harvard and historical portraits from the city were moved into the Copley Square building.

The intellectual leaders of Boston, traveling far and wide, made the museum their project. Probably the first Egyptian art to reach America were New Kingdom pieces brought from Luxor in 1835 by John Lowell. Harvard University and the museum engaged in a prolonged dig that resulted in great Old Kingdom pieces for the department. The "grand tours" of Edward Perry Warren brought collections of Classical Antiquities, including some of Boston's glorious Greek vases, to the museum. One year after the museum opened, Edward S. Morse went to Japan to find and collect historic art. He was joined by Ernest Fenollosa, one of the first American scholars seriously to study Japanese art. Through him the Asiatic department—which includes work from China, Korea, Japan and Cambodia—had its beginnings. On Fenollosa's third trip to Japan he was accompanied by Dr. William S. Bigelow. Eventually Dr. Bigelow's collection of 1,000 Japanese objects came to the museum. It is absurd to try to single out treasures from this rich hoard. I shall resort to a few favorites: the grim little *Mongolian Youth* of the Chou period (4th to 3rd century B.C.), firmly holding two sticks on which are perched alabaster birds; the delicate handcrafts of Japan, some executed on paper, some on silk, Huan period (late 12th century); the *Pair Statue of King Mycerinus and His Queen* from Egypt's IV Dynasty, a noble and surprisingly human-

Sanchi, Indian: Yakshi Torso
(Courtesy Museum of Fine Arts,
Boston, Mass. Ross Collection)

Edgar Degas: Deux Jeunes
Femmes Visitant au Musée
(Courtesy Museum of Fine Arts,
Boston, Mass.)

looking couple, completely lacking the rigidity of the period's portraiture. Boston's Egyptian holdings are considered on a par with the Metropolitan's, though Boston has yet to bring over a whole temple (see Metropolitan).

The painting collection goes back to the 12th century with a rare and beautiful fresco taken from the apse of a Catalan church, Santa Maria de Mur, now installed in its own small chapel. It proceeds through Italian and Spanish masters such as Duccio, Titian, Tintoretto, El Greco and Velázquez. The northern schools hold fine examples of Rogier van der Weyden, Lucas van Leyden, Rubens, Rembrandt, Ruisdael and Frans Hals with his *Portrait of a Man*. *The Martyrdom of St. Hippolytus* is a stunning triptych by an anonymous Flemish artist. French painting culminates in Monet's figure *La Japonaise*, Manet's *The Street Singer*, Cézanne's masterful *Mme. Cézanne in a Red Chair*, Renoir's *Le Bal à Bougival*, and what Gauguin considered his masterpiece, *Where Do We Come From? What Are We? Where Are We Going?* Eminent Americans are here too: Stuart's unfinished portraits of George and Martha Washington, found in his studio after his death, works by Copley, Trumbull and a host of artists who recorded our leaders, our ancestors, our historical past. Space is devoted to Boston's native son Paul Revere. Copley's portrait of the patriot silversmith hangs along with portraits of Mr. and Mrs. Paul Revere done at a later date by Gilbert Stuart, and priceless pieces of Revere's silver are dis-

played. The Karolik Collection is one of the richest in America in 17th and 18th century American furniture, 19th century American paintings and drawings by both obscure and well-known artists. The furniture which Erastus Salisbury Field used in his portrait of *Joseph Moore and His Family* is in the collection, together with the painting. The contemporary group continues to grow in importance—Larry Poons, Robert Motherwell, Franz Kline, Kenzo Okada and the late Morris Louis, plus all the archival material on that talented artist. Among European examples are two stunning works, Giacometti's *Femme Qui Marche* and Picasso's powerful *Rape of the Sabines*. The print section is vast, with holdings of distinction in every category but especially in 15th century Italian and German examples.

Boston's latest triumph is the acquisition of Starboard House, home of Forsyth Wickers in Newport, Rhode Island. The predominantly 18th century French collection is installed in a new decorative arts wing in such a way as to re-create the original home atmosphere, in paintings, furniture, *objets d'art* and sculpture.

A large recent addition holds the administrative offices, a restaurant and the education department. It also allows more space for the Far Eastern group, which the museum maintains is the greatest assemblage of Far Eastern Art under one roof anywhere in the world.

CAMBRIDGE

HARVARD UNIVERSITY: BUSCH-REISINGER MUSEUM OF GERMAN CULTURE

Kirkland Street at Divinity Avenue, Cambridge, Massachusetts

Hours: Mon.–Sat. 9–5
Closed: Sat. in summer, Sun.

Another specialized museum not to be missed, the Busch-Reisinger contains the largest collection of German cultural objects outside Germany. It is administered in cooperation with the Fogg Museum.

Although the collection shows Gothic and Medieval works, its strength lies in its 20th century works, much from the Bridge and Blue Rider groups (see Pasadena). The Bridge was formed by Erich Heckel, Ernst Kirchner and Karl Schmidt-Rottluff to bring together artists of different schools, as the name suggests. Emile Nolde, whose group of religious paintings is outstanding, was a part of the movement for a short time. The museum houses the most complete archives on Gropius and the Bauhaus in existence. The Bauhaus, founded in 1919 by Walter Gropius in Weimar, Germany, was a famous school of architecture, design and the crafts. After it was closed by the Nazis, a new Bauhaus was opened in Chicago by Moholy-Nagy in 1937.

HARVARD UNIVERSITY: FOGG ART MUSEUM

Quincy Street, Cambridge, Massachusetts

Hours: Mon.–Sat. 9–5; Sun. 2–5
Closed: Major holidays, weekends during July and Aug.
Library

The pleasantly dimensioned Renaissance lobby at the Fogg, designed by Richard Holman Hunt, is the center around which revolve collections encompassing the whole evolution of art. The first museum opened in Hunt Hall in 1895 and moved to the present site in 1927. Through such distinguished men as art historian Charles Eliot Norton and Paul Sachs, teacher, curator, director and father figure, to a host of museum directors, the museum soon took a prominent place in both training programs and collections. Its range covers Eastern and Western, Prehistoric to Modern. One graduate and pupil of Norton's who was influenced by him was Grenville Winthrop, a New Yorker with New England connections. Winthrop was a benefactor of Harvard's from 1923 on. In 1943 the university received from him its largest bequest, 3,700 objects plus his papers, diary and accounts. The scope of the collection is wide: Pre-Columbian gold, Medieval works, the largest collection of Pre-Raphaelite paintings extant. It is, however, in the field of 18th and 19th century British and French drawings and in its Archaic Chinese jades

and bronzes that the Winthrop Collection excels. The jades, numbering 600 pieces, make up one of the great collections in the world. The superb Paul and Meta Sachs group of 19th century French drawings, together with the Winthrop material, places the Fogg second only to the Morgan Library's and the Metropolitan's drawing section.

For a small museum, its variety is wide: from the compelling little figure on an English hammer beam (circa 1430) to the marble sophistication of Guillaume Coustou the Elder's bust of *Louis XV*; from Simone Martini and Lorenzetti to contemporary painters Kenneth Noland, Morris Louis, Kline, Vicente, de Kooning, Pollock, Brooks and David Smith. The early American collection contains among other portraits one of Copley's masterpieces, *Mrs. Thomas Boylston*. Furniture and examples of English and early American silver accompany the paintings. *The Grace Cup*, by the American silversmith John Coney, was given to Harvard at the 1701 commencement.

In the field of Classical art, Greek and Roman sculptures include the marble *Meleager* after Skopas, a leading artist of the Alexandrine period, and a portrait of the Emperor Trajan. The Medieval section contains several Romanesque capitals from Moutier-St. Jean and an 11th century Virgin from Santa Maria de Tahull. In cleverly lighted cases are 12 unique terra cotta Bernini sketches, some for his famous monuments, such as the angel for the altar of the Sacrament in the Vatican. Fra Angelico, Filippo Lippi and Lorenzo Lotto represent the Renaissance; Rubens highlights the Baroque. Early 19th century French painters besides Delacroix are David, Géricault and Ingres with his important *Odalisque and Slave*. Move on to Cézanne's *Monsignor Chocouet* and Degas's sketch for *The Cotton* Market to a fine Impressionist group which includes five Monets and two exceptional Pissarro landscapes. If the casual visitor is sometimes bemused to see copies, frankly fakes, and masterpieces hanging side by side, it is because the Fogg really takes itself seriously as a teaching museum—and why not? Many of America's leading directors, curators and professors of art history call it alma mater.

Though a bastion of scholarship, the Fogg manages an engaging air of informality. Storage racks easily accessible from main galleries allow the visitor to see old favorites not on display. On two floors below ground is one of the most efficient and

comprehensive libraries in existence. A passageway links the library with the Harvard Department of Visual and Environmental Studies housed in a splendid building designed by Le Corbusier, his only work in America.

Chinese, 8th century, T'ang Dynasty: Adoring Bodhisattva (Fogg Art Museum, Harvard University, Cambridge, Mass.)

J. A. D. Ingres: Odalisque with a Slave (Fogg Art Museum, Harvard University, Cambridge, Mass.)

HARVARD UNIVERSITY: PEABODY MUSEUM OF ARCHAEOLOGY AND ETHNOLOGY

Divinity Avenue, Cambridge, Massachusetts

Hours: Mon.–Sat., holidays 9–4:30; Sun. 1–4:30

These world-famous collections have been gathered primarily from expeditions sponsored by Harvard University. The major sections include Prehistoric, Oceanic, African and Pre-Columbian. Though not now displayed with élan, the large collections of American Indian art are being reinstalled with an eye to visual impact as well as ethnological significance. Both quantitatively and qualitatively the Peabody assemblage is difficult to surpass.

LINCOLN

DE CORDOVA AND DANA MUSEUM AND PARK

Sandy Pond Road, Lincoln, Massachusetts

Hours: Tues.–Sat. 10–5; Sun. 1:30–5

New England artists are well nurtured in this lovely spot on a wooded hilltop. Long a community center for the arts with changing exhibitions, lectures and concerts, the museum also maintains a permanent collection. New Englanders Townley, Wolfe, Boyce, Chaet, Alcalay, Kepes, Aronson, Knaths and Hyman Bloom are represented, along with such internationally known artists as Kline, Moore, Rickey, Ortman, Sutherland, Sheeler, Liberman, Salemme and Vasarely. Five major exhibitions are presented a year; while they tend to be contemporary, the arts of other times and cultures occasionally crop up. The museum also conducts a year-round program of arts and crafts classes for children and adults with total annual enrollment of more than 3,000 students.

NORTHAMPTON

SMITH COLLEGE MUSEUM OF ART:
TYRON ART GALLERY

Elm Street, Northampton, Massachusetts

Hours: Tues.–Sat. 11–4:30; Sun. 2–4
Closed: Mon., major holidays

In 1872, six years after Smith College was founded, through a bequest of Sophia Smith, $5,000 was appropriated to form an art collection. Thomas Eakins's *In Grandmother's Time* was bought directly from the artist in 1879. As early as 1905 Smith established a chair for the teaching of art. Thus it comes as no surprise that Smith has one of the most distinguished art collections of any American college.

The new art museum is still called by its old name, Tyron Hall (named for Dwight W. Tyron, painter and professor of art at Smith from 1886 to 1923). Opening off Elm, a pleasant residential street, the museum and art department are partially divided by a large courtyard that serves as exhibition space and walkway to the campus beyond. A wall of one-way mirrors doubles the size of the court. Three stories above is a shed of gabled skylights, part clear glass, part mirrors. The reflections cast below on trees and sculpture create a handsome effect and certainly should lift the spirit of any student trudging through to class.

Part of the permanent collection is usually on display in the large downstairs gallery. Daylight floods the galleries through a series of skylight sheds that show treetops and sky. The important thrust took place in the early 1920s, when antiquarian Joseph Brummer gave five canvases by Spanish-born Juan Gris. The collection of 18th through 20th century French masters illustrates the development of modern painting. *Pyramids*, by Hubert Robert, leads into David and Ingres. Of several Corots, *Italian Hill Town* and *Jumièges* command special admiration. And Courbet's powerful eight-foot *Preparation of the Village Bride* is possibly the museum's proudest possession. Another strong Courbet, *Portrait of Mr. Nodler, the Elder*, is here, while the son, *M. Nod-*

Edwin Romanzo Elmer
Mourning Picture (Sm
College Museum of Ar
Northampton, Mass.)

ler, the Younger, also by Courbet, hangs in the nearby Spring-field Museum of Fine Arts.

The Impressionists are here in force: Degas's *Portrait of René de Gas*, Renoir's portrait of *Mme. Edouard Maitre*, Monet's *The Seine at Bougival*; also Cézanne, Vuillard, Bonnard and three Seurat studies for his *Un Dimanche à la Grande Jatte*. Picasso's *La Table* (circa 1920) complements the Juan Gris 1914–1916 quintet. German Expressionism is represented by a splendid Ernst Ludwig Kirchner, *Dodo and Her Brother*.

From other lands, in other styles: some 60 Archaic Chinese jades, Shang and Chou dynasties; Dutchman Hendrick Terbrugghen's *Old Man Writing by Candlelight*; a splendid Arp; contemporaries Bontecou, Kline, Marini, Moore, Baskin and Nickford.

Most museums have their conversation-piece paintings, and Smith's is surely *Mourning Picture* (circa 1889), by Edwin Romanzo Elmer. Such works, executed to commemorate a deceased loved one, were the macabre vogue in the late 19th century. Smith's canvas shows an endearing child holding the symbolic lamb; her home, parents and toys complete the composition.

Late acquisitions are two stunning terra cottas, *Nymph* and *Satyr*, by the French sculptor Clodion.

The upstairs 20th century gallery is dominated by Frank Stella's *Damascus Gate, Stretch Variation III*, plus works by Kline, Bontecou, Nevelson.

The classical and Medieval sculptures are placed in purposeful juxtaposition in an adjacent gallery.

The print and drawing section is unusually fine—the scope roughly from Rembrandt to Rauschenberg. The gallery looks over the leafy court. The mirrored skylights of the court ingeniously deflect the sun from the print room while allowing for daylight. Tables and cases are adroitly designed and roll about easily to hold the most outrageously outsized of contemporary prints. A second print and drawing cabinet which excludes daylight is also here.

SOUTH HADLEY

MOUNT HOLYOKE COLLEGE
South Hadley, Massachusetts

Hours: Mon.–Fri. 11–5; Sat. 1–5; Sun. 2:30–4:30
Closed: school holidays
Library

A heroically scaled *Victory of Samothrace* takes her stand under the cantilevered mass that is the front of Mount Holyoke's new art building and museum. A mirrored rear wall gives the impression that she is striding toward one. The building, made of cast-in-place concrete and brick, contains a library, studio and even a foundry. The museum, auditorium and sculpture court form their own unit on the first floor.

The original art gallery opened in 1876 with the gift of important canvases by Bierstadt and Inness. At the turn of the century the art department weighed in heavily with sculpture and artifacts assembled from Egyptian exploration funds, thus giving Mount Holyoke treasures it could ill afford today, such as Pre-Dynastic pottery, canopic jars, alabasters and bronzes. Through the years generous alumnae have enabled the college to assemble a collection of considerable scope, especially in the field of antiquities. Galleries of Classical, Medieval, Renaissance and Asian art have been established. The drawing collection,

with examples by Guercino, Paulus Brill, Jacob Jordaens and continuing, if somewhat spottily, to Kandinsky, is impressive in its quality. The same can be said of the print collection.

The long gallery used for changing exhibits leads into the sculpture court, where Leonard DeLonga's *Warriors* counterpoints Barbara Hepworth's *Single Form (Antiphon) Opus 490.*

The 20th century is represented by Edward Avedisian, Paul Jenkins and many gifts from the Mr. and Mrs. Roy R. Neuberger Collection, including paintings by Marin, Avery, Holty and Sheeler.

The new building, designed by Hugh Stubbins of Cambridge, Massachusetts, is set in a serene campus and interestingly integrated with the rest of the college buildings.

Interior, Caroline R. Hill Gallery of Medieval and Renaissance Art
(Mount Holyoke College, South Hadley, Mass.)

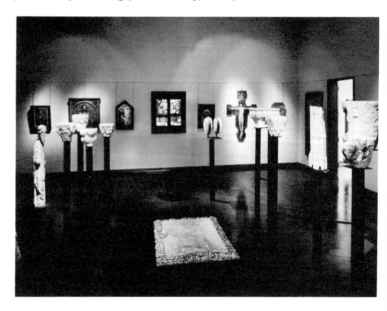

SPRINGFIELD

MUSEUM OF FINE ARTS
49 Chestnut Street, Springfield, Massachusetts

Hours: Tues.–Sat. 1–5; Sun. 2–5
Closed: Mon., major holidays, Sun. during July and Aug.
Library

A deft hand worked on this arrangement. Except for the print rooms, a gallery of contemporary art and two attractive galleries of fine Chinese bronzes and ceramics on the first floor, the collection flows in orderly succession around a two-story "tapestry court" in which a 16th century Spanish palace façade has been reconstructed on one entire wall. In the Gothic room at the head of the stairs the focal piece, a carved wood Spanish altar, depicts scenes from the life of Christ. The Renaissance gallery features *The Crucifixion Triptych* by Goswyn van der Weyden, grandson of the great Rogier van der Weyden, whose masterpiece, *The Descent from the Cross*, hangs in the Prado. In the Dutch galleries nestle little landscapes by Jacob van Ruisdael and Jan van Goyen and Gerrit Berckheyde's *The Great Church at Haarlem*. Seventeenth and 18th century French galleries center on a handsome Chardin, *Still Life, Refreshment*.

Two 19th century French portraits to note: Courbet's *Portrait of M. Nodler, the Younger*, a strong, straight rendering of a dour and troubled youth, and *Baron von Schwiter* by Delacroix. Don't attempt to walk through the *trompe l'oeil* door next to the Harnett *trompe l'oeil Emblems of Peace*, and don't miss Homer's *Promenade on the Beach* in the American section.

One of the oddities of American painting is set in the gallery devoted to the work of Erastus Salisbury Field: his 9-by-13-foot *Historical Monument of the American Republic*. Until the advent of the daguerreotype, Field was a successful New England folk artist. Dr. Frederick B. Robinson, the museum's former director, suggests in a brochure on Field that he did the work for a design competition for the central building at the Philadelphia Centennial. Tower after tower rises like a tiered wedding cake, quotes from the Bible and historical scenes imposed on their

surfaces. Field's involvement with the slavery issue prompted him to give Lincoln the place of honor. Each tower represents an important sequence in American history. Angels atop the tallest spires wave the stars and stripes.

Important holdings in the early print field concentrate on English, French and American 19th century work and more than 3,000 Japanese prints. The museum's entrance is on a pleasant quadrangle around which are a science museum, the city library, the William Pynchon Museum of Connecticut Valley History and the George Walter Vincent Smith Art Museum, a well-preserved embodiment of late 19th century collecting propensities in jade, porcelain, armor, embroidery and such.

Robert Indiana: The Calumet (Brandeis University, Rose Art Museum, Waltham, Mass.)

Winslow Homer: Promenade on the Beach (Museum of Fine Arts, Springfield, Mass.)

BRANDEIS UNIVERSITY: ROSE ART MUSEUM
Waltham, Massachusetts

Hours: Tues.–Sun. 1–5
Closed: Mon., major holidays

The growth of the holdings of the Rose Art Museum since its opening is nothing short of a director's dream. Although the basic collection came into being in 1950, the 1961 erection of the handsome little glass and stone building added impetus. The interior forms one spacious high-ceilinged room with additional space on the lower floor. Stairs float downward over a rectangular pool where sculptor Reg Butler's *Figure in Space* is anchored in a small round green island. An addition to the building is planned to house the Rose Collection of Early Ceramics and service areas for the museum.

The scope ranges from the Egyptians to the present day, with more than 2,500 works illustrating the evolution of art. Since the museum is small, the rest of the campus shares some of this material. Oceanic art is on permanent exhibition in Schwartz Hall, prints and drawings in the new Spingold Arts Center next to the museum. While the Renaissance and Baroque periods are covered, and the late 19th and early 20th centuries upheld by Boudin, Monet, Degas, Renoir, Bonnard and Pascin, it is to the art of today, its experimentation and its exploration, that this young university museum is dedicated. Exhibitions are not confined to the 20th century, but the main emphasis is on provocative exhibits that stress our time. Some of the artists in the permanent collection are Robert Indiana, James Brooks, Ellsworth Kelly, Grace Hartigan, Morris Lewis, Roy Lichtenstein, Matta, Marisol, Ludwig Sander, Claes Oldenburg, Robert Rauschenberg, de Kooning, Dubuffet and Motherwell. The list is long.

WELLESLEY

WELLESLEY COLLEGE ART MUSEUM: JEWETT ARTS CENTER

Wellesley, Massachusetts

Hours: Mon.–Sat. 8:30–5; Sun. 2–5
Closed: Mid-June–Aug., major holidays

Established in 1883, the Wellesley College Museum has found an excellent home in the Jewett Arts Center. Designed by Paul Rudolph, the pink brick building is in harmony with the campus complex. The museum forms a bridge between the two wings sheltering drama, music and art activities. Changing print and drawing shows line the broad corridors. The impressive sculpture collection includes one of the most notable Roman copies of Greek sculpture in America, *Athlete of Polykleitos.* Other distinguished pieces: a German carving, *Standing Saint or Apostle,* thought to be the only piece in the United States by the north German sculptor Henning von der Heide; an exceptional cast of Giovanni Bologna's *Rape of the Sabines;* and Duchamp-Villon's stern and intellectualized bust of Baudelaire, one of the fine 20th century pieces in the group. The painting section harbors one very good early Italian panel painting, but the strength of the collection is in Baroque art and works of Bernardo Strozzi, Marco Ricci, Pietro da Cortona, Luca Giordano, Salvator Rosa and Alessandro Magnasco. Among the Dutch is an arresting little Gerard Terborch, *Soldiers at Night.* Terborch brings this mundane scene to life through his clever use of light and shade.

Among contemporary European paintings is a large 1913 Kokoschka, *Two Nudes,* and Fernand Léger's forceful *Mother and Child.* Later 20th century painting, represented by one of the most outstanding groups of paintings in a college museum, includes artists of the Color School such as Kenneth Noland, Jules Olitski and Jack Bush.

The Jewett Arts Center serves not only the students who, enviably, cannot reach their classes in the center without being exposed to works of art, but also the town of Wellesley and the surrounding community.

WILLIAMSTOWN

STERLING AND FRANCINE CLARK ART INSTITUTE
South Street, Williamstown, Massachusetts

Hours: Tues.–Sun. 10–5
Closed: Mon.
Library

The new handsomely monolithic wing of the Clark Art Institute does not attempt to integrate itself with the white Vermont marble parent building, but makes its own strong statement instead. Pietro Belluschi, in association with the Architects Collaborative, designed the wing, which is joined to the older building by a wide passageway over the drive. The new area contains galleries for changing exhibitions, one of which looks out over a main-floor sculpture court roofed by a grid of plastic domes that gives a clear view of the changing sky. The auditorium and library are also here. From the gallery windows one looks out at the surrounding mountain ranges of New York and Vermont, as well as the Graylock range, which includes the highest point in Massachusetts. One also sees the 140 acres the museum owns, a pure George Inness landscape, russet leaves (in the autumn) and grazing cows included. The institute's library is unique—everything a student needs. Eventually the four floors will contain 100,000 volumes on art history from the Renaissance to the present. The books, manuscripts, slides, screens for viewing and study carrels are here in an ambience of quiet beauty. The place is downright seductive, and any student from nearby Williams College interested in the arts who doesn't take full advantage of this scholarly haven is a dolt.

When the Clark museum opened in 1955 it was the neatest surprise package ever delivered to an art world usually well aware of what the left and right hands are up to. Clark, retiring by nature, had his paintings, prints and silver scattered through four houses, one of them abroad. He had no art advisers, since he bought only to please himself and used a variety of dealers. Any paintings he loaned were shown anonymously. Perhaps this reticence stemmed from the fact that his brother, Stephen Clark,

Hans Memling: The Canon Gilles Joy
(Sterling and Francine Clark Art
Institute, Williamstown, Mass.)

from whom he was estranged, was a well-known collector (the Clark brothers were grandsons of Edward Clark, an early stockholder of the Singer Sewing Machine Company). But the paradox of the shy Mr. Clark was that when he realized his time was running out, he could not bear the idea of having his collection dispersed. There was nothing for him to do but to follow other major collectors such as Freer, Frick, Morgan, to name a few, and build a museum. In spirit and in person few donors have been closer to the museums they inspired than the Clarks. Many collectors have turned their homes into museums (e.g., Frick, Huntington, Phillips) but few have turned the museum into a home. The Clarks did just that, moving into one side of the small marble temple while installation plans were in process around them. The French Gallery was the master bedroom while the long corridor served as a drawing room. Mr. Clark spent the last year of his life in a wheelchair supervising the placing of each work of art. Both Sterling and Francine Clark are buried under the white marble entrance.

With the exception of a few really distinguished works which have been purchased since Mr. Clark's death, the collection is the pure expression of his catholic taste. A clue to the present Clark purchasing policy is the quality of Fragonard's *Portrait of a Man (The Warrior)*, acquired in 1964, which Charles Sterling,

curator of the Louvre, called one of the most beautiful and significant Fragonard *portraits de fantaisie* in existence. The museum's aim is to develop and extend the collection without distorting the wishes of the founder. While buying his 30 Renoirs and works by Degas in many media, Mr. Clark also was indulging in the then unfashionable French Salon painters—Gérôme and Carolus-Duran—and acquiring a bar-sized Bouguereau. Indeed, the latter artist's *Nymphs and Satyr* hung in the famed Holland House bar for many years. Clark's penchant for Renoir and French culture probably stemmed from the fact that his wife was French and he lived many years in Paris. Most of the Renoirs hanging bear the stamp of Renoir's dealer, Durand Ruell.

The permanent collection is installed in the older building. Wide corridor galleries ideal for small works surround a central core of large galleries, the crown of which is the square skylighted room which holds most of Clark's Renoirs. The canvases are mostly of his early period—*At the Concert*, for example, and *Onions* dating between 1875 and 1890—only *The Letter* (1895–1900) giving a foretaste of his later "hot" period.

Pierre Auguste Renoir: At the Concert (Sterling and Francine Clark Art Institute, Williamstown, Mass.)

Chronologically, paintings extend from the later Middle Ages and Renaissance in Italy, France and the Low Countries to the end of the 19th century. A slight indication of the riches to be found in Williamstown: a seven-part panel altarpiece by Ugolino di Nerio; Piero della Francesca's *Madonna and Child with Four Angels*, purchased by Mr. Clark in 1914 and never publicly seen until 1957; a predella panel from the Bichi altar by Luca Signorelli; Renaissance works by Mantegna, Crivelli, Memling, Mabuse Corneille de Lyon, Le Nain. Some galleries hold works of one period or country, including decorative arts, such as Gallery 7 with a Hobbema, van Ruisdael, Teniers and Dirk Hals. Handsome examples of Dutch silver are here. The quality of the works of art in this museum is so high it's a useless gesture to cite specific works; I'll content myself with a few favorites: Gericault's *Trumpeter of the Hussars*, Rubens' *The Holy Family under an Apple Tree* (this is another version of the outer wing of Rubens' great altarpiece in the Kunst Historische Haus in Vienna), Turner's *Rockets and Blue Lights* and most of the Degas and Lautrecs.

Of the 11 Corots, *Mlle. du Puyparlier* is a favorite. No wonder Corot hated to part with this picture. He painted for 25 years before he sold a canvas, and then was desolate because his "collection of Corots was broken up."

The American section may be small numerically, but seven Homers, including such works as *Eastern Point, Prouts Neck* and the delectable *The Bridle Path, White Mountains*, plus numerous John Singer Sargents should go a long way toward satisfying the public. The Clark leaves the showing of contemporary works to the nearby Williams College Museum of Art.

The drawing section extends from Dürer to Monet, the prints from the 15th century Italian Mantegna to the Swedish Anders Zorn, with the heaviest concentration in both media on the 18th and 19th centuries. The Degas and Lautrec prints alone deserve a special visit. Clark's silver collection is among the most distinguished in the country; it contains more than 600 examples of Old English and Continental work and American examples including five pieces by Paul Revere. There is a rare set of English Apostles spoons—one of seven known (the Metropolitan just became heir to another set which had been lying in the James B Mabon family silver chest on Park Avenue for 40 years). An im-

pressive 1726 tea tray made in London by Paul De Lamerie is one of 35 of his works in the group. Another beauty is a George III milk jug presented to Benjamin Franklin when he went to London to plead the Colonies' cause. An etched chain, symbolizing the unity of the mother country and America, joins the body of the jug to the lid—a lid America was soon to blow off.

WILLIAMS COLLEGE MUSEUM OF ART

Lawrence Hall, Williamstown, Massachusetts

Hours: Mon.–Sat. 10–12, 2–4; Sun. 2–5
Closed: Major holidays, spring and Christmas recess

Like other such college institutions, this one, founded in 1926, developed as a general museum to aid in the teaching and appreciation of art. Its collection starts with antiquities, including Greek and Etruscan pottery, and comes down to the present. It wisely avoids concentration in areas, such as painting, in which nearby Clark Institute is strong. Williams's European section, 1300–1900, is composed mainly of sculpture, drawings and prints. Through changing exhibitions and acquisitions that cover the range of contemporary media, the college brings to students and to the community the latest art trends, a field not exploited by the Clark.

The museum's home is an 1846 Greek Revival building with a large first-floor gallery, a formidable Ionic rotunda and smaller galleries upstairs. Set in the downstairs gallery, accompanied by proper furniture and *objets d'art*, is a series of Spanish paintings. Highlights are *The Annunciation* by Juan de Valdés-Leal of Seville, *The Executioner* by Ribera and *A Knight of Santiago* by Francisco Pacheco—a surprising bit of Iberian civilization in a high corner of Massachusetts. A second-floor gallery evokes the Middle Ages with panel painting, sculpture, ivories and manuscripts. One Medieval stained-glass panel, originally from France, turned up in a Williamstown barn. Recent acquisitions: a superb millefleur tapestry (Franco-Flemish, 16th century) and an almost life-sized *Mater Domini* (Italian, 15th century). Carved in wood and richly polychromed, the figure is shown in adoration. Two portrait heads, one an ancient Roman mosaic, the other a Byzan-

tine fresco, are interestingly juxtaposed here. The growing print and drawing collection holds Old Masters and contemporaries, and the rotunda shows ancient and modern pieces. The second-floor rotunda gallery with its neo-classic dome supported by Ionic columns presents an installation challenge that students and staff have met with sometimes stunning success. Despite the disparity of this container and the things contained—contemporary painting by, among others, Matta, Tapies, Miro, the Japanese sculptor Nagare, a Duchamp-Villon fountain, a stunning Cambodian 10th century *Female Deity*, lunettes by Elihu Vedder that are studies for the lunettes in the Library of Congress, distinctive African pieces—the overall effect is one of harmonious and unexpected unity. To complete the mélange an assemblage of open black umbrellas installed by the students floats from the dome in an enchantingly surrealistic pattern. Here also in this many-pillared space are large 9th century B.C. Assyrian reliefs, part of Operation Missionary, a project which sent to various New England colleges reliefs from the dig at Nimrud, capital of the Assyrian Empire (see Amherst).

Masayuki Nagare: Valor (Williams College Museum of Art, Williamstown, Mass.)

WORCESTER

JOHN WOODMAN HIGGINS ARMORY MUSEUM

100 Barber Avenue, Worcester, Massachusetts

Hours: Mon.–Fri. 9–4; Sat. 10–3; Sun. 1–5
Closed: Major holidays

The visitor to Worcester interested in armor should not miss the John Woodman Higgins Armory Museum. This is no static collection of suits of mail but a history of tools, armor and weapons from the Stone Age through the period of gladiators to the days of King Arthur and Roland to the Japanese armor of 1700.

Period paintings, tapestries, stained glass windows, furniture and armorial banners are included.

WORCESTER ART MUSEUM

35 Salisbury Street, Worcester, Massachusetts

Hours: Tues.–Sat. 10–5; Sun. 2–5. Oct.: Tues. 10–10
Closed: Mon., major holidays

The museum's main entrance is fittingly on Salisbury Street, for the Salisburys have been prominent in Worcester since Stephen Salisbury I came from Boston around 1767 and set up shop to dispense flour, nails and rum, staples of the time. In the Salisbury room in the early American section are portraits of several Salisburys by Stuart, Gulliger and Harding; Samuel F. B. Morse's *Chapel of the Virgin at Subiaco*, which Stephen II commissioned when he met Morse while doing the Grand Tour of Italy; and family heirlooms, including some splendid Paul Revere silver. As early as 1896 a Salisbury was instrumental in forming a corporation of friends to found an art institution. Dying a bachelor in 1905, he left almost his entire fortune to endow the museum. In 1933 a building in Italian Renaissance style with galleries arranged around a large central court was added to the museum's modest structure. In 1940 and again in 1966 additions and

remodeling were necessary because of the expanding collection.

Set in the large foyer floor and around the walls are superb mosaics from 1st to 6th century A.D. Antioch. (Other examples from the same dig are the pride of Baltimore and Princeton.) To the left is a complete 12th century Romanesque chapter house taken from a Benedictine monastery near Poitiers, France, and built into the museum in 1932. Of the frescoes in the next gallery, *The Last Supper* from near Spoleto, late 13th century, is the most powerful and has retained a great deal of clarity. Among the antiquities are a rare bronze piece, *Portrait of a Lady*, Roman circa A.D. 138, and a ravishing female torso *Heepheres*, unusually sensuous for 5th Dynasty Egypt. A favorite among the antiquities is a tiny, wild-eyed figure (Sumerian, 3000–2500 B.C.) discovered in 1937 below the floor of a temple at Khafaje near Baghdad; it impressively demonstrates that a small piece can be monumental.

The holdings of Greater India are strong. The galleries of Asiatic and Oriental cultures flow into each other. The delicate subtleties of Persian art—the manuscripts, miniatures, fabrics, and trappings of that rich civilization—are displayed together. One of the best and most comprehensive Japanese print collections in the country emphasizes the 17th and early 18th centuries. Another Japanese treasure is a 9th century 11-headed Kannon, life-sized and carved in wood. Kannon is most often known as the deity of mercy. Resting on a headband are 11 small heads surrounding a figure of Amida Buddha.

A large, pleasant first-floor lounge looks out on a sculpture court that joins the museum to the new art school. A giant Pomodoro rests here, while an equally massive Beverly Pepper guards the outside entrance. Now enveloping almost a city block, the wing is a highly successful blending of old and new. One more wing is being projected which will give space for changing exhibitions and the growing contemporary group.

Aside from known artists such as Kline, Kelly, Wesselman, Guston and Hartigan, younger artists are being collected, among them Katherine Porter, Gary Hudson and Jane Kauffman.

Upstairs, the painting galleries begin with strong Italian primitives: *The Madonna and Child in a Rose Garden* by Stefano da Verona; the Florentine Pesellino depicting the triumph of

Ralph Earl: Mary Carpenter (Worcester Art Museum, Worcester, Mass.)

prayer over magic in *The Miracle of St. Sylvester;* Piero di Cosimo's *The Discovery of Honey.*

San Donato of Arezzo and the Tax Collector, by Lorenzo di Credi, was done at a time when Italians took their taxes seriously and when both di Credi and da Vinci worked in Verrocchio's workshop. Some experts believe that da Vinci painted this scene of the saint praying for a tax collector falsely accused of taking public funds, or that he at least had a hand in it.

Leave plenty of time for the Rembrandt, the Heda, the Saenredam, the Goya, the El Greco and the Ribera in the Dutch and Spanish galleries.

Arnaldo Pomodoro: Rotante dal Foro Centrale
(Worcester Art Museum, Worcester, Mass.)

A skylight heightens the cheeriness of 18th century England in Gallery 205. Gainsborough's *The Artist's Daughters*, tender and evocative, recalls the story of his younger daughter's insanity. With what gentleness the painter profiles the vacant little face. Here too is Sir Thomas Lawrence's outsize portrait of *Mr. and Mrs. Jacob Dunlop*. William Hogarth's subtly satirical portraits of Mr. and Mrs. William James are as fine a brace of paintings as Hogarth has done. As early as 1921, the museum purchased Gauguin's poignant Tahitian period *Te Faaturuma*.

There are delights for the lovers of early American art. Ralph Earl, a native of Worcester County, like many young Colonial painters, went off to England to study; unlike most, he did not ape the fashionable London portrait school. Though done in England, his *Portrait of William Carpenter* has American directness and native charm. Earl's *A View of Worcester* is as it should be in Worcester. A pre-Revolutionary painting of major im-

portance is the *Self-Portrait* by Thomas Smith, who arrived in America about 1650 from Bermuda as a sea captain, it is said. Instead of the usual landscape, arbitrarily used as backgrounds for portraits, Smith painted himself against a brig sailing into battle.

The masterpieces of the American collection are surely the portraits of *Mr. John Freake of Boston* and *Mrs. Freake and Baby Mary*. Though by an unknown painter, seldom have portraits come better documented. Mrs. Freake's birthday in Dorchester, Massachusetts, is recorded, as is young John Freake's arrival in Boston from England in 1658. He became a successful merchant, constable and shipowner.

A recent acquisition in the 19th century American field is Thomas Cole's *Christ Tempted in the Wilderness*. A large painting, it was once twice the size. It is speculated that in order to make the painting more salable, Cole himself may have cut it in half. Worcester's half is Christ triumphant over evil, while the devil, having failed, sulks at the Baltimore museum.

The Pre-Columbian gallery is arresting in its beautiful installation. Perhaps the fact that Stephen Salisbury III was truly interested in archaeology accounts for the museum's unusual Primitive material, much of which he collected in Central America long before the modern vogue for it.

The Dial (1880–1929) was a little magazine synonymous with the best in arts and letters. Its monuments endure at the Worcester Museum. *The Dial* collection consists of works assembled for reproduction in the magazine and its subsidiary, *Living Arts*. The drawing and watercolor section is naturally strong, especially in the line drawings used in the magazine's text. Egon Schiele's *Seated Nude Girl* and *Self-Portrait* and Charles Demuth's *After Sir Christopher Wren* stand out. A catalog at the sales desk portrays the spirit of the venture as well as its history.

Worcester has been called a connoisseur's museum. Quite an accolade for a relatively small museum, but then two of the 20th century's most distinguished directors, Francis Henry Taylor of the Metropolitan and Daniel Catton Rich of the Art Institute of Chicago, retired there, thus enriching Worcester with their expertise and judgment.

Chinese, Han Dynasty: Jar in the Shape of a Hu (University of Michigan Museum of Art, Ann Arbor, Mich. Mr. and Mrs. Henry Jewett Greene Memorial Collection)

MICHIGAN

UNIVERSITY OF MICHIGAN MUSEUM OF ART

State Street and S. University Avenue, Ann Arbor, Michigan

Hours: Daily 9–5; Wed. 9–5, 7 P.M.–9 P.M.; Sun. 2–5
Closed: Major holidays

The works of art that the University of Michigan started buying as early as 1855 drifted about the campus like orphans until 1910, when they were gathered together in Alumni Memorial Hall. In 1946, collections reassessed, the museum became a modern functioning entity. Among survivors of the weeding process: an 1862 gift, *Nydia*, a marble by the sculptor Randolph Rogers, a leading figure in the late stages of the Classical Revival; Charles Wimar's *The Attack on an Emigrant Train*; and Eastman Johnson's *Boyhood of Lincoln*. As with most university museums, Ann Arbor's is primarily a teaching museum; its collections and exhibition program tend to reflect the strength of different university departments.

Best described as American Classic, the building has recently been smartly remodeled. The large entrance gallery is used for the permanent collection or changing exhibitions. A second floor holds historic Western painting and sculpture. Side galleries contain Oriental art. A feature on the lower floor is a reference room with easily available study racks for material not on display. The drawing collection is especially strong, with some emphasis on architectural and ornamental material ranging from 16th to early 19th century. The painting section covers late Renaissance and middle Baroque to the present, with beautiful entries by Conrad Marca-Relli, Robert Indiana, Roland Ginzel, James Brooks and a stunning Hans Arp bronze. The print collec-

tion is equally rangy, some 400 Whistlers mingling with fine Japanese holdings, the whole print scene reaching from Altdorfer to Archipenko and beyond. The Oriental group, seeded by the collection of a revered teacher, James Marshall Plumer, includes ceramics, bronzes, jades, wood and metal sculpture, and paintings. An interesting small group of Iranian ceramics is being formed. Among the contemporary sculpture excitements are examples by Englishmen—Chadwick, Meadows, Caro, Butler, and Robert Adams—plus Lipchitz, Arp, Giacometti, Seymour Lipton and David Smith.

A major catalog accompanies each major exhibition. The biannual Museum of Art bulletin analyzes in scholarly fashion important purchases. With a remodeled building and new preservation study and exhibition techniques, the university can look forward to an expansion of its already noteworthy scholarly tradition.

DETROIT

DETROIT INSTITUTE OF ARTS

5200 Woodward Avenue, Detroit, Michigan

Hours: Tues.–Sun. 9:30–5:20
Closed: Mon., major holidays
Restaurant, library

The Detroit Institute of Arts grew out of an art loan exhibition initiated by a newspaperman, William Brearley, in 1883. By 1889 James E. Scripps, publisher of the *Evening News*, had given 70 Old Masters to the museum, some of them among the best paintings in the collection.

An Italian Renaissance building, companion to the public library across the street, was erected in 1927. Two recent wings give the museum 11 acres of floor space. Both the north and the south wings open into courts, their three-storied roofs supported by elegant brass columns. The outside marble walls of the main museum ingeniously form the inside walls of the court. Galleries on all floors lead to overhanging balconies. Windows in stair-

wells and at corners soar from ground to roof. A thoughtful ges-
ture is an underground garage.

The great hall with its armor and tapestries leads to the
Diego Rivera court. When one recovers from the shock of the
powerful, stridently colored frescoes by the Mexican master in
an Italianate setting punctuated by pilasters, pylons, grilles and
Baroque masks, the genius of Rivera as a muralist hits home.
Somehow unity is established. The life of the auto worker from
embryo to assembly line, the monster machines, everything that
goes into the making of an automobile shows upon the walls.
Donor Edsel Ford made one stipulation, that the subject matter
must have to do with Detroit.

The museum's objective is to show in sequence the arts of
human civilization. The encyclopedic aim is modestly realized in
some areas, spectacularly well in others. Dominating Baroque
paintings from the 17th and 18th centuries is Rubens's *St. Ives
of Trequier*, a relatively early work of imposing scale and bril-
liant color, generally agreed to be entirely by the master's hand.
Don't miss the small Rubens sketch of *Briseis Returned to
Achilles*, made from one of a series of tapestries. All trace of the
tapestries has disappeared, and the last record of them is in an
1852 catalog by Viollet-le-Duc, the great 19th century architect
and medievalist. The surmise is that they were burned to obtain
their gold and silver thread.

In one of the finest collections of North European paintings
in America, an undisputed masterpiece is Pieter Brueghel the
Elder's *The Wedding Dance*, equally admired by scholars and
schoolchildren. Among the earlier Italian works there are three
marvelous small Sassettas of the Passion. These Renaissance
paintings were separated in the 18th century and finally brought
back together in Detroit in 1953. The museum had bought the
first of its Sassettas from Sir Joseph Duveen in 1924 and acquired
the second in Assisi in 1946. Chivalry is not dead, even in the
auction house. When the last of the trilogy went up for sale
at auction in London, sympathetic museum directors refrained
from bidding against Detroit.

It's the rare "find" that keeps art scholars happy and alert;
one occurred recently in the heart of London's Piccadilly. The
mother superior of All Saints Roman Catholic Convent sent to
Sotheby's auction house a small painting which had hung in the

Greek, Cycladic Period: Man Playing a Syrinx
(courtesy of the Detroit Institute of Arts,
Detroit, Mich.)

Michelangelo Merisi da Caravaggio: The Conversion of the Magdalene
(Detroit Institute of Arts, Detroit, Mich. Gift of the Kresge Foundation and
Mrs. Edsel B. Ford)

convent parlor for years. It was recognized as a panel from a predella representing the Passion. Other panels from the same predella were discovered in the 19th century and are in the Vatican, the Fogg Museum and the Philadelphia Museum. Detroit's panel, *Resurrection*, is attributed to the Master of Osservanza (Osservanza is a convent outside Siena), whose 15th century work has long been confused with Sassetta's. Another panel "find" is the Sienese Giovanni di Paolo's *St. Catherine of Siena Dictating the Dialogues*. A great addition to the Italian painting section is Caravaggio's brilliant *The Conversion of the Magdalene*. The provenance of this fine late 16th century work (it is dated 1598) makes interesting reading. The canvas left Italy in 1897 with its proper export stamps. It entered and remained in the collection of an Argentinian family until purchased in 1973 by Detroit.

There is a treasure trove of small Flemish and German works. In van Eyck's *St. Jerome in His Study*, the illustrious Father and Doctor of the Western Church is busy translating the Bible from Hebrew into Latin. One of the first examples of oil painting, it is as fresh and brilliant as it was when van Eyck did it more than 500 years ago.

The Dutch galleries are popular favorites. Ruisdael's *The Windmill* and *Canal Scene* are placid little paintings, contrasting sharply with his darkly romantic *The Cemetery*. In *The Visitation*, Rembrandt sets and dresses this scene from the life of the Virgin in his own 17th century. *A Woman Weeping* is one of his smaller gems; *Portrait of an Officer in a Plumed Hat* is a recent acquisition. Terborch's *Lady at Her Toilet* is one of the artist's tours de force, brilliant in its depiction of satiny stuffs and textures. Less brilliant but equally satisfying is this master of genre's *Man Reading a Letter*.

The Oriental section has one of the great Chinese paintings in America, *Early Autumn*, by Ch'ien Hsuan. Early European sculpture—from the 3rd to 14th centuries—includes particularly fine examples of German, French and Italian carvings. The small Gothic room, off the main hall, holds three carvings of the *Madonna and Child*, one by Tino di Camaino, one by Bonino da Campione and one by Andrea Pisano which looks astonishingly contemporary.

The outstanding American section goes the distance—primi-

tive to now. Of great popular interest is Copley's *Watson and the Shark*. After he settled in London, Copley met Brook Watson, an Englishman who told him how, as a young apprentice seaman swimming in Havana Harbor, he had been attacked by a shark. He was saved, but not until the shark had made off with his leg. The painting, commissioned by Watson, was Copley's first ambitious excursion outside the field of portraiture. The original is now in the National Gallery, Washington; an almost identical version hangs in the Boston Museum of Fine Arts. Detroit's oil is a smaller version signed and dated 1782. Charles Willson Peale's *The Lamplight Portrait* is a direct, affectionate portrayal of his brother, James Peale, the miniature painter. In this work Charles Peale was unusually preoccupied with light, using lamplight to dramatize a portion of the face much in the manner of Georges de la Tour, the French painter. Just about every great name in American art is here, including Whistler, whose *Nocturne in Black and Gold: The Falling Rocket* caused the noisy defamation suit between Whistler and Ruskin. But the strength of the collection lies in its completeness, including the lesser names that contribute so much to American art. The John S. Newberry Collection of 19th and early 20th century drawings and prints strengthens an already important group of graphics that begins with the 15th century.

The contemporary American section covers most of the major American artists' work, sometimes in stunning examples such as the Tony Smith *Gracehoper*, surely his largest sculpture, resting on the museum grounds. Both the north and the south courts are ideal for the sculpture they contain: Jean Arp, Henry Moore, G. Alden Smith and Mark di Suvero, to name a few from the fine collection.

Decorative arts holdings are used in proper context, whether it is to create an ambience in the galleries or in a period room. Detroit's Renaissance Room is one of the few in America. The Mrs. Horace E. Dodge bequest brings the decorative arts section even more to the fore, with Fragonard's four *Scenes of Country Life*, a pair of commodes by Etienne Levasseur, one by Jean Henri Riesener and a great pair of *torchères* of Claude Thomas Duplessis. Other paintings in the French section include Poussin, Oudry, Nattier, Georges de la Tour. The Robert H. Tannahil bequest of paintings is mostly French Impressionist and Post-

Impressionist, including Cézanne's *Portrait of Madame Cézanne, The Three Skulls* and *Mont Ste. Victoire,* van Gogh's *The Diggers* and Picasso's *Melancholy Woman* and master drawings, predominantly 19th and 20th century.

The Tannahill bequest of more than 150 African works together with the Mennen Williams group and the museum's own African collection will have an important new installation. One of the pleasures of this museum is in its small surprises. Egyptian, Greek, Assyrian and Persian arts are far from neglected. The prehistoric Irish gold cache is a coup and an enchantment, the small Cycladic *Flute Player* a gem.

Detroit is so much a symbol of industrial-America-on-wheels that it is easy to forget it was founded by a French aristocrat, and that as late as 1830 city proclamations were made in both French and English. A fire in 1805 devastated the town. Some of the links with Detroit's Colonial past are in the museum's unique French Canadian collection. Provincial wood carvings, many of them of religious subjects, are here along with a fine and growing collection of rare French Canadian silver.

F L I N T

DE WATERS ART CENTER: FLINT INSTITUTE OF ARTS
1120 E. Kearsley Street, Flint, Michigan

Hours: Mon.–Sat. 10–5; Sun. 1–5; Tues., Thurs. 7 P.M.–9 P.M.
Closed: Legal holidays
Library

The 45-year-old Flint Institute of Arts moved to the De Waters Art Center in 1958. In 1966 a new wing was added, doubling the institute's space; the result was a low-slung complex built on simple clean lines around an inner glassed-in courtyard. Through all seasons William Zorach's handsome *Spirit of the Dance,* Rickey's 25-foot-high mobile *Two Lines Oblique,* and David Hare's *Man Learning to Fly* preside there.

At the institute's entrance is a rich panel of stained glass

John Singer Sargent: Garden Study of the Vickers Children (De Waters Art Center: Flint Institute of Arts, Flint, Mich.)

by Abraham Rattner. Exhibitions change in the large galleries at the left. A small Oriental collection contains jades, ivories, porcelain and Chinese scroll paintings. A Renaissance room of grand proportions holds tapestries, furniture and *objets d'art*. The Fountain Gallery contains the major portion of the painting collections, and beyond is what must be the most elegant and comfortable members' room and library in museum circles.

The collection is small but, like everything else in Flint, growing. There is a fine, atypical Cassatt, also works by Sisley, Chagall, Hassam, Sargent, Vuillard, Vlaminck, Renoir, Redon, Utrillo and Jawlensky, as well as works by Americans Stuart, Heade, Harnett, Cropsey and Wyeth. But it is in the area of contemporary American art that the collections are strongest. Eighteenth century Germanic goblets and rummers, formerly in the Hohenlohe and Lubeck collections, sparkle now in Flint, as does the choice collection of 200 antique paperweights. African sculptures from the collection of Governor H. Mennen Williams, former assistant secretary of state for African Affairs, have come to the museum.

However, it is in its continuing program that the institute is especially fortunate. The juried Flint Art Fair, held each June on the museum lawns, attracts thousands. Major exhibitions accompanied by scholarly catalogs, such as "Art of the Great Lakes Indians," are features in Flint.

KALAMAZOO

KALAMAZOO INSTITUTE OF ARTS: GENEVIEVE AND DONALD GILMORE ART CENTER

314 South Park Street, Kalamazoo, Michigan

Hours: Tues.–Fri. 11–4:30; Sat. 9–4; Sun. 1:30–4:30
Closed: Mon., major holidays, last two weeks in Aug.
Library

Kalamazoo is an Indian word for "water boiling in the pot," and the pot where the art simmers here is a handsome building erected by Skidmore, Owings and Merrill. Built in the shape of a C around a garden court, it has an outdoor-indoor ambience, and even its nether regions—mail and printing rooms, workshop, tool crib, matting room, photo printing lab—make larger museums envious. Incorporated in 1924, its first meeting in the YWCA, the art center moved about, gaining the momentum that resulted in the present 1961 structure. An ingenious removable-panel system provides space for large painting exhibitions or, when removed, reveals built-in wall cases for display of three-dimensional objects.

The institute aims to establish a distinguished collection of prints, drawings, watercolors and small sculpture from all parts of the world, as well as 20th century America. Sculptures by Zorach, Barlach, Calder, Epstein and Gauguin are good initial ingredients, and an active, changing exhibition program keeps the spacious galleries alive with new excitement.

Jacques Lipchitz: Daniel Greysolon, Sieur du Luth (University of Minnesota, Tweed Museum of Art, Duluth, Minn.)

MINNESOTA

UNIVERSITY OF MINNESOTA: TWEED MUSEUM OF ART
Duluth, Minnesota

Hours: Mon.–Fri. 8–4:30; Sat., Sun. 2–5
Closed: Major holidays

George P. Tweed was a financier and a public-spirited son of Duluth. The art museum named for him forms a handsome link between two wings of the new humanities building. Light and contemporary in feeling, its brick walls and wide glass façade provide an excellent backdrop for the assertive canvases of some of its changing exhibitions. Students passing through receive, perhaps in spite of themselves, a broad visual education.

The Alice Tweed Tuohy gallery, opened in 1965, doubles the space. Paneled in walnut, it is congenial to the 19th century French and American art which dominates the permanent collection. Some Frenchmen here are Corot, Rousseau, Millet, Daubigny, Cazin, Jules Dupré and Boudin; some Americans: Martin, Twachtman, Luks, Glackens and Mauer. Homer's *Watching the Sea*, Inness's *Approaching Storm* and an unusually direct Sargent, *Portrait of a Young Man in Khaki*, are also here. In addition to its university chores, Tweed is the only gallery serving northern Minnesota, upper Wisconsin and part of Canada. For these far reaches, it is *the* community museum.

Outside the gallery entrance in the Ordean Court is Jacques Lipchitz's nine-foot statue, *Daniel Greysolon, Sieur du Luth*. Lipchitz has presented du Luth in a costume mixture of American trapper and French dandy. He wears the long wig popular at the courts of the Louis' (two such wigs were found in du Luth's Montreal apartment). Having no likeness to guide him,

Lipchitz said, "He will look like a builder, a man who looks at a place and says, 'This is where I want a city.'" He stands on a 13-foot column, jaunty, arrogant—commanding the city of Duluth to be brought into being.

MINNEAPOLIS

THE MINNEAPOLIS INSTITUTE OF ARTS

2400 Third Ave. South, Minneapolis, Minnesota

Hours: Sun., Mon., Wed., Fri. 12–5; Thurs. 12–9; Sat. 9–6; Closed: Tues.
Restaurant

Half a dozen northwest empire builders ran Minneapolis, lock, stock and culture, around the turn of the century. Although the Minneapolis Society of Fine Arts had been founded in 1883, nothing much happened until 1911, when the bankers and bakers, restive at the philistine state of affairs, gave a dinner and between the sherry and the champagne pledged $350,000 to build the biggest art museum west of Fifth Avenue. Now less than a decade away from the 100th anniversary of its founding, the museum is making spectacular additions to the classic old McKim, Mead and White building. Retaining the shell, the architect Kenzo Tangé wrapped wings of a sympathetic white-glazed brick around the former stone edifice. Tangé is an architect of international reputation, but this is his first venture on the North American continent. From both an architectural and a conceptual viewpoint, the project can only be described as vast.

One wing encompasses the old building of the Minneapolis College of Art and Design plus a four-storied new edifice connected to the complex by a walkway. Another wing holds the Children's Theater, which could be the envy of any Broadway house. (Get the brochure on the purpose and accomplishments of this unique organization.) The classical façade of the old museum is artfully presented as a period piece within the new structure. Monolithic in concept the project is saved from its bigness by what can only be called the architect's grace in han-

dling space. In the museum, windows are placed strategically to bring the outside park into the interior space. No dreary halls here; bridges cross courtyards and niches form small balconies for viewing. The interior design, with even the plexiglass cases seamless, is brilliantly understated so that while works of art are given preeminence a blithe spirit pervades. The entrance through a new wing brings the visitor to an introductory gallery where audiovisual presentations describe special exhibitions or help him locate certain areas.

Unique in American museums, at least on this scale, is the "open-shelf" policy. For example: in the Oriental section, one person may walk through satisfied with the aesthetic experience alone; another, attracted to a Ming pot and wishing to see other examples, steps to the adjacent study area where, given the museum's extensive holdings, dozens of objects will be spread before him; or another person, wanting total immersion, steps into an equally accessible curatorial area where a scholar in the field will assist him. Several of these resource areas are now available in the museum. This open-door policy dispels the ivory-tower image of the museum, but its success will lie in the ability of the curator-scholar to put the neophyte at ease. The conservation area has an amphitheater suspended above it where the public can watch the mystical rites of restoration.

The collection continues to expand, but in the meanwhile one can still see old favorites taking on different aspects in their new ambience. All cases are of plexiglass and are three-dimensional, thus giving a luminous and airy feeling to the objects within. From a bridge spanning third-floor galleries, one looks down at a floating platform, suspended above the main court, which holds Classical sculpture. Another high bridge, glass enclosed, joins the museum to the children's theater and serves as a two-storied restaurant as well. This glass enclosure is part of a four-story skyway that joins sections of the building on different levels. Views abound, including one of Philip Johnson's skyline sculptural shafts, the Investor Diversified Services Center.

The institute is rich in Oriental bronzes and European paintings of the 17th, 18th and 19th centuries. The Alfred F. Pillsbury bronzes are notable for their quality and their scope, as are the Pillsbury-Searle jades. A recent bequest further enriches the Oriental section. It is the distinguished Richard P. Gale collection

of Japanese prints and paintings of the Ukioye School.

In the fine decorative arts section is a tea service made by the Revolutionary silversmith Paul Revere. Hogarth's *Sleeping Congregation* dozes over the mantel in the Queen Anne Room. Dated 1728, it is one of his finest excursions into high satire. In the print room, two engravings of the same subject show slight variations in treatment.

Minneapolis's Poussin, *The Death of Germanicus*, has the distinction of being the only non-Louvre painting ever to be shown in one of the Louvre's scholarly Dossier exhibitions. Strangely, this was France's first view of the canvas as it was painted in Rome for the Barbarini family and hung in their *palazzo* from 1623 to 1958. That self-appointed art critic Napoleon Bonaparte said, "One can never forget compositions like the *Germanicus*—once having seen them. The French school of painting must return to the ideas of Poussin."

Some of the important later French painters shown are Cézanne, Pissarro, Monet, Gauguin and Renoir, all in top form, as are Matisse, with his *White Plumes*, Bonnard, with his hot and glowing *Dining Room in the Country*, and Degas, with his *Portrait of Mlle. Hortense Valpincon*. Magritte, Balthus and de Chirico have joined the French.

El Greco's *Christ Driving the Money Changers from the*

Nicolas Poussin: The Death of Germanicus
(Minneapolis Institute of Arts, Minneapolis, Minn.
William Hood Dunwoody Fund)

Temple was a work of his early thirties. A later version is in the Frick in New York. El Greco has painted in the lower right-hand corner portraits of four people to whom he felt indebted: Titian, Michelangelo, Giulio Clovio and Raphael. Oddly enough, in all the years that El Greco worked in Toledo, a few miles from Philip II's court, he got only one commission, *St. Maurice and His Legion*, from the king. And though it remains in the Escorial, it was never placed over the altar for which it was designed. Philip preferred the opulent paintings of the Italians, especially Titian, whose pupil El Greco was. Also not to be missed are the Fra Angelico, *St. Benedict*, and the large Prud'hon, *The Unity of Love and Friendship*.

For many years Rembrandt's *The Suicide of Lucretia* was thought to have been painted *before* she "sheathed in her harmless breast a harmful knife," for her gown was spotless, her dagger poised. Following the cleaning of the painting, her fate was seen to have been accomplished in the bloody stain on her dress.

Giovanni Benedetto Castiglione's *The Immaculate Conception*, considered the most important Castiglione outside Italy, has come to the museum. A number of drawings connected with it are in the Windsor Castle collection.

Important 20th century canvases are *La Vie Conjugale* by Roger de La Fresnaye, *Still Life* by Juan Gris, and Léger's Cubist *Table and Fruit*. Beckmann's large triptych *Blindman's Bluff*, Marca-Relli's *Trial*, Charles Close's *Frank*, Larry River's enormous *Studio*, Cy Twombly's *Blackboard Painting*, Tom Wesselmann's *Expo Mouth* and Bob Rauschenberg's *Acre* are but a few of the paintings that bring the collection to the present.

UNIVERSITY OF MINNESOTA: UNIVERSITY GALLERY

316 Northrop Memorial Auditorium, Minneapolis, Minnesota

Hours: Mon.–Fri. 11–4; Sun. 2–5
Closed: Sat., major holidays

Rich as the museum fare is in the Twin Cities, the visitor should not forego a trip to the University Gallery. The permanent collection is mainly 20th century: Marsden Hartley and Alfred

Henri Matisse: White Plumes
(Minneapolis Institute of Arts,
Minneapolis, Minn.
William Hood Dunwoody Fund)

Maurer are well ensconced; so is notable contemporary sculpture. But many of the temporary exhibitions you might encounter could well span centuries. A new and exciting exhibition policy which is broadly cross-disciplinary in scope is in the making. By the time you get there, the gallery may have settled into a new home, or there may be a series of galleries on both the Minneapolis and the St. Paul campuses, for the university is moving toward the implementation of a "gallery system" encompassing several facilities.

WALKER ART CENTER

Vineland Place, Minneapolis, Minnesota

*Hours: Summer: Tues.–Sat. 10–8; Sun. 12–6. Winter: Tues., Thurs.
10–8; Wed., Fri., Sat. 10–5; Sun. 12–6*
Closed: Mon., major holidays
Restaurant

One does not expect to find a Mont-Saint-Michel of modern art on the plains of Minnesota, but the combination of Edward Larabee Barnes's Cubist monolith of eggplant-colored brick and

he contemporary masterpieces housed in the Walker seems to
ustify the comparison. One enters a spacious lobby, shared in
ommon with the adjacent Tyrone Guthrie Theater, then moves
eft into the Walker. The building is set on a broad base with
a series of rectangular cubes spiraling upward to form a helix.
The route inside leads one up broad stairs that alternate with
amps and seduce the visitor from one gallery to the next. No
awareness of architectural detail interferes with viewing. As one
ounds a corner, Louise Nevelson's powerful black *Sky Cathedral
Presence* itself becomes a wall. Thirteen smaller Nevelsons, from
early Cubist pieces to recent columns, stand nearby in their self-
made black forest. The largest of Stella, Still, Kelly, Franken-
thaler, Rauschenberg, Morris Louis and other outsized canvases
hang in a gallery of what appears to be limitless space. At the
summit, a glass wall relates one to the first of a series of three
outdoor sculpture terraces that form steps to the roof. On these
platforms, holding their own against the Minneapolis cityscape
and God's sky, are works by some of our giants of sculpture:
Lipchitz, Calder, Moore, Marini and the Smiths—David and
Tony. An outdoor-indoor restaurant on the top terrace gives the
diner the best of two worlds.

The museum shop (which in many museums is too often a
clutter area) has been adroitly designed so that, for evening
functions, display shelves fold into smart white kiosks.

Adjacent is an interpretative gallery. Sitting on comfortably
carpeted bleacher seats, one is introduced through various audio-
visual forms to material related to a featured exhibition. For
example, during a Kandinsky exhibition, there would be a con-
tinuous showing of an analysis of his work, complemented by
Russian films, music and illustrated lectures.

The contemporary section has its roots in such paintings as
Franz Marc's *Blue Horses* and Joseph Stella's *American Land-
scape*. Marc, with Klee, Kandinsky and others, founded the Blue
Rider group in Germany before World War I.

The history of the museum seems to have been from riches
to, well, not exactly rags, to riches. T. B. Walker, a lumber mag-
nate, was one of the omnivorous turn-of-the-century collectors
who amassed Chinese ceramics, armor, Renaissance paintings,
snuffboxes—you name it, he collected it. By 1879 he had enlarged
his house and opened it to the public. Eventually there were 14

Kenneth Noland: Cantabile
(Walker Art Center,
Minneapolis, Minn. Eric
Sutherland photo)

rooms full of art, and Mrs. Walker had to hire a maid to do nothing but answer the doorbell.

In 1926, when Walker was eighty-seven, he built an art center. Not long after, Depression doldrums hit lumbering and consequently the museum. At one point the staff consisted of Mr. Walker's former chauffeur, a self-trained curator and a maintenance man. The WPA arts project moved in and saved the day by establishing a lively community arts program. This changed the traditional direction the museum was following, and plunged it into an ambitious design program. *Design Quarterly*, museum-spawned, became and still is an important publication in the field. The World War II boom revived the lumber business, and the center was once more self-propelled. Top-flight experts reassessed Grandfather Walker's collection, and for a period the minor Old Masters lingered uncomfortably among the brash Abstractionists. Today there is little of the original collection left but a small gallery of top white and green jade, a simple link and tribute to the man who made it all possible. The Walker has achieved a national reputation for the innovative character of the exhibitions it holds, many of which circulate to other museums in America.

T. PAUL

HE MINNESOTA MUSEUM OF ART
05 St. Peter Street, St. Paul, Minnesota

Hours: Tues.–Sat. 11:30–5
Closed: Sun., major holidays
Restaurant

COMMUNITY GALLERY
30 East 10th Street, St. Paul, Minnesota

Hours: Mon.–Sat. 9–5; Sun. 1–5

The former St. Paul Art Center not only has a new name (see heading); it has or will shortly have two new addresses. An outgrowth of the St. Paul Art School, the institution established its first permanent home in a mansion on Summit Avenue. (The avenue, two miles of which have just been declared a historic monument, conjures up memories of F. Scott Fitzgerald, whose youth flamed in its elegant homes.) Later, it shared space with the downtown Science Museum. Indeed, the Community Gallery, where changing exhibitions are held, remains in the Science Museum for now. However, the stately old Federal Court building, another historic monument, is being turned into a Fine Arts complex, and eventually the Community Gallery, with its art school, outreach programs and changing exhibition galleries will occupy approximately half of this building.

The Minnesota Museum proper, established in the handsomely renovated old Woman's City Club, is but three blocks away. Its important activities are the National Bi-Annual Craft exhibition (confined to fiber, clay and metal), and the National Bi-Annual Contemporary American Drawing exhibit. Using the "build a better mouse trap" theory, the museum has, through the last ten years, built a collection of contemporary drawings of remarkable quality. As Hyatt Mayer, curator emeritus of the Metropolitan Museum, said of St. Paul's collection, "If Rip Van Winkle wanted to know where American drawing was heading,

he could not do better than board the first plane from the Cat skills to St. Paul." There is always a selection on view, and the collection is open to the serious aficionado.

In visiting the museum take the elevator to the fourth floor and proceed downward. The small Oriental section contains some striking textiles, screens, Sung and Ming pots. Besides the ancient arts of Japan there is a large collection of contemporary Japanese prints, including some by members of the Sosaku Hanga groups, those artists who rejected the traditional wood block technique and evolved their own more Westernized methods and ideology. Though objects change frequently in these pleasant, light galleries, the six-panel Edo period screen, *Scholars and Birds*, usually remains, as does *The Actors* by Takashi Sato, a huge, amusing drawing that forms a bold rear wall.

The third floor contains the decorative arts, including a paneled, curved library removed from the Summit Avenue house. The Paul Manship Collection is installed here. A native son, Manship gave half of his collection to the Smithsonian's National Collection of Fine Arts. Though he is known for his monumental pieces such as the *Prometheus Fountain* at New York's Rockefeller Center, logistics fortunately demanded that the smaller ones come to St. Paul. These works are not models for his many commissions, but vital little pieces free of the academic setness of his large sculpture.

As we noted earlier, the changing exhibition program will eventually occupy space in the nearby Federal Court building.

Japanese, Tomb Period: Haniwa Horse
(Minnesota Museum of Art, St. Paul, Minn.)

MISSOURI

WILLIAM ROCKHILL NELSON GALLERY OF ART AND ATKINS MUSEUM OF FINE ARTS

4525 Oak Street, Kansas City, Missouri

Hours: Tues.–Sat. 10–5; Sun. 2–6
Closed: Mon.
Library, restaurant

William Rockhill Nelson, crusading editor, owner and launcher (in 1880) of the Kansas City *Star*, fell in love with Rembrandt's *Night Watch* on his first trip to Amsterdam's Rijksmuseum. He promptly hired a Dutch artist to do a full-sized copy and had it shipped home to Kansas City. Thus began his love affair with the Old Masters. Nelson's heirs (he died in 1915), in accordance with his wishes, willed his estate to the city for the purchase of works of art. Another Kansas Citian, Mary M. Atkins, left funds for a building. Few museums have opened so well accoutered. Experts, heady with the knowledge that millions were accruing, scoured the art markets of the world. From Europe and the Orient to the heart of our wheat and beef belt flowed great treasures. A quarry of colossal black marble was imported from the Pyrenees to the Missouri prairies, where it was carved into 12 gigantic columns for the great central hall. When the building opened in 1933 it was the last word in classical opulence. "Instant museum" does not guarantee instant quality, but the combination of wisdom, wealth and "eye" has given Kansas City a choice collection that is usually attained by the average slow-growth museum only by sometimes painful deaccessioning. Only a section of the huge building was occupied. Now, a mere 40 years later, the last of the building's space is being readied for a

Germain Pilon: St. Barbara
(William Rockhill Nelson
Gallery of Art, Atkins Museum
of Fine Arts, Kansas City, Mo.
Nelson Fund)

Attributed to Hsü Tao-ning: Fishing in a Mountain Stream (William Rockhill
Nelson Gallery of Art, Atkins Museum of Fine Arts, Kansas City, Mo.
Nelson Fund)

wo-story section for Japanese art and a gallery for the Impressionist paintings.

The painting galleries were deliberately kept small, to each room its own period. Gallery III, for instance, holds the Flemish painters, Brueghel, Memling, Gossaert Patinier and the beautiful *Madonna and Child in a Gothic Room* by Petrus Christus, who helped to initiate the Renaissance in northern Europe. The Dutch gallery includes Rembrandt, Ruisdael, Rubens's impressive *The Sacrifice of Abraham*, painted in 1612–1613. Application for a reproductive print was made to the States General at The Hague as early as 1614.

With range and distinction, Kansas City presents France in sculpture, painting and drawing. There is Poussin's *Triumph of Bacchus*, one of the finest Poussins in America, from a series of bacchanals commissioned, oddly enough even for so worldly a churchman, by Cardinal Richelieu. Another of the series hangs in the Louvre, while *Triumph of Neptune* was purchased from the Hermitage for the Philadelphia Museum. Kansas City has one of the drawings for *Triumph of Bacchus*. Among its holdings, too, are a great late French Renaissance sculpture, *St. Barbara*, by Germain Pilon, and the original small wax study for Rodin's *The Thinker*, of which many U.S. museums, including Kansas City, have large bronze casts. A gallery of French Impressionists and Post-Impressionists holds Gauguin's *Reverie* and Degas's *Ballet Rehearsal* (for which the National Gallery has the sketch).

In Gallery XI, are the important Spanish painters—Goya, Velázquez and Zurbarán, whose magnificent *Entombment of St. Catherine* was taken to France by Marshal Sault at the end of the Napoleonic war with Spain. Thought to have been sold with other Sault paintings (1847–1854), it was discovered in a fine state of preservation though slightly sooty in the family chapel in the 1950s. It came to the gallery in 1961. El Greco is shown with a subdued but glowing *Penitent Magdalene* and his worldly *Portrait of a Trinitarian Monk*.

To the right of the museum's entrance, the ancient Near East is dramatically represented by *The Kneeling Bull*. This capital from the Hall of One Hundred Columns at Persepolis, each column 65 feet high, is in a black marble gallery where the black limestone of the bull luminously plays against the dark-veined marble. He shares this elegant background with the stern, finely

chiseled *Head of Hammurabi*, first lawgiver of Babylon. Examples from the Etruscan, Greek and Roman civilization are here, with one of the rare wood statues from Egypt, *Portrait of Methethy*, late V Dynasty, Saqqara. Medieval and Renaissance sculpture follows with a great altarpiece from Valencia, Spain, attributed to the circle of Andrea Marzal de Sas. In a tranquil cloister from a monastery near Beauvais, a splendid French Romanesque capital is used as wellhead. The Medieval sculpture gallery adjoining holds examples of ivories, enamels and Gothic sculpture.

The American wing starts with Justus Engelhardt Kühn, Jeremiah Theus and Benjamin West, and includes Raphael Peale's teasing trompe l'oeil *After the Bath*. In the George Caleb Bingham Gallery are his famous genre paintings, such as *Canvassing for a Vote*. Bingham, an ardent Whig, painted it in 1852 and sent it to Paris to have engravings made. It was lost and turned up again in 1954, when a Florida physician, knowing the museum owned several Binghams, wrote to its conservation department concerning the care of his *Canvassing for a Vote*. Shortly after, the museum was able to purchase the painting. Bingham's portraits are little known outside the Middle West, but most of Missouri's prominent families commissioned him to "do a likeness." Kansas City's ancestral citizens are shown in a range from Bingham's first brittle efforts through the softer, Sullyesque style found in *Portrait of Elizabeth Dillingham Keller* and a fine *Self Portrait*.

The large gallery of contemporary European and American works holds Juan Gris, the German Expressionists, Ron Davies, Tom Wesselmann, Dwain Hanson, Ralph Humphry, Wayne Thiebaud, Roy Lichtenstein, Stanley Landsman and de Kooning's *Woman IV*. Jackson Pollock is represented by an oil, a watercolor of a western scene and a painted porcelain bowl and plate. The latter is a gift of Mrs. Thomas Hart Benton, the wife of Pollock's early mentor.

A rich decorative arts section includes the Burnap Collection of English Pottery, the largest of its kind outside England, with unique precious examples from every period, beginning with primitive Medieval wares. The *Codrington Punch Bowl*, largest known covered bowl, has joined the distinguished Atha Collection of English Silver. Kansas City has installed its fine collection

of miniatures in a spectacularly innovative, high-domed pale blue gallery.

The group of Oceanic, Pre-Columbian and African art and the splendid drawing and print collection could be dwelt on, but that would leave no time to follow the road that leads most people to Kansas City's Museum of Art—its famed Oriental collection, which embraces in varying degrees the arts of the Near East, Iran, India, Indonesia, Southeast Asia, Korea, Japan and China. The major part of the museum's second floor is given to these collections.

The Indian bronze group is the largest in this country. The Indian temple room, a composite of several temples, with its lacy intricate ceiling and complex paneling, somehow manages a unity that enhances the bronze and wood sculptures it holds.

Japanese holdings, especially its strong paper screen collection, will be enhanced by the new two-story gallery. The Chinese section, by far the largest, begins with the pottery and jade objects of Neolithic times and brings us to 20th century painting. The main gallery is a construction of a Chinese temple, the climax of which is a large 14th century fresco against which reposes a heroic-sized sculpture of polychromed wood, *The Bodhisattva Kuan-Yin*. Another gallery holds an early noteworthy piece: one of the few secular subjects of the period, it is a relief, *The Empress as Donor with Attendants* (Northern Wei Dynasty). The emperor and his attendants rest at the Metropolitan. The gallery of Chinese furniture delights. The textured *Bed with Alcove* is a rare, handsome example of Ming Dynasty craftsmanship. It can be ingeniously folded for its owner's trips from summer to winter palace. Most of these unique pieces date from the 14th to the 18th centuries.

The famed painting collection has been given a new installation. One enters a precious world—a Ste. Chapelle of Chinese painting. All the mysterious and rich minutiae of the artist's world comes to life in this skillfully displayed and subtly lighted arrangement of paintings. The aficionado will be filled with joy here; the neophyte will become an addict. In other galleries the treasures spread from ancient bronzes to the painted pottery of the 1st century A.D., from tomb figures to 14th century hammered silver to 18th century drawings from north India. The riches flow on. When one considers that these noble collections

have been formed since 1930, that they illustrate a cultural tradition that ranges from approximately 1200 B.C. into the 20th century, it's a little short of a "loaves and fishes" miracle.

ST. LOUIS

THE ST. LOUIS ART MUSEUM
Forest Park, St. Louis, Missouri

Hours: Tues. 2:30–9:30; Wed.–Sat. 10–4
Closed: Mon., Jan. 1, Dec. 25
Library, restaurant

Few museums are as auspiciously situated as St. Louis. Built on a hill in Forest Park, a large preserve in the heart of the city, the museum dominates and invites. The large Classical structure, erected in 1903 by Cass Gilbert, is divided by a barrel-vaulted sculpture court. When the projected wing is built, the Corinthian columns at the end of this space will lead into Fountain Court, the major central area of the stunning plan. Another entrance to this space (popular because it is near the parking area) leads one inside and over a bridge, at the end of which the great dimensions of the court burst forth. The four-storied colonnades that lead back into the older area stand like great pieces of temple sculpture. The new wing proceeds into a series of tiers that form major exhibition space. Administration, education, library and a charming restaurant overlooking the park are all placed here.

It is difficult to assess St. Louis's treasures. The strongest holdings are perhaps in European paintings from Impressionism through Cubism, and in the whole historical scope of American paintings. A stunning gallery of 20th century European art is adjacent to the sculpture court, and while the works may change from time to time one can see in top examples Moore, Maillol, Lipchitz, Giacometti, Picasso and Miró. Also Braque's *Blue Mandolin*, Modigliani's *Elvira Resting on a Table* and, of course, Henri Matisse's *Bathers with Turtle*. Painted in 1908, the intensity of the color and the powerfully delineated figures showing

the female form in three attitudes give the canvas a richness and solidarity that mark it one of Matisse's masterworks. Acquired by a German, Karl Osthaus, the painting was taken from the Folkwang Museum in Essen by the Nazi government and ordered sold at auction in 1939 in Switzerland, where it was purchased by Mr. and Mrs. Joseph Pulitzer, Jr.

St. Louis scores in almost every field of painting with distinguished examples and astuteness of judgment. Certainly purchasing Manet and Sisley in 1915 and 1916 was far-sighted.

A few treasures of North European art: *A Portrait of Lady Guildford* by Hans Holbein the Younger; Cranach's *Judgment of Paris*, one of several known versions, and of unusual quality; a small, round *Crucifixion* by Gerard David which reminds, with its precise, glowing colors, that the artist was also an illuminator of books. There are stunning examples in the Dutch school of Rembrandt, Frans Hals, Terborch and de Hooch.

The High Renaissance group is crowned with paintings by Titian, Veronese, Tintoretto. In medieval times, craftsmen and painters worked more or less anonymously under the patronage of the Church, but as kings and rich men, such as the Medicis, began to rival the Church as patrons of art, artists emerged as individuals. In Florence, Rome and Venice, masters like Titian wielded considerable influence on their times and places. The *Ecce Homo* by Titian was painted in his high or late phase. More recent additions are Jean Clouet's *Portrait of a Man with Gold Coins* and Pompeo Girolamo Batoni's *Portrait of Cardinal Jean de Rochechouart*. The regrouping of the American section has brought together not only Earl and Copley but an early picture by John Greenwood, the satirical *Sea Captains Carousing at Surinam*, one of the few pieces of 18th century genre painting by an American artist. John Johnston's *Still Life* is one of the earliest dated American still lifes (1810). We move on to beautiful landscapes by Cole and Cropsey to the American Impressionists to early and mid-20th century painters of the quality of Weber and Hopper, to the present with Don Judd, Morris Louis, Frank Stella, Ellsworth Kelly and St. Louis's own Ernest Trova. The museum does well by George Caleb Bingham; though born in Virginia, he was known as "the Missouri artist" and in 1875 became the state's adjutant general. His *Raftsmen Playing Cards* is probably the best-known Bingham in the collection, but the

Jean Clouet: Portrait of a Man
with Gold Coins (St. Louis Art
Museum, St. Louis, Mo.)

Pablo Picasso: The Fireplace
(St. Louis Art Museum, St.
Louis, Mo. Gift of Joseph
Pulitzer, Jr.)

small, atypical and quieter *The Old Friend Horse* delights too.

Though much of the material is not always on view, St. Louis
presents a picture of culture in the Mississippi Valley from the
days when the city was a fur trading post through the glamorous
years when sidewheelers plied the broad river. The conquering
of the redskin, whether by treaty or treachery, is depicted in
painting, sculpture and prints. Sagas of buffalo hunts, of trappers
and traders and wagon trains, are by artists from Catlin to
Remington.

There is a good American Decorative Arts section highlighted
by two stunning stained glass windows, circa 1885, by John La
Farge. Similarly, the general decorative arts section, though
small, concentrates on important examples. The textiles collection
has recently been enriched by a group of Continental and Ameri-

can embroideries, mostly of religious subjects. The antique Near Eastern carpet collection has been further developed by gifts from the daughter of James K. Ballard, who originally assembled this distinguished group.

Practically all the important cultural facets of civilization are represented, some with stunning examples, such as the *Bearded Bull's Head* (Sumerian, 2800–2600 B.C.) and the notorious *Egyptian Cat Saite* (circa 500 B.C.). The cat was purchased in 1937 for $14,000 (the city museum is supported by a mill tax levy). The unemployed picketed the museum with signs "Cash for cats but not for humans." Since Egypt no longer allows its ancient art to leave the country, it would be impossible today to obtain such a treasure.

Another great piece of sculpture is *Satyr*, considered one of the finest High Renaissance carvings in America. It is now identified as the work of Giovanni Angelo Montorsoli, a Florentine. Long attributed to Michelangelo, it stood for generations in the Barberini Palace in Rome before it was brought to St. Louis. In 1937 Prince Urban Barberini wanted to sell the piece in New York, but the Pacca Law of 1905 forbids exportation of important works of art. The prince finally made a deal with Mussolini, who drove a hard bargain. Barberini had to give a Raphael to the government before *Satyr* could leave Italy.

The stunning linenfold panel stairway taken from a court in Morlaix, Brittany, is one of the most complete examples of late Gothic woodwork in America. Morlaix, a walled town constantly

Piet Mondrian: Composition of Red and White (St. Louis Art Museum, St. Louis, Mo. Gift of the Friends of the St. Louis Art Museum)

besieged by the British, had to grow up rather than out. Different families inhabited each floor—a forerunner of our modern walk-up.

In a strong Medieval section are Romanesque columns and capitals, a tempera panel by Ugolino da Siena, and a rare French 12th century polychromed wood Madonna.

The Chinese section is especially strong in early bronzes and Sung and Tang ceramics, partly because Lionberger Davis, a longtime patron of the museum, was an astute collector of the culture. Another treasure is the painting *Fish Swimming amid Falling Flowers* attributed to Lui Tsai, Sung Dynasty (960–1280). In a small gallery off the main hall, the life of ancient China teems in miniature. Scratching hens and playful children, temples, houses and model figures all made of clay are arranged to re-create a village street during the Han Dynasty (206 B.C.–A.D. 221). The whole effect of everyday life in the hamlets along the great Chinese trade routes is charmingly and vividly displayed. The growing Japanese group is strongest in ceramics.

The African sculpture is set apart in a spiraling space of tobacco brown color that lends a note of jungle mystery.

The Etruscans, the Greeks, Near Eastern art, each is given its importance. A gallery of Pre-Columbian art includes a wide range of Peruvian pottery and textiles. Western Mexico and the Gulf Coast are well represented by both ceramics and goldwork.

Though the mill tax levy for museum support has aroused occasional resentment, as in the case of the Egyptian sculpture, most of the time it gives the citizens of St. Louis a proprietary feeling toward their museum.

WASHINGTON UNIVERSITY GALLERY OF ART

Steinberg Hall, Forsyth Boulevard, St. Louis, Missouri

Hours: Weekdays 8:30–5; Sat., 10–4; Sun. 1–5

Although the Washington University Gallery of Fine Arts in Steinberg Hall was built in 1960, the history of the university collections began almost a hundred years earlier, when through the enthusiasm of one man, Halsey C. Ives, free evening art classes for 18 people were established at the university.

In 1881 Wayman Crow, a St. Louis merchant, gave a building

to the university which was to be known as the St. Louis Museum of Fine Arts. Situated at 19th and Locust streets, it consisted of five large studios, a classroom and an auditorium. The William Bixby Fund was established to purchase works of American art.

With the closing of the Museum of Fine Arts in 1906, however, the collections came on hard times. Housed in the new City Art Museum of St. Louis, established after the St. Louis World's Fair of 1904, the old paintings, as the new museum grew, were relegated to storage and strewn about corridors and classrooms on campus.

With the coming of art historian Horst W. Jansen to the university in 1941, the department sprang back to life. The collections were reassessed and drastic measures taken to bring them up to date, since practically no 20th century work was represented. A purchasing plan to encompass the past 40 years of European and American modern art was developed. Within a year, about 30 significant pieces had been bought, including Braque, Beckmann, Baziotes, Stuart Davis, Max Ernst, Juan Gris, Soutine, Guston, Tamayo, Miró, Moore, Degas and Calder. Nothing but a top example of a painter's work was eligible. The dollar went further in 1945's art market.

Steinberg Hall is a handsome building set on the edge of the campus, accessible to one of St. Louis's main traffic arteries. A center section of glass shows off a large, arresting Lassaw, plus sculptors Chillida, Rodin, Laurens, Consagra, Renoir, Moore and Lipchitz. Changing exhibitions and parts of the now rich permanent collection are shown here. Of the galleries on the lower floor, one houses Pre-Columbian, Indian, New Guinean and Oceanic art. Much of the material is on idefinite loan from the Morton D. May Collection. Some of Mr. May's famous German Expressionist paintings are here also.

There is a small group of early European paintings—Murillo, El Greco and others—a representation of the English portrait school, and a fine group of American 19th century canvases—Harding, Kensett, Church and Durand, and Bingham's authoritative *Daniel Boone Escorting the Settlers through Cumberland Gap.*

The tradition of displaying works of art throughout the university carries on. Professors stoop to various forms of chicanery in order to hang a favorite painting behind their desks.

Edward Hopper: Room in New York (University of Nebraska Art Galleries: Sheldon Memorial Art Gallery, Lincoln, Nebr. F. M. Hall Collection)

Gaston Lachaise: Floating Figure (collection of the University of Nebraska, Sheldon Art Gallery, Lincoln, Nebr. Sheldon Bequest)

NEBRASKA

UNIVERSITY OF NEBRASKA ART GALLERIES: SHELDON MEMORIAL ART GALLERY
Lincoln, Nebraska

Hours: Tues. 10–10; Wed.–Sat. 10–5; Sun. 2–5
Closed: Mon., major holidays

Not the least of the works of art at the University of Nebraska Art Galleries is the building itself. Designed by Philip Johnson, the Sheldon is modest in size, monumental in conception. Its simple travertine exterior is bisected by glass arches that rise to the building's height and form a large sculpture hall. Big golden disks set into the ceiling provide light patterns at night that make the gallery a glowing showcase from a block away. A sculpture garden adjoins the gallery at the south and west. To deparch the Nebraska summer, the sculpture is installed among trees and fountains. Important works by Gaston Lachaise, Jacques Lipchitz, Bruno Lucchesi, Elie Nadelman, Reuben Nakian, Julius Schmitt, Brancusi, David Smith, Tony Smith and William Zorach constitute the nucleus of the garden display.

The key to the serenity of the entrance hall is its restraint. Instead of the frequent jungle of sculpture, only noble pieces stand here: It might be Noguchi's *Song of the Bird* and a 19th century American wooden horse that looks as if he had pranced out of the T'ang Dynasty.

An art collection came to this prairie campus long before many an eastern university could claim one. The first painting exhibition was shown in 1888 under the auspices of what is now the Nebraska Art Association. Progress was steady, if slow; but since 1930 the purchase of works of art of distinction has ac-

celerated. Though primarily an American collection, a few European modern masters, such as Kirchner, Barlach and Brancusi, are seen at their best.

Among the 20th century Americans are Walt Kuhn, Max Weber, Stuart Davis, Edward Hopper, Mark Rothko, Morris Louis, James Brooks, Helen Frankenthaler, Conrad Marca-Relli, Robert Motherwell and Robert Indiana. Four works by Marsden Hartley range from the poetic *Autumn, Lake and Hills*, 1907, to his much stronger, much later *Mt. Katahdin*. Cole, Blakelock, Eakins, Moran and Ryder speak for the 19th century. Within its first ten years of activity the gallery collection has acquired noteworthy concentrations of 24 works by Blakelock, 16 works by Hartley, 15 by Henri and 28 by Maurer. The art gallery has recently acquired paintings and drawings from Blakelock's family (he died in 1919). Importance must be attached to this fact, as Blakelock is one of the most forged American masters. The quality is high, and some of the oils show a style which is unexpected and unique in the artist's work.

A print gallery whose walls are effectively covered with biscuit-colored carpeting also has a print cabinet for scholars' use.

Sold in Nebraska's museum shop are only *original* works of art, including small sculpture, prints and ceramics.

OMAHA

JOSLYN ART MUSEUM

2200 Dodge, Omaha, Nebraska

Hours: Tues.–Sat. 10–5; Sun. 1–5
Closed: Mon., major holidays
Library

A stone's throw from Main Street, a city-block-sized, pink marble, Egyptian-style temple houses the museum. Even the reliefs that ornament the façade, dedicated to Indians, buffaloes, and Mr. Joslyn's business activities, are in the two-dimensional profile style of the early dynasties. The illusion is disturbed only by

four Classical columns at the portico. On a first visit, use the main entrance into the floral court. Here the architecture of the Spanish Moors takes over, its arches borne on thin columns, its fountain green tile. Off the court an interesting area, "The Ancient World," features Egyptian, Greek and Roman works.

Not a rich institution, the museum uses its masterpieces in conjunction with minor works to evoke specific periods in the history of art. The Middle Ages begin left of the Moorish court. A model of the 12th century church St. Trophime at Arles, France, shows the low, massive strength of Romanesque construction, the grandeur of the sculpture in the center-door tympanum. Illuminated manuscripts, silver, carved ivory, round out the period. Lorenzo di Credi's *Madonna and Child with Angels* and a handsome Spanish-Romanesque fresco dominate the early Renaissance gallery. Everything from coins of the realm to small bronzes illustrate the period.

Joslyn rightly boasts of one of the fine Titian portraits in America, *Man with Falcon.* Here the statesman General Giorgio Carnaro gazes intently at the falcon, as if trying to define the power of so small a bird; the burnished red and gold of the falcon's jacket and the gleam of the general's sword accent the monumentality of the figure in its slate-gray and brown garb. Titian has built into this portrait, with its noble head and powerful body, all the dignity and richness of Venetian 16th century life.

Copley's *Lord Cornwallis* typifies 18th century America. The general stands in his red coat, his hand resting on what was to Colonials the real symbol of his power, a cannon.

A small but succinct version of Renoir's *Two Girls at Piano* keys the French Impressionist gallery. Several large galleries to the right of the courtyard are used for changing exhibitions and contemporaries, among them Pollock, Lipchitz and Grant Wood's *Stone City, Iowa.* Downstairs galleries record life on the American prairies. Because there is no natural history museum in the region, the physical environs of Nebraska, and especially their effect on artists, are carefully studied. One case shows comparisons between Indian tools and modern tools—there is a surprising similarity. In artifacts, engravings, painting and sculpture the story unfolds: the French in the Northwest Territory, the Lewis and Clark expedition, the Indians and the army of the frontier,

the evolution from sod house to log cabin, the record in paint by Alfred Jacob Miller, Seth Eastman and George Catlin of buffalo hunts and tribal rites. Catlin was the first artist of stature to go West for the express purpose of documenting the tribes pictorially. Important indefinite loans are Charles Bodmer watercolors from the Prince Maximilian expedition, 1832–1834, to the interior of North America; and Alfred Jacob Miller's field paintings when he accompanied Captain Stewart's expedition. Finally, there is the territorial expansion that followed the building of the railroads. A large section is devoted to Indian crafts, and the work of the Aleutian Islanders and Eskimos should not be missed. The paintings on elk hide have the charm of much of the early cave painting.

Period rooms show the evolution of Omaha parlors, from Pony Express to Late Antimacassar style. A handsome auditorium seats 1,200.

Edgar Degas: Ballet Dancer, Dressed (Joslyn Art Museum, Omaha, Nebr. Gift of M. Knoedler & Co., Inc.)

NEW HAMPSHIRE

DARTMOUTH COLLEGE: HOPKINS CENTER ART GALLERIES

Hanover, New Hampshire

Hours: Daily 12–5, 7 P.M.–10 P.M.; Sun., 2–5
Closed: Major holidays

The center, named in honor of Ernest Hopkins, president of Dartmouth College, 1916–1945, owes its existence to John Sloan Dickey, president, 1945–1970. It was designed by Wallace K. Harrison of the architectural firm of Harrison and Abramovitz and completed in 1962. Approximately a city block in area, it houses a stunning complex of drama, music and visual arts facilities, including four art galleries, a sculpture court and many studio and craft-shop areas. The enormous second-floor lounge is probably the best place on any campus in America for showing large paintings. There Rothko, Kelly, Noland, Vicente, Anuszkiewicz and Zox are displayed to best advantage. Called "The Top of the Hop" by the students, it faces one of the most beautiful village greens in New England.

The galleries at Hopkins Center are used for changing three-week exhibitions, most of which are organized by Dartmouth, although some are traveling shows. A major feature of the gallery program is a top-quality one-man show for each of the artists in residence at Dartmouth, at least four a year, with catalog and poster. The roster includes Boghosian, Etrog, Hadzi, Judd, Krushenick, Murch, Rauschenberg, Rickey, Seley, Stella, Zajac and Luie and Morton Kaish.

In 1773 Governor John Wentworth, a trustee, gave the college a silver bowl made by two of Revere's competitors, Daniel

José Clemente Orozco: Detail of
Mural (Dartmouth College:
Hopkins Center Art Galleries,
Hanover, N.H.)

Henchman and Nathaniel Hurd, thus starting Dartmouth's art
collection which contains many fine examples of Paul Revere
silver.

The collection has more than 10,000 items and is strongest in
European and American paintings, graphics and sculpture of the
19th and 20th centuries. There is a group of noteworthy Assyrian
reliefs, a good selection of Chinese bronzes and ceramics, some
Pre-Columbian, African and Oceanic sculpture, and a few in-
teresting Early Christian mosaics and Greek icons. Among many
fine paintings there is a Zurbarán, a Goya, a Turner, a Reming-
ton, an Eakins, a group of Sloans, a Glackens, a Gris and a Ratt-
ner. The 100 etchings of Picasso's *Vollard Suite* are gems in a
large and high-quality print collection.

Not to be missed is the famous group of frescoes in Baker
Library by José Clemente Orozco on the epic theme of civiliza-
tion in America from the earliest migrations through the Pre-
Columbian era to the 20th century. Orozco painted this 3,000-
square-foot mural from 1932 to 1934 while he was a member of
the art department faculty.

The influence of Dartmouth's famous alumnus Daniel Web-

ster is everywhere. There is a room of Webster memorabilia in Baker Library. He successfully defended the college when the state tried to annex it to the University of New Hampshire. The trustees maintained that Dartmouth received its charter from the king and should remain the independent college it is today. The school was founded in 1769 by Eleazar Wheelock, a missionary, as a college seminary for Indians.

MANCHESTER

THE CURRIER GALLERY OF ART

192 Orange Street, Manchester, New Hampshire

Hours: Mon.–Sat. 10–5; Sun. 2–5
Closed: Major holidays

Moody Currier, banker and one-time governor of New Hampshire, was deeply involved with the 19th century development of Manchester, a mill town where the Amoskeag textile mills still dominate the city. Though not a collector himself, Currier was for many years president of the Manchester Art Association.

The land on which the Currier house stood was given to the city together with an endowment for building a museum. Italian Renaissance in style, it resembles a modest *palazzo*. The collection is small but unusually impressive. The result: the enjoyment of paintings of top quality in an uncluttered atmosphere.

The European painting and sculpture section ranges from the 13th century to the present. The Medieval and Renaissance periods are represented by a series of images of the Madonna and Child, which include works by Perugino, Benedetto da Maiano, and Joos van Cleve. One of the most absorbing objects is the Tournai tapestry, circa 1500, which is a lively encyclopedia of late medieval life—a hunting scene replete with dogs, flowers and birds.

Dutch 17th century is represented by Jacob van Ruisdael, Jan van Goyen and Jan de Bray.

Moving into the 19th century, Monet's *The Seine at Bougival*

is full of the splendor of his first experiments with light shimmering through a line of dusty trees.

The 20th century European group, while again not large, is of high quality. Picasso is here at his impudent best in *Woman Seated in a Chair*. American works range from a pre-Revolutionary portrait by Copley to Anuszkiewicz and Nevelson. Strong Realists such as Hopper, Kuhn, Sheeler and Wyeth are here, along with watercolors by Homer, Demuth and Prendergast.

Upper New England decorative arts dominate one section, as would be expected. In furniture the emphasis has been placed on northern New England, and especially New Hampshire. Few towns of 100,000 can boast so rounded a collection or one that includes an important painting of such local interest as *Amoskeag Canal* by Charles Sheeler. It depicts the canal and mills that made up Manchester's history. The policy of buying relatively few objects but those of high quality makes the Currier one of the most satisfying small museums to visit in the country.

Claude Monet: The Seine at Bougival (Currier Gallery of Art, Manchester, N.H.)

NEW JERSEY

MONTCLAIR ART MUSEUM

3 South Mountain Avenue, Montclair, New Jersey

Hours: Tues.–Sat. 10–5; Sun. 2–5
Closed: Mon., major holidays

The Montclair Museum has been selected as a prototype of small museums across the country. Because the audience is a return one, the emphasis is on changing exhibits. In the case of Montclair, the very good painting collection constantly revolves. The only permanent exhibit here (on the second floor) is American Indian material which includes Southwest, Northwest, the Central Plains and Eastern Woodlands Indians.

In 1909 William T. Evans, a Montclair citizen, gave a collection of paintings to the town with the proviso that the city fathers build a museum in which to house them. They demurred. In 1914, fearing to lose the collection (Mr. Evans had already given part of it to the Smithsonian), Mrs. Florence O. R. Lang donated funds for the erection of the present Neo-Classical building.

Although the aim here is to build a general collection, the strength lies in the American painting section and begins with such well-known names as Smibert, Earl, Wollaston, Blackburn, Badger, Copley, Stuart and Peale. George Inness, who lived in Montclair from 1888 to 1894, is represented with 13 works. Because William Evans believed in collecting contemporary paintings there are good examples of Hassam, Blakelock and Whittredge. Among today's contemporaries are: Baziotes, Shahn, Motherwell, Opper, George L. K. Morris, and Elaine de Kooning.

247

Lee Gatch and Ben Shahn, both of whom lived in New Jersey, are well represented.

Other holdings include late Renaissance paintings, sculpture and tapestries, English and Irish silver, 19th century costumes and a microcosm of Chinese life in a fine and unique collection of about 700 Chinese snuff bottles.

Exhibitions are held in large first-floor galleries. The museum's lively art school has its own entrance.

Tibetan Wheel of the Law (Newark Museum, Newark, N.J. Edward N. Crane Memorial Collection)

NEWARK

NEWARK MUSEUM
49 Washington Street, Newark, New Jersey

Hours: Mon.–Sat. 12–5; Sun., holidays 1–5
Closed: Major holidays

When John Cotton Dana was asked to take over the Newark Library in 1902 he immediately began to hang paintings and prints on the walls. Out of this simple beginning the Newark Museum, in two rooms of the library, was chartered seven years later. In 1926 merchant-philanthropist Louis Bamberger gave the present three-storied building which houses history, science and works of art with a deliberate interplay among the three.

Dana insisted that the museum be "where there is movement of people." During the languid summer lunch hour, businessmen and office workers stroll the galleries, listen to jazz concerts or watch lunchtime art and craft demonstrations held in the garden. The garden also plays host to monumental sculpture by David Smith and James Rosati. For fire buffs there is a fire museum on the grounds full of antique firefighting memorabilia.

The collection is primarily American, starting with John Smibert, John Wollaston, William Williams (the talented but little-known teacher of Benjamin West), Joseph Badger, Ralph Earl and John Singleton Copley. The Copley, *Portrait of Mrs. Joseph Scott*, was painted at the height of his mature style, around 1765. It remained with Mrs. Scott's heirs until purchased in 1948 by the museum. Newark was a pioneer in collecting American folk art and has invaluable holdings. "Support the artist of your time and place," exhorted Dana. One summer, a trustee cabled Dana, who was in Europe, to spend $10,000 for European art. Dana answered: "We'll spend it at home." And they did just that. Some contemporary examples are Lippold, Thiebaud, Mallary, Rosenthal, Corbett, Bannard. Lassaw, Segal, Okada, Diller, Niles Spencer and Lee Gatch are importantly represented. There is an especially beautiful Childe Hassam, *Gloucester*, in the American Impressionist section.

Dana felt it wise for Newark, just across the Hudson from the Metropolitan's incomparable Old World treasures, and at a

time when there was no Museum of Modern Art or Whitney Museum of American Art, to concentrate on American painting. Through the years gifts have given a more catholic range to the collection. The European painting group is growing. Mediterranean antiquities, mostly small objects, are installed with zest and distinction. Also Newark has the splendid Shaefer classical glass collection, and its Tibetan material ranks with that of the Natural History Museum of New York and Chicago. The basic group was collected by Dr. Albert Shelton, a medical missionary who traveled in eastern Tibet from 1905 to 1920. The museum has continued to build on this collection over the years.

It was the founder's philosophy that only by becoming critically aware of simple things about them—the shape of a teacup, the grace of a chair—could people come to an appreciation of art; accordingly, the museum has built up a matchless historical collection of things made by New Jersey craftsmen and keeps abreast of contemporary craft production. Dana was also responsible for buying as early as the 1920s fine examples of African and Oceanic art. Although some of the collections rotate a good deal, the Tibetan, African and Oceanic holdings are on permanent view.

The baronial 1884 house next door to the museum that belonged to the Balentine family is being restored by the museum. It will contain rooms of the period plus related decorative arts. A new parking lot with access through the museum's garden makes Newark's treasures much more accessible than heretofore.

PRINCETON

PRINCETON UNIVERSITY: THE ART MUSEUM

Princeton University, Princeton, New Jersey

Hours: Tues.–Sat. 10–4; Sun. 2–4
Closed: Mon., major holidays

Integrating a contemporary building into the mellow Georgian campus of Princeton was no mean accomplishment, but it has been achieved through the use of simple planes and the same

pale plum-colored stone that appears among the gray granite of other buildings. Openness is the keynote of the three-level interior of this 1966 art museum. One enters into a sculpture court with a skylight supported by travertine piers. The U-shaped gallery surrounding the court is a half-flight upstairs, and open spaces between the two levels allow the visitor to look through to the lower galleries. This arrangement distracts some, entices others. Narrow floor-to-ceiling windows give the feeling of Oriental scroll paintings that change with the seasons. Dogwood time is a favorite.

Because of the museum's function as a university museum, working closely with the Department of Art and Archaeology, there are few galleries with permanent installations. The extensive collections are constantly drawn upon for exhibition, often to supply assignments for students, often for the more general enjoyment of visitors. The range is from antiquity to the present, but certain areas of particular note are Chinese painting and bronze vessels; Pre-Columbian objects; Greek and Roman antiquities; Medieval and early Renaissance art; Italian painting, and prints and drawings (with particular emphasis on Italian drawings).

Certain of the galleries have structural installations of a semipermanent character. A series of Roman pavement mosaics excavated by Princeton at the Syrian city of Antioch is set into the floors and walls of the gallery devoted to ancient art (some mosaics also greet the visitor in the lobby); at one end is a replica of an ancient fountain with a mosaic pavement of swimming fishes. The figured and geometric designs have been selected to give a span of five centuries of mosaic art. The gallery for Medieval art is decorated with 14th and 15th century French windows and doorways that serve to frame sculpture or pieces of stained glass. A balustrade and colonettes from Palma di Majorca, dated 1549 in the carving, divide the long room into sections, and the stairway of the ensemble serves as access to a small gallery for a constantly changing display of prints and drawings chosen from the museum's large and varied collection. Set into the wall at the opposite end of the room from the stairway is one of the museum's treasures, a panel of stained glass from Chartres Cathedral which has had a colorful history since its removal in the 18th century by church authorities. Two paint-

ings which are usually in this gallery are also of particular note: Hieronymus Bosch's *Christ before Pilate* and Lucas Cranach's *Venus and Amor*. Clustered at the foot of the stairs to the lower level are cases containing objects related to various Central and South American cultures, as well as to African and Oceanic areas. Nearby are the galleries of Far Eastern art. The group of ceremonial vessels of the Shang, Chou and Han dynasties is an impressive assemblage. There are several pieces of Chinese, Japanese and Indian sculpture of importance. Paintings are changed to fill the needs, of course, but the presence of certain treasures, such as a landscape of the Sung Dynasty, can usually be counted on.

The painting section, aside from the areas mentioned, holds

Pablo Picasso: Head of a Woman (Princeton University, The Art Museum, Princeton, N.J.)

Dutch and Flemish art, canvases by Nattier, Chardin and 19th century artists such as Constable, Delacroix, Boudin and Monet. The American school is well represented. Thomas Sully's full-length *Mrs. Reverdy Johnson* is one of 18 Sullys here. John Singleton Copley paints the American merchant *Elhanah Watson* against the background of a sailing vessel. The story goes that Copley was finishing the portrait in England when Parliament, through George III, announced the Colonies' independence, whereupon the artist painted the American flag on the ship, starting a vogue of flag painting that continues right up to Jasper Johns.

Although not part of the museum's holdings, the John B. Putnam Memorial Collection should be mentioned so that visitors who are interested in contemporary sculpture can reserve time to see the pieces which are installed in various parts of the campus. A catalog is in preparation, but in the meantime a list and map of locations are available at the museum's front desk. The poured concrete *Head of a Woman* by Picasso is directly in front of the entrance to the museum and is the landmark toward which the visitor aims when walking the short distance from Nassau Street.

TRENTON

NEW JERSEY STATE MUSEUM

205 West State Street, Trenton, New Jersey

Hours: Mon.–Sat. 9–5; Sun. 2–5
Closed: Major holidays

This pleasant cultural complex on the banks of the Delaware houses the arts, archaeology, ethnology and history. Alexander Calder's stabile *The Red Sun* (a model for the colossal sculpture done for the Mexico City Olympics) is the beacon that leads one to the handsome first-floor museum space. One area is usually reserved for the permanent collection and recent acquisitions.

The collection is primarily American with emphasis on New

Jersey artists and craftsmen, and some distinguished artists are represented: John Marin with an oil, watercolors, prints and drawings; Ben Shahn's paintings, complete limited editions of his graphics, his library and the two large mosaics *Tree of Life* and *Atomic Table*. These will be mounted in the plaza outside with a seating arrangement in front of them. Other New Jersians represented are: Tony Smith, George Segal, Clarence Carter, Richard Anuszkiewicz and the late Burgoyne Diller. The late 19th century is well represented, and the Stieglitz Group is being concentrated on.

Alfred Stieglitz and the photographer Edward Steichen had founded in 1905 the Photo-Secession Gallery. By 1908, it was known as Gallery 291 (291 Fifth Avenue) and Stieglitz was showing paintings and sculpture. The first American exhibitions of Matisse, Toulouse-Lautrec, Rousseau and Brancusi were held here. Among the American painters he introduced were Max Weber, Arthur Dove, John Marin, Alfred Maurer, Arthur B. Carles, Marsden Hartley, Elie Nadelman and Georgia O'Keeffe, whom he married.

New Jersey is widely known as a historic center for glass, ceramics and porcelains, and the museum's Decorative Arts Center is concentrating heavily in these areas. Among its treasures is a complete 1876 tea set made for the Philadelphia centennial of that year. The adjacent auditorium holds long side galleries in which are mounted Thomas Eakins's bronzes commemorating the Battle of Trenton (December 26, 1776). The battle was not only Washington's first positive military victory but a terrific morale builder for his ragged army. These bas-reliefs, *The Continental Army Crossing the Delaware* and *The Opening of the Fight*, are among Eakins's finest works. Predestined to be victims of air pollution, the sculptures were saved by an offer of the Hirshhorn Foundation to have two duplicate castings made, one for the Foundation and one for a monument. The originals are now preserved and handsomely shown in the museum.

NEW MEXICO

UNIVERSITY ART MUSEUM: THE UNIVERSITY OF NEW MEXICO
Fine Arts Center, Albuquerque, New Mexico

Hours: Tues.–Fri. 11–5; Sat. 10–4; Sun. 1–5
Closed: Mon., national holidays

The University Art Museum, accessible at the entrance to the campus, serves the community of Albuquerque as well as the student body. A José de Rivera sculpture, moving sinuously, beckons one into the exhibition area. Although space does not permit showing much of the permanent collection at any one time, it includes an especially fine group of Spanish Colonial silver; an extensive lithography collection, particularly strong in 19th century French works; and painters who became a part of the New Mexican scene—such as Ernest Blumenschein, Julius Rolshoven, Cady Wells, B. J. O. Nordfeldt and Ward Lockwood.

The university museum's real triumph, however, is its photographic section. Its archives contain the largest group of photographic prints of any university museum in this country. The greats of history are here: Roger Fenton, photographer of the Crimean War, Paul Martin and Francis Firth of England, David O. Hill, the Scotsman, Gertrude Kasebier, Felice Beato, Eduard-Denis Baldus—all pioneers in photography as an art form.

ROSWELL

ROSWELL MUSEUM AND ART CENTER
11th and Main streets, Roswell, New Mexico

Hours: Daily 9–5; Sun., holidays 1–5

The adobe building on Route 70 was built as a Federal Arts Project in 1937. Since then the museum has grown from one gallery and a few small offices to 12 galleries with complete facilities including a planetarium. Through its museum, Roswell honors prominent New Mexican residents, among them artist Peter Hurd, poet Witter Bynner, and Paul Horgan, longtime president of the museum and a writer whose *Great River* won the Pulitzer Prize.

Most of the paintings in the permanent collection are southwestern, either in origin or in subject matter. There is an important Georgia O'Keeffe, *Ram's Skull with Brown Leaves*, an

Marsden Hartley: Landscape, New Mexico (Roswell Museum and Art Center, Roswell, N.M. Gift of Ione and Hudson Walker)

arly John Marin, *Blue Mountain*, and examples of Marsden Hartley's painting done in New Mexico. One can usually find a epresentative collection of the New Mexican artist Peter Hurd's work, devoted to the people of the countryside and landscapes of its dramatic panoramas, on display.

Witter Bynner's collection of Pre-Columbian art has been nstalled permanently. This distinguished New Mexican poet also nade several trips to Peking and gave more than 200 examples of Chinese painting, jade and bronzes to Roswell. Some of it is usually on view. Although modest, it is well chosen. During his years in China translating Chinese poetry, Bynner made friends with many scholars and in his selection was, he said, "prevented rom indulging or enjoying my ignorance."

As with practically every United States museum, the growth of both activities and collections keeps demanding more space. In 1958 the building doubled in size, and the end is not in sight.

The museum has added science to art with two new galleries. One is in honor of Dr. Robert H. Goddard, father of modern ocketry, who between 1930 and 1941 conducted his world-renowned research in the development of high-altitude rockets ust northwest of Roswell. The outdoor exhibit includes his irst launching tower and models of rockets of that period. In-loors are his original drawings and some pieces of experimental apparatus. The other gallery is devoted to natural science and he ecology of southeastern New Mexico.

SANTA FE

INTERNATIONAL INSTITUTE OF IBERIAN COLONIAL ART

Library Building, University of Santa Fe, Santa Fe, New Mexico

Hours: Mon.–Fri. 9–5; Sat., Sun. 1–4

The collection is housed in the stunning new library on the edge of the campus, off the main road between Santa Fe and Al-buquerque. Its purpose is to preserve the architecture, painting,

sculpture and related arts of the Philippines and Asia, and the Spanish and Portuguese colonies in the western hemisphere Many fine examples, especially in the field of painting, are shown in the library's mezzanine. Appurtenant is a library of photographic, microfilm and other scholarly apparatus.

LABORATORY OF ANTHROPOLOGY

1100 Block of the Old Santa Fe Trail, Santa Fe, New Mexico

Hours: Mon.–Fri. 8–12, 1–5
Closed: Sat., Sun., holidays

Outstanding collection of Pueblo Indian pottery, Navaho and Pueblo textiles, silver, basketry and the arts and crafts of other tribes.

MUSEUM OF NAVAHO CEREMONIAL ART

1100 Block of the Old Santa Fe Trail, Santa Fe, New Mexico

Hours: Tues.–Sat. 9–5; Sun. 2–5
Closed: Mon., Jan. 1, Dec. 25

The museum, housed in an octagonal building symbolic of a Navaho hogan, offers sand painting, ritual objects, carvings and artifacts of the Navaho culture. There is also a research library and a file of Navaho chants.

MUSEUM OF NEW MEXICO: FINE ARTS MUSEUM

124 East Palace Avenue, Santa Fe, New Mexico

Hours: Tues.–Sat. 9–5; Sun., holidays 2–5
Closed: Mon. except summer; Jan. 1, Thanksgiving, Dec. 25

Though international work is shown here, the main emphasis in sculpture and painting is on New Mexico artists and those who, since the opening of the West, have been drawn to record her history or the awesome beauty of her landscape: George Catlin,

Ralph Blakelock and Albert Bierstadt. Later Robert Henri, Randall Davey and John Sloan painted here. The latter two settled close to Santa Fe for long periods. Sloan encouraged contemporary Indian artists and helped in the preservation of their older art forms.

Cady Wells, Ward Lockwood and B. J. O. Nordfeldt carried on the tradition. Today's visitors will see in the permanent collection and in other exhibitions a cross section of the work of current New Mexican painters. There are more than 700 paintings by Indian artists in the collection, some of them from early in this century.

MUSEUM OF NEW MEXICO: MUSEUM OF INTERNATIONAL FOLK ART

Old Pecos Trail, Santa Fe, New Mexico

Hours: Tues.–Sat. 9–5; Sun., holidays 2–5
Closed: Major holidays

The Museum of New Mexico is a complex of which the International Folk Art Museum is one of four parts. Built on a promontory of sweeping vistas about two miles from the center of Santa Fe, the charming, indigenously styled building by John Gaw Meem harmonizes with its sister museums on the same plateau—the Museum of Navaho Ceremonial Art and the Laboratory of Anthropology.

An analysis of the collection made in 1950 revealed 39 percent European, 31 percent from the Americas, 22 percent from Asia and 8 percent from Africa. Lately the emphasis has been on Spanish Colonial arts and the arts of New Mexico.

A fine catalog vividly documents the religious and secular art of the Spanish Colonial period. The furniture, whether crudely or skillfully done, is elegant in line; the religious paintings and carvings evidence a sturdy faith that survived massacre and isolation. The rarest paintings are those done on buffalo hide by the Franciscan friars after the reconquest of the territory by the Spaniards in 1692. The colonials, isolated and lacking tools, had to do everything in the simplest manner. Under the missionaries' guidance they, along with the half-castes and the Indians, learned

José Rafael Aragon, Bulto:
Bishop (Museum of Interna-
tional Folk Art, Santa Fe, N.M.
Laura Gilpin photo)

José Rafael Aragon, Retablo:
La Alma de la Virgen (Museum
of International Folk Art, Santa
Fe, N.M. Laura Gilpin photo)

to paint and carve in the round. By 1800 native imagemakers created everything from altar screens to small bultos for homes. Properly, a bulto is a religious object carved in the round, while a retablo is a painting. We are inclined to use the misnomer "santos" for both forms, each of which is illustrated. The santero, or saintmaker, could do either, moving from settlement to settlement, executing commissions for church or home. The bulto-illustrated *Bishop* is by José Rafael Aragon, who worked in New Mexico during 1826–1865. The retablo of the Virgin is also by Aragon. Handed down from father to son, the art flourished in remote villages well into this century. The handsomest example of Colonial Baroque in the Southwest is an altar ordered by the governor of Santa Fe in 1760. It is now in the Church of Cristo Rey. The stone reredos, extremely beautiful, graced the Cathedral of Santa Fe, but was walled up by some 19th century clergymen who preferred the Victorian amenities to this unique and stunning piece. Rediscovered in the 1930s by a German historian, it was used as the focal point for a new parish church built by John Gaw Meem, the architect of the museum. It is the only known stone reredos in the southwestern United States. The church is situated halfway between the museum and downtown Santa Fe and should not be missed.

The floor plan of the museum is simple: a large section for changing exhibitions and an open storage space. The exhibitions are important, definitive shows that are on view for a year or more. The open storage space is in itself a work of art. Arranged by category and origin, the composition is beautiful, the information explicit. Only a small part of the material can be on view. Qualified scholars wishing more information have a treat in store: the stacks are arranged as aesthetically as the exhibits.

The founder and donor, Florence Dibell Bartlett of Chicago, summered for many years in New Mexico. The museum is a testament to her dream and drive.

Tompkins H. Matteson: The Studio of Erastus Dow Palmer, Albany
(collection Albany Institute of History and Art, Albany, N.Y.)

NEW YORK

ALBANY INSTITUTE OF HISTORY AND ART
125 Washington Avenue, Albany, New York

Hours: Tues.–Sat. 10–4:45; Sun., holidays 2–6
Closed: Mon.
Library

The Albany Institute of History and Art is unabashedly regional. From the furniture, silver and paintings of the Dutch burghers who founded the city, to contemporary art, the institute is concerned with the area immediately surrounding Albany. The Dutch period room of circa 1660 sets the tone. Few regions along the eastern seaboard, except possibly Charleston, South Carolina, have preserved their heritage as carefully as Albany.

One gallery is devoted to portraits done by Albany area artists between 1700 and 1750. Frequently called Patroon Painters, these people constitute (as the Albany catalog attests) the first significant group of native American painters recognized by art historians. Although the sitters are identified, most of the portraits such as the one of the Gansevoort Limner are by anonymous artists. One exception is *Sir William Johnson*, done by John Wollaston, an English painter who worked for a short time in America. In 1754 Sir William sent the portrait to his father in Ireland. The painting, with an accompanying letter in which Sir William complained that the artist had not painted his shoulders broad enough, came back to Albany in 1921 through Johnson family members.

A particular prize here is a group of 12 religious paintings taken from Biblical scenes. They were undoubtedly adapted from

illustrations in Dutch Bibles. Though obviously by untrained artists, they are delightful and rich in color.

The lower-floor cases usually hold china, silver or artifacts of the region. The pleasant members' lounge, open to the public, affords a background for the extensive group of aquatints of canal life and Hudson River steamboat history. Important theme exhibitions are held in the spacious adjoining gallery; whether historical or contemporary, they are always associated with the region. The adjacent library building is an extension of the museum, and includes a large picture rental library. Over one fireplace hangs an important Asher B. Durand, *Reminiscences of an Old Man.* The entrance foyer holds charming, small paintings by Albany artist Waller M. Palmer. A canvas done in 1857 by Tompkins H. Matteson shows Palmer's father, Erastus Dow Palmer, a sculptor, in his Albany studio. Every piece of sculpture in the painting, except the statue of Sophocles, is owned by the institute. The only nonregional material in the institute is an English period room taken from the Duke of Richmond's house and an adjoining gallery of English pottery and china.

One hopes that some day when all the marble on the Mall is paid for the city will build or enlarge the museum so that more of the collection can be on view.

BROOKLYN

THE BROOKLYN MUSEUM

Eastern Parkway and Washington Avenue, Brooklyn, New York

Hours: Wed.–Sat. 10–5; Sun. 11–5; holidays 1–5
Closed: Mon., Tues.
Library, restaurant

Twenty minutes by subway from the Grand Central area in Manhattan, The Brooklyn Museum offers a staggering wealth of material. For a first visit a floor map is helpful. The approved plans of this McKim, Mead and White building called for a quadrangle, of which the present museum is only one side.

Opened in 1897, Brooklyn was one of the first in the field to emphasize the arts of Africa, Oceania and Pre-Columbian America. The Hall of the Americas on the first floor exhibits 50 centuries of colorful and exotic art of the Indian people from the Arctic to Argentina: the giant totem poles, house posts and masks of the Northwest Coast tribes; the textiles and pottery of the Pueblo culture; war bonnets and shields of the Plains Indians; stone and jade sculptures of the Maya, Aztec and Olmec; gold pieces from Costa Rica; Peruvian, Chilean and Argentinian work from the Chavin period, 1000 B.C. to the conquest of the Inca in the 16th century. The outstanding collection of African art, begun a half century ago, has been augmented by ancient bronze and wood sculpture from Nigeria, Mali and the Congo.

When one steps off the elevator at the third floor and walks through the hall of Assyrian wall sculpture into the kingdoms of Egypt, Old, Middle and New, one is simply stunned by the richness of it all. Chairs in the large galleries make it possible for comfortable reflections on glorious treasures, whether household objects or portraits of the deities of different dynasties. The galleries around the auditorium on the same floor hold works of the ancient Middle East and Coptic Egypt.

The Egyptian Department, while not as large as Boston's or that of the Metropolitan, ranks with them in quality. Brooklyn's interest in the Nile civilizations is historical, archaeological and definitely aesthetic. Selecting what to praise is impossible. An extensive library of Egyptology is open to scholars. The arts of Islam and the Indian East are set in handsome new quarters. The introductory gallery contains large color transparencies of Islamic architecture and a map illustrating the buildings and countries connected with the exhibit. Also on view are other objects showing the spread of trade and the resultant interweaving of cultures throughout the Middle Eastern countries. Gathered from Persia, Egypt, Turkey and North Africa, the works of art are displayed in a series of small galleries flanking a center aisle and culminating in an arched room containing a pavilion with a 19th century Qajar painted and gilded ceiling.

This Persian Near Eastern delight shares space with India and the Orient. Brooklyn is the place in metropolitan New York to see the arts of India, from important examples of bronze and stone sculpture from the Indus River civilization of 2000 B.C.

Indian, Rajasthan: Female Torso
(courtesy of the Brooklyn
Museum, Brooklyn, N.Y. Gift of
Mr. & Mrs. Richard Shields)

William Williams: Deborah Hall
(courtesy of the Brooklyn
Museum, Brooklyn, N.Y. Dick S.
Ramsay Fund)

From Mohamerieh: Bird Deity
(courtesy of the Brooklyn
Museum, Brooklyn, N.Y.
Permanent Collection)

through the golden age of the Gupta period to the exquisite miniature painting of the 16th through 18th centuries. The Chinese and Japanese holdings flow from here.

The museum's American paintings are on permanent view and are shown in breadth and depth. A significant historical collection, it begins with *The Van Cortlandt Boys* by an unknown artist and ranges through the Colonial, Federal and Hudson River schools to excellent examples of individualists, such as George Caleb Bingham's *Shooting for Beef*, the romantic Quidor's *Money Diggers*, and Eakins's portrait of *William Rush Carving His Allegories of the Schuylkill*. The landscape school is especially well represented. There are major holdings in Sargent and Homer watercolors. There are galleries of the American Impressionists, the Eight, the American Scene painters. Another innovation is the Paintings Study Gallery. One thousand paintings have been brought from storage into a well-lighted, humidity-controlled gallery. A long wall contains sliding panels of categorized and documented canvases. This gallery is open by appointment only.

The print and drawing section of 25,000 holdings has been known since 1947 for its biennial exhibitions and has drawn attention to the fine contemporary collection, but there are strong Old Master holdings, including 75 Dürer etchings and woodcuts, first and second states of Goya's *Los Caprichos*, more than 100 examples of *Die Brücke* and *Der Blaue Reiter* group, also drawings of such quality as van Gogh's *Cypresses* and Lautrec's portrait of his mother. There is an exhibition gallery outside the print and drawings department. Visitors are admitted by appointment to the study rooms.

The fourth floor holds the decorative arts section, which counts among its displays entire houses. The Jan Martense Schenck House (1675) is the earliest intact New York building. Colonial and Victorian rooms abound. The "Turkish Room," that delightful innovation of the pipe-smoking, turn-of-the-century male, is bedizened with bead portieres, divans and braziers. It was removed intact from John D. Rockefeller's house on 53d Street. The room had been designed for Belle Yarrington Worsham, who later married Collis Huntington and then his nephew Henry (see Henry E. Huntington Library and Art Gallery). Rockefeller bought the house furnished and left it unchanged. Brooklyn's Decorative Arts section is basically American but has European backup material. Don't miss the Art Deco rooms. Costumes, for which the museum is well known, range from the 18th century to the present, while textiles range from the Renaissance. A feature of the department is a unique multimedia theater giving thematic presentations with music. Shows are presented twice a day on weekdays and are continuous on weekends.

An impressive rotunda gallery on the fifth floor holds sculpture by Lehmbruck, Reg Butler, Mary Frank and Beverly Pepper. A large adjoining room shows works by Wolf Kahn, Jimmy Ernst, Sidney Goodman, Robert Dash, Helen Frankenthaler and Laurence Calcagno. One can go on with Krasner, Rosenquist, Nevelson, de Kooning and George L. K. Morris. When Brooklyn bothers she usually goes in depth.

To the great store of treasures in the museum, a first has been added: a sculpture garden for the preservation of America's vanishing architectural past—corbels, lintels, capitals, friezes, caryatids, every form of ornament saved from distinguished buildings. Among the latest are the original base of Karl Bitter's

fountain in front of the Plaza, plaster grotesques from the ceiling of the old Metropolitan Opera House and two of Peter Cooper's inventions for the support of Cooper Union. Other examples include a cast iron railing from the *Police Gazette* building in San Francisco and a fierce lion of formed zinc from Steeplechase Park; also, a giant bull's head from a tannery in lower Manhattan. Classical stone or terra cotta medallions rest on beds of ivy, and nostalgic street gas lamps cluster about. Generations of Americans raised on the austerities of glass box constructions will be grateful for this "remembrance of things past."

BUFFALO

ALBRIGHT-KNOX ART GALLERY
1285 Elmwood Avenue, Buffalo, New York

Hours: Tues.–Sat. 10–5; Sun. 12–5
Closed: Mon., major holidays
Restaurant

During the Civil War the third art gallery in the United States opened in the staid town of Buffalo, population 81,000. A long-time resident, artist Albert Bierstadt, donated to the museum its first gift, his painting of the *Marina Grande* in Capri. This painting, then contemporary, perhaps unwittingly set the pattern for Buffalo, for the strength of the collection lies in its 19th and 20th century American, European and Latin American holdings. Acquiring the work of contemporary artists has been consistent policy.

The little collection took shelter where it could until 1900, when public-spirited John J. Albright financed the construction of an imposing Neo-Classic museum building. Mr. Albright was only the first of Buffalo's men of wealth to give time and money to the Albright Gallery. Indeed, it became the final social and civic accolade to be elected to the museum's board of trustees. The board was and is the town's most exclusive club, with procedures more dynastic than democratic. Ordinarily, death alone changes the trustee slate.

Tradition was shattered in the case of A. Conger Goodyear, who had inherited the board membership from his father. As one of the purchasing committee, Goodyear in 1926 pushed the purchase of Picasso's *La Toilette*. Outraged trustees protested so vigorously that at the next board election Mr. Goodyear was ousted. He immediately moved to New York and became the first president of the new Museum of Modern Art. Later, when Goodyear offered to buy the Picasso for the $5,000 it had cost the Albright, the more far-seeing trustees refused to let it go.

The winds of change began to blow about the marble halls a few decades ago and with the building of the Knox wing in 1962 reached gale proportions. The policy of the Albright-Knox Gallery is to build the collection toward the future, reaching back into the past only in those areas that strengthen the museum's raison d'être, such as Post-Impressionism, Constructionism, Cubism, Futurism, Surrealism, Geometricism. A few in these categories to come to the museum have been Antoine Pevsner, Naum Gabo, Raymond Duchamp-Villon, Gino Severini, Robert Delaunay, Max Ernst, Jean Arp, Max Bill, Jean Metzinger and Albert Gleizes.

A new wing, designed by Gordon Bunshaft, flows with grace and simplicity from old conventions to space so flexible that even such outsized audacities as Lucas Samaras's *Mirrored Room* are manageable. The wing forms an interior garden court open to the sky. On one side is one of the most pleasant museum restaurants in the country. Diners look out on major works by Baskin, Armitage, Butler, Rickey, Nakian and David Smith. While the most used entrance is through the new Knox wing and adjacent parking lot, the impressive old colonnaded entrance on Lincoln Parkway gives one better orientation. One enters a beautifully proportioned Greek temple to find major works of such masters as Maillol, Moore, Rodin, Lehmbruck and Lipchitz set in lonely splendor. Side enclosures hold small antiquities and sculptures that are delightfully arranged for no other reason than that in the classical definition of beauty, when seen, they please. A minute Henry Moore, *Reclining Figure*, rests beside a small Mesopotamian figure, another by a Sumerian piece.

As with most museums, didactics plays a part in Buffalo's program, but this is primarily a museum for the eye. Whether it's Suzanne Valadon's drawing *The Bath* or Barbara Hepworth's

Paul Gauguin: The Yellow
Christ (Albright-Knox Art
Gallery, Buffalo, N.Y. General
Purchase Funds)

Three Standing Forms, one feels that the work was chosen because it satisfied a well-trained eye.

Placed in one case is Picasso's *Nymph and Satyr* series, 14 rare pieces of brilliant royal blue glass executed in Venice by Egidio Constantini. A series of three, one is in the Picasso estate, the other at the Peggy Guggenheim Museum in Venice.

A gallery of Asian art and one with earlier American painting including the Bierstadt that caused it all leads into the Modern Old Master room: Pollock, Motherwell, Gorky, Kline, Gottlieb and de Kooning are seen in stunning examples. Giant Clyfford Stills are marshaled together in their own gallery. Morgan Russell, co-founder with Stanton MacDonald-Wright of Synchronism, one of the more important bridges between European avant-garde and American art prior to the Armory Show of 1913, fittingly hangs in the stairwell that joins the old and new Albright-Knox. Russell and MacDonald-Wright formed this school of painting, which was really a philosophical attempt to state the place of color in painting.

The small but top group of Post-Impressionists was enhanced by Conger Goodyear's bequest of van Gogh's *La Maison de la Crau* and Paul Gauguin's *Spirit of the Dead Watching*, which complements his famous *The Yellow Christ*, also in the museum collection. Not one to hold a grievance, General Goodyear gave to Buffalo during his lifetime, and as bequests at his death in

Interior Gallery (Albright-Knox Gallery, Buffalo, N.Y.)

1964, a total of more than 360 works of art. A major Derain, *The Trees*, has recently been acquired. The museum is indeed fortunate in her patrons. Seymour H. Knox, longtime president, has given hundreds of important works, representing artists in depth and world trends in general. Buffalo's contemporary sculpture collection is one of the most important in the country. Much of it was purchased by far-sighted directors when the sculptors were just earning their reputations.

Gordon Washburn, a former director of the museum, picked up in a Paris warehouse Lehmbruck's *Kneeling Woman* for $75 in storage charges. One does not even speculate on what it would bring today. Baskin, Marisol, Nakian, Noguchi, Notruba, Milowski, Tony Smith, Max Bill, Nevelson, Mallary, Penalba, Pepper, Liberman and James Wines are but part of a long list of other distinguished sculptors who are represented.

Not only are the Soulageses, Tobeys and Vasarelys acquired but also the young and unknown. Buffalo keeps in close touch with the new developments in the arts around the world and reports the action in the form of avant-garde painting and sculpture shows and happenings of an experimental nature in music, theater and the dance.

CHARLES BURCHFIELD CENTER: STATE UNIVERSITY COLLEGE AT BUFFALO

1300 Elmwood Avenue, Buffalo, New York

Hours: Mon.–Fri. 10–5; Sun. 1–5
Closed: Sat., major holidays

Directly across from the Albright-Knox, the center is a "must" for those interested in the work of Charles Burchfield and artists of the western New York area. Burchfield went to Buffalo in 1921 as a designer for Birge wallpaper and resigned in 1929 to devote himself to painting. The center, situated in Rockwell Hall at the State University College at Buffalo, has commodious exhibition space for artists of the area and is the respository of Burchfield art, letters, journals and other memorabilia.

COOPERSTOWN

NEW YORK STATE HISTORICAL ASSOCIATION

Fenimore House, Cooperstown, New York

Hours: Daily 9–5; May, June, daily 9–6; July, Aug., daily 9–9
Library

Fenimore House and the adjacent Farmers' Museum are concerned chiefly with the history of New York State, but many artists and artisans who recorded the epic of an emerging nation and the men who fought for, planted and governed her along the way are represented here.

The house was built in the 1930s on the site of a cottage occupied by James Fenimore Cooper (1789–1851). At the end of the corridor to the right of the entrance is the Hall of Life-Masks, 18 of them, done by John Henri Isaac Browere. This sculptor, poet and painter developed a process that enabled him to go far beyond the usual technique of the medium. Eminent Americans, among them Thomas Jefferson, Martin Van Buren,

John Adams and De Witt Clinton, are displayed in telling like-
nesses.

The 19th century landscape group includes not only that
triumvirate of Thomas Cole, Asher B. Durand and Thomas
Doughty, usually accepted as the founders of the Hudson River
School, but other competent if lesser names, such as Robert
Havell, E. C. Coates and James D. Hart.

The portraits are outstanding. There is an especially brilliant
Gilbert Stuart done in London in 1786 of *Joseph Brant,* a pro-
British Indian chief of the Mohawk tribe. Another penetrating
painting is Benjamin West's *Portrait of Robert Fulton.* Fulton,
an artist as well as an inventor, was a pupil of West's. Fulton's
experimental work with the submarine torpedo is suggested in
the canvas's background, where flames are seen shooting up out
of the sea.

Genre paintings, of course, play an important part in the
collection: Long Islander William Sidney Mount's *Eel Spearing
at Setauket,* Thomas Waterman Wood's *The Village Post Office*
and E. L. Henry's *On the Erie* represent the best.

The folk art collection shows how, in wood, metal and stone,
known craftsmen carved the symbol of our patriotism, the eagle,
or fashioned tools for work or made weather vanes or rugs or
samplers with which to decorate their homes. One of the pieces
by a known artist is by Samuel McIntire, a prominent Salem
woodcarver. It is the stern board from the ship *Mt. Vernon* and
shows George Washington's home carved in bas-relief. This col-
lection made by working people for their own enjoyment or use
is one of the most varied and important in America.

William Sidney Mount: Eel
Spearing at Setauket (New
York State Historical Asso-
ciation, Cooperstown, N.Y.)

HUNTINGTON, LONG ISLAND

HECKSCHER MUSEUM

Prime Avenue and Route 25A, Huntington, Long Island, New York

Hours: Tues.–Sat. 10–5; Sun. 2–5
Closed: Mon., major holidays

The day the Heckscher Museum, a five-winged marble building and surrounding park, was given to Huntington, virtually the whole town turned out to accept the gift. Business was suspended, the movie houses were closed, a regimental band played, and firecrackers punctuated the speeches. It was the citizens' tribute to August Heckscher, a German immigrant who made a fortune in mining. Now, a few decades since its opening, the museum has employed Marcel Breuer to design a new wing.

The basis of the collection is European painting from the 16th to the 20th centuries and includes Dutchman Caspar Netscher's *Portrait of an Opulent Dutch Lady* and Antoni van Stralen's *Dutch Winter Sport in Holland.* Two canvases of the French school are L. M. Van Loo's *Lady with a Hurdy-Gurdy* and George Michel's *Clouds and Hills.* Mr. Heckscher, like other

George Grosz: Eclipse of the Sun (Heckscher Museum, Huntington, L. I., N. Y.)

early 20th century collectors, was enamored of English portraiture, and among his examples is a fine Raeburn, *Adam Rolland of Gask*. A recently published catalog of the museum's American paintings shows a collection strong in 19th century landscapists: Albert Bierstadt, Ralph Blakelock, Frederick Church, Homer Martin, Thomas Moran, and his brother and teacher, Edward Moran.

Although lively contemporary exhibitions are held, until recently acquisitions policy has largely ignored the 20th century. The George Grosz *Eclipse of the Sun*, one of his most important canvases in America, is now in the collection and should be an incentive toward moving into 20th century collecting.

ITHACA

HERBERT F. JOHNSON MUSEUM OF ART: CORNELL UNIVERSITY

Ithaca, New York

Hours: Tues.–Sat. 10–5; Sun. 11–5 (open summer)
Closed: Mon., major holidays

High above Cayuga's waters Cornell built its new art museum. According to tradition, Ezra Cornell stood on the same site when he declared his intention of founding a university in Ithaca. Cornell must have had a feeling for grandeur in nature, for few museums in the country have more spectacular views.

The I. M. Pei building that rises like a sturdy box kite seven stories high takes advantage of the cityscape below, the lakescape, the mountainscape. Wide corridor galleries hold sculpture and decorative arts impervious to daylight coming from broad window areas, while painting and print galleries fold inward.

Whether it's the Friedel Dzubas narrow painting *Red Spoke* that shoots up like a flame almost two stories high or the landscape pressing through the glass on three sides, the entrance gallery is "charged" space. The sense of drama is sharpened by glimpses of galleries above. One experiences a contrast between the buff-colored poured concrete forms in a passageway or bridge

and the areas of simple rectangular spaces, wood floors and walls softened by the use of off-white open-weave linen.

Founded in 1953, the museum's home was the Andrew Dixon White house, which had been the residence of Cornell's presidents since 1872. The present structure is a gift of Herbert F. Johnson (Johnson's Wax), class of 1922 and longtime trustee of the university. He has been involved for many years in collecting contemporary arts and crafts and in giving them wide museum circulation.

Particularly strong in Asian art, the museum devotes its top-floor galleries to this area—the George & Mary Rockwell Galleries hold ceramics that range from Neolithic to the 19th century, with heaviest emphasis on Chinese, Korean and Japanese cultures. One gallery has excellent examples of Chinese finger painting prevalent in the early 18th century. (There is nothing new under the sun: American children thought they invented finger painting; Chinese artists used their elongated fingernails as pens, cutting them in different ways to achieve different effects.) '

The graphics section holds more than 7,000 prints and is known for the superb quality of its contents. Mantegna, Dürer (including 22 etchings of the *Small Passion*), Whistler and

Entrance Court (Herbert F. Johnson Museum of Art, Cornell University, Ithaca, N. Y.)

Toulouse-Lautrec are represented in depth, along with Wyndham Lewis with a large collection of sketches.

Four galleries are installed with the museum's American and European collection of painting and sculpture.

Part of the pleasure in visiting this museum is that there is variety in the space—small galleries that soothe the viewer and unexpected vistas that entice him on to further viewing.

N E W Y O R K C I T Y (Manhattan)

ASIA HOUSE GALLERY

112 East 64th Street, New York, New York

Hours: Daily 10–5; Sat., holidays 11–5; Sun. 1–5
Closed: Summer
Library

The object of the gallery, which is an adjunct of the Asia Society founded by John D. Rockefeller 3rd in 1957, is to bring the finest works of art from ancient Asiatic cultures to the New York public.

Three major exhibitions are held between September and June, with material gathered from museums and collections around the world. A few samples: the sculpture of Thailand; Shah 'Abbas and the Arts of Isfahan; the Art of the Korean Potter. For each exhibit a leading specialist in the field is invited to be the guest director. Max Loehr, for instance, did the impressive show of Ritual Vessels of Bronze Age China.

With the announcement that Mr. Rockefeller is giving the Asia Society much of his collection of Japanese, Chinese, Khmer and Indian works, which include painting, pottery and ceramics, and more than 100 pieces of sculpture in stone, bronze and wood, the policy of holding only guest exhibitions will undoubtedly change. A munificent gift providing the wherewithal to house this generous bounty was also given. But for the next few years the building (designed by Philip Johnson) will still be the Asia Society's home. It is a seven-story shaft of smoky glass

between two brownstones. The shows are strikingly presented in the second-floor galleries. A pleasant lounge and library on the main floor level lead to a garden that matches in tranquility the museum itself.

It is wise to call, as the gallery is closed between exhibitions.

CHINA HOUSE

125 East 65th Street, New York, New York

Hours: Mon.–Fri. 10–5; Sat. 11–5; Sun. 2–5
Closed: Major holidays

In a pleasant town house that holds only one exhibition gallery, New Yorkers are treated to two exhibitions a year of some phase of Chinese art. They run for a period of three months and are frequently on aspects of Chinese art not generally covered. One such show brought together ceramics of the Liao Dynasty for the first time in America. Another will dwell on some precious aspect of nature such as "Wintery Forests, Old Trees." Renowned scholars are invited to assemble these exhibitions. In the meantime China Institute, under whose aegis all this happens, runs a busy program of lectures and courses on practically every phase of Chinese life. Incorporated under the University of the State of New York, China House offers credits for many courses.

THE CLOISTERS

Fort Tryon Park, off Riverside Drive, just south of Dyckman Street, New York, New York

Hours: Tues.–Sat. 10–4:45; Sun., holidays 1–4:45
Closed: Mon.

High above the Hudson is a monastic medieval world abounding with everything but chanting monks. Architectural elements including five cloisters have been welded into a harmonious whole. A Spanish Romanesque apse from the Church of St. Martin, Fuentidueña, Spain, was reassembled stone by stone. It took persistence and horse trading on the part of James Rorimer,

longtime curator of the Cloisters, to pry the apse from a reluctant Spanish government. The assemblage that is the Cloisters was made possible through the generosity of John D. Rockefeller, Jr., but the growth and direction of the medieval enclave is a testament to James Rorimer, the late director of the Metropolitan and the Cloisters. Other greats include the St.-Guilhem Cloister, the medieval sculpture group; the Hunt of the Unicorn tapestries; the Spanish gallery, which holds *Annunciation with St. Joseph and Donors* by the Master of Flémalle (accepted by most scholars as Robert Campin); the Treasury, three rooms set aside for smaller works of exceptional quality, such as the Chalice of Antioch, reliquaries, illuminated manuscripts, enamels and bronzes. From the sculpture harvest that the sculptor George Grey Barnard gathered from abandoned French farms and ruined churches and which the Metropolitan bought in 1925 to a late important purchase, the *Bury St. Edmond's Cross* (also called the Cloisters Cross), acquisitions have always been of the highest quality. The cross, though only 2 feet high, is brilliantly carved on both sides with 108 figures and many inscriptions in Latin and Greek. So akin to the spirit of the Europe of the Middle Ages are this museum's cloisters, walks and medieval gardens that moments of peace can be found here even in 20th century Manhattan.

COOPER HEWITT MUSEUM OF DECORATIVE ARTS AND DESIGN

9 East 90th Street, New York, New York

Hours: Mon.–Sat. 10–5; evening hours to be announced
Closed: Sun.

The museum, formerly housed at Cooper Union, a college founded by philanthropist Peter Cooper, has not only moved uptown but has become an affiliate of the Smithsonian Institution. The former Andrew Carnegie mansion is the new address. The building is being restored to approximately what it was in Carnegie's day, while at the same time allowing for changes that will enable much of this stupendous collection to be on display. Already an encyclopedic collection, it will include, along with

films, photographs and color slides of the whole collection, an archives of color, pattern and symbols and a spectrophotometer for measuring color. Besides the public exhibition areas there will be space for an auditorium and workshops. Future plans will tie the 90th Street house used now for administration into the main building as a special programs area (that rare green oasis, the garden, will probably be scrapped for a new wing in the year 2000). One cannot detail this collection. It is recognized as one of the foremost museums of decorative arts in the world.

The textiles range from ancient Egypt to contemporary American. The wallpaper collection is surpassed only by the specialist wallpaper museum at Kassel, Germany. The museum's challenge is to make all this material not only accessible to the scholar but understandable to the public. One gallery will show wall treatments, whether through textiles, leather, paper or wood. Another will show, by use of the collection's finest examples, the evolution of ceramics. The furniture collection ranges from the 17th century to Marcel Breuer's 1927 chair. Architectural elements of woodwork, primarily 18th century French, have no rivals outside Paris. And so it goes, through laces and textiles and metalwork. While the drawing and print holdings naturally relate to architecture, design and ornament, somehow a remarkable group of 19th century works by such top artists as Frederick E. Church (2,000 oil sketches) and Winslow Homer (300 drawings) were acquired.

FINCH COLLEGE MUSEUM OF ART

62 East 78th Street, New York, New York

Hours: Tues.–Sun. 1–5
Closed: Mon.

Founded in 1900 by Mrs. Jessica Finch Cosgrave, a fighting suffragette, Finch College is now located in a cluster of brownstones, a step from some of Madison Avenue's most important galleries. There is a small Old Master section, and distinguished exhibitions are held, usually of challenging but lesser-known aspects of art history.

However, it is in the contemporary field that the fighting spirit of Mrs. Finch Cosgrave lives on. Trends are explored with daring and verve. Thought-provoking, scholarly exhibitions showing the creative process of some of our most avant-garde artists are given. When the museum is not spinning with one of these shows, the modest but good contemporary collection is on view.

THE FRICK COLLECTION
1 East 70th Street, New York, New York

Hours: Sept.–May: Tues.–Sat. 10–6; Sun., Feb. 12, Election Day 1–6; closed Mon., major holidays. June–Aug.: Thurs., Fri., Sat. 10–6; Sun., Wed. 1–6; closed Mon., Tues., July 4 Children under 10 not admitted to the collection; those under 16 must be accompanied by adults. Group visits by appointment only.

The progress of Henry Clay Frick from $1,000-a-year clerk in his grandfather's distillery (Old Overholt) to coke oven operator worth a million took until his thirtieth birthday. There was nothing in Henry Clay Frick's Pennsylvania Mennonite background to feed a love of the visual arts, but he had it, instinctively and early. At twenty-one, when he applied for a loan, the bank reported, "on job all day, keeps books evenings, may be a little too enthusiastic about pictures but not enough to hurt . . . advise making loan." His first purchases were in the then popular Barbizon painters, those French 19th century artists who gave up the rigidities of the academic style to work directly from nature.

But Frick's love of painting transcended fashion. As early as 1901, four years before he moved to New York and began his serious collecting, he acquired Vermeer's *Girl Interrupted at Her Music Lesson*, a Monet and in 1902 Hobbema's *Village Among Trees*. Rembrandt's *Artist as a Young Man* was purchased in 1899. In 1905 he acquired *St. Jerome*, one of the first El Grecos to enter a private collection in America.

The art dealer Joseph Duveen has been credited with building the Frick Collection, but Frick made a substantial beginning before that supersalesman arrived. Roger Fry, English art historian and critic, kept Frick informed of the state of the Euro-

Hans Memling: Portrait of a
Man (Copyright The Frick
Collection, New York, N.Y.)

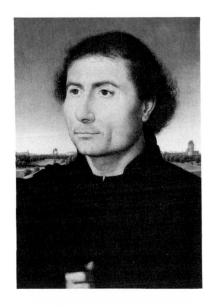

Giovanni Bellini: St. Francis in
Ecstasy (Copyright The Frick
Collection, New York, N.Y.)

pean art market. In 1910 Frick heard that Rembrandt's *Polish Rider* was for sale and sent Fry off to Poland for it; it hangs in the West Gallery today.

Frick conceived of his residence, begun in 1913, as his monument and an eventual public museum. The front door of the house leads into an entrance hall from which an elegant flowered and fountained court can be seen. The court was once the carriage entrance. The oval room, gallery and lecture room are the only post-Frick additions. If one turns left at the entrance one is at once in the mansion as it was in Mr. Frick's day.

We owe the delectable Fragonard Room to Duveen. He had purchased 11 panels from the Morgan estate with Frick in mind. The four largest were commissioned by Mme. du Barry for her château at Louveciennes, which had been presented to her in 1769 by Louis XV. After the panels had been installed she decided not to keep them. One conjecture as to why she rejected them is that they had ceased to be in the most fashionable style. During the long period in which they were being executed there was a turning from the Rococo style to a more ordered one based on Classical prototypes. The château was built in this new classicizing manner, and Mme. du Barry may have felt they looked out of place. The museum's Fragonard room is filled with great 18th century furniture, including a pair of consoles by Jean Henri Riesener, others by Pierre Dupré, Houdon's masterful bust of the *Comtesse du Cayla*, and gay figure groups by Clodion—perfect foils for Fragonard's witty and delicate paintings.

Although the Frick's arrangement is less subject to change than that of most museums, occasional purchases make a certain amount of shifting necessary. The Piero della Francesca *St. John the Evangelist* is now seen through the arch of the Enamel Room. The Piero, one of the truly great paintings in America, shows the aged introspective saint standing barefoot, his monolithic figure wrapped in a blood-red robe. Here, too, is Duccio's *Temptation of Christ*, one of three Duccios in the United States (the others are in the National Gallery and the Boston Museum). The sumptuous enamel collection spans the later 15th, 16th and 17th centuries, with signed pieces by such master enamelists as Leonard Limousin. A recent acquisition sometimes on view here is a small grisaille painting by Pieter Brueghel the Elder, *The Three Soldiers*. It graced the collections of both Charles I and James II.

The West Gallery is alive with Rembrandt, Hals, Van Dyck, Ruisdael, Hobbema and two large, brilliant Turners. Turner's *Cologne: The Arrival of the Packet Boat: Evening* so overshadowed the two Lawrences it hung between at the Royal Academy in London that Turner obligingly put a coat of darker varnish on it. The smaller Turner, *Morthlake Terrace*, in the library, is in quiet contrast to the *Packet Boat*. It was painted shortly after he came up to London.

El Greco's *St. Jerome* hangs over the fireplace in the Living Hall, separating those disparate Englishmen *Sir Thomas More* and *Sir Thomas Cromwell* (who had almost nothing in common except that Henry VIII had both their heads chopped off). Holbein painted them after Erasmus introduced him to Henry's court, and the portrait of More is thought to be his first English work. Across the room, between two portraits by Titian, is Giovanni Bellini's *St. Francis in Ecstasy* in a gentle landscape bathed in Italian sunlight. Of it Osbert Sitwell wrote, "Christianity speaks through every leaf and we are back in the lost world of simplicity and understanding." Spread through the rooms is a fine collection of Renaissance bronzes.

Other canvases not to be missed are Vermeer's *Mistress and Maid* and *Officer and Laughing Girl.*

In Frick's official biography, George Harvey pictures him on sleepless nights wandering in the West Gallery, trying one chair after another to find the best light for looking at a painting he loved. He really saw paintings and, in the last years of his life, with a trained eye and relentless zeal, went after the best.

THE SOLOMON R. GUGGENHEIM MUSEUM

1071 Fifth Avenue, New York, New York

Hours: Wed.–Sat. 10–6; Tues. 10–9; Sun., holidays 12–6
Closed: Mon., July 4, Dec. 25
Café

Lacking the skill of Lewis Mumford, the temerity of art critic Emily Genauer, the savior-faire of that arbiter of taste Russell Lynes, I shall not spend much time describing the Frank Lloyd Wright building which houses the Guggenheim Museum. So

much has already been said about it that anything more is likely to be repetition.

The building is a stunner, and I defy anyone to step into its spiraling rotunda and not be lifted by the daring of the concept. The happiest way to enjoy both the building and its paintings (after an initial look at the great dome from below) is to take the elevator to the top and walk down the sloping ramp. Almost all exhibitions are hung to be seen specifically in this order. Freed of the restrictions of conventional galleries, the paintings shout or murmur across the large perspective of the open court. They live in what is in fact a single, continuous gallery, unwinding as it descends and letting each canvas make its point in relation to all the others in a complex total harmony. Bays along the outer walls succeed in establishing an intimacy between individual painting and individual viewer.

Although the museum presents major exhibitions such as the popular Brancusi, Mondrian and Dubuffet retrospectives of recent years, universal favorites from its own vast permanent collection, like old friends, keep reappearing—Chagall's *Green Violinist*, Rousseau's *Football Players*, Cézanne's *Clockmaker*, Modigliani's *Nude*, Brancusi's seallike sculpture *Miracle*. This is to mention only a few of the approximately 4,000 works in a collection that includes the largest group of paintings by Vasily Kandinsky to be seen in any of the world's museums, as well as many important paintings by Delaunay, Klee, Léger and Marc.

Solomon R. Guggenheim was one of seven sons of mining magnate Meyer Guggenheim. The sons, continuing their father's investments in the good earth, went from Canada to the Congo making fortunes even greater than Papa's. Solomon, in the tradition of the time, became a collector of Old Masters, and it was not until 1926 that a painter friend, Baroness Hilla Rebay, introduced him to the delights of nonobjective works. Over the next two decades, on many trips to Europe, a collection of modern masters was built. The new collection was first displayed in 1939 in a gallery at 24 East 54th Street under the direction of the Baroness. This gallery, known as the Museum of Non-objective Painting, was the conversation piece of its day. The rather mystical atmosphere featured heavily draped walls, recordings of Bach and Brahms, and silver-framed paintings hung at what critic Aline Saarinen described as "ankle level." Despite

these eccentricities of installation, the museum had a considerable impact on the art public, and when Solomon died in 1949 he had already approved Frank Lloyd Wright's plan for its permanent quarters on upper Fifth Avenue.

In 1952, when James Johnson Sweeney succeeded the Baroness as director, the museum's exhibition policy was broadened to include the full range of contemporary art. This change was brought about by the trustees, who felt that the earlier, rather rigid adherence to the nonobjective idiom implied the possibility of a finality of artistic expression which was out of keeping with the museum's original revolutionary educational objectives. To give formal recognition to its new format, the museum's name was changed to the present, stylistically neutral designation as the Solomon R. Guggenheim Museum. The newly christened museum actually moved into its permanent home in Wright's visionary structure in 1959. There, under the leadership of its present director, Thomas M. Messer, the museum has continued to enlarge the scope of its exhibitions and of its permanent collection.

Several recent additions to the permanent collection have

Interior View from Top Ramp (Solomon R. Guggenheim Museum, New York, N. Y.)

been of monumental scale: Léger's *Grand Parade*, Dubuffet' *L'Hourloupe, Nunc Stans,* and Francis Bacon's *Crucifixion* trip tych. Also of imposing dimensions is Miró's *Alicia*, a cerami mural commissioned by Harry F. Guggenheim in memory of hi wife, Alicia Patterson Guggenheim. Dedicated in 1967, this worl is now on permanent display at the top of the first ramp, where it is often seen with its earlier sculptural counterpart, Miró': eight-foot ceramic *Portico*. Recently acquired works of smalle size, though equal artistic merit, have included Klee's *In the Current Six Thresholds,* Jawlensky's *Helene with Red Turban* and Miró's *The Tilled Field.*

A testimonial to the museum's broadened interests is the Justin K. Thannhauser wing, with its 75 Impressionist and Post Impressionist masterpieces. This special gallery, which forms a level oasis in the visitor's spiral journey, houses works by Gau- guin, Cézanne, van Gogh and, perhaps most notably, 34 Picassos a chronological selection touching upon the *oeuvre* of this cen- tury's greatest artist. Vuillard's *Place Vintimille*, Modigliani's *Young Girl Seated* and *Woman Ironing* of Picasso's Blue Period are among the works which may be contemplated in this intimate setting.

Joan Miró: The Tilled Field (Solomon R. Guggenheim Museum, New York, N.Y.)

Not only the collection, but the building itself, is undergoing expansion. A two-story annex designed by Frank Lloyd Wright's leading disciple, William Wesley Peters, was recently completed on the northeast corner of the museum's lot. This annex, by permitting the relocation of certain administrative functions, has increased exhibition space by nearly one-third and frees the top ramp to flow in ribboned harmony with the whole. More recently the outdoor space between two building components was glass enclosed and modified to accommodate a café and relocated bookstore, thus providing a needed public facility while freeing the entire ground floor of the main gallery for display purposes.

HISPANIC SOCIETY OF AMERICA

Broadway between 155th and 156th streets, New York, New York

Hours: Tues.–Sat. 10–4:30; Sun. 2–5
Closed: Mon., major holidays
Library

America is indebted to Archer M. Huntington for that island of Spanish culture anchored on upper Broadway in Manhattan. Huntington was the son of Collis P. Huntington, railroad and shipbuilding magnate. Instead of throwing his considerable creative energies toward industry, the son, with a thoroughness known to few, decided to explore Iberian culture.

The antiquities section holds artifacts found on archaeological digs in Spain. Huntington, in his eagerness for knowledge of the development of the culture, undertook an excavation in 1898 in what had been a Roman town near Seville (now Santeponce). The work was abandoned the same year when the Spanish-American War broke out. In 1904 he founded the Hispanic Society of America as a free public library and museum, and a year later the building program started. The opening took place January 20, 1908. One of the society's earliest panel paintings, *Virgin and Child Enthroned*, School of Jaime Huguet, is one of its most engaging works of art. Seldom will one see a Christ child endowed with such appealing naïve dignity or such a quizzical Madonna. A large Catalan altarpiece by the Spanish painter

Pere Espolargues of Molino represents the Flemish phase. An
tonio Marco's penetrating portrait of the third *Duke of Alba*
Luis de Morales's *Virgin with the Yarn Winder*, Francisco d
Zurbarán's *Saint Rufina*, three Velázquezes, including an atypica
Portrait of a Young Girl, and El Greco's *The Holy Family* ar
here. Great paintings all.

In the museum built on land that once belonged to Joh
James Audubon, one can find, in miniature, a cross section o
every facet of Spain's art heritage: Iron Age artifacts and ex
amples from the Roman period on the peninsula; the sophisti
cated pottery and ironwork from the Hispano-Moresque period
gold, silk, brocades, ivories, tiles, silver, painting and sculptur
from Spain's great age under Ferdinand and Isabella; Renais
sance liturgical objects; richly carved furniture of the 16th and
17th centuries.

The sculpture group begins with early Phoenician-styl
ivories, pre-Roman and Roman bronzes. The pottery dates from
historic times, but the Hispano-Moresque and Spanish luste
pottery, as well as the 16th century enameled glass from Cata
luña, is most important. The furniture is representative of His
panic cabinetmakers from the 15th to 18th centuries. Spain'
national pastime, bullfighting, its history, art and appurtenance
from the 13th century to modern times, are on display in a sep
arate gallery.

The Goyas include the sketch for scenes of the *Massacre o
the Third of May*, and four portraits, including a stunning one
of *Don Manuel Lopena*. A portrait of the *Duchess of Alba* shows
her dressed exquisitely but rather forbiddingly all in black. A
comparison piece still owned by the Alba family portrays her in
the same stance in white muslin. Perhaps the most appealing
and certainly the most free in brushwork is the *Portrait of Pedro
Mocarte*, a singer attached to the Toledo Cathedral. There are
a few paintings of the 20th century, but those early Picassos so
thoroughly Spanish in feeling are missing.

A monumental sculpture of *El Cid* done by Anna Hyatt
Huntington, the founder's second wife, stands before the museum.
A replica was presented to the city of Seville in 1927.

The library contains more than 100,000 books relating to the
history and culture of Spain, Portugal and colonial Hispanic
America.

THE JAPAN SOCIETY

33 East 47th Street, New York, New York

Tours: Mon.–Fri. 10–5; Sat. 11–5; Sun., holidays 1–5

There's a little bit of Kyoto to be found on East 47th Street. Japan's prestigious architect Junzo Yoshimura has erected a house that while taking care of the society's busy program and exhibition schedule gives instant serenity. Perhaps it's the reaching bamboo tree that grows out of the reflecting pool or the view of the pebbled garden beyond. By the time one mounts the floating bamboo staircase to the mezzanine exhibition area one is in the mood to see anything from Haniwa sculpture (3rd to 6th century) to contemporary prints. There is a small study group of Japanese material but no permanent collection. Works of art are integrated throughout the building. If the current exhibit is of ancient material, works of art elsewhere in the house are liable to be contemporary. A handsome Nagare sculpture is set in pebbled splendor at the end of a conference room.

Usually three exhibits of important loans from Japan or United States' collections are held each year. Authoritative catalogs written by scholars appear with each exhibition. The program supports classes and language study groups. There is a delightful small auditorium where lectures are given and Japanese films shown.

Since Japan House is closed to the public when exhibitions are not being held, it is best to telephone first.

THE JEWISH MUSEUM

1109 Fifth Avenue (92d Street), New York, New York

Hours: Mon.–Thurs. 12–5; Fri. 11–3; Sun. 11–6
Closed: Sat.

The gargoyled French Renaissance home of the Felix Warburgs built in 1908 was presented to the Jewish Theological Seminary of America in 1947 to house its collection of rare ceremonial objects. In 1962 the Albert A. List wing was added, doubling the exhibition space and giving the museum a modern entrance.

The Jewish Museum is the permanent repository in the United States for the most extensive and comprehensive collection of Judaica in the country.

Included in the permanent Judaica collection are objects which range from archaeology of the Holy Land to contemporary silver ceremonial objects executed in the museum's silversmith workshop. Among the outstanding pieces in the collection are a beautiful blue Persian mosaic wall from the 16th century believed to be part of an ancient synagogue, a terra cotta jug dating from the time of Moses and fragments of the Genizah ark unearthed in Cairo which dates back to the 13th century. New acquisitions include a small, ornate bronze casket, early 17th century Italian, with Hebrew inscriptions.

The museum also presents changing contemporary exhibits of paintings, photography, sculpture and architecture. These have to do with Jewish life and culture, for example an exhibition of Leonard Baskin's series of 20 watercolors of the Passover story. A variety of interesting special events includes a film series, Sunday afternoon lectures and concerts, walking tours and children's programs.

THE METROPOLITAN MUSEUM OF ART

Fifth Avenue at 82d Street, New York, New York

Hours: Tues. 10–9; Wed.–Sat. 10–5; Sun., holidays 11–5
Closed: Mon.
Restaurant, library

No single American institution presents a more complete expression of man's artistic endeavor than the Metropolitan. John Jay, lawyer, diplomat, abolitionist and one of the founders of the Republican party, is credited with instigating the founding of the museum. A Union League clubman, he roused fellow members to action—including artists John Kensett and Worthington Whittredge (the same Whittredge who posed as Washington in Emanuel Leutze's famous *Washington Crossing the Delaware*). In 1870 the Metropolitan Museum of Art was incorporated. It moved from its first home, a former dancing academy, to the Douglas Manor on West 14th Street, and in

880 to a building in Central Park designed by Calvin Vaux, one of the architects of the park. As early as 1893, William Morris Hunt designed a new front for the building. A 1964 expansion produced the handsome Thomas J. Watson Library, largest art reference library in the United States, together with galleries for the drawing, print and photographic collections. Exhibitions are held here, and study rooms are open to the public by appointment.

In 1969 "the great grey lady of upper Fifth Avenue" had her face lifted, and now in the mid-seventies her girth is expanding prodigiously. The firm of Roche, Dinkeloo and Associates has devised a master plan for additions and reconstruction. The new Lehman Pavilion—a museum within the museum (the collection must be kept as a unit)—opens beyond the great Medieval Hall. A new wing to the south houses the Department of Western European Arts. One can speak only in superlatives. There are splendid rooms from palaces and great houses, plus European decorative arts dating from the Renaissance to 1900. Extending from the Egyptian galleries and encased in what must be the biggest insulated glass box ever is that refugee from the rising waters behind the new Aswan Dam—the Temple of Dendur. It was given in gratitude by Egypt's government for America's part in saving the great monuments of Abu Simbel from the same deluge. The colossal move has been accomplished: Dendur is being reassembled in a close approximation of how it looked on the sunny banks of the Nile. An artificial lake aids the illusion.

The Egyptian section touches on every aspect of the ancient Nile Valley through 40 centuries, from the reconstructed tomb of Per-Neb, a Memphite dignitary of the VI Dynasty, to the skillfully wrought pendants of queens. According to Thomas P. F. Hoving, the present director, the gift of the obelisk in 1881 (in Central Park) triggered the flow of Egypt's antiquities into the museum. The present building program allows for reinstallation of the galleries, which will be arranged in chronological order. Those marvelous sculptures from the temple of Queen Hatshepsut at Deir el Bahri will have a setting reminiscent of their time and place. A faïence sphinx of the XVIII Dynasty has entered the collection.

The Greek holdings are strong in Cypriot art, partially because General Luigi Palma de Cesnola, an Italian who won his

stripes in our Civil War, made important excavations in Cyprus
In 1879 he became the Metropolitan's first director. An important
late addition to the department is the calyx krater by the painter
Euphronios and the potter Euxitheos.

The Near Eastern Department contains not only great As
syrian sculpture but exquisitely wrought gold and silver vessels
the carved ivories and the arts and artifacts of Sumeria, Meso
potamia and Sythia. One enters the Far Eastern section through
the Arthur B. Sackler gallery, which is dominated by a huge
richly conceived wall painting, Buddha Assembly (Yuan Dynasty
XIV century), and a great sandstone Bodhisattva, both from the
province of Shensi. Another gallery which should be called the
"gallery of contemplation" holds a collection of Chinese sculp
ture said to be the most important in one institution in the West
ern world. Twenty-five Chinese paintings from the Sung and
Yüan periods are late gifts. With the exception of Istanbul's
Topkapi Museum, the Islamic section is unmatched in the world
At last the unparalleled collection of musical instruments has
been given a brilliant "see and hear" installation. One can see
and hear the earliest example of the piano as we know it today
or exotic instruments from the Far East, Oceania or Africa. The
sophisticated electronic equipment that accomplished this is
called Telesonic. The head set is rented at the gallery entrance

Egypt XVIII Dynasty: Sphinx of King Amenhotep III (Metropolitan Museum
of Art, New York, N. Y. Lila Acheson Wallace Gift Fund)

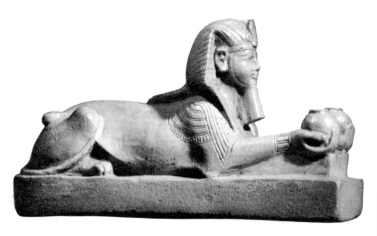

Diego Velázquez: Portrait of Juan de Pareja (Metropolitan Museum of Art, New York, N.Y. Isaac D. Fletcher Fund, Jacob S. Rogers Fund and Bequest of Adelaide Milton de Groot [1876–1967], Bequest of Joseph H. Durkee, by exchange, supplemented by Gifts from Friends of the Museum, 1971)

Although gifts of Primitive art had come to the museum as early as 1866, they were given no special department until 1969, when Governor Nelson Rockefeller gave a munificent gift of Oceanic, African and Pre-Columbian art in memory of his son Michael C. Rockefeller, who lost his life while engaged in anthropological research in the South Pacific. Housed in the southern arm of the museum are such giant objects as the carved ancestor poles of southwest Guinea. Particular strength lies in the material from the New Hebrides and New Caledonia.

Wonders of the Middle Ages are shared between the museum and the Cloisters it administers. The arms and armor collection rank third in the world. The drawing and print collections have no parallels in the country. Six hundred and seventy drawings from the distinguished collection of James Jackson Jarves (see Yale) came to the museum when it opened in 1880 in the park. Though the range is wide, holdings are strongest in Italian and French works. The breadth and variety and condition of most prints are stupendous. The photography section got under way with a gift in 1928 from Alfred Stieglitz.

A stroll through the Elysian fields of paintings takes one from Italian Primitives through practically every school and country, with such magnificence as Giotto, Duccio, two Raphaels, Fra Filippo Lippi. A recent addition is *Coronation of the Virgin*

by Annibale Carracci. In the Dutch galleries are four Vermeers, including the oft-reproduced *Woman with the Water Jug,* Terbrugghen's compelling *The Crucifixion with the Virgin and St. John.* Highlighting the more than 30 Rembrandts is *Aristotle Contemplating the Bust of Homer. Flora* or *Lady with a Pink* satisfies me. The Venetian paintings of which the museum has glowing examples have been given a new installation reminiscent of the sunny opulence of Venice. Among the examples are Titian, Tintoretto, Bellini, Tiepolo, Lotto, Crivelli and Veronese with, among others, his magnificent *Mars and Venus United by Love.*

El Greco's only landscape in this country, *View of Toledo,* hangs in a gallery opulent with Spanish treasures, such as *Portrait of Juan de Pareja* by Velázquez. A self-portrait of de Pareja, who was Velázquez's mulatto assistant, hangs in the Hispanic Museum on upper Broadway. In the French galleries one sees Poussin's women being abducted, Boucher's and Fragonard's ladies swinging, flirting, posturing, and a galaxy of breathtaking Impressionist and Post-Impressionist canvases.

The new American Wing folds around the northwest corner of the building and includes a covered garden court. A corridor at the rear of Dendur provides an entrance from the museum. Another entrance from the west side now makes it possible to come into the wing directly from the Park. The space consists of three floors and 35 period rooms. The heart of each floor is a large gallery in which a general summary of styles is given. Some paintings hang appropriately in period rooms, but there are also exhibition galleries and orientation areas for the vast holdings beginning with the Primitive painters, Robert Feke, Smibert, Badger, Wollaston, then West to Copley with ten examples, historical paintings, genre works, the Hudson River School, on to the Ashcan School. There are splendid examples of Eakins, Homer, Cassatt, Whistler and Sargent (the latter's famous *Madame X*—Mme. Pierre Gautreau, whose décolletage shocked the 1884 Parisians when the picture was exhibited. It was sold by Sargent to the Metropolitan in 1916).

Twentieth century art, starting after the Armory show, has its own permanent exhibition space in the main building. The George A. and Arthur H. Hearn Fund, established early and exclusively for the purchase of American art, has been a great boon to the department. Twentieth century "old masters" such

as Stanton MacDonald-Wright, Morgan Russell, Hartley, Sheeler, Kuhn, Hopper, Wyeth, Dove, Hofmann, Albers, O'Keeffe, Gorky, Stuart Davis and Tobey are all shown in fine examples. Fortunately some of the contemporary "old masters" are still with us, living to see themselves well established in their time and place. Later movements, Abstract Expressionism, Pop art, Minimal sculpture, are handsomely covered. Jackson Pollock's *Autumn Rhythm* and David Smith's *Becca* are representative of the character and force of the 20th century department.

The Costume Institute, with its own entrance at 83d Street and Fifth Avenue, reviews dress historically, aesthetically and engagingly. The Junior Museum has its entrance at 81st Street and Fifth Avenue. With peepholes, slides, filmstrips, acoustical guides, vivid and scholarly exhibitions from which adults can also profit are assembled for the young. A library, auditorium and snack bar complete the junior picture.

Robert Lehman, perhaps the last of the "Renaissance princes," bequeathed to the museum in 1969 the collection he and his father Philip before him had gathered. In rooms designed around a garden court, the Lehman Pavilion reproduces the last arrangement Robert Lehman made of his paintings, sculpture, decorative arts and tapestries. The lower-level galleries for changing exhibitions of drawings and display areas for precious objects are arranged around a small outer court designed as an *orangerie*. The strength lies in 14th and 15th century Italian masters: a small *Annunciation* by Botticelli, Lippo Vanni's *Madonna and St. Ansanus*, Carlo Crivelli's *Madonna Enthroned*. That strain is continued in paintings by Memling, Cranach, and Petrus Christus's famous *St. Eligius*, Rembrandt, El Greco and a great Ingres portrait, the Impressionists and even some of the Fauves. Until it came to the Metropolitan, the drawing collection was considered one of the most extensive in private hands. The heady decorative arts section includes Renaissance bronzes and jewelry, Limoges enamels, Gothic tapestries and Persian faïence—as we said: a truly princely collection.

At a visitors' booth by the main entrance such questions as "The shortest way to Aristotle?" are answered, and tours are plotted to conform with an individual's time and interest. The old public parking lot has gone underground into three-tiered space housing 462 cars.

PIERPONT MORGAN LIBRARY

29 East 36th Street, New York, New York

Hours: Tues.–Sat. 10:30–5; Sun. 1–5
Closed: Mon., major holidays

The Pierpont Morgan Library, erected in 1906 by the legendary architectural firm of McKim, Mead and White, has become one of New York's classic landmarks. The Renaissance-style *palazzo* was commissioned by Morgan, a lordly, astute collector and financial genius, to house his collection of rare manuscripts and works of art. Today the main entrance is through the annex next door, formerly the site of Morgan's home. A gallery to the left is used for rotating exhibitions from the library's holdings: manuscripts, illuminations, prints or drawings. A long corridor, also used for exhibitions, leads to the West and East Rooms of the older edifice. The West Room, or Study, is opulent with red damask walls, heavily carved furniture, majolica, Limoges, faïence, and alabaster pieces, arranged much the same as it was in Morgan's day. Here he entertained princes and churchmen, intellectuals and writers and, of course, art dealers. Among the paintings are Memling's *A Young Man with a Pink*, Tintoretto's *Portrait of a Moor*, Perugino's *Virgin and Two Saints Adoring the Christ Child*, and Cranach the Elder's small circular wedding portraits of Martin Luther and his wife Catherine.

The East Room houses one of the great libraries of the Western world, including the Constance Missal (circa 1450), believed to predate the Gutenberg Bible, and works from the press of the first English printer, William Caxton. There are manuscripts with glowing illuminations and Books of Hours such as the exquisitely wrought little paintings in the *Hours of Catherine of Cleves* and the opulent, yet delicate, jeweled front cover of the 9th century Lindau Gospels. Many of the manuscripts are in richly jeweled and sculptured covers, works of art themselves. The Old Master drawing collection is staggering: Filippo Lippi, Francesco Primaticcio, Fra Bartolommeo, along they go through the centuries, Brueghel, Tintoretto, Constable, Blake, van Gogh. While the three-tiered library stacks in this handsome room full of sculpture and *objets d'art* are not open to the public, some rare letters and manuscripts are always on display. Documents of Erasmus,

Louis IV, Machiavelli, Racine, Voltaire, Balzac, Blake, Dickens, Wordsworth, Ruskin, Maugham, they're all there down to John Steinbeck's manuscript of *Travels with Charley.*

An ornate vestibule by H. Siddons Mowbray is decorated with classical figures, mosaics, interpretations of the Muses and four marble columns on which rest delicately carved alabaster lamps. It was the original entrance to the library and certainly gave a foretaste of the riches to follow. No Morgan Library exhibition should ever be missed. The combination of important holdings, historical context and visual excitement is difficult to surpass.

MUSEUM OF AMERICAN FOLK ART

49 West 53d Street, New York, New York

Hours: Tues.–Sun. 10:30–5:30
Closed: Mon., major holidays

Opened in 1963, the museum is devoted to the folk tradition in American art and design. A portrait done by an itinerant artist, a Pennsylvania Dutch chest, a carved weather vane, a rubbing from a New England gravestone, or a bulto (see Santa Fe, Museum of International Folk Art)—whatever the subject, one is assured of seeing excellent examples of the work of many of America's gifted though untutored artist-craftsmen.

MUSEUM OF THE AMERICAN INDIAN

Audubon Terrace, Broadway at 155th Street, New York, New York

Hours: Tues.–Sun. 1–5
Closed: Mon., holidays, Aug.

This museum is devoted to the art of the Indian in all the Americas, North, Central and South. As Frederick Dockstader, the director, remarks in his book *Indian Art of the Americas*, we tend to think of Indian art as pertaining to the U.S. and Canada. Also some collectors of Pre-Columbian art tend to forget that the Mayans, Aztecs and Incas were Indians. The collections here are

stupendous and not only show the objects as art forms (whether designed for household, political or religious use) but give us a lesson in history and the effect of migrations, wars and intertribal marriage on art styles.

The collections form the largest assemblage of North American Indian material in the world. The life of the Indian is interpreted through everyday objects, dress, ceremonial and religious pieces. The Creek, Cherokee, Iroquois, Algonquin, Navaho, Hopi, Seminole—all the old tribal names are here.

In the Mexican and Central American section we see the stone carving of the Mayans, perhaps the most art conscious of all the ancient Americans, and the ceramics and jade of Costa Rica, Honduras and Guatemala. The South American art forms are rich and varied, especially those of Peru, which include textiles, jewelry, masks of gold and bronze and highly inventive and beautiful pottery.

The museum is next door to the Hispanic museums.

MUSEUM OF THE CITY OF NEW YORK

5th Avenue between 103d and 104th streets, New York, New York

Hours: Daily 10–5; Sun., holidays 1–5
Closed: Mon., Dec. 25

Gracie Mansion, now the official home of New York mayors, housed the museum from 1923 until 1932 when it moved to its present spacious Georgian building.

The museum documents the city's political, social, cultural and economic history in an engaging manner.

In a "please touch" area children are invited to handle many objects. Dramatic impact is ensured with extensively used dioramas with small ladders for tiny viewers: model rooms show interiors from 1690 to the late Victorian opulence of John D. Rockefeller's house on West 54th Street. A Duncan Phyfe Room offers fine examples from America's master cabinetmaker's workshop. A recent addition given by Duncan Phyfe's descendants is the sideboard he made for his wife. Another recent addition is an alcove of Alexander Hamilton memorabilia including Hamilton's desk, a portrait of Mrs. Hamilton by Ralph Earl and

one of Hamilton by John Trumbull. It is this likeness by Trumbull that is engraved on our ten-dollar bill. The museum also has a definitive collection of early New York silver. The print collection numbers more than half a million items of paintings, prints and photographs of New York City. The theater collection contains the most complete history of the New York stage ever assembled, while the richly endowed toy collection covers the whole field of playthings, with its dolls and dollhouses of outstanding note.

For orientation and chronological viewing go first to Cityrama Gallery on the main floor. As Joseph V. Noble, director of the museum, says, Cityrama "is a unique multimedia, audio-visual exhibition utilizing authentic three-dimensional objects to trace the history of New York from 1524 to the present." In a lively 17-minute presentation that includes flashbacks to the "for real" first fire engines, the last horse-drawn coach and opera box 28 from the old Metropolitan, all the museum's exhibits are put into proper perspective. From here one should move to the first-floor Dutch Gallery. The history of New York City, Nieuw Amsterdam as it was called, is re-created from the silver and pewter of the patroons and the tools of the working people. A replica of the fort that guarded the harbor is also on display. More and more the museum's exhibitions reach out into the neighborhoods and reflect the present as well as the past. Special events ranging from concerts for adults to puppet shows for children take place from October through May. This is definitely a family museum.

MUSEUM OF CONTEMPORARY CRAFTS OF THE AMERICAN CRAFTS COUNCIL
29 West 53d Street, New York, New York

Hours: Tues.–Sat. 11–6; Sun. 1–6
Closed: Mon.

Aside from being a viewing platform, through group exhibitions and one-man shows, for the best craftsmen in the country, the museum has a library and keeps up-to-date files on craftsmen and craft schools throughout the country. The files are kept by

the Research and Education Department at 44 West 53d Street and are open to the public. The council is the museum's parent organization. First- and second-floor galleries show changing exhibitions, about four a year. Galleries 1 and 2 on the second floor are for either one-man exhibitions or an extension of one large exhibition.

MUSEUM OF MODERN ART

11 West 53d Street, New York, New York

Hours: Mon.–Sat. 11–6; Sun. 12–6; Thurs. 11–9
Closed: Dec. 25
Restaurant

By setting a policy, at its inception in 1929, of forming a collection of the immediate precursors of modern art and the most important living artists, the museum assumed a formidable task, for immediate ancestors are often in disrepute and contemporary masters are at times difficult to judge. The museum, now 46 years old, embodies its policy magnificently.

The collection begins around 1875, though 97 percent concerns the 20th century. You can float along on a lily pad with Monet or be catapulted into a world of kinetic, frenetic sculpture wired for sound or movement by the Swiss artist Jean Tinguely, or for sculptured light by Chryssa, the Greek-American who brought neon into the museum world.

As with many museums throughout the United States, this one was started by women. One day over a luncheon table Miss Lillie P. Bliss, Mrs. Cornelius J. Sullivan and Mrs. John D. Rockefeller, Jr., presented a full-blown plan for a museum to A. Conger Goodyear, who, fresh but undaunted from a modern art battle in his hometown (see Buffalo), became the museum's first president. Alfred H. Barr, Jr., who had been teaching art history to young women at Wellesley, was made director. The same Alfred Barr, retiring after 39 years of service, left a collection which is probably the best survey of modern art in the world.

Although the museum's permanent collection crosses all national boundaries, America has had the greatest representation, starting with its first purchase, Edward Hopper's *House by the*

Railroad. The inaugural show was held in an office building at 730 Fifth Avenue, and such crowds clogged the elevators that the landlord threatened to cancel the lease. In 1939 the museum moved to its present handsome quarters. In 1964 a large east wing and more garden space were added; then in 1966 the museum took over the entire former Whitney Museum, which had fortuitously been placed so that it forms in effect a west wing. Here, in the first study center that had all its cataloged art available, scholars may examine works not on public view. The library has been enlarged and moved here, thus making archival material relative to the collection accessible to scholars. The museum's bookstore, now next door at 21 West 53d Street, has been enlarged to carry other art publications, multiples, and so on.

No less revealing of the surging, volatile spirit that infuses the Modern are its varied services. The film library presents one of its classics twice a day and also loans films. The photography department, set up in its new Edward Steichen gallery, preserves the old and explores the new. Today practically every self-respecting museum has a gallery of photography, but the Modern pioneered in the field as it has in so many other areas. The first exhibition was held in 1932, and a Department of Photography was opened in 1940. The Philip L. Goodwin Galleries of Architecture and Design take us from Tiffany glass and the Bauhaus Movement into "Now." The Abby Aldrich Rockefeller Print Room makes available for study more than 7,000 original graphics by modern artists. (Call for an appointment.) The Paul Sachs Galleries of Drawings offer quiet space for close perusal and reflection.

Behind these activities stands the solid presence of the permanent collection. While only a small portion of more than 20,000 works of art can be shown at one time, and major upheavals in arrangement occasionally take place, we are assured that perennial favorites will be on view. Going to the museum and not finding Rousseau's *Sleeping Gypsy* would be like meeting Groucho Marx without his cigar. A few show stoppers such as Jackson Pollock's *No. 1* are usually on the first floor, as are the museum's important changing exhibitions. The small galleries to the west are used for recent experimental work, or perhaps simply some area that a curator wishes to build an exhibition around. On the second and third floors (get the museum's excellent

Pablo Picasso: Guitar (Museum
of Modern Art, New York, N. Y.
Gift of the artist)

Henri Rousseau: The Sleeping Gypsy (Museum of Modern Art, New York, N. Y.

floor plan) one is guided through a visual history of the important art movements, including Post-Impressionism, Cubism, Futurism, Surrealism and Abstract Expressionism. Artists such as Matisse and Picasso have their own galleries, although Picasso, who cannot be contained in any "ism," is represented in many galleries. Brancusi also has his own elegant gallery in the sculpture area.

In stunning examples throughout the galleries one is given a visual education. To isolate favorites such as van Gogh's *Starry Night* or Miró's *Birth of the World* would be to court frustration: there are too many. To mislead Hitler's inspectors Beckmann's important *A Departure* was shipped out of Nazi Germany in 1937 as *Scenes from Shakespeare*.

It is hard to say whether the Modern takes over Picasso or Picasso the Modern. More than 40 of his works, exclusive of drawings, prints, posters and a rug, belong to it. Some, like *Les Demoiselles d'Avignon* of 1907, presaging the rigidities of Cubism, are landmarks. *Guernica*, that threnodic protest against war and brutality, is here, as is its antithesis, *Night Fishing at Antibes,* a canvas full of subtle harmonies in muted color, tender and playful. *The Charnel House*, a major work inspired by the first release of news prints of concentration camps, is here too. A late gift of Picasso himself, and the first gift of sculpture by him to any museum in the world, is a 1912 Cubist construction in sheet metal and wire, *The Guitar.*

The museum's garden foliage has come of age. Tall trees drip their leaves over Moore's *Family Group*. The Belgian sculptor Oscar Jespers's *St. Anthony* is tempted under a white birch tree. Vargas's *Snake* leers from its ivy bed. Rodin's *Balzac* is aloof, while Maillol's *Nude* plays eternally in the moss-green pool. Miró's great bronze Moon Birds, a recent gift, will probably join this select group soon. The upper terrace holds the more optically abrasive examples of sculpture.

The overriding philosophy at work here is that contemporary art is a facet of contemporary life, that frenetic painting is the product of a frenetic age, and that the museum is a platform on which to exhibit the period we live in.

NEW-YORK HISTORICAL SOCIETY

170 Central Park West, New York, New York

Hours: Daily, 1–5; Sat., 10–5; Sun., 1–5
Closed: Mon., major holidays

In a pleasant installation covering the entire fourth floor and gleaming with clustered spot lighting, some 260 paintings from a collection of 2,000 oils, watercolors, prints and miniatures have been hung.

Founded in 1804, the society exhibits here its rich repository of figures from our historical past: the Stuyvesants, Van Alens, Schuylers and Ten Eychs who settled New York, along with Washington, Adams, Hancock, Franklin, Jefferson and others who brought the nation into being. Some are painted by artists whose names are lost to us, others by men who, in recording that past, acquired their own fame.

Portraits of George and Martha Washington by Rembrandt Peale are guarded by two enormous and fierce carved American eagles. The society boasts one of the finest, largest groups of 19th century genre and landscape painting in the country. Those old favorites Thomas Cole's *The Course of Empire* shine forth in splendor along with less grandiose but more satisfying canvases such as J. F. Kensett's *View from West Point*. The new installation gives one a chance to reappraise former acquaintances and to meet the newcomers in this far from static institution.

WHITNEY MUSEUM OF AMERICAN ART

945 Madison Avenue, New York, New York

Hours: Daily 11–6; Sun., holidays 12–6; Tues. 11–10
Closed: Dec. 25

Gertrude Vanderbilt Whitney, great-great-granddaughter of the railroad tycoon Cornelius Whitney, was the founder of the present Whitney and also a serious sculptor. In 1908 she opened her McDougal Street studio to struggling young artists who had no place to exhibit. By 1918 the Whitney Studio Club had been formed with Juliana Force as director. Mrs. Force, a small,

amber-haired dynamo from Doylestown, Pennsylvania, had no background for her job (she had run a secretarial school), but she was an organizational genius. The two women working in tandem for 30 years did much to give the American artist a showcase. Mrs. Force became one of the first woman museum directors in the country.

The club, center of fun and accomplishment (Edward Hopper, John Sloan and the sculptor John Flannagan were first shown there) grew so rapidly that a row of houses on West 8th Street was remodeled to form the Whitney Museum, which opened November 18, 1931. Here the Whitney matured into the country's major sponsor of American art, and here it remained, except for an interlude of 12 years on West 54th Street, until it opened in triumph in 1966 on upper Madison Avenue. The new Whitney, designed in smoky gray granite by Marcel Breuer, sits on its site like a fortress. The interior blends rough concrete walls with smooth teakwood, enormous "wall-to-wall slate" galleries with deeply carpeted enclosures for intimate viewing. A sunken sculpture court at the entrance allows passersby to look down and enjoy the works of art. Standing within, one feels the true monolithic relationship between the sculpture and the building.

Several years ago, to the astonishment of the art world, the Whitney sold its holdings in art prior to 1900. Happily that decision has been rescinded, and a curator has been appointed to rebuild in this area of American art.

More than any other museum in the country, the Whitney has been the artists' museum. In the beginning, Mrs. Force, aware of her own limitations, turned to the artists to put on exhibitions. From every show Mrs. Whitney bought artists' work, and the Whitney carries on that policy today. Instead of giving medals and awards for its big shows, it purchases works of art. The Whitney's alternating annuals of painting and sculpture have now been combined into a biennial which includes both. This continues the Whitney's policy of encouraging living American artists, and presents a cross section of new developments throughout the country. The Whitney's holdings in 20th century American art are the largest in the country. Through the years certain paintings have become so identified with the museum that they could justifiably be called "Whitney masterpieces": Charles Demuth's *My Egypt*, Walt Kuhn's *The Blue Clown*, Alexander

Ilya Bolotowsky: Blue
Rectangles (collection of
Whitney Museum of
American Art, New York,
N. Y.)

Exterior Sculpture Court
(Whitney Museum of American Art,
New York, N. Y., Ezra Stoller photo)

Brook's *The Sentinels,* Edward Hopper's *Early Sunday Morning,* George Bellows's *Dempsey and Firpo,* David Smith's *Hudson River Landscape,* Ben Shahn's *The Passion of Sacco and Vanzetti,* Charles Sheeler's *River Rouge Plant* and Isamu Noguchi's *Humpty Dumpty.* A few late acquisitions are from the studios of Mark Rothko, Kenneth Noland, Conrad Marca-Relli, William Wiley, Robert Motherwell, Dan Flavin, Jim Dine, Jackson Pollock, Franz Kline, Robert Mangold, Helen Frankenthaler, Morris Louis, Chuck Close and Richard Estes. Major recent acquisitions include Richard Lindner's *Ice,* Alfred Leslie's *Self-Portrait,* Florine Stettheimer's *Sun,* Bradley Walker Tomlin's *Number 1,* Clyfford Still's *Untitled, 1957,* Claes Oldenburg's *Ice Bag,* Frank Stella's *Agbatana I* and the Edward Hopper bequest of about 2,000 works of art. The Howard and Jean Lipman Foundation gave important sculpture by such artists as Nevelson, Calder, Samaras, Kienholz, Morris, Serra, Irwin, Judd, Trova, Snellson and Chamberlain, along with a continuing yearly gift.

Not only has the Whitney acquired a new home, it has also acquired a new image. As the founder intended, its openings attract both established and young artists. Its Tuesday evening series of avant-garde and classical music, plus programs in the performing arts, have packed the galleries. Among those recently appearing at the Whitney have been Merce Cunningham, Virgil Thomson, Anthony Burgess, Terry Riley, Gil Evans and Iannis Xenakis.

The Museum's New American Filmmakers Series presents annually three 12-week programs and shows approximately 250 individual films a year. It is a forum for new developments in American filmmaking.

In a refurbished loft, the Art Resources Center at 185 Cherry Street is a studio facility for underprivileged high school students. In addition, the Education Department operates the Independent Study Program at 29 Reed Street for college students in art history and studio work. An innovation for New York is the Whitney's Branch Museum at 55 Water Street, a facility supported by business institutions in lower Manhattan and staffed by the Education Department interns. The branch museum is open from 11 to 3 and brings approximately eight exhibitions a year to the not yet tired businessman and the secretary working in the Wall Street area.

POUGHKEEPSIE

VASSAR COLLEGE ART GALLERY

Taylor Hall, Raymond Avenue, Poughkeepsie, New York

Hours: Mon.–Sat. 9–4:30; Sun. 2–5
Closed: Thanksgiving weekend, Christmas, spring and summer
vacations

The off-campus visitor will find the museum conveniently located in Taylor Hall just to the right of Taylor Gate. The Charles M. Pratt Collection of Far Eastern Pottery and Porcelains contains objects from China, Southeast Asia, Korea and Japan, from the Han Dynasty to the 19th century. Much of the jade collection is richly carved and ornamented. Boys ride buffaloes; willow trees spread their branches over streams and pagodas. The group is divided into utilitarian, ornamental and symbolic objects, none earlier than the 17th century.

Paintings begin with the school of Giotto and the 14th century Taddeo Gaddi, proceed to Baroque and Dutch. The Italians range from the 15th to the 18th centuries and exemplify what Agnes Rindge Claflin, longtime distinguished professor of art, called "the Berensonian enlightenment" (see Gardner Museum, Boston). The French are represented by Jean Leon Gerome's *Camels at a Watering Place* and Hubert Robert's *The Octavian Gate and Fishmarket*, a rollicking view of the life of the common man under Louis XVI.

It is refreshing to come upon the Hudson River boys, those masters of the grandiose, in beautiful small examples. The 20th century is well represented and growing. Ben Nicholson and sculptors Henry Moore and Barbara Hepworth speak for the English. Hartigan, Rothko, MacIvor, I. Rice Pereira, Agnes Martin and Joan Mitchell are but a few in the American section. But it is in its drawing and print collection that Vassar distinguishes itself. Shown in a well-lighted gallery where close scrutiny is encouraged, the prints number, in the Felix Warburg donation alone, 75 Rembrandts, including a superb impression *Portrait of Jan Six*, and more than 50 Dürers. Thirteen major Rouaults are included in over 200 prints from the 20th century.

Hubert Robert: The Octavian Gate and Fishmarket (Vassar College Art Gallery, Poughkeepsie, N.Y. Paulus Leeser photo)

In an outsized portrait by Charles Loring Elliot, Matthew Vassar stands against the typical 19th century Classical pillared and balustraded background, pointing to the impressive new Vassar Female College painted in the distance (the word "female" was eliminated from the college name in 1867). In 1861, the year the college was incorporated, the James Renwick building must still have been on the drawing board, for the architect was busy working on St. Patrick's Cathedral in New York at the time and the college did not open until 1865. Matthew Vassar had an art gallery in mind from the beginning, for in 1864 he purchased an entire collection of oils, watercolors and drawings (only a few of which are still in the gallery) from the chairman of the art committee, Dr. Elias L. Magoon. The painter and inventor S. F. B. Morse was one of the original committee members.

While the Vassar museum is specifically a teaching institution, it is hoped that some day more space will be available in which to show to student and public alike many fine objects which are at the present in storage.

PURCHASE

THE NEUBERGER MUSEUM: STATE UNIVERSITY OF NEW YORK, COLLEGE AT PURCHASE

Anderson Hill Road, Purchase, New York

Hours: Tues.–Fri. 11–5; Sat., Sun. 1–5
Closed: Mon., major holidays

The latest art museum to open as this book goes to press is situated on the campus of the newest college in New York State. Indeed the cranes will be swinging for some time on Anderson Hill Road as the huge complex which involves eight major architects and is masterminded by Edward Larabee Barnes gets under way. The unrelentingly stark exterior of architect Philip Johnson's building is softened by a series of small sculpture courts, each holding major works by such sculptors as Barbara Hepworth. A stairwell leading to the second-floor gallery relieves the rectangular monotony. Here the Neuberger collection is on permanent rotation. The strength of the group is in mid-20th century masters—in Hartley, Levine, Hopper, Avery, Stuart Davis, Sheeler, the New York School with Pollock, de Kooning and Rothko. But Mr. Neuberger strays happily about; there are some 19th century Americans such as Thomas Cole and Thomas Moran, and in-depth holdings in Louis Eilshemius. The collection grows constantly. Sculptures by Philip King and Michael Sandle are recent additions.

The important Constructivist collection, assembled by sculptor George Rickey, is here. As David Gebhard states in the catalog of the collection, "It is rare in the history of art that an artist is, at the same time, historian and collector of the movement to which he belongs." The term derives from the art of a group of Russians working together from 1913 to 1922. Mr. Rickey describes it as "geometrical and non-mimetic." Two galleries hold collections of African art and art from New Guinea. Prints and drawings are in a third-floor gallery.

An innovative feature, brain child of director Bryan Robertson, is to fill one enormous gallery with paintings done *in situ* and designed to fit four rectangular areas devised by the archi-

tect Philip Johnson. Cleve Gray was the first artist invited to accept this space challenge. His *Threnody* sequence of 14 paintings each approximately 20 feet square cannot justly be described here except to say that it is a lament for the dead that manages triumphant overtones. Other artists will be invited to work in this environment. The one stipulation is that the works be easily removable for storage. The undertaking is so vast that each accomplishment will probably be in place for about a year. One of the most fascinating aspects of the museum not seen by the visitor is a series of workshops below the stairs where students and faculty can design and produce exhibits. Seminar rooms are adjacent to storage space so works of art can be wheeled in for discussion.

ROCHESTER

MEMORIAL ART GALLERY OF THE UNIVERSITY OF ROCHESTER

490 University Avenue, Rochester, New York

Hours: Wed.–Sat. 10–5; Sun. 1–5; Tues. 10–9
Closed: Mon., major holidays

Beginning in 1913 with two paintings, four plaster casts and "a lappet of lace," the collection has become, especially with Buffalo's Albright Gallery going all out for the 20th century, the most important general museum in the state outside New York City. The building, with its classical lines and columned fountain court, proves an admirable setting for the Medieval treasures which distinguish Rochester among smaller museums of America in that field.

In 1926 a wing doubling the original space was added, and in 1968 a commodious, clean-lined west wing opened. The sculpture garden at the right of the entrance holds Henry Moore's *Vertebrae*, one of three sculptures and nine drawings by Moore that the museum owns. The main door is now here. One enters the concourse gallery, which may contain Warhol, Vicente,

Olowe of Ise: Housepost,
Front and Rear View
(Memorial Art Gallery of the
University of Rochester,
Rochester, N. Y. Richard
Margolis photos)

Albers, Tobey, Reinhardt, Hofmann or others in the permanent
collection. Or the gallery and the large adjoining rooms may be
used for a special exhibition.

Ancient art concentrates on the Egyptians, Mesopotamians,
Greeks, Etruscans and Romans. A strange little figure from
Babylon (1900–1500 B.C.), a sphinx from Karnak and two rare
jars from the Aegean decorated with happy warriors are but a
few examples. The galleries of Asian art and the Primitive arts
remain fairly constant. The latter holds examples from North
America, Africa, including a fine Nigerian piece, *Female Figure*,
and works from Colombia, Guatemala, Mexico and Peru. For-
tunately for Rochester a rare Mayan stele, *Two Dancing War-
riors*, from Yucatan was acquired before the Mexican govern-
ment banned export of its national treasures.

But, as mentioned before, Rochester's pride is her rich
Medieval collection: sarc phagi, capitals, ivories, illuminated
manuscripts, enamels, a frescoed apse from a chapel in Auvergne,
sculpture, stained glass, tapestries. A highlight among many
objects is a 13th century French limestone capital, *Doubting
Thomas, Christ and Apostles*. That St. Thomas's head is missing
merely sharpens the wonder. The Renaissance includes panel

paintings such as *Madonna and Child Enthroned,* by the Master of the St. Ursula Legend, and *St. Margaret with Donor* by another 15th century artist, Vrancke van der Stockt. This panel is the right wing of a triptych; the left is to be found at the Allen Memorial Museum in Oberlin, Ohio. The painting schools of the 17th to 20th centuries give us Rembrandt, Van Dyck, Hals, Reynolds, Raeburn, Magnasco, Philippe de Champaigne, Boucher, Delacroix, Constable, Courbet, two splendid Monets, Degas, Braque, Léger, Matisse, Picasso and a fine Cézanne, *L'Estaque.* The Americans start with Primitive painters and the Colonials. A stern portrait of Nathaniel Rochester, the city's founder, is here, together with an engaging canvas by George Catlin which was commissioned by the Colt Firearms Company as an advertisement. It shows Indians pinging away at a skyful of flamingoes with Colt's best. The gallery of early American art and artifacts includes Federal pieces from Rochester and the Hudson Valley area and some delightful Victorian decorative aberrations. Homer, Eakins and Ryder are shown, along with the Eight—those recorders of the homely side of American life—and later 20th century old masters, Max Weber, Hans Hofmann and Stuart Davis. The sculpture section is continually being enriched. Maillol, Tony Smith, Nadelman, Noguchi and Lachaise take their place with new talents such as local sculptor Bill Sellers.

Don't leave Rochester without visiting the International Museum of Photography at George Eastman House.

SYRACUSE

EVERSON MUSEUM OF ART

401 Harrison Street, Syracuse, New York

Hours: Tues.–Sun. 12–5; Sat. 10–5
Closed: Mon.

The Everson Museum, designed by I. M. Pei, is quite consciously a piece of abstract sculpture. As *Progressive Architecture* remarked at the time of the museum's opening in 1968, "it is a work of art to house works of art." To paraphrase Max W.

Sullivan, the then director who nurtured every phase of planning and construction, it is a glowing, pink Croghan granite structure of intractable character. The granite was quarried 80 miles from Syracuse.

The entrance hall staircase convolutes to an upper balcony platform. The rough, rose beige walls of the court are softened by balcony boxes of greenery. The four large upstairs galleries are connected by corridors looking over the central entrance court, where sunlight pours from skylights around the ceiling's edges.

The Everson's roots go back to 1896 and the Syracuse Museum of Fine Arts, which it succeeded. It has been well known on the national scene since 1932, when it established a National Ceramic Bi-Annual that continues to bring together the leading ceramicists in America.

Paintings tend to be American and range from primitive to current. The heaviest holdings are probably in the early 20th century school: Arthur B. Davies, Childe Hassam, William M. Chase, Robert Henri, John Sloan and a few offbeats, such as Louis Eilshemius. Some contemporary artists represented by important works are Henry Moore, Barbara Hepworth, Morris Louis, Jason Seley and Ernest Trova.

Areas of specialized interest are the Lake Collection of 18th and 19th century English porcelains and the Cloud Wampler Collection of Oriental Art with special emphasis in its Chinese holdings. In the field of antiquities Syracuse proudly displays ten Greek vases from her long-ago sister city Siracusa (founded 734 B.C.).

Charles E. Burchfield: Six O'Clock (Everson Museum of Art, Syracuse, N.Y.)

But this is an action museum. Every effort is made to involve the community in the museum's activities and exhibitions. It has even been called a mini convention center. One innovation which, it is hoped, will have far-reaching effects is Syracuse's program at the Auburn (New York) State Prison designed to bring inmates back into society through art instruction. An exhibition of their work, called "From Within," was deemed worthy by art critics to travel to other museums in the United States.

In direct contradiction to its far-out programs is the museum's relation to the Onondaga Historical Association. A spacious downstairs gallery gives permanent residence to the association to display art and artifacts of historical significance of the region.

SYRACUSE UNIVERSITY: LOWE ART CENTER

309 University Place, Syracuse, New York

Hours: Mon.–Fri. 9–5
Closed: Major holidays

The university's main collection is housed in the Lowe Art Center on campus. During the 1960s the center embarked on an ambitious plan of commissioning murals for its various buildings. Among the artists participating were Jean Charlot, Marion Greenwood, Anton Refregier, Kenneth Callahan, Adja Yunkers, Robert Goodnough, Fred Conway and Ben Shahn. Shahn's work is a mosaic based on the famous Sacco-Vanzetti case. A gift to the university of Rico Lebrun's massive, moving triptych, *The Crucifixion*, sparked the project.

The spine of the collection at Lowe is in the American painting, sculpture and craft field. An exception is the recently acquired John R. Fox collection of Korean ceramics, which range from the Silla through the Yi dynasties. Another enviable gift is the Cloud Wampler print collection of more than 600 prints ranging from the 16th century Albrecht Altdorfer to the 20th century.

Sculptors Zorach, Duckworth, Lipchitz, Bertoia, Chaim Gross and Mestrovic, longtime sculptor in residence at Syracuse, are shown in monumental examples.

UTICA

MUNSON-WILLIAMS-PROCTOR INSTITUTE

310 Genesee Street, Utica, New York

Hours: Mon.–Sat. 10–5; Sun. 1–5
Closed: Major holidays
Library, restaurant

Not-so-old-timers will remember the two stately 19th century houses on Genesee Street that comprised the Munson-Williams-Proctor Institute. It all started when the Williams sisters married the Proctor brothers and established homes side by side. With an assist from Munson money (the sisters' mother was a Munson), they started traveling and collecting. The museum, chartered in 1919, opened in 1935 as a community cultural center. Several years ago one house was razed to make way for a new museum. The other, Fountain Elms, separated by a terrace and grove of honey locust, has been restored to its 1850 splendor. Rooms are done in period, and galleries of America's early decorative arts installed, plus memorabilia of the heyday of the Erie Canal.

The new museum built in 1960 is an exciting contrast. Its architect, Philip Johnson, raised an austere granite block on concrete piers sheathed in bronze, and set the building into a slope which reveals its full five stories from the back, while the entrance is reached directly from the street over a short bridge of stairs. In the entrance sculpture court even monumental pieces such as Leonard Baskin's *Angel* and Gaston Lachaise's *Torso* are, through placement, beautifully understated. Marino Marini's *Dancer* is poised under a fig tree whose leafy branches shoot above the second-story balcony. The hanging double stairway, audaciously simple, gives an elegantly Baroque feeling of space against teakwood walls and travertine floors. Wide balconies, from which the galleries flow, are suffused with natural light, pouring through the glass dome.

The institute collections are primarily of American art and decorative arts from the 18th century, with some European 20th century examples. There are also Old Master prints, Japanese woodcuts, and a collection in process of the ancient, primitive

ınd archaic cultures. But the emphasis is on today, as even this
·andom selection makes clear. There are major sculptures, such
ıs Duchamp-Villon's *The Horse* and Maillol's *Ile de France.*
Calder's *Three Arches,* an enormous stabile that looks like a pray-
ing mantis, is installed on the museum grounds. Major works
ɔf art are by Picasso, Mondrian, Kandinsky, Klee, Gris, Nichol-
son, Rouault, Luks, Henri, Stuart Davis, Pollock, O'Keeffe, Dove,
Marsh, Weber, Kuhn, Sheeler, Palmer, Gorky, Stamos, Tomlin,
Rothko, Okada, Baziotes, Marca-Relli and Nevelson.

For years the contemporary section gained impetus from
Edward Wales Root. His concern with American artists helped
build the extraordinary 20th century group. From nearby Clinton,
where he lived in the Homestead, house of his grandfather, Oren
Root, he acted as consultant on purchases. By the time he died
in 1956 he had enriched the institute with more than 200 im-
portant canvases, plus drawings and prints. Today the Home-
stead fittingly has become the Edward W. Root Center.

The early American works by Earl, Copley, Stuart, Peale and
others and the genre painters David Blythe and Eastman John-
son hang on teakwood walls on the lower floor. Four Hudson
River School paintings by Thomas Cole are handsomely installed.
This *Voyage of Life* series was commissioned for St. Luke's
Hospital in New York, where they hung for decades over four
radiators, getting darker and darker every year. The museum
bought and restored them to their original sumptuous, if muted,
colors. They epitomize the period influenced by England's Lake
Poets and our own Nathaniel Hawthorne. A second version of
this series is in the National Gallery of Art in Washington, D.C.
The institute owns the bulk of Arthur B. Davies's work. A native
of Utica, Davies was president of the revolutionary Armory
Show Group (1913), and he also advised Miss Lillie Bliss, a
founder of New York's Museum of Modern Art, on the building
of her collection.

A small gallery has been added at either end of the long
front gallery upstairs. One holds fine, small objects of Cycladic,
Etruscan, Egyptian, Greco-Roman and some Persian art; the
other, Mayan, Olmec and Zapotec pieces, including an outstand-
ing Olmec relief, *Colossal Jaguar Mask,* of the middle or late
Pre-Classic period, probably 800–100 B.C., found near Chalcat-
zingo, Morales, Mexico.

I find Utica one of the most thoroughly satisfying small museums in the country. A unique feature is a highly imaginative playroom for children, staffed so that the young may frolic while their parents contemplate.

Piet Mondrian: Horizontal Tree (Munson-Williams-Proctor Institute, Utica, N.Y.)

Interior, Sculpture Court (Munson-Williams-Proctor Institute, Utica, N.Y.)

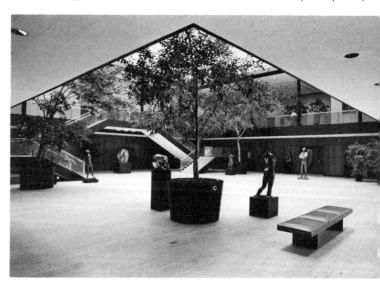

HUDSON RIVER MUSEUM

511 Warburton Avenue, Trevor Park, Yonkers, New York

*Hours: Tues.–Sat. 10–5; Wed. evenings 7–10; Sun., holidays 1–5
Closed: Mon., Christmas Eve and Day, New Year's Eve and Day
Library*

The 1877 home of financier John Bond Trevor situated on a slope of riverfront that is now Trevor Park became the museum's home in 1924. In 1969, the museum having outgrown its Victorian limitations, a new wing was added that takes advantage of the sloping terrain. The institution is now a complex that contains a museum, a historic house, a library and a planetarium. One enters an enclosed courtyard that opens into them. The house, whose interior was designed exclusively by John Locke Eastlake, is being restored as closely as possible to his original design. Eastlake, an Englishman and a tastemaker of the late 19th century, had a great influence in the United States. His book *Hints on Household Taste* was a best seller that dealt with such practical aesthetics as what *is* good taste.

The entrance-floor exhibition space is used for small shows or as a lead to the downstairs major exhibition space. From the end of the large gallery one looks out to the grandeur of the river and the high Palisades beyond—a real Hudson River School painting. The emphasis is on American culture, but at least once a year a major exhibition such as "The Arts of Oceania" is held. These are usually in-depth exhibits showing every facet of the culture and accompanied, whenever possible, by visual and audio aids.

The permanent collection is comprised of mostly 19th and 20th century masters with such artists as Ray Parker, George Segal, Richard Anuszkiewicz and Leon Smith being well represented.

Bronze Greek Head (University of North Carolina,
William Hayes Ackland Memorial Art Center,
Chapel Hill, N. C.)

NORTH CAROLINA

UNIVERSITY OF NORTH CAROLINA: WILLIAM HAYES ACKLAND MEMORIAL ART CENTER
South Columbia Street, Chapel Hill, North Carolina

Hours: Tues.–Sat. 10–5; Sun. 2–6
Closed: Mon., major holidays

The Ackland Art Center is the only museum in the United States where the donor's remains actually lie within the building his bounty made possible. Like those of Renaissance patrons of old, Ackland's sculptured, recumbent figure rests on a marble sarcophagus. Done in bronze by Milton Hebald with Baroque echoes, it is an imposing piece of sculpture. Ackland's interest in the arts led him to set up a trust to benefit students and public alike in the pursuit of the visual arts. His stipulation was that the institution be in the South.

Although the collections are formed primarily for the needs of students, their quality is far above that of most institutions of like size. The range is from Egyptian to Pop. A recent acquisition and a beauty is a bronze Greek head of the 1st to 4th century. Other important holdings are an impressive Limoges crucifix and a *Portrait Bust of Louis II de Bourbon, Prince of Condé* by Antoine Coysevox. The artist has given Louis XIV, friend of Molière and Racine, a strength and vitality seldom found in posthumous portraits. Among the works of art are: Delacroix's *Cleopatra and the Servant*, Rubens's *Imperial Couple*, Lancret's *The Dance before the Tent*, an important 1910 Max Weber, and a gleaming Arp *Sculpture-Seuil*. The shifting contemporary scene is shown in changing exhibitions. This center has many scholarly

exhibitions to its credit, and the art explorer roaming through
the scraggly pines of North Carolina would do well to check in
at Chapel Hill.

CHARLOTTE

MINT MUSEUM OF ART

501 Hempstead Place, Charlotte, North Carolina

*Hours: Tues., Wed., Fri. 10–5; Thurs. 10–9; Sat., Sun. 2–5
Closed: Mon., major holidays*

Few museums have been erected by an Act of Congress and
fewer still put to such varied uses as Charlotte's attractive Mint
Museum, designed in Classic Federal style in 1835. Before the
California gold fields opened, this North Carolina region was a
major gold-mining area. The government needed a mint nearby,
so up went its building. During the Civil War the building was
turned into conference headquarters, then became a hospital.

Museum Façade (Mint Museum of Art, Charlotte, N. C.)

From 1900 to 1903 Thomas Edison performed experiments there. Removed to its present site, it was opened as a museum in 1936. A new wing, adroitly placed so as not to detract from the purity of the Federal façade, has been added. Its center is a theater in the round, with galleries on the periphery.

The small permanent collection consists of Italian, Renaissance, Baroque, Dutch and some American paintings. Among the latter: Inness, Cropsey and a beautiful little John La Farge. An Allan Ramsey portrait of Queen Charlotte, for whom the town was named, hangs in the English gallery along with King George III, and Benjamin West's *Agriculture Aided by Arts and Commerce*, painted for Queen Charlotte's lodge at Windsor. Turner watercolors and an 18th century sedan chair, done after designs of Robert and James Adam, add to the English ambience.

The Delham Collection holds one of the country's most significant groups of documentary ceramics—ranging from Neolithic, Chinese, Near Eastern and Medieval, to 18th century and contemporary. The collection is strongest prior to the 18th century. There is a newly formed and beautifully installed Pre-Columbian section.

The museum hosts 11 state regional exhibitions, and a rental sales gallery offers work from these shows. With the opening up of space and rearrangement of the collections this small museum is a delight.

RALEIGH

NORTH CAROLINA MUSEUM OF ART

107 East Morgan Street, Raleigh, North Carolina

Hours: Tues.–Sat. 10–5; Sun. 2–6
Closed: Mon., major holidays
Library

Like her sister museum across the border in Richmond, Virginia, Raleigh's original collection was left by one man to a state that had no place in which to house it.

George Bellows: Nude with Fan (courtesy of North Carolina Museum of Art, Raleigh, N. C.)

When Robert F. Phifer, bachelor, *bon vivant*, traveler, died in 1928, his paintings hung in the Salamagundi and Calumet clubs in New York. Some 50 more hung or were stacked in his New York apartment. They had been willed to the North Carolina Art Society providing it assumed responsibility for housing them. Temporary quarters were found in a state agricultural building. The present museum opened in 1956 in a renovated Highway Department building. Robert Lee Humber, president of the North Carolina State Art Society, having wrung a promise of a million dollars' worth of paintings from the Kress Foundation, badgered the state into a matching grant. William Valentiner, longtime head of the Detroit Museum, came out of retirement to assume directorship. The Phifer Fund still provides for major contributions; top among them is Stefan Lochner's *St. Jerome in His Study*, and a fine group of Spanish still lifes.

The museum's emphasis is on painting, though there is a small group of Greek and Roman antiquities and two stunning Old Kingdom reliefs, VI Dynasty, are recent acquisitions. The Kress Collection starts with Giotto and his school, and includes Tintoretto and Veronese and some northern Europeans.

The museum is rich in Rubens, including his portraits of *Philip III* and *Dr. Theodore de Mayerne*, court physician to

James I and Charles I of England. His *The Bear Hunt* is a fierce picture of plunging horses and plumed gallants wrestling with the bear. The animals are the work of Paul de Vos, a painter attached to Rubens's workshop, whose forte was animal portrayal. Several canvases by Van Dyck, Rubens's great pupil, include a full-length portrait of *Mary, Duchess of Lennox*, with her young son in the habiliment of Cupid beside her. The French rooms have a *fête galante* air about them, with bouncing Boucher cupids romping about on clouds and five Beauvais tapestries depicting carefree life in prerevolutionary France. Nattier has painted Mme. de Pompadour's daughter-in-law, *Madame de Vintimille*, splendidly alive, adjusting the Grecian headdress which the artist liked his sitters to wear. Chardin's handsome *Kitchen Table with a Ray Fish* brings us back to reality. The museum has two splendid Rembrandts, *Young Man with a Sword* and the richly expressive *Esther's Feast*, painted when the artist was only twenty. Another accomplishment of a twenty-year-old here is Raphael's *St. Jerome Punishing the Heretic Sabinian*.

In every one of the 56 galleries there are treasures: Teniers the Younger's *Armorer's Shop*, probably dating from the years when he was painter and curator for the governor of the Spanish Netherlands, Archduke Leopold William; Hendrick Terbrugghen's *Young Man with a Wine Glass by Candlelight*; and Frans Pourbus the Elder's *God Creating the Animals*—Pourbus was one of the first artists to paint animals from life.

The American section begins with Copley's *Sir William Pep-*

Georgia O'Keeffe: Cebolla Church (courtesy of North Carolina Museum of Art, Raleigh, N. C.)

perell and His Family. It was done after both painter and sitters had turned their backs on the American Revolution and settled in England. Copley, who became a Royal Academician, shows in his canvas the elaborate composition characteristic of the English portrait school. A poignant footnote: Lady Pepperell died during the voyage back to England. When her husband commissioned the portrait, Copley, who had painted Lady Pepperell before her marriage, drew on his memory and used his own wife as the model for the figure. Also at Raleigh: Gilbert Stuart's portraits of the king and queen during whose reign America won independence, George III and his wife Charlotte.

Raleigh's collecting in the 20th century field is not exactly venturesome, but two recently acquired canvases show the artists at their best: George Bellows's *Nude with Fan* and Georgia O'Keeffe's *Cebolla Church*. To Raleigh Dr. Valentiner left 19 canvases by Morris Graves, three Diebenkorns, three Beckmanns, paintings by Baziotes, Gottlieb, Miró, Klee and Kandinsky, and a group of German Expressionist works. Perhaps Valentiner's concentration on this group was due to the fact that his sergeant in the German army, World War I, was Franz Marc, a member of the Blue Rider movement.

A new museum is in the making for Raleigh with Edward Durell Stone as architect. Director emeritus Justus Bier and the staff have presented a detailed and thoughtful statement relating to architectural needs. The design includes an auditorium, conservation laboratory, audiovisual areas, cafeteria, picnic room for school children, an extended gallery for the blind (Raleigh was one of the first museums to have such a gallery) and a complex of educational galleries. While the site has not at this writing been determined, it is to include ample grounds for outdoor sculpture.

OHIO

AKRON

AKRON ART INSTITUTE
69 East Market Street, Akron, Ohio

Hours: Sun.–Fri. 12–5; 10–5; Wed., Thurs. evenings 7–10

The Akron Art Institute is a good example of how a lively museum can be created without much of a permanent collection to draw from. The museum, however, is again building in this area. One main gallery contains selections from their 20th century collection—Warhol, Judd, Davis, Clarke, Segal, Bell and Diao plus earlier works of Burchfield, Henri, Chase, Dewing and others. The remainder of the building has a changing program, dealing with architecture, design and all of the 20th century expressions.

CINCINNATI

CINCINNATI ART MUSEUM
Eden Park, Cincinnati, Ohio

Hours: Mon.–Sat. 10–5; Sun., holidays 1–5
Closed: Thanksgiving, Dec. 25
Restaurant

Cincinnati was ready for art well before this museum opened in 1886. Early settlers had carted their family portraits, spinets and libraries across the mountains to settle on the banks of the Ohio.

In 1837 Nicholas Longworth sent the young sculptor Hiram Powers abroad to study. In the 1850s the Ladies Academy of Fine Arts planned a "gallery of good taste." But the Civil War intervened. The ladies, or their daughters, made a second start in 1877 with the Women's Art Museum Association; nine years later a formidable Romanesque building, the core of today's museum, was opened.

To the right and left of the entrance is the world of antiquity. Rare Nabataean sculptures of the 1st and 2nd century from southern Jordan are to the left. Nowhere else outside Jordan can one see such a collection of Nabataean figure pieces. Proceed directly ahead for a résumé of Egyptian, Greek and Roman life and culture: a tense little Etruscan warrior of 6th to 5th century B.C.; a sacrificial heifer, a 3rd century B.C. copy of a sculpture by Myron. The original, a life-size bronze, stood on the Acropolis for centuries, then disappeared. An Athenian late 6th century B.C. bronze bull, grand and elegant, is a pet of scholars and amateurs. To the right of the entrance are pieces from the ancient Near East, pre-Persian, Persian, Sasanian and Islamic cultures.

In the next series of galleries are many works not large in scale but monumental in their significance, covering 3,000 years of Mesopotamian history. Noteworthy is the gold *Libation Bowl* of Darius the Great showing lions hunting. Found at Persepolis, it is inscribed in three languages "Darius Great King" (522–485 B.C.). Some stone reliefs also from Persepolis are placed as if they were *in situ* on the grand staircase.

A time span of centuries unrolls in works from Moslem India, greater India and China. *The Four Sages of Shang Shan,* largest and most important of the five unquestioned paintings which survive from the hand of Ma Yüan (A.D. 1190–1224), is among the rarest masterpieces of Chinese painting in America. The transition from East to West takes place in the decorative arts wing, beginning with a gallery of 18th century Chinese export ware popularly called Lowestoft. French, English and American period rooms adjoin a Henri IV salon (1608–1610), a bijou of painted panels recounting the story of Torquato Tasso's influential poem *Aminta.* With justifiable pride, Cincinnati stresses its own past. The Greek Revival hallway of the 1815 Kilgour House is set with marble busts of famous "Cincinnatians." Thomas Jefferson gave

the cider jug in the wall case to John Adams in the twilight of their lives. A plate from the Mount Vernon dinner service was a present from Washington to Hamilton.

Other galleries show silver, Continental porcelain, American glass and Cincinnati's own contribution to Art Nouveau, Rookwood pottery. An oval gallery downstairs holds late Roman and early Christian sculpture and leads into the Medieval Hall, one of the most satisfying enclaves in the museum. Among treasures here are a French 13th century sculpture of the donor of the Hospice of Salins and the great 12th century Spanish sculpture, the figure of *Don Sancho Saiz de Carillo*. This rare tomb portrait of wood lies on a low casket and has been faithfully reconstructed from the site in the Ermita de San Andres, Mahamud, province of Burgos. The noble head rests on a pillow. One hand holds gauntlets, while sword, chain and ring, accouterments of knighthood, can be seen.

Painting galleries are upstairs, with the Alms Wing reserved for changing exhibitions. The mood of the Italian Room is reminiscent of a great *galleria* in a Florentine *palazzo*. Again the centuries unroll. Who better represents the Renaissance than Mantegna with his *Esther and Mordecai*, one of six Mantegnas in America? Or Titian with his *Portrait of Philip II*, which Berenson called "a great painting, heroic without rhetoric," or Fra Angelico and his tiny tondo, *Madonna and Child with Goldfinch?*

We pass through the Spanish gallery to the reconstructed apse of San Baudelio de Berlanga (Spain). To fully appreciate the apse and its frescoes, get the monograph (in the museum shop) written by director emeritus Philip R. Adams. The story of the frescoes' transfer and tribulations makes fascinating reading.

The Spanish gallery holds great retables (the raised surface back of the altar, usually a painted triptych) at either end of the room. One by Lorenzo de Zaragoza shows events in the life of St. Peter. The other, the *Tendilla Retable*, was painted when the Count of Tendilla had defeated the Moors and Spain was mistress of the New World, the year Philip II became king of Spain.

Holland and Flanders are handsomely represented in Cincinnati by Rembrandt's *Young Girl Holding Medal*, Rubens's sketch of *Samson and Delilah*—a painting which scholars mark

Persian, 5th Century B.C.:
Attendant Carrying Wine-
skin (Cincinnati Art Mu-
seum, Cincinnati, Ohio)

as the beginning of Rubens's mature career (circa 1609)—Hans
Memling's two small panels of saints, Pieter de Hooch's precise
and luminous *Game of Skittles*, works by Ruisdael, Terborch
and Van Dyck, Nicolaas Maes's engaging *Titus, Son of Rem-
brandt*, and Joos van Cleve's portrait of the connoisseur king,
Francis I. It was Francis who brought Leonardo da Vinci to
France and in whose hands the aged Leonardo left the *Mona
Lisa*.

The English school contains Raeburn, Reynolds, Romney and
Lawrence, while Gainsborough has a room all to himself with
four landscapes and nine portraits, including *Lord Greville* and
a rare miniature of *Lord Mulgrave*, who commissioned *The
Cottage Door*, one large version of which hangs in the gallery.
The French galleries, extending back to Claude, celebrate the
flowering of art under the kings named Louis with paintings by
Watteau, Boucher and Fragonard, continue to the classicism of

Hans Memling: St. Stephen
(Cincinnati Art Museum,
Cincinnati, Ohio)

Ingres, the drama of Delacroix, and culminate in that great chapter of French art, Impressionism. Cézanne's first dated canvas, *Still Life with Bread and Eggs,* is wonderfully strong and rich. *Undergrowth* by van Gogh is a beautifully tranquil canvas from what we think of as his violent period, one month before he killed himself.

Octagonal galleries break the monotony of rectangular ones. One, full of small French treasures, leads into the new Mary Johnston galleries with great Braques, Picassos, Grises, Rouaults, de Staëls and Modiglianis that have come to the collection from a recent bequest. Among the prints are many rare and unique Old Masters, an extensive contemporary group and the most complete single collection of contemporary Biblical and religious prints in the country.

Representing America is a large and handsome section of paintings. Two delightful portraits are Charles Willson Peale's

Paul Cézanne: Still Life with Bread and Eggs
(Cincinnati Art Museum, Cincinnati, Ohio)

of Mr. and Mrs. Francis Bailey. Benjamin West's *Laertes and Ophelia* fills an entire wall and must have posed an engineering problem when Nicholas Longworth had it hauled over the Alleghenies in the 1830s. The painting had belonged to Robert Fulton, the inventor. Frank Duveneck, born across the river at Covington and presiding teacher in his time at the museum's art academy, is well represented as well as other native son artists, John Twachtman, Worthington Whittredge and Henry F. Farny, painter of western scenes, who has a gallery of his own. Outstanding is Grant Wood's savagely satirical *Daughters of Revolution* with *Washington Crossing the Delaware* shown in the background. The American watercolor section is rich in works by Homer, Sargent and Whistler.

The large center gallery upstairs is dominated by two enormous murals by Miró and Steinberg, commissioned for the Terrace Plaza Hotel. Shown with a large Calder mobile, these refugees from the Hilton chain are seen to fine advantage.

The museum is not strong on contemporary works, although there are good examples of Walt Kuhn, Will Barnet, Hans Hofmann, Balcomb Green, Helen Frankenthaler, Jim Dine, Sidney Butchkes, George Rickey, and so on. The Contemporary Arts

Center of Cincinnati picks up where the museum leaves off. The three great museums in Ohio complement rather than compete with each other: Toledo with its definitive glass collection, Cleveland with its Medieval and Oriental treasures, and Cincinnati with its superb Near Eastern holdings.

CONTEMPORARY ARTS CENTER
115 East 5th Street, Cincinnati, Ohio

Hours: Tues.–Sat. 10–5; Sun. 12–5

The Contemporary Arts Center keeps Cincinnatians in step with the latest developments on America's current art scene. Having no permanent collection, the staff devotes all its energies to bringing in or creating innovative exhibitions. A few have been "Eat Art," done by artists working in edible material, "20th Century Folk Art" and "Extraordinary Realities." Comparable to the Swiss and German Kunsthalles, the museum is a platform for viewing the current, the experimental, even the audacious in art movements.

A handsome shopping arcade reminiscent of Milan's Galleria occupies the first floor of the building. Broad stairs leading from the skylighted gallery bring one to the center, which occupies the entire upper tier. The large exhibit area has windows strategically placed to view the heroic sculpture on Fountain Square.

TAFT MUSEUM
316 Pike Street, Cincinnati, Ohio

Hours: Mon.–Sat. 10–5; Sun., holidays 2–5
Closed: Thanksgiving, Dec. 25
Library

The Charles Taft home, built in 1820 for Morton Baum, mayor of Cincinnati, evidences the transition from Federal to Greek Revival architecture. Baum sold the house to Nicholas Longworth. Later it passed to the Tafts, who gave it to the city in 1932 for a public museum.

Today, the lovely old edifice is virtually its original self. Tall cases in the style of the moldings and the mantels have been added to hold the decorative arts. These are rich in French Renaissance jewelry, Chinese porcelain, Italian majolica, rock crystal and enamels. Distinguished are two Leonard Limousin portraits, one of the *Duc de Guise* and the other of *Thomas Cranmer, Archbishop of Canterbury.*

Many canvases hang exactly where they did during the long years that the Tafts occupied the house. The Dutch and English schools of painting are strong with 12 Turners and three important works by Hals. There are three Rembrandts: *Man Leaning on a Sill* and *Portrait of a Young Man*, an early work which can be compared with his late *An Elderly Woman*, in the same room. There are two Goyas—*Toreador* and *Portrait of Queen Maria Luisa*. In the second, the artist comes as close to satire as was safe for a court painter, showing the queen as a plump woman with a mean little mouth, vainly overjeweled, her crowning arrogance a foot-long diamond arrow stabbing through a mop of black hair.

The necessarily static quality upstairs disappears as one descends to the Garden Gallery, an area given over to lively tem-

porary exhibitions. These range from Taiwan's *Fifth Moon Group* to exhibitions for children that are so amusingly sophisticated that the parents are the ones who must be led away.

Gardens around the house make a haven from the streets of downtown Cincinnati. Nicholas Longworth spent a good deal of time on the plantings. A family story tells how a tall young man leaned over the fence one day and asked Longworth, grubby in old gardening clothes, if he thought his master would mind his looking around the gardens. Without identifying himself, Longworth took the stranger around. The young man was Abraham Lincoln on his first trip to Cincinnati.

CLEVELAND

THE CLEVELAND MUSEUM OF ART
11150 East Boulevard, Cleveland, Ohio

Hours: Tues., Thurs., Fri. 10–6; Wed. 10–10; Sat. 9–5; Sun. 1–6; for special events, the Education Wing may remain open until 10 P.M.
Closed: Mon., major holidays
Restaurant, library

Since its opening in 1916 the museum has been blessed with enlightened trustees and collector-donors and astute directors. As early as 1905 Henry Watson Kent, a staff member of New York's Metropolitan Museum and a man knowing in the design and operation of museums, defined for the newly formed institution the function of a museum as "acquisition, exhibition and exposition." This basic principle has been adhered to by the Cleveland Museum ever since.

William Milliken, curator from 1919 and director from 1930 to 1958, brought international fame to the institution with the purchase of the cream of the Guelph Treasure. This was the greatest Medieval cache to come on the market in a century. Hitler bought what was left for the Third Reich. Recent Medieval acquisitions, a group of early Christian sculptures, include four

tours de force in marble of *Jonah and the Whale.*

Money, rapacity and an "eye for excellence" have fashioned Cleveland's superb collections. What is now acknowledged one of the most important ancient Chinese objects in America, *Cranes and Serpents* (late Chou, 600–22 B.C.), was turned down years ago by Boston and the Freer before being picked up by Cleveland. *The Death of Adonis* by José de Ribera was found dirty and unattributed in a Geneva library by Sherman Lee, the present director. The same discernment was demonstrated when a striking early Velázquez, *Portrait of the Jester Calabazas,* came into the Cleveland fold. An extremely important painting by the 16th century German artist Matthias Grunewald, one of two in this country (the other is in the National Gallery in Washington), has recently come to the museum. Little is known of Grunewald's life. His paintings number about twenty, including his great masterpiece the Isenheim altarpiece at Colmar, France. Cleveland's *St. Catherine of Alexandria* is presumably part of an altarpiece, which is known through drawings in German and Dutch collections, but which has disappeared. *The Descent from the Cross* has been described by Sherman Lee as one of the most important Baroque ivories known. Commissioned by Prince Eusebius von Liechtenstein from sculptor Adam Lenckhardt in 1646, the 17½-inch piece includes eight figures carved from a single piece of ivory.

The original white Georgian marble Neo-Classical building had been added to in a traditional manner as the need arose. In 1971 an educational wing designed by Marcel Breuer was built. It houses two lecture halls, three audiovisual rooms, classrooms and a 750-seat auditorium. Music has always played an important part in the museum's programs, and the great organ formerly in the Garden Court has been moved here.

While the old entrance is still used, the large handsome foyer joining the new wing is a popular beginning point. To the left of its main door is a gallery of noble proportions and innovative lighting which is used for changing exhibitions. On the second floor a great headless Mesopotamian figure of dolerite stone, his hands in folded majesty, leads one into the antiquities, where in striking installations the cultures flow. To isolate treasures is impossible. The Hittite priest-king figure gives way to the Egyptian, the Greek and the Roman; the little *Negro Beggar,*

an Alexandrian bronze of the 2nd century, on to the early Christian and Byzantine and Medieval objects, none of this in profusion but in highly selective examples.

The Oriental and Asiatic galleries unfold their mysteries from the Bronze Age to later sophistication from China, Japan, India and Southeast Asia. Whether it's the Bronze Bell of fifth century China, the monumental placidity of the seventh century Cambodian *Vishnu* or the exquisite delicacy of the Korin-style small lacquer box of 17th century Japan, every object is almost reverently placed. The Oriental section also holds the delectable *Chinese Album* of paintings, three great early landscape scrolls, Shang-Yin and Chou bronzes, the Imperial Collection of Sung Dynasty porcelains, and the only group in the Western world of Japanese Buddhist wood sculpture of the 7th and 8th centuries. The Japanese scrolls are rotated every two months. Cleveland's collection of Japanese art encompasses every facet of the country's civilization.

Japan, Nambokucho Period: White Robed Kannon (Cleveland Museum of Art, Cleveland, Ohio. Leonard C. Hanna, Jr., Bequest)

Hittite Priest-King Figure (courtesy Cleveland Museum of Art, Cleveland, Ohio. Leonard C. Hanna, Jr., Bequest)

The gallery that holds the impressive Indian sculpture is so arranged that one can view it from above before performing the slow ritual of descent to inspect its nearer beauties. The Pre-Columbian group is again not large but choice, including a noble Olmec *Stone Figure*, a great Mayan head of a god, a Mayan bas-relief of a priestess in ceremonial headdress and a terra cotta and turquoise mask of Mexico's Mixtec culture.

Matthias Grünewald: St. Catherine (Cleveland Museum of Art, Cleveland, Ohio. Leonard C. Hanna, Jr., Bequest)

Western painting starts with an Italian Primitive which an early donor had the wit to purchase from James Jackson Jarves (see Yale) and with Giovanni di Paolo's *St. Catherine Invested with the Dominican Habit*. Filippino Lippi's tondo of the *Holy Family with St. Margaret and St. John* is one of the great Lippis. Rembrandt's moving *Old Man Praying* has lately joined three other Rembrandts here. *Diana and Her Nymphs Departing for the Hunt* is an early work of Rubens's mature period, a style little known in America. The recently acquired and only Guido Reni altarpiece in America was commissioned by the Barbarini family in Rome. Cleveland's smallest painting is one of its most famous: a 7-by-5-inch section of a larger polyptych of *St. John the Baptist*, attributed to the Master of Flémalle (see the Cloisters). The galleries glow with Titian, Tintoretto, El Greco. Goya's portrait of the *Infante Don Luis de Borbon* is one of the great Goyas in America. Entering the small gold and white airy gallery of German and Austrian Baroque art is like stepping onto a cloud. Monet's shimmering *Water Lilies*, with the sweet sleepy smell of the garden about them, and Picasso's *La Vie*, from his Blue Period, indicate the strength of the Impressionist and Post-Impressionist section.

Prints range from 15th century Italians and Germans to the present. A late acquisition from Prince Liechtenstein's Collection is Antonio Pollaiuolo's *Battle of Naked Men*, which has been identified as a previously unrecognized first state of the work.

Since the building of its 1958 wing the American section has broadened its historical survey by more than 500 works. The expanding contemporary section constitutes a small museum of modern art and makes a smashing impression when installed in the large first-floor gallery. A few examples are Olitski, Diller, Noland, Bontecou, Johns, Chamberlain, Tworkov, Rothko, Lindner, de Kooning (surely his most womanly woman) and Noguchi.

To speak of the Cleveland Museum and not pay tribute to Leonard Hanna would be like ignoring Andrew Mellon in speaking of the National Gallery. Through long years the Hanna Fund aided the museum in its purchases. Hanna's fine collection of some 40 19th century French paintings was left, together with his considerable estate, to the museum. Like Mellon a modest man, he would not allow the wing his money built to bear his name.

COLUMBUS

COLUMBUS GALLERY OF FINE ARTS
480 East Broad Street, Columbus, Ohio

Hours: Daily 12–5
Closed: Major holidays
Library

The museum's founding father, Francis C. Sessions, was in the familiar 19th century tradition—a wealthy private collector who left his home, his pictures and his statuary to the city.

In 1931 a pleasant Neo-Classic building replaced the Sessions house, and into it went Ferdinand Howald's distinguished collection of contemporary American art. No one knew what led Howald, a thoughtful, reticent bachelor and owner of the town's leading furniture store, to become one of the century's most courageous and selective collectors of American art. By 1908 Howald was purchasing such American Impressionists as Ernest Lawson and works of other then unknown young artists. A recluse, he never met any of the men whose paintings he collected with such taste and foresight. He did most of his buying through the small Daniels Gallery on New York's Madison Avenue, including some of the first canvases by Peter Blume, Max Weber and Kuniyoshi. Later, he moved into the modern French field, buying Picasso and Matisse at a time when most midwesterners were still looking for bargains in Bierstadt. The glory of Howald's gift to Columbus is one of the finest collections extant of such recognized Americans as Marin (28 watercolors), Demuth (28), Prendergast (14) and the largest group of Pascins in any museum in the country.

Another collector important in the gallery's growth was Frederick Schumacher. His preferences were for the English portrait school and 17th century Dutch flower painting. An outstanding picture in the Schumacher group is the portrait of *William Robert Fitzgerald, 2nd Duke of Leinster* by Sir Joshua Reynolds, executed with all his subtle richness and elegance.

The stately entrance to the museum opens into the Derby Court, a high skylighted space, hospitable to large sculpture and painting. One addition, courtesy of the Derby Fund, is *Christ*

Triumphant over Sin and Death by Rubens. Large altarpieces completely by Rubens's hand are unusual outside European royal collections or the churches for which they were painted. Rubens did this one in 1618 at the zenith of his productivity. Another Derby Fund picture, *Christina Bruce, Countess of Devonshire*, by Anthony Van Dyck, was painted about 1632 and remained in the family until its recent migration to America. From Derby Court the new wing (1974) opens into stupendous second-floor gallery space which will be used mainly for temporary exhibitions. The main entrance of the wing (designed by Columbus architects Van Buren and Firestone) is on the east side of the building. The elegant spacious foyer and broad stairwell form a perfect background for such large contemporary paintings and sculpture as those of Carl Morris, Helen Frankenthaler, Robert Goodnough, Kenneth Noland, Stanley Twardowicz and Archipenko. While the

Pablo Picasso: Boy with Cattle (Columbus Gallery of Fine Arts, Columbus, Ohio. Gift of Ferdinand Howald)

general range of the collection is wide, beginning with the antiquities and including some fine pieces of Renaissance sculpture, painting predominates.

In Sebastiano del Piombo's portrait of *Vittoria Colonna and Ferdinando d'Avalos*, her husband, del Piombo caught the fine, austere intelligence of Vittoria Colonna, for it was around her that writers, artists and the intellectuals of the day gathered. Del Piombo's own teacher, Michelangelo, was Vittoria Colonna's long-time platonic love, and of her he was to say that she perfected his character as a sculptor perfects his clay model, "by carving it into hard living stone." A magnificent portrait by Bronzino of the elderly Vittoria hangs in the de Young Museum in San Francisco.

Most of the French paintings, with the exception of Renoir's charming *Madame Henriot in Fancy Dress Costume*, are modest in scale. Among the group are an especially succinct landscape by Derain, four Matisses, Monet, Lautrec, Picasso's *Boy with Cattle*, and a slightly surrealist charmer, *The Trooper* (1872), by Jacques Mauny.

One American gallery holds important treasures: Winslow Homer's *Girl in the Orchard*, William Harnett's *After the Hunt*, Walt Kuhn's *Veteran Acrobat*, and the picture that Thomas Eakins certainly considered one of his best works. On election to the National Academy the custom was for the artist to give the academy a painting he wished to be remembered by. Eakins gave at his election in 1902 *The Wrestlers*.

The town takes inordinate pride in its native son, painter George Bellows. Some of his choicest paintings, including *Portrait of My Mother, Polo at Lakewood, Blue Snow* and *Children on the Porch*, are here in the Bellows room.

The decorative arts section, not large but general in concept, has been given a new installation on the lower floor.

DAYTON

DAYTON ART INSTITUTE
Forest and Riverview avenues, Dayton, Ohio

Hours: Tues.–Fri., Sun. 12–5; Sat. 9–5
Closed: Mon., major holidays
Library, restaurant

Italian Renaissance *palazzi*, above all the Villa d'Este, inspired the museum Mrs. Harrie G. Carnell gave Dayton in 1929. (Recently a handsome new art school wing has been added.) The ponderousness of the architecture is relieved by inviting conversational areas that beckon hospitably as one enters. On the twin stair landing hangs a portrait of *Elias Jonathan Dayton*, the city's founder. It is a good example of the popular 19th century painter Thomas Sully. The stair continues to a high-ceilinged marble sculpture hall.

Originally, as in many museums, the collection reflected the predilection of the donor. Mrs. Carnell preferred Oriental art. However, out of a sizable collection, much is reserved for study; only objects of top quality are displayed, on the theory that the average layman benefits most from seeing the best. The best includes a small silver vase of the T'ang Dynasty (A.D. 618–906) with birds and animals in exquisite gold reliefs, one of two such pieces in America. The other is in the Boston Museum of Fine Arts. In the last Oriental gallery, the dawn of Chinese Buddhist sculpture is exemplified by a Bodhisattva head from the temple caves (Northern Wei Dynasty, about A.D. 500). This was carved from the living rock of a cave temple. Simple and strong, the head is a fine contrast to a sophisticated and worldly Kuan Yin head in dry clay of the Sung Dynasty, A.D. 960–1279.

Many fine pieces show the range of Indian culture. Favorites are a vital carving of *Shiva and Parvat* (7th to 9th century) from central India and a granite, 10th century, south Indian *Vaishnavi*. Rare Korean stoneware that looks like bronze is from the Old Silla Dynasty. The Pre-Columbian collection, Chavin and Mochican, also holds Mayan pieces and what must be one of the finest gold and copper funerary masks in existence. A large Mayan

Chimu, Peru: Mummy Mask (Dayton Art Institute, Dayton, Ohio)

relief on which traces of polychrome remain shows two old priests sitting cross-legged, eyeing each other.

With limited acquisition funds, Dayton's purchasing policy seems to be to outwit the market, hence the good collection of Baroque paintings purchased just before the current vogue for that exuberant school. Today concentration is on marble sculpture, including small Franco-Flemish pieces and a monumental *Aphrodite Pudico* with Eros astride a dolphin, Greco-Roman period. Among the paintings is one fine psychological canvas, *Portrait of a Widow*, by Ludovico Carracci. In 1848 it was put up for sale in a Paris auction room as a portrait of Mary Stuart by Velázquez. The attribution was not entirely foolish, as scholars who have lately studied Velázquez hold that he may well have been influenced by Ludovico, who, with his painter nephews, had established the first academy of painting in Bologna some years before Velázquez, young and impressionable, visited Italy. Other recent purchases are *Boy Violinist* by Hendrick Terbrugghen, the

first Dutchman influenced by Caravaggio; Rubens's painting of his friend *Daniel Nys; St. Sebastian* by Paolo Pagani; and *St. Francis in Ecstasy* by Bernardo Strozzi. A superb *quattrocento cassone* panel by Jacopo del Sellaio is here.

A gallery off the sculpture hall holds small 19th century canvases, among them two by Edward Edmondson, a talented Dayton 19th century painter who has recently been rediscovered. Edmondson seemed equally adept at portraiture, landscape and still life. Dayton owns 29 of his canvases.

The museum keeps abreast of current forms. Some artists represented are Oldenburg, Warhol, Appel, Lichtenstein, Olitski, Reinhardt, Motherwell, Ray Parker and Carl Morris. A rather atypical, stunning, small silver piece by David Smith was done the year before he died.

OBERLIN

ALLEN MEMORIAL ART MUSEUM
Oberlin, Ohio

Hours: Winter: Mon.–Fri. 10–12 (side gate), 1:30–4:30; 7 P.M.– 9 P.M.; Sat. 10–12 (side gate), 2–5:30; Sun. 2–5:30. Summer: Mon.–Fri. 10–12, 2–4; Sat., Sun. 1–5
Closed: Major holidays

Cass Gilbert, New York architect, called upon local quarries for this buff and pink Italianate museum, the gift of Dr. Dudley Peter Allen, a distinguished Cleveland surgeon. As soon as it opened in 1917, the first college museum west of the Alleghenies, the trustees embarked upon the serious business of forming a collection. Charles L. Freer (see Freer Gallery, Washington) had previously given Chinese and Japanese paintings and ceramics. The opening of the museum stimulated more check writing. But it was the establishment in 1940 by a former graduate, R. T. Miller, of a generous purchasing fund that allowed the college to compete in the marketplace for such masterpieces as Hendrick Terbrugghen's *St. Sebastian* and Jusepe Ribera's *Blind Old Beggar*. The

Benjamin West: General Kosciusko (Oberlin College, Allen Art Museum, Oberlin, Ohio)

Kress Foundation added to the considerable 15th and 16th century Italian group. While not abounding in great names, the canvases are of unusual interest, especially the Dutch, German and Spanish. The 19th century French come off well, with works by Cézanne and Pissarro and two gleaming Sisleys (though English by birth, Sisley is always counted among the French). A little charmer is *The Crowd* by Felix Vallaton. Daumier, on seeing Monet's *Garden of the Princess, Louvre* in a gallery window, urged the proprietor to take the horror out. While not agreeing with Daumier, we prefer the Monet *Wisteria* also at Oberlin. Kokoschka, Kirchner, Modigliani, Picasso, Braque and Matisse bring us into the 20th century, to Jim Dine and Larry Poons, Morris Louis and Frank Stella.

Sculpture starts with the Sumerians and Egyptians, goes on to the Etruscans and Romans, proceeds from the Copts to Medieval and Renaissance artists. A wild little Tuscan *Mask of a Fawn* is arresting. An early 17th century Netherlands ivory, *Expulsion from*

Paradise, shows a coy and unrepenting Eve and Adam. Rodin's *Prodigal Son*, Picasso, Maillol, Despiau, Moore, Arp, Oldenburg and Sol LeWitt bring sculpture to the present. Those interested in American glass will find a selection from a group of 1,400 pressed goblets on display during the summer months. The 1967 catalog of the collection, compiled by art historian Wolfgang Stechow, is a must for the serious visitor.

TOLEDO

TOLEDO MUSEUM OF ART

Monroe Street at Scottwood Avenue, Toledo, Ohio

Hours: Sun., Mon., holidays 1–5; Tues.–Sat. 9–5
Closed: Jan. 1, Dec. 25
Library, restaurant

Understandably, one of the great collections in Toledo is glass— ancient, Islamic, European and American. Edward Drummond Libbey transferred his glass manufacturing company from Cambridge, Massachusetts, to Toledo in 1880. With him he brought Mike Owens, who invented the first machine for blowing bottles, the basis of the Libbey-Owens success and fortune. Unlike many other tycoons of the era, Libbey had a deep love of the arts. When most American drawing rooms were hung with Barbizon forests, he was purchasing for his home the Rembrandt and Hals which form the basis for Toledo's fine Dutch and Flemish collection. His was the motivating force behind a group of citizens to open, in 1901, Toledo's first art gallery in one large room of a downtown office building.

In 1912 the first portion of the present museum was opened. The Classical entrance façade remains the same today. Two large wings which tripled the museum's size were built in 1933. As the collections grew they expanded into this space. The final extension in 1971 allows for galleries for changing exhibitions. A print study room contains a fine collection of contemporary prints as

well as the usual Old Master representation. The second entrance on Grove Place, close to the museum parking lot, leads into this wing. Despiau's monumental bronze *Assia* stands here in greeting. However, on a first visit one should use the main entrance and orient oneself with a floor plan.

When it comes to glass, all roads lead to Toledo and its important historical collection. A stunning new installation has been created—a glass museum within the museum proper. The ancient glass, whether Egyptian, Syrian, Sassanian or Mycenaean, is shown in distinguished examples. Toledo has a fine Roman piece, Amphora or Cameo Vase, 1st century, which is comparable to the British Museum's Portland Vase. There are superb examples of Islamic glass, including the Toledo Flagon (Toledo, Spain, circa 1500), and European glass through Art Nouveau. American glass starts with the Jamestown Eight glass blowers, members of the group who settled in Virginia in 1607, and ends with a stunning example of Dominick Labino, who works in Toledo. Cut glass for which Libbey set the standard is interestingly represented.

The American painting section is not large, but all important periods are covered. One starts with the contemporaries such as Kitaj, Rothko, Reinhardt, Jimmy Ernst, Hedda Sterne and Frank Stella, and in orderly fashion works back through the 20th century to the Ashcan group, the genre painters, the Hudson River School to the Colonial period of Smibert, Greenwood, Copley and

Mameluk Dynasty: Islamic Sweetmeat Jar and Cover (Toledo Museum of Art, Toledo, Ohio. Edward Drummond Libbey)

Guido Reni: Venus and
Cupid (Toledo Museum
of Art, Toledo, Ohio.
Edward Drummond
Libbey)

Ralph Earl, represented by his stiffly appealing portrait of *The
Taylor Children*. Another high point is Thomas Cole's *The Archi-
tect's Dream*, a mixture of architectural monuments from the
pyramids to Gothic spires.

The Medieval Cloister is actually composed of arcades from
three abbeys but is so artfully reconstructed as to seem a single
unit (unless one studies the capitals).

The European painting section, while strongest in French art
from the 17th century to Matisse and de Staël, covers the Italian,
Dutch and Flemish well.

A glorious gay and light Rubens, *The Crowning of St. Cathe-
rine*, conveys an atmosphere more secular than religious. Paul J.
Sachs, the Harvard art historian, called this canvas "beyond ques-
tion the finest and purest Rubens in the country." Among the
Spaniards, Velázquez, El Greco, Zurbarán and Goya dominate.

Room from the Château de Chenailles (Toledo Museum of Art, Toledo, Ohio. Gift of Mr. & Mrs. Marvin S. Kobacker)

Christ at Gethsemane El Greco presents an atypical and in-
triguing study in circles—the sleeping Apostles wrapped in a
womblike fold, a round of guards, and a great moon plunging
through the clouds. His Annunciation on the same wall is a tender
personal interpretation. Italian paintings range from a severe
Romanesque panel to 17th century Baroque canvases. Piero di
Cosimo's Adoration of the Child is surely one of the two or three
great Renaissance tondi in America. Two figure panels by Luca
Signorelli are part of an altarpiece commissioned for the Bicchi
Chapel in Sant Agostino, Siena. An important predella panel from
the same altar is at the Clark Institute, Williamstown, Massachu-
setts. Of several impressive paintings acquired in the last few
years Mattia Preti's Feast of Herod, the horrifying scene of Salome
before the court, painted by the Neapolitan Baroque master, and
Pietro da Cortona's The Virgin Appearing to St. Bernard majes-
tically represent the Italian 17th century. A masterpiece that en-
tered the collection in 1964 is Francesco Primaticcio's Ulysses and
Penelope, a rare easel painting showing Ulysses recounting his
adventures to his wife Penelope. It is based on a fresco in the
Gallery of Ulysses at Fontainebleau, Primaticcio's greatest work.
Gerard David's St. Anthony Raising the Drowned Child is one
of three altarpiece scenes here illustrating St. Anthony of Padua's
miracles (the center panel is in the National Gallery). David, an
artist of the early Dutch Renaissance, painted in rich, deep colors.
Guido Reni's Venus and Cupid, a stunningly painted canvas, was
in the Dukes of Mantua collections, then lost for 100 years until
it appeared recently in a dealer's gallery. An important sculpture
is the over-life-sized limestone figure of the Greek goddess Am-
phitrite by Michel Anguier, court sculptor during the reign of
Louis XIV. A copy in marble is in the Louvre. Toledo's piece was
so popular during the 17th and 18th centuries that numerous
small replicas in bronze were made of her.

The decorative arts section has been enhanced by a series of
semicircular galleries, flowing enclaves which hold only its most
distinguished objects. Crowning the department is an engaging
17th century French room from the Château de Chenailles. Set
in the carved, gilded woodwork are 18 oil paintings which tell
the story of Rinaldo and Armina.

Libbey's last purchase was Manet's Portrait of Antonine
Proust (Proust wrote a book on Manet). The museum took it from

there and has built a fine group of Impressionist and Post-Impres-
sionist paintings. Don't overlook Cézanne's *The Avenue at Chan-
tilly* or an equally fine Courbet, *Landscape Near Ornans;* or the
older masterpiece, Poussin's *Mars and Venus,* and a great
Boucher, *The Mill at Charenton.*

Several galleries have been given a new dimension through
the discreet but interesting use of sound. By pressing a button
you can see and listen to a brief description of a period, or a
specific painting. An enchanting mid-18th century pagoda clock
softly plays Oriental tunes while a series of paintings flash on its
bell tower. In another gallery a Dutch cabinet organ plays a
period piece with the press of a button and gives its own history.
The as yet small African section concentrates on sculpture rather
than masks, house objects and such.

As a delightful special feature, a concert hall, or peristyle, with
a ceiling that turns blue to emulate the sky when the lights dim,
seats 1,700. This Hellenistic amphitheater is one of the most beauti-
ful auditoriums in the country. And it's acoustically perfect.

YOUNGSTOWN

THE BUTLER INSTITUTE OF AMERICAN ART

524 Wick Avenue, Youngstown, Ohio

Hours: Tues.–Sat. 10–4:30; Sun. 1–5
Closed: Mon., Thanksgiving, Dec. 25

J. G. Butler, Jr., was on a train headed for New York when he
received word that his house, with his collection of paintings, had
burned down. Twenty-four hours later the redoubtable Mr. Butler
was making plans with architects McKim, Mead and White for a
fireproof museum. Two years later, in 1919, the Butler Art Institute
opened. The present director, Joseph G. Butler, the grandson of
the founder, is the only hereditary museum director in the country.

In Youngstown, a town of one industry (steel) and many na-
tionalities, where the Poles did not speak to the Italians or the
Italians to the Germans, Grandfather Butler's decision to buy

othing but American art for his museum, a startler at the time,
worked as a bridge between nationalities.

The oldest paintings usually hang in the entrance gallery: a
Copley, a Stuart, a delightful Earl, the Strycker sisters, and a
magnificent pair of portraits by Charles Willson Peale. The big
three of the 19th century are well represented: Homer by *Snap
the Whip* plus a drawing and wood engraving of the painting,
Eakins by *The Coral Necklace* and *Portrait of General Cad-
walader*, and Ryder by the small *Roadside Meeting*. Another
beauty is Whistler's *The Thames from Battersea Bridge*. One
downstairs gallery shows sculpture and ceramics of the region, no

Everett Shinn: Dancer in White (Butler Institute of American Art,
Youngstown, Ohio)

mean collection, as some of the top ceramicists we have work
and around Cleveland. On the stair landing is a complete set
miniatures of the presidents of the United States. All those pr
dating Woodrow Wilson were once owned by Diamond Ji
Brady, who is said to have lost them in a poker game . . . but n
to Mr. Butler. Two galleries have a sea theme, the second
generation Mr. Butler's hobby. Clipper ship paintings, engraving
ship models, Fitzhugh Lane's ships and Reginald Marsh's lust
Belles of the Battery enjoy one another's company. Steamshi
paintings and prints have joined the others, so the group is no
called "From Sail to Steam."

Sole survivor of the fire that inspired the museum is a uniqu
American Indian group (it was on loan to the library at the time
Much of the work is by E. A. Burbank, cousin of the naturalis
Luther, and J. H. Sharp. Burbank worked among the Siou
Apaches, Crows and Zunis, while Sharp went north to the Black
foot tribes. In small oil paintings of chiefs—Charging Skunk, Kick
ing Bear and Little Wound—each man had an intimate approac
and fresh, vital style. No monotony here.

Though there are 16 galleries, the museum can display at on
time only a fifth of what the Butler owns. Generally on view ar
Burchfield's *September Wind and Rain*, Wyeth's *Sunset* an
Shahn's *Inside Looking Out*. Among contemporary painters ther
is the romantic realism of Colleen Browning and the starker real
ism of Carroll Cloar, plus interesting examples of Jack Zajac an
Philip Evergood. Most of the Action painters, the Minimal paint
ers, and many of the experimenters and pacesetters are missing
This is a museum whose director can afford the renaissance
gesture of purchasing and exhibiting only what he believes in
And he does.

Added in 1969, the 50th anniversary year, are two large air-
conditioned galleries where special exhibits and traveling shows
are held.

OKLAHOMA

OKLAHOMA ART CENTER
3113 Pershing Boulevard, Oklahoma City, Oklahoma

Tours: Tues.–Sat. 10–5; Sun. 1–5
Closed: Mon., major holidays

Ever since the Art Center was established in 1936 as a WPA arts project, it has been lively with lectures, concerts and traveling exhibitions. National and international shows have kept Oklahomans in touch with world art movements, while at the same time there has been concentration on the Southwest. The center is host to an Eight State Exhibition of Painting and Sculpture, a Young Talent show, and the National Print and Drawing Show. The collection consists of American contemporary painting and sculpture, some Old Master paintings and prints, good contemporary prints recently enriched by a gift of German Expressionist graphics, American glass and some Chinese porcelain. American holdings include works by Louis Eilshemius, Cameron Booth, Morris Kantor, Emil Carlson, Julian Levi, Nicolai Cikovsky, Cleve Gray and George Bellows.

Ground was broken for the present building in 1957. A round structure, its hub is an open court, ideal for the display of the sculpture collection.

T U L S A

THOMAS GILCREASE INSTITUTE OF AMERICAN HISTORY AND ART

2500 W. Newton Street, Tulsa, Oklahoma

Hours: Mon.–Sat. 9–5; Sun., holidays 1–5
Closed: Christmas
Library

In 1899 Thomas Gilcrease's father, part Cree Indian, received 160-acre tracts of land for his family. When he was twenty young Thomas obtained drilling tools for his tract; two years later he had become an instant millionaire and bought his first paintings That was in 1912. In 1963 a new museum was erected to house the prodigious collection of Remingtons (21 oils, 18 bronzes), Russells (29 oils, 25 watercolors, 28 bronzes), Catlins (74 oils, 137 watercolors) and a number of works by Alfred Jacob Miller, the first painter of the Rocky Mountain territory. This collection is second only to the one in the Smithsonian. But Gilcrease's in-

Thomas Moran: Grand Canyon (Thomas Gilcrease Institute of American History and Art, Tulsa, Okla.)

terest went far beyond the saga of the West. There are remarkable portraits of great Americans painted by artists of the caliber of Robert Feke, Ralph Earl, John Smibert and Benjamin West. The only portrait made from life of President James Madison (by Charles Willson Peale) is but one of many surprises to be found at the museum. Albert Bierstadt, Ralph Blakelock and Charles Wimar are shown in important examples, while Thomas Moran fills a handsome gallery with his romantic scenes.

When in 1955 Gilcrease found himself financially embarrassed and offered his collection to Tulsa for $2,500,000, grateful citizens voted four to one for a bond issue to purchase it. When he became solvent again he continued to add to the collection. When he died, a year and a half before the present building opened, Gilcrease had devoted much of his life to furthering America's historical art heritage.

A wealth of other material is still being cataloged: Mound Indian and Eskimo artifacts, Central American jades, Olmec terra cottas, and Incan and Mayan treasures.

The library collection is staggering: Cortés's papers, including his proclamation of the conquest of Mexico; Columbus's first known letter to his son from the New World; the original of Penn's Treaty, and the letter written by General Joseph Warren in 1775 telling Paul Revere to "proceed on a ride with all dispatch."

PHILBROOK ART CENTER

2727 South Rockford Road, Tulsa, Oklahoma

Hours: Tues.–Sat. 10–5; Tues. 7:30 P.M.–9:30 P.M.; Sun. 1–5
Closed: Mon., major holidays
Library

When oil magnate Wait Phillips retired, he left his ornate villa and his gardens to the Southwestern Art Association to develop as a museum. The Tulsa Art Association later merged its collection and funds with the association. The change of pace from elaborate Italianate décor on the ground floor to adobe-style galleries which have been added below is interestingly abrupt. In the adobe galleries, pottery is grouped according to pueblos and tribes. Clark Field, who assembled the pottery, chose only the best speci-

mens from those made for the Indians' own use. The American Indian wove into his baskets the history of his culture; those found in caves of Colorado, Utah and New Mexico tell of our early civilization. More importantly, the museum is actively helping the modern Indian to express himself creatively. Using new techniques and idioms, he draws on his own rich past for inspiration.

John Singleton Copley: Portrait of a Lady (Philbrook Art Center, Tulsa, Okla.)

It is, after all, not such a big step from the design of a Navaho blanket to an abstract painting.

The museum owns about 300 American Indian paintings which are constantly rotated, and holds an annual juried exhibition of Indian painters.

The upper galleries are used for changing exhibitions and to display the Kress and Clubb collections. Kress representation is in Italian art from the 14th to the 18th centuries. When her husband struck oil, Laura Clubb was teaching school in Kaw City, Oklahoma. Mr. Clubb asked his wife what they should do with "all that money," and Laura was ready with her own answer. She headed for Northwestern University and a course in the history of art. The next step was Europe. Her best buys, however, were the Americans Albert Blakelock, Alexander Wyant and Thomas Moran.

In 1871 Moran made his first of three trips with the Geological Survey of the Territories into the almost unexplored Yellowstone region. The artist's canvases, with their sense of the grandeur and extravagant beauty of Yosemite and Yellowstone, showed Americans the wonder of this enchanted, unknown land and led to the preservation of much of the area in national parks. Moran's quick watercolor sketches gave easterners their first idea of the magnitude and glory of the West. In 1872 and 1874 the government, through an Act of Congress, purchased two large Moran oils, *Grand Canyon at Yellowstone* and *Chasm in the Colorado*. They hung for years in the old Senate Office Building and are now on loan to the National Collection of Fine Arts, Washington. Moran is well represented in Tulsa.

A section of the main floor has been remodeled to house the excellent Gussman Collection of African Sculpture and the Ancient Heritage Collection, which includes art of Egypt, Mesopotamia, Etruria, Greece and Rome.

Another innovation at the Philbrook, which is doing so much to preserve the visual record of the West, is a gallery of southwestern architecture, commencing with today's skyscrapers and going back to Indian pueblos and cave dwellings.

Chinese Tomb Statue: Polo Player on Galloping Horse
(University of Oregon Museum of Art, Eugene, Ore.)

OREGON

UNIVERSITY OF OREGON MUSEUM OF ART

Eugene, Oregon

Hours: Tues., Thurs. 11–5; Wed., Fri.–Sun. 1–5
Closed: Mon., major holidays

The Murray Warner Collection of Oriental Art given to the university in 1921 inspired both state legislators and private citizens to erect a museum on campus. The Friends of Art, not a feature on other college campuses, does much to promote visual arts in this hall of Academe.

While the base of the Warner Collection is from the cultures of China and Japan, there are also works from Cambodia, Mongolia and Russia, as well as American and British works which show Oriental influence. Two galleries are devoted to the sculpture of India and Korea. A unique piece presented by New Yorker Winston Guest in 1957 is the Imperial Jade Pagoda from the palace of the Emperor K'ang near Peking. All jade and nine feet tall, the pagoda was rescued when the British and French fired the palace in the middle of the 19th century. Sold later to a Shanghai jeweler, it eventually came into the hands of our own famous Oriental firm of C. T. Loo. India and Nepal are also represented, and one gallery is given to Persian miniature painting and manuscripts.

A permanent gallery has been opened to show the important collection of Northwest contemporary art—more than 500 works, both archival and major, by the internationally renowned Northwest painter Morris Graves. Other talented Northwest artists shown are Tom Hardy, Mark Tobey, James McGarrell, Carl and Hilda Morris, Kenneth Callahan, Louis Bunce and, of course,

C. S. Price. While each has developed his personal idiom, the drama of the Puget Sound area, ringed by mountains and tall pines, seems subconsciously to permeate much of the work.

An extensive and varied changing exhibition program provides for the needs of both campus and town.

PORTLAND

PORTLAND ART MUSEUM

South West Park at Madison Street, Portland, Oregon

Hours: Tues.–Sun. 12–5; Fri. 12–10
Closed: Mon., major holidays

Portland's history established a climate for art. Her early settlers, sea captains and professional men, sailed around the Horn, their libraries and *objets d'art* stowed in the ships' holds. In 1914 while the rest of the art world was still reeling from New York's famed 1913 Armory show, Portland exhibited the Armory's most controversial painting, Marcel Duchamp's *Nude Descending a Staircase.* Also in 1914, Miss Sally Lewis purchased the first Brancusi to come to America, *Muse.* She later gave this to the museum along with a distinguished collection of Classical antiquities.

The building, designed by Pietro Belluschi in 1931, is a handsome structure of orange-red brick and travertine. Because it is as successfully contemporary today as it was in the 1930s, Mr. Belluschi's major extension of 1967 tunes itself perfectly to the original building.

A mall extends down one side. Here heroic sculptures by Renoir, Moore, Hepworth, Archipenko and Meadmore are placed each in its own tranquil setting. Adjacent downtown Portland seems far away.

The entrance, or sculpture court, with its large asymmetrically placed skylight, rises above the ceiling height of the second-floor galleries, giving dramatic views from all levels.

While it is a general museum, Portland specializes in certain areas: three large galleries, coming off the court, hold the arts of

the Northwest Indians, Pre-Columbian art and the arts of the Cameroons. The Northwest artifacts were gathered by Axel Rasmussen, superintendent of public schools in Skagway, Alaska. The culture of the Indians, from northern Canada to Alaska, and east to the Cascades, is shown in heraldic columns and totemic monuments as well as minute carvings. The increasingly important silver collection with some 750 items is focused on the Huguenot silversmiths working in London. The small Kress Collection and works related to the period include Bronzino's *Mother and Child*. A Boucher portrait, *Mme. de Pompadour*, has joined the collection. It would seem that Boucher never tired of painting Pompadour or the mistress of Louis XV of sitting for Boucher. Portland's portrait boasts a long provenance of titled French owners. The lady left her homeland via William Randolph Hearst to Marion Davies.

Constantin Brancusi: Muse (Portland Art Museum, Portland, Ore. Gift of Miss Sally Lewis; Eliot Elisofon photo)

Rembrandt van Rijn: Portrait of a Young Lady (Allentown Art Museum, Allentown, Pa. Samuel H. Kress Memorial Collection)

PENNSYLVANIA

ALLENTOWN ART MUSEUM

Fifth and Court streets, Allentown, Pennsylvania

Hours: Tues.–Sat. 10–5; Sun. 1–5
Closed: Mon., major holidays

Allentown is the only city in the United States that boasts a Kress Collection but not a Kress store, a regular stipulation for the gift. Rush Kress made this possible. Returning to his native heath in the Lehigh Valley (the Kress home was in nearby Cherryville), he promised the city fathers a group of Kress pictures. With this impetus, the art center, which was established in 1939, raised the money to purchase and convert a 1902 Presbyterian church to museum use. Edgar Tofel, a New York architect, has recently designed a new wing whose contemporary plan flows easily along with the Neo-Classical older building. The wing encompasses a children's gallery, a sculpture garden, terrace studios and exhibition space. There is a gallery of interpretation where didactic exhibitions are held to explain the different forms and media of the language of vision. It could be called a "teaching people to see" gallery.

Two spacious rooms hold the paintings of the Kress Collection, two smaller ones the drawings and prints. The Kress northern European paintings are especially fine. There's an incisive *Portrait of Anton Flugger* of the famous Augsburg banking clan by Hans Maler. There are Jan Steen, Jacob van Ruisdael and Adrian van Ostade. A sparkling Rembrandt called *Portrait of a Young Lady* in the catalog has lately been identified as a portrait of Saskia, Rembrandt's young wife. Two other stunning canvases are *Portrait of a Man* and *Portrait of a Woman* by Paulus Moreeles. Dressed in

their stiff black brocades and lacy white ruffs, this pair traveled to England, where one of their owners, eager to acquire such substantial ancestors, had his family's coat of arms painted on the left-hand corner of the canvases. Recently, cleaning removed the newer paint and the escutcheons. Among the Italians is Canaletto's *The Piazzetta* in Venice, which is typical Canaletto with the Church of San Marco front left and San Giorgio Maggiore silhouetted against the sky. *Portrait of a Gentleman* is attributed to Girolamo Romanino, while *St. Jerome Penitent* is assigned to Lorenzo Lotto.

The museum's one period room is the library of a 1912 house built in Minneapolis by Frank Lloyd Wright. A rather large room, it conveys Wright's use of space and materials. The living room of the house is in the Metropolitan Museum.

The 19th and 20th century collection is growing. What the museum lacks in the way of a permanent collection is made up for by its scholarly program. Whether it's "The City in American Painting" or "Sharp Focus Realism: Then and Now," the visitor is bound to encounter a thoughtful, challenging exhibit where the installation is on a par with major museums.

CHADDS FORD

THE BRANDYWINE RIVER MUSEUM

Route 7, Chadds Ford, Pennsylvania

Hours: Daily 9:30–4:30
Closed: Dec. 25

This part of the country should not be left without visiting the Brandywine River Museum in Chadds Ford (a half hour from Wilmington). It is one of the most original little museums in America. Using a 19th century grist mill, the architect John R. Grieves has bound it with a three-story silolike glass tower on the river side, leaving the character of the mill intact. The floors of old paving brick form a link between the old and the new. On any level one looks inward at the galleries or out at the leafy beauty of the countryside. The collection is American all the way.

Starting with Charles Willson Peale portraits, the main body of the work represents the Brandywine artists Howard Pyle, the well-known illustrator, N. C. Wyeth, his son Andrew and grandson James. There is a full schedule of exhibitions, lectures and musicals.

The far sides of the cobblestone courtyard hold permanent stalls that form a low roofline around the complex. In summer it holds a farmers' market. Undoubtedly, this is the only museum in the country with such a community-oriented appendage.

MERION

THE BARNES FOUNDATION

300 N. Latch's Lane, Merion, Pennsylvania

Hours: Fri., Sat. 9:30–4:30; Sun. 1–4:30
Closed: Mon.–Thurs., major holidays, July, Aug.
Visitors limited to 100 Fri. and Sat.; 50 on Sun. For reservations write or call (215) 667-0290. No children under 12.

Much has been written about the self-made Argyrol King, Dr. Albert C. Barnes. Stories of his taste and testiness are legion. Although he amassed one of the great collections in the world of French 19th century art, he let only those few favored by his whims see it. Museum personnel were anathema to him. Embittered when he moved to suburban Merion only to be ignored by the "Mainliners," he spent much of his time taking pot shots at socialites, especially if they collected art. The real cause for a lifetime of such behavior probably stemmed from the public's reaction to the first exhibition of his collection shown at the Philadelphia Academy of Art in 1921. Cézanne and especially Matisse, with his flat planes and shocking juxtaposition of colors, were too much for Philadelphians. Barnes, mingling in the crowd, heard himself categorized as a freak and Matisse as a fraud. As for the press, they went down for the count when they looked at Soutine. After that the Barnes door closed. Nevertheless, remembering his own lean school days, Barnes established an art school in conjunction with his gallery and was most generous to the few students he admitted.

Henri Matisse: Joie de Vivre (Barnes Foundation, Merion,
Pa. Copyright 1975 by The Barnes Foundation)

Today the foundation is known as an educational institution and
does not wish to be thought of as a museum in the conventional
sense of the term. On days when the galleries are closed to the
general public, they are used as part of the students' educational
program.

It was William Glackens, the painter, a friend of Barnes from
grammar school, who introduced him to the world of art. When
Barnes had successfully launched Argyrol he packed Glackens off
to Europe with $20,000 to spend on paintings. But the doctor was
soon self-propelled and became a familiar figure in the galleries of
Europe and America.

After his death in 1951, the door, though it took a court order
to make it happen, opened ever so slightly. (The Barnes Founda-
tion is tax exempt, and restive Philadelphians decided it was time
to share the collection they were helping to pay for.)

The impact on entering the first gallery is terrific; one of Cé-
zanne's great *Cardplayers, Nudes in a Landscape* and the unsur-
passable *Woman in a Green Hat*, along with 20 Renoirs, hang in
a rectangular gallery two stories high. Between tall windows is a
three-part mural of wonderfully convoluted dancing nudes by
Matisse, who after a great deal of persuasion came to Merion to
do them. Twelve smaller galleries fan out on either side. The
paintings in almost every gallery are stacked two or three tiers
high. Each picture has a small plaque with the artist's name on

the frame, but canvases hanging over the door jambs are for the far-sighted only. Period furniture and *objets d'art* have no labels. There is no catalog of the collection, no titles or dates on the paintings except those occasionally distinguishable on canvas.

The doctor's method of arrangement in the galleries was audacious. No attempt to place works of art in periods or schools was made. One small room contains Titian, Juan de Flandres, the American Milton Avery, El Greco, a large antique soup ladle, an Italian Primitive and a Pennsylvania Dutch chest. But such was the doctor's eye that no matter what the mixture of style, period, medium, color, the whole thing comes off. Other unlikely companions are Tintoretto, the Primitive Horace Pippin, Courbet, some New Mexican santos and Soutine. Barnes, with his prophetic eye, is said to have purchased 60 Soutines at $50 each long before the artist's recognition in the art world. One small gallery overflows with African sculpture, an infinite variety of American and European drawings, and a jack for changing a wagon wheel. Another holds a case of Egyptian pots and Navaho jewelry, over which, assembled in two straight lines, are French and German miniatures from the 12th to 14th centuries. The doctor liked hardware: every gallery has its quota of antique metalwork—locks, flanges, bolts, knobs, scissors, nutcrackers, andirons, hinges—all so felicitously placed that they weave into the total hanging without distracting. Even two ancient meat saws that crown a group of small Picassos, Klees, Demuths and Pascins seem to belong. In the

Georges Seurat: Les Poseuses (Barnes Foundation, Merion, Pa. Copyright 1975 by The Barnes Foundation)

big upstairs gallery the Matisses bloom alongside El Greco's *St. Francis and Brother Rufus* and van Gogh's *The Postman*, purchased with a fraction of the original $20,000 Glackens had been given to spend.

A small, superb Lautrec hanging in a dark little upstairs gallery could easily be missed. It's of a poignant, untidy woman in a white blouse. She can hold her own against any of Lautrec's important canvases. But I hope the museum remains as it is, a tribute to the eye and individuality of a man with the courage to collect what he pleased and to hang his collection as he pleased. All I ask is a little more accessibility for the public and a little more light in which to view the works of art. Maybe the latter isn't even necessary: after all, the small Monet I saw was so filled with light it would have illuminated a coal bin . . . a solitary figure on a pale green houseboat floating along the backwaters of a silvery stream, all gray green, whites and aloneness. I wonder what Monet titled the painting. Dr. Barnes wouldn't tell us if he could.

PHILADELPHIA

INSTITUTE OF CONTEMPORARY ART

Fine Arts Building, 34th and Walnut streets, University of Pennsylvania, Philadelphia, Pennsylvania

Hours: Mon.–Fri. 9–5; Wed. 9–9; Sat., Sun. 12–5
Closed: Summer

Housed on the campus of the University of Pennsylvania and a part of its graduate school of fine arts, the institute provides the most *au courant* exhibitions and programs in town not only for students but for citizens of greater Philadelphia as well. Its aim is to present, through scholarly but lively exhibitions, the latest national and international trends in art. David Smith and Andy Warhol were introduced to Philadelphia under its auspices. Christo and Tony Smith held their museum debuts here (an exhibit shared with Hartford's Wadsworth Atheneum). Five exhibi-

tions, lectures and a children's program are held each season. There is no permanent collection.

PENNSYLVANIA ACADEMY OF THE FINE ARTS

Broad and Cherry streets, Philadelphia, Pennsylvania

Hours: Tues.–Sat. 10–5; Sun. 1–5
Closed: Mon., major holidays

As Philadelphia's Independence Hall is the cradle of American liberty, so the Pennsylvania Academy of the Fine Arts in the same city is the cradle of American art, or at least the cradle for the gathering and putting on public view of works of art. As E. T. Richardson, scholar of American art and former president of the academy, notes, "The institution is one of the oldest in the world, being formed before the National Gallery of London, the Prado in Madrid or the Alte Pinakothek in Munich."

For an establishment considered so typically American, its beginnings were strange. Paraphrasing Mr. Richardson, in 1793 a South Carolinian named Joseph Allen Smith went abroad and picked up paintings, casts of antique sculptures and bits of jewelry. The influence of the French Revolution affected Italy before he could get his collection out of the country, but in 1800 he managed to ship two cases to a Philadelphia friend with the stipulation that they be given to the city. Philadelphians rose to the occasion, organized the Pennsylvania Academy of the Fine Arts as a combination art academy and museum, built a small Classical building on Chestnut Street and in 1805 opened the doors. There were three artists among the founders: Charles Willson Peale, his son Rembrandt Peale and William Rush, America's first name sculptor. The present building, now a historical landmark, was commissioned in 1871. The architectural firm of Furness, Hewitt and Frazer was chosen. (Louis Sullivan was a seventeen-year-old draftsman in the office at that time.) Hyman Myers, project manager for current restoration of the building, describes the façade as "an eclectic combination of historical architectural styles. Gothic tracery . . . a French Mansard roof, Renaissance rusticated bases and Medieval corbeling . . . decorative interpretations of . . . Arabesque ornaments, Byzantine tiles and Venetian Gothic inlays."

Interior with Stairway (Pennsylvania Academy of
the Fine Arts, Philadelphia, Pa.)

As John Coolidge, professor of Fine Arts at Harvard, says,
"Like its peers, the Paris Opera House, the vast Galleria of Milan
. . . the Academy is one of the rare masterpieces of 19th century
architecture."

In the early days, with the artist Thomas Birch as the first
"keeper," the business of collecting and showing American art
became paramount. The Lansdowne full-length portrait of Wash-
ington by Gilbert Stuart has been in the academy since 1811,
when it was shown in the first painting annual. In 1816 the build-
ing was mortgaged to buy a huge Washington Allston. Again in
1835 the academy took a mortgage in order to raise $7,000 to
purchase Benjamin West's *Death on a Pale Horse*, which was ac-
quired from his son. West worked in England on the huge paint-
ing from 1783 to 1817. It caused an immediate sensation when it

came to America. Such intrepid collecting has led to the acquisition of paintings that have become milestones in the history of American art and to great wealth in many of the museum's collecting areas: 44 Thomas Sullys, 61 canvases by members of the Peale family, 29 Gilbert Stuarts and 14 sculptures by William Rush. The collection begins with Gustavus Hesselius, one of our first recorded painters, and comes down to the present day.

Philadelphia is fortunate, for its beneficent connoisseurs each collected in his own way. The genre school and landscape school are almost as well represented as the great portrait collection. The Annuals held until the last few years enabled the academy to build a good early and mid-20th century collection with such artists as Arthur B. Carles, John Marin, Ben Shahn and Walter Stuempfig.

The academy is frequently called "the Frick of American painting" (see Frick Museum, New York), and it is unfortunate that space is so limited that only a small part of the collection can be on view. However, some of the stars are always on permanent display (the Benjamin West is permanently installed at the head of the stairs), and more and more interesting theme shows are held. It was Charles Willson Peale who stated the academy's aims, "to unfold, to enlighten and to invigorate the talents of our countrymen."

PHILADELPHIA MUSEUM OF ART

Benjamin Franklin Parkway at 26th Street, Philadelphia, Pennsylvania

Hours: Daily 9–5
Closed: Major holidays
Restaurant

The Philadelphia Museum of Art was established in 1876 under the name of the Pennsylvania Museum and School of Industrial Design, and a home was found for it in Memorial Hall. There it remained, gathering collections until it moved in 1928 into the vast ten-acre, partially opened Greco-Roman temple we know today. A progression of civic-minded citizens has enabled Philadelphia to build one of the richest collections in America. Prob-

ably the first important gift came in 1903 from Dr. Robert H. Lamborn. It consisted of about 75 Mexican-Spanish Colonial religious paintings. It would be impossible to assemble this important group of Colonial works today. Among others in the fine and diverse painting division are the John G. Johnson, Arensberg and Gallatin groups. The Johnson is a truly encyclopedic amalgam of Western European painting from the 12th century to the dawn of Impressionism, with its most important holdings in the Flemish Primitives of the 15th and 16th centuries, early Spanish and French, and unrivaled masterpieces of Italian Renaissance and 17th century Dutch art. Rogier van der Weyden's *Christ on the Cross with Virgin and St. John* is certainly one of the most poignant and sublime religious paintings in the world. As Aline Saarinen relates in *The Proud Possessors*, a flip of a coin brought the two altar wings together in Philadelphia. Johnson and his collector friend P. A. B. Widener were shown them by a Paris dealer, who would sell them only as a pair. Johnson persuaded Widener to buy one. They flipped a coin, and the panel *Virgin and St. John* went to Johnson. Later Widener, who could not find a spot in his home for the *Crucifixion*, offered it to his friend for the purchase price. Jan van Eyck's tiny, masterful *St. Francis* was sold as a Dürer in the 1820s in Portugal for $40.

The Arensberg Collection is a stupendous and beautifully integrated assemblage of 500 works of art, from the 20th century (20 magnificent Brancusis) back to the Primitives. Extraordinary, monumental, Pre-Columbian sculptures are harmoniously installed with eminent Cubist works by Braque, Picasso, Gleizes and Juan Gris. Thirty Marcel Duchamp paintings include the show stopper of the Armory exhibition, *Nude Descending a Staircase*. The A. E. Gallatin group, with such outstanding canvases as Léger's *The City* and Picasso's *Three Musicians*, complements the Arensberg. The Louis Stern Collection of 19th and 20th century French and American painting is intimate in scale and hangs together as it did in Mr. Stern's home, interspersed with examples of antiquities and Primitive and modern sculpture. As early as 1893, Mrs. William P. Wilsback gave a collection of painting but more importantly left a purchase fund to the museum. Many of the fine 19th century French group purchased from the Alexander J. Cassatt family (Mary Cassatt, the artist, was a Philadelphian) came from this and the Carroll Tyson Fund.

Thomas Eakins: The Concert Singer (Philadelphia Museum of Art, Philadelphia, Pa. Photograph by A. J. Wyatt, Staff Photographer)

Important works of Philadelphia painter Thomas Eakins, such as *The Concert Singer*, are shown against red-velvet walls sympathetic to the ambience of the period in which Eakins painted. Mrs. Eakins gave the museum 36 major oils, plus 16 sketches by the artist whom many scholars consider America's most distinguished painter.

The print and drawing section is a major department of the museum and has an inviting gallery for changing exhibitions as well as a permament display of the techniques of printmaking. A pleasant print study room is open to the public. The range is wide, the quality distinguished.

Perhaps because the museum's first and longtime director, Fiske Kimball, was an architectural historian of note, some of the best period rooms in the country are in Philadelphia, their interiors a composite of the fine and decorative arts. Again, a Philadelphian, John D. McIlhenny, gave much that strengthened this department. There are Flemish, Dutch, Italian Renaissance, Jacobean and French interiors, and impressive English manor

Nicolas Poussin: The Birth of Venus (Philadelphia Museum of Art, Philadelphia, Pa. George W. Elkins Collection. Photograph by A. J. Wyatt, Staff Photographer)

house drawing rooms. With charming chauvinism, most of the American wing is oriented to Philadelphia and her renowned cabinetmakers, silversmiths, and architects; the surrounding countryside contributes Pennsylvania Dutch interiors and artifacts.

In the extensive decorative arts section are fashion galleries that trace American dress from demure 18th century Quaker garb to Grace Kelly's wedding gown. A wing is being opened that will house a children's museum with its own entrance.

Romanesque cloisters and portals are the setting for art of the Middles Ages. The architecture and sculpture of 16th century India blend in a pillared hall from Madura to form an ensemble unmatched outside India. A splendid new gallery off the Madura Hall holds additional distinguished Asian pieces.

In the great hall of a Chinese palace of the late Ming Dynasty is the rock crystal collection of the 18th century Emperor Ch'ien Lung. The Japanese ceremonial teahouse and Buddhist temple with its green garden of fir and bamboo is unique in America. A new gallery of Thai and Cambodian treasures is dominated by a

Paul Cézanne: The Large Bathers (Philadelphia Museum of Art, Philadelphia, Pa., Wilstach Collection. Photograph by A. J. Wyatt, Staff Photographer)

carved sandstone Cambodian figure of the pre-Khmer period (7th to 9th centuries).

Although contemporary art, with the exception of sculpture, has not been collected to any degree, hopeful signs appear with the inclusion of such artists as Lee Krasner, Leon Kelly, Franz Kline, Morris Louis and Robert Rauschenberg. Philadelphia owns undoubtedly the only painting that is meant to be walked on. It is a stretch of pavement from Franklin's Footpath to the museum steps, an area about the size of a football field. Done by Gene Davis in alkyd paint with 15 bulletin colors, it was commissioned as part of the museum's Urban Outreach program and is guaranteed to light up any day. The museum also administers the nearby Rodin Museum (Benjamin Franklin Parkway and 22d Street), which houses an extensive collection of the artist's work, and three Colonial houses in the park—Mount Pleasant, Cedar Grove and Leita Street House.

Many of the great collections that Fiske Kimball, with gargantuan verve and sometimes equally gargantuan nerve, gathered for the museum are being given brilliant new installations.

UNIVERSITY OF PENNSYLVANIA: UNIVERSITY MUSEUM

33d and Spruce streets, Philadelphia, Pennsylvania

Hours: Tues.–Sat. 10–5; Sun. 1–5
Closed: Mon., major holidays
Restaurant, library

As no study of mankind can be made without including the arts as well as the artifacts of a civilization, the University Museum of the University of Pennsylvania—while primarily concerned with archaeology and ethnology—is so rich in the arts that it demands inclusion in this book of general "art museums."

On December 6, 1887, a proposal was put to the trustees of the University of Pennsylvania by a group of public-spirited Philadelphians to send an expedition to Babylon. The gentlemen would finance the endeavor with the stipulation that "all finds which can be exported are to be brought to the City and to become the property of the University of Pennsylvania, provided said University furnish suitable accommodations for the same in a fireproof building." Thus was born the famous University Museum. As Percy C. Madeira wrote in his excellent book on the history of the museum, *Men in Search of Man,* "The time and the place were right for both scholars and dollars."

The first unit of the present museum was completed in 1899 and high time too, for a note from the board of managers dated 1898 states that cases of objects from Nippus, Etruria and South America were being delivered faster than they could be unpacked. A new five-story academic wing and sculpture garden were completed in 1971.

Since its beginning the museum has sent out more than 250 expeditions all over the world. They were the first to excavate in Nubia and have trekked from Thebes, Ur, Memphis and Crete to the Amazon Basin, Alaska, Peru, the rain forests of Guatemala, Tikal, Piedras Negras.

The collections assemble by areas. On the main floor: North, South and Middle America. Our own North American Indian culture covers three galleries, from a ritual carved wooden deer mask from a prehistoric site at Key Marco, Florida, to 20th century Indian pots. A great mine of gold works from Panama, Ecuador, Peru, Colombia and Costa Rica glimmers in a treasure hall.

Khafaje Figure (University of Pennsylvania,
University Museum, Philadelphia, Pa.)

The rotunda holds some of the rare and most beautiful Chinese
art in any private museum: huge frescoes from the Moon Hill
Monastery, Buddhist sculpture of the Wei and T'ang dynasties,
bas-reliefs unmatched outside China from Emperor T'ang T'ai
Tsung's tomb.

The magnificent Egyptian holdings were mainly excavated by
the museum, though some of the best prehistoric pieces came from
British expeditions that the museum helped finance. The Upper
Egyptian gallery has great sculptures: one room is filled with
Nubian materials; other galleries hold alabaster, faïence, pottery,
stone and bronze sculpture.

The African material, gathered long before the present "dis-
covery" of African art, features fine pieces from the Belgian Congo
and West Africa. The Near East spans 5th century B.C. to the
Islamic period. The Mediterranean Basin is represented by the
arts of Italy, Mycenae, Crete, Cyprus and Greece. Few corners of
the ancient world are not represented in the University Museum.
With it and the Philadelphia Museum of Art, which by general
agreement concentrates primarily on post-Christian art of the
Western world and Oriental art since A.D. 1000, Philadelphians
are witness to much of man's creative endeavor.

The paperback guide to the collections, with its charts, maps
and histories, is not only instructive but engrossing.

PITTSBURGH

CARNEGIE INSTITUTE: MUSEUM OF ART

4400 Forbes Avenue, Pittsburgh, Pennsylvania

Hours: Weekdays 10–5; Tues. 10–9; Sun. 1–5
Library, with own entrance
Restaurant

At a time—1896—when every other art-minded American million-aire was plunging in Old Masters, Andrew Carnegie told the trustees of the museum he had just founded, "The field for which the gallery is designed begins this year," thus, probably unwittingly, establishing the first institution devoted to contemporary art. And with surprising catholicity he added, "Let us hope that the pictures exhibited here . . . will be of all schools." That same year the first Carnegie International was held. These triennials of contemporary art, both European and American, brought important turn-of-the-century works to the museum. The first recognition our own Thomas Eakins won was at the 1907 show, and the German Expressionists were represented extensively and early.

Winslow Homer's *The Wreck* was the first purchase for the permanent collection, and Whistler's *Sarate* was his first picture to be acquired by an American museum. Another extraordinary canvas is Oskar Kokoschka's *Thomas Masaryk*, a telling portrait as well as a historical document of special interest to Pittsburgh: visiting there in 1918, Masaryk signed the pact prerequisite to the proclamation of the Czechoslovakian Republic.

As a man who bobbed up from a $1.25-a-week job as a bobbin boy in a cotton mill to a $175,000,000 fortune, Carnegie was not only venturesome in setting his sights but generous to the new institution. Andrew Carnegie's gift to the city of Pittsburgh is a French Renaissance quatrefoil of a building which houses the library, music hall, natural history museum and art institute.

In 1974 an enormous new wing, the Sarah Mellon Scaife Gallery, was opened. Designed by Edward Larabee Barnes in the same gray granite as the parent building, the wing flows straight along from the façade of the old building with massive symmetry. The wide open-air entrance court holds sculpture and greenery.

Inside, a charming café overlooks the court. The entrance adjacent to the parking lot brings the drama of Barnes's addition into focus. Two entire sides of the wing are high glass walls looking over a stepped-down sculpture court interlaced with sycamore trees; a cascading fountain flows against the far court walls. The wide granite stair leads to the second-floor galleries, and is second only to the Metropolitan's staircase in grandeur. The new wing's exhibition galleries form space that can only be called colossal. These white-on-white galleries are in continuous flow with natural but controlled daylight.

The Old Master group is set nearby in a small gentle ambience. A few are *Head of Christ* by Gerard David, *Holy Family with Elizabeth and St. John* by Quentin Massys, Nicola d'Ancona's

Nicola di Maestro Antonio d'Ancona: Madonna and Child Enthroned with SS. Leonard, Jerome, John the Baptist, and Francis (Museum of Art, Carnegie Institute, Pittsburgh, Pa. Collection of Howard A. Noble)

Madonna and Child with saints Leonard, Jerome, John the Bapti
and Francis, and the delightful *Madonna and Child with Music*
Angels by the Master of the Lucy Legend.

Sarah Mellon Scaife played a role in Pittsburgh, in directo
Leo Arkus's words, analogous to Mrs. H. O. Havemeyer at th
Metropolitan and Mrs. Potter Palmer at Chicago's Art Institute
Many of the fine Impressionists and Post-Impressionists, includin
the 19-foot Monet *Water Lilies*, came through Mrs. Scaife
bounty, and now her family carries on the tradition.

A few outstanding works in the European field are Pissarro'
Great Bridge at Rouen, Jean Bazaine's *Dawn*, Alfred Manessier'
Crown of Thorns and Ensor's *Temptation of St. Anthony*, whi
American gold medalists have included Alfred Maurer, Abbot
Thayer, Ernest Lawson, Arthur B. Davies, Leon Kroll, Georg
Bellows, Franklin Watkins, Alexander Brook and Peter Blum
Matisse's *Thousand and One Nights* and *Odalisque with Gree*

Frederick Edwin Church: The Iceberg (Museum of Art, Carnegie Institute,
Pittsburgh, Pa. Howard N. Eavenson Americana Collection)

Headdress, van Gogh's *The Plains of Auvers,* Bonnard's *Nude in Bathtub* and Cézanne's great *Landscape Near Aix, the Plain of the Arc River* are more samplings from this rich collection. Other important though smaller works are Cézanne's *Rocks at the Seashore,* Picasso's 1906 *Head of a Boy,* four Degas, Renoir, Lautrec, Corot—one could go on. The growing print section holds 80 Dürers and more than 60 early state Rembrandts.

The Americans are well represented especially in 19th and mid-20th century holdings. David G. Blythe, self-taught genre painter who did most of his work in and around Pittsburgh, is seen in 25 works, John Kane, Pittsburgher and true Primitive, in eight. As its founder would have wished, the contemporary group continues to grow and will have its own bank of galleries in the new wing. Two entrances take one to the old building, where a greatly expanded Decorative Arts Collection, gift of the late Ailsa Mellon Bruce, will be housed. Mrs. Bruce, daughter of Andrew Mellon and a native of Pittsburgh, gave a collection of European furniture, paintings and silver of superb quality. The present antiquities gallery and the treasury room also remain in the old building. The museum has a good small Oriental collection and a growing group of Oceanic and African objects.

Although the Carnegie no longer stresses its Internationals and is more concerned with becoming a general museum, it was these early splendid exhibitions that brought the institute fame and began the enrichment of its painting collection.

Henri Matisse: Still Life with Lemons (Museum of Art, Rhode Island School
of Design, Providence, R. I. Gift of Miss Edith Wetmore)

RHODE ISLAND

MUSEUM OF ART: RHODE ISLAND SCHOOL OF DESIGN
224 Benefit Street, Providence, Rhode Island

Hours: Tues.–Sat. 11–5; Sun. 2–5
Closed: Mon., major holidays, Aug.

The best way to ensure not missing some of this museum's treasures is to get a floor map at the entrance. It's a many-leveled building. It all began when three ladies from Providence came home from the Philadelphia Exposition of 1875 dissatisfied with the crafts in the Rhode Island section. Somehow $1,675 had been left over from the state's contribution to the exposition, and with this they launched the Rhode Island School of Design. Gradually rooms were added for use as a museum.

In 1904 Charles L. Pendleton of Providence gave to the museum his fine collection of 18th and 19th century furniture. Pendleton House, built in 1906 to house the collection, is an exact copy of the Potter House built in the 1790s and still standing at 72 Waterman Street. Pendleton House is an engaging Georgian dwelling full of such outstanding early Americana as Newport furniture, China-trade porcelains and New England silver. Drawings by Copley, Feke and Rhode Islander Gilbert Stuart adorn the walls. The main building of the museum and Pendleton House joined in 1926.

Stepping through the Georgian doorway of the museum, you will see only a few Classical marbles on view. No surfeit of material, no compulsion to show everything the museum owns at once, will overcome you. Even Etruscan and Greek jewelry is sparingly displayed. In the first gallery, small ancient bronzes are set in shadow boxes, each little creature or vessel isolated so that

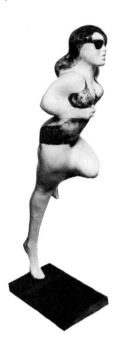

Frank Gallo: Running Girl (Museum of Art, Rhode Island School of Design, Providence, R. I. Albert Pilavin Collection, Twentieth Century American Art)

you and it can hold private communion. Among ancient Greek and Roman sculptures is *Torso of a Woman* (520–510 B.C.). The block-like strength recalls the Egyptians, but the slightly modeled breasts and the fall of the drapery are pure Greek humanism. The Classical collection—Roman fresco paintings and splendid portrait busts—is generally rated third in America, bowing only to Boston and the Metropolitan. An early 13th century Spanish crucifix dominates the Medieval galleries, but treasures like the stone *St. Peter* from the abbey church in Cluny, France, quietly assert themselves. Tilman Riemenschneider, a German sculptor of the transition period, Gothic to Renaissance, used the linden wood *Pietà* here as a model for many of his larger pieces.

After the Medieval, small galleries flow along, offering in fine sequence the major periods of Western art, whether it's a High Renaissance bronze by the 16th century German Georg Vischer or a small oil on panel, *Resurrection*, by the Italian Previtali. *Turbulent Jerusalem Delivered* and a moving oil sketch, *The Combat Between Tancred and Clorinda*, are by Tintoretto, that long-lived artist who formed the bridge between High Renaissance and

Baroque. Effulgent Baroque slips into Rococo, with Tiepolo casting his talents on church, palace and boudoir with gay and witty impartiality. His ceiling painting is from a Venetian *palazzo*. In another gallery Neo-Classicism revolts against Rococo. Late Romanticism and Delacroix move abruptly to the Realism of Courbet. Much of Courbet is relentless, almost brutal. But in *The White Mill*, darkly accented white on white, Courbet achieved a serenity that comes close to poetry. Edouard Manet, contemporary of Courbet, did *Le Repos*, a portrait of the painter Berthe Morisot. Don't miss three small Monet beauties and a Degas.

From Cézanne, van Gogh, Lautrec, we move to Renoir's glowing *The Shepherd Boy;* from Braque, Matisse, Kokoschka, to the superb Picassos, including a 1911 Cubist still life. The 15-inch model the sculptor Manzù did for his large *Cardinal Enthroned* in Bologna has all the latter's strength and dignity.

When the Rhode Island School of Design moved to new quarters on campus, the museum gained gallery space for changing exhibitions, 19th and 20th century Americans, and another interest—contemporary Latin American art. The Colombian Fernando Botero, the Nicaraguan Armando Morales and the Argentinian Luis Filipe Noe are a few of the Latins here.

New emphasis has been brought to the print and drawing section, 18th, 19th and 20th centuries. An outstanding gift of 537 British watercolors and drawings makes the museum a major center for the study of British art. The contemporary section continues to grow with an imposing Wilfredo Lam, Roy Lichtenstein, Leo Manso, Jean Pierre Raynaud and many others. Upstairs the Primitives, the Orient, and the Near East hold sway. In the Abby Aldrich Rockefeller Collection, 640 Japanese prints frequently change places. Rodin's *Balzac*, the sturdy nude that caused an uproar in 1898 Paris, rests quietly in the museum's garden court.

Henrietta Johnston: Marie du Bosc (Mrs. Samuel Wragg)
(Carolina Art Association, Gibbes Art Gallery,
Charleston, S. C.)

SOUTH CAROLINA

CAROLINA ART ASSOCIATION: GIBBES ART GALLERY

135 Meeting Street, Charleston, South Carolina

Hours: Tues.–Sat. 10–5; Sun. 2–5
Closed: Mon., major holidays

Although the Carolina Art Association was formed a couple of years before the booming across the bay at Fort Sumter started the Civil War, its real expansion began when the association moved into its present home, the Gibbes Art Gallery. Erected in 1905, in the days when architects vied with each other in the game of more cupolas, taller windows and fancier pilasters, its grandiloquent space is better adapted to Hiram Powers's marble sculptures than to the hanging of paintings.

Nevertheless, on view is a splendid group of early American portraits by such well-known painters as Jeremiah Theus, Benjamin West, Gilbert Stuart, Rembrandt Peale, Samuel F. B. Morse and Washington Allston. Unfortunately, lack of space precludes the showing of this distinguished group except for an occasional exhibition or during the summer.

Charleston has the distinction of harboring what is probably America's first artist, at least as far as signed works are concerned. Henrietta Johnston and her husband arrived in Charleston from Ireland in 1705. (According to American art scholar E. P. Richardson, Justus Engelhardt Kühn came to Maryland in 1708, and Gustavus Hesselius settled in Philadelphia in 1711.) It was thanks to her improvident husband, who fell into the Atlantic on the crossing, that Mrs. Johnston became an artist. Though retrieved, Mr. Johnston understandably never recovered from the experi-

ence, and his wife turned to pastels as their means of support. The museum owns five.

Another pride of the Gibbes Gallery is its collection of miniatures. The largest group of Charlestonians is by Charles Fraser, a native son. Fraser's notebook, with a watercolor on every page, shows him to be a sensitive landscapist as well. Edward Greene Malbone was another native miniaturist. His descendant, Leila Waring, who died in 1917, was the last of the line in this precious, succinct art form.

The print gallery is expanding, especially in the area of Japanese prints. In the contemporary field, the museum, wisely chauvinistic in light of its history and budget, has through exhibitions and purchases encouraged mainly South Carolinian artists. This is changing, however, and other important contemporary Americans are being added, which is as it should be. After all, Peggy Guggenheim's collection was first seen outside New York in Charleston in 1937, and Joseph Albers showed there as early as 1944.

The visitor interested in American art should not miss the paintings just down the street at City Hall, where hangs a trio of portraits of famous men by famous artists: George Washington by John Trumbull, Andrew Jackson by John Vanderlyn, and James Monroe by Samuel F. B. Morse.

COLUMBIA

COLUMBIA MUSEUM OF ART

Senate and Bull streets, Columbia, South Carolina

Hours: Tues.–Sat. 10–5; Sun. 2–6
Closed: Mon., major holidays
Library, planetarium, nature garden

Few art museums are as felicitously located, for native and visitor alike, as Columbia's. In the heart of the city, it is two blocks from the state capitol, one block from the university, and one from U.S. 1. The museum opened its doors in 1950 with high hopes, $5,000 and an old house. Even this modest beginning didn't take place

Attic Black-Figure Lekythos (Columbia
Museum of Art, Columbia, S.C.)

overnight, but was the outgrowth of the Columbia Art Association
started in 1916. The "old house" is a commodious mansion whose
great hall and broad stairway lend themselves to the flow of
traffic engendered by one of the liveliest programs a museum could
undertake. Ample-sized wings have been added. Ambitious plans
call for about a 20-acre area in which an overall complex hous-
ing the visual arts, the performing arts and the sciences will be
built.

There are small clusters of Pre-Columbian and Chinese objects,
examples of such masters as Van Dyck and Rubens, and such fine
American paintings as Washington Allston's *Coast Scene on the
Mediterranean, Elizabeth Deas* by Jeremiah Theus and *Portrait of
James McCord* by John Wesley Jarvis. But the museum's true
distinction lies in its Kress collection. To have an illuminating
companion on your visit, purchase a catalog of the Kress paint-
ings; all scholarly attributions are listed, and the detective-story
aspect of tracing origins makes fascinating reading. The Kress
assemblage is divided into three groups: early Christian, High
Renaissance and late Baroque. A star among the early Christian
works, placed in a small, chapellike gallery, is Matteo di Giovan-
ni's heavy-lidded *Madonna and Child with St. Catherine of Siena
and St. Sebastian.* The other two Kress galleries are rich in treas-
ures and appropriate furniture. For instance: Andrea Solario's

Madonna and Child and Tintoretto's imposing *A Gentleman of the Emo Family*. For years the background of Tintoretto's painting was black, but after 1948, when it came into Kress possession, careful cleaning brought out a clear view of the papal fortress, Castel Sant' Angelo. A recent acquisition is an Attic black-figured Lekythos—late Archaic style.

Another purchase is a portrait of one of South Carolina's first chief justices, Peter Edgarton Laigh, painted by John Singleton Copley in 1756 when Copley was nineteen. Though Copley never visited the Carolinas, a search into South Carolina's archives revealed that the chief justice had made a trip to Boston at that time. Lost for years, the picture was discovered at Stratford-on-Avon. It will hang either in the museum or in the governor's office. Wherever he comes to rest, the return of the native was a coup for Columbia.

GREENVILLE

GREENVILLE COUNTY MUSEUM OF ART

106 Dupont Drive, Greenville, South Carolina

Hours: Mon.–Fri. 9–5; Sat. 9–1; Sun. 2–6
Closed: Major holidays

In the last edition of this book it was stated that this was a museum to watch. Now, seven years later, in a smart new building this is still a museum to watch. Established in 1958 in a mansion whose architecture can best be described as odd (the mistress of the house was the architect, but she was no Isabella Stewart Gardner—see Boston), its redesigned interior afforded room for experimentation and growth. Experiments in audiovisual techniques developed into a sustaining program named Electragraphics. The visual, the narrative, the oral soar into the wild blue yonder as Greenville's staff attempts to keep ahead of today's young museum visitors.

The new museum incorporates a control room, a small studio and a larger projection theater. While collecting and displaying

Seymour Lipton: Reef Queen
(Greenville County Museum of
Art, Greenville, S. C.)

works of art in the usual way, the museum defends its multimedia position in the words of the director of the Electragraphics program: "Paintings purchased will hopefully increase in value; electronic equipment only depreciates. But, like the automobile whose real value is in where it can take us, Electagraphics' aim is to guide the museum visitor toward a more aware appreciation of the arts."

The new building is located between the Greenville Little Theater and the public library. It was made possible by a Greenville industrialist, Arthur Magill, and matching public funds. Its trapezoidal form, dictated by the shape of the land, necessitated a vertical design divided by an earth-to-roof skylight. This design allows viewing from one gallery level to another. Using poured concrete in wooden forms, Greenville architects Craig and Gaulden have given an understated elegance to the museum.

The aim in collecting is to emphasize the North American continent. There is some Pre-Columbian material, some 18th and 19th century painting and sculpture, but the strength will lie in 20th century works of art. Some contemporaries include Edward Higgins, Jack Tworkov, Mark di Suvero, Seymour Lipton and Wolf Kahn.

A Student Artmobile goes out from the museum's lively art school.

BOB JONES UNIVERSITY ART GALLERY AND MUSEUM
Greenville, South Carolina

Hours: Tues.–Sat. 12–5; Sun. 1:30–6
Closed: Mon., Jan. 1, Dec. 25

"Unique" is the word most often used to describe the Bob Jones
University collection, and I can't find a more accurate adjective.
To fully savor the aura of the museum, one must understand the
orientation of the university itself. It was founded 40 years ago
by the Reverend Bob Jones as a fundamentalist school, preaching
with no apologies "the old-time religion" and the absolute au-
thority of the Bible. The tradition is being carried on by Bob
Jones, Jr., and Bob Jones III. Keeping up with the Joneses, who
are sometimes referred to as "the Holy Trinity," means no smok-
ing, drinking, gambling or dancing on campus.

The collection of Christian religious art was begun by Bob
Jones, Jr. In 1965 a sumptuous new museum opened in a re-
modeled campus building. Wood-paneled Gothic and Renaissance
rooms have been installed. Truly distinguished furniture—cas-
sones, commodes, chairs, a Gothic dressoir from Avignon—graces
the painting galleries. As the museum's first brochure stated: "A
red carpet has been placed over the sawdust trail." Actually, the
boldly colored carpets and walls in some galleries almost lead to
visual indigestion. However, the heady High Renaissance and
ebullient Baroque paintings manage to hold their own against
yellow walls and purple carpets or purple walls and yellow car-
pets. John Coolidge of the Fogg summed it up as expressing "a
marvelous lack of timidity." After the first dozen galleries, the
décor falls into a more tranquil pattern. The 28 galleries follow in
numerical sequence and are arranged by country and period.

The overall strength here probably is in the major works of
minor masters and in its 14th to 18th century Italian paintings.
However, the Spanish, French, German, Dutch and Flemish
schools are well represented. The range is from a monumental
Sienese crucifix, circa 1370, to a rather spectacular 19th century
Gustave Doré, *Christ About to Take Up the Cross.*

Even within the restricted framework, the fare is rich and
varied: *Salome with the Head of John the Baptist* by Lucas
Cranach the Elder; the enchanting *Madonna of the Fireplace* by
Jan Mabuse (Gossaert); *Pentecost,* which is said to be the only

work of Juan de Juan in America. Also in the Spanish section is *St. Catherine Appearing to the Family of Bonaventura in Prison* by Francesco de Herrera the Elder, one of a series of four paintings, two in the Louvre, the third at the Prado. The Italian section includes three recently acquired magnificent sections of a great altarpiece by Paolo Veronese, a set of *Four Evangelists* by Guido Reni, *Procession to Calvary* by Giovanni Antonio Bazzi (called Sodoma) and *Holy Family and St. John the Baptist* by the 16th century Venetian Vincenzo Catena. Among the Dutch paintings, *The Holy Family in the Carpenter Shop* by Gerard van Honthorst is a gem.

The War Memorial Chapel, a short distance from the museum, is a must for students of 18th and 19th century American art. Seven grandiose canvases by Benjamin West—their theme, fittingly enough, *Revealed Religion*—are part of a series commissioned by West's patron George III for Windsor Castle. Before the project could be completed, the king's mind had deteriorated and West was left with the canvases. The posthumous sale of his work in 1829 included many from this series. They hung in an English country house until 1962, when they were auctioned at Christie's in London. Six were acquired at the sale for the university, and a seventh was presented as a gift. They are particularly suited for the chapel of what must be the country's most unusual university.

Gerard van Honthorst: The Holy Family in the Carpenter Shop (Bob Jones University Art Gallery and Museum, Greenville, S. C. Unusual Films)

Winslow Homer: Reading by the Brook (Brooks Memorial Art Gallery, Memphis, Tenn.)

TENNESSEE

BROOKS MEMORIAL ART GALLERY
Overton Park, Memphis, Tennessee

Hours: Tues.–Sat., holidays 10–5; Sun. 2–5
Closed: Major holidays

In 1966 the Brooks Memorial Art Gallery celebrated its 50th birthday. Set in the green of Overton Park, the building's marble façade is a copy of New York's Morgan Library. A wing was added when the Kress Foundation, whose founder, Samuel Kress, began his career as a storekeeper in Memphis, gave 30 works of art to the gallery. Two of these, to which the museum points with particular pride, are Canaletto's *View of the Grand Canal at San Vito* and Romanino's *Mystic Marriage of St. Catherine*. A second addition which tripled the exhibition space was opened in January 1973.

The gallery has a fine collection of English portraiture and landscapes with works by Gainsborough, Reynolds, Hoppner, Hogarth, Lawrence, and Romney, among others. The Richard Wilson painting *Temple of the Sibyl at Tivoli* is a good example of this artist's work. Van Dyck's splendid portrait of Queen Henrietta-Maria of England was in Charles I's collection.

American paintings range from Copley to contemporary. Ralph E. W. Earl, son of the well-known 18th century painter Earl, did the *Portrait of General Andrew Jackson, President of the United States*. So successful was he that he spent the last 12 years of his life painting Jackson and is buried beside Jackson's tomb at the Hermitage, Jackson's mansion in Nashville. Some contemporary Americans in the collection: Kenzo Okada, Theodoros Stamos, Andrew Wyeth, Josef Albers, Carroll Cloar, William Congdon, Walter I. Anderson, Marisol and George Rickey.

Fernando Botero: Santa Rosa de Lima (University of Texas at Austin, University Art Museum, Austin, Tex. Barbara Duncan Collection)

UNIVERSITY OF TEXAS AT AUSTIN: UNIVERSITY ART MUSEUM

San Jacinto and 23d Street, Austin, Texas

Hours: Mon.–Sat. 9–6; Sun. 1–5

THE MICHENER GALLERIES

Humanities Research Center
21st Street and Guadalupe, Austin, Texas

Hours: Mon.–Sat. 10–5; Sun. 1–5
Closed: Thanksgiving, Dec. 25

The university art department and gallery could not be more felicitously situated than it is, on the broad avenue that is the heart of the campus and at the foot of the hill leading to the Lyndon B. Johnson Memorial Library. The football stadium lies directly across the street, and the museum's director claims that before the games on Saturday at least 5,000 of the audience visit his museum.

The building's first floor contains an auditorium, exhibition galleries, library and research department. Art is looked at, talked about and studied all on one floor. The library and print cabinet are open to the public.

The Michener Galleries in the recently opened Humanities Research Center are also strategically located on the southwest corner of the campus directly across from the main business area serving the university community.

In its collecting, the museum's chief interest is in art of the Americas, its holdings including the impressive collection of more

than 300 20th century American paintings given by novelist James A. Michener and his wife, and the fine Barbara Duncan Collection of Latin American Paintings and Drawings, a recent gift of Mr. and Mrs. John C. Duncan. The permanent collection also includes more than 1,000 prints and drawings, representing 600 years of graphic art.

The exhibition program consists of a wide variety of exhibits displayed in the three galleries of the art museum proper and the two Michener galleries. In this program, as in its collecting, special emphasis is in the area of art of the Americas—both contemporary and historical—but exhibits of sculpture, painting, architecture, crafts, photography, theater arts, graphics, textiles and design from all over the world are included in the museum schedule.

So diverse and lively, yet scholarly, is the program that as Austin becomes more and more a convention city, hotel managers have begun calling the museum to check on its exhibitions and lecture activities.

The university at Austin is also a major repository of book art, including important unpublished material on Colonial Mexico, much of it visual in nature.

CORPUS CHRISTI

ART MUSEUM OF SOUTH TEXAS

1902 North Shoreline Drive, Corpus Christi, Texas

Hours: Tues.–Sat. 10–5; Sun. 1–5
Closed: Mon., Dec. 25

Philip Johnson, the architect of several museum buildings, has this to say of his latest one erected in Corpus Christi: "I tried to design a space that in itself without any pictures, without any reason for being, would be exciting." He succeeded. The museum built on a wharf on the Gulf of Mexico is a concrete monolith, most of it rough, with a few of the interior areas polished. Mr. Johnson may be said to have given the first painting to the permanent collection, for what meets the visitor's eye on entering is a large window

framing an enchanting view of the Gulf. There it rests in sunshine or in gale, never to be lent, varnished or restored.

The large two-storied main gallery is granted another dimension to viewing in its second-story 60-foot walkway. This bridge also leads to a roof sculpture court and a skylighted upper gallery. Cascading greenery is used effectively to open areas. Intimate galleries on the first floor are usually used for the decorative arts and small sculpture.

There seem to be two ways of starting a museum these days: spend your money forming a collection and house it wherever you find hanging space, or erect the building first and hope that the citizens will rally round and fill it. Corpus Christi opted for the latter. In the meantime a broad program of loan exhibitions keeps Corpus Christians alert to the changing contemporary art scene.

DALLAS

DALLAS MUSEUM OF FINE ARTS

Fair Park, Dallas, Texas

Hours: Tues.–Sat. 10–5; Sun. 1–5; holidays 1–5
Closed: Mon., Dec. 25
Restaurant (not open weekends), library

The Dallas Art Association was formed in 1903 by a group of women to stage art exhibits in the public library. In the 1920s, after a good deal of soul-searching, they finally decided to allow men to serve on their board. The present museum opened in 1936 in the Fair Park, just a short walk from the Midway.

Nowhere is the spirit of expansion and change that pervades the whole museum world more evident than in Dallas. The main entrance has been moved to lead into a new wing around a sculpture court dominated by a large Barbara Hepworth. Intimate galleries for drawing and craft exhibits are here also. Upstairs a series of galleries designed for temporary exhibitions lead into the permanent installation beyond.

Recently the museum has changed its orientation. Although the collections formerly included some art of the past, the em-

George L. K. Morris:
Composition (Dallas
um of Fine Arts, Dalla
Purchased with the ai
funds from the Natio
Endowment for the A

phasis was on Texas and regional art. The aim now is to build a group of prime-quality objects of all periods, with the strength in 20th century work and the art of the Americas. Already fine Etruscan pots and gold ornaments, a unique pre-Archimedean piece and a large 4th century Greek figure found near Athens have arrived. Of comparable antiquity, but from the New World, is the museum's extensive collection of Pre-Columbian art. Beginning with stone sculptures in the Olmec, Meczala and Chontal styles, dated from 1500 B.C. to 500 B.C., the collection continues to the Mayan period.

One of the French school's best examples is the happy *Apple Pickers*, a product of Camille Pissarro's Pointillist period. Important American canvases are Gilbert Stuart's *John Ashley, Esquire* and *Mrs. Ashley*, George Bellows's *Emma in Blue*, Edward Hopper's *Lighthouse Hill* and Andrew Wyeth's *That Gentleman.*

A huge two-storied court that used to be the entrance, and logically could be again, is dominated by Henry Moore's *Reclining Figure No. 3*. The sculpture's vast scale is matched by canvases around the white brick walls by Motherwell, Adolph Gottlieb and Morris Louis. Other distinguished works are by Lee Bontecou, Louise Nevelson, James Dine, George Rickey, Gerald Murphy, Francis Bacon and George L. K. Morris.

A strong area of collection for the museum is now African sculpture, with the recent addition of the distinguished Clark and Frances Stillman Collection of Congo Sculpture. Primarily of

wood, with some ivory and metal, the collection includes ancestor figures, fetishes, objects of use or status and masks.

The Mexican Tamayo's *El Hombre* stands 18 feet high in smoky blue and red earth colors, showing man wrestling with the universe. It was commissioned especially for this court.

The Dallas Museum remains unique in its care and treatment of native artists. Their work and their lives are documented with biographies, photographs and slides. The museum sponsors a series of competitive events, including the North Texas Painting and Sculpture Exhibition, the Southwestern Print and Drawing Competition, the Texas Crafts Exhibition and Southwestern Photography, held on a rotating basis.

MEADOWS MUSEUM

Southern Methodist University, Dallas, Texas

Hours: Mon.–Sat. 10–5; Sun. 1–5
Closed: Dec. 25
Library

The museum, endowed by the Meadows Foundation in 1965, occupies a large corner of the university's Fine Arts Center. Its dedication is to Spanish culture, and it includes a major research library and archives. The collection extends from the 15th century to Picasso. Among masterpieces in the rapidly growing collection are Zurbarán's *Mystical Marriage of St. Catherine* and Murillo's *Jacob Laying the Peeled Rods before the Flock of Laban*, one of a series of five paintings on the life of Jacob. William B. Jordan, director of the museum, has followed in scholarly fashion the peregrinations of the paintings (*Art Journal*, Spring 1968): the Cleveland Museum acquired one in 1966; two were purchased by the czar of Russia in 1811 and remain in the Hermitage in Leningrad; the fifth canvas was sold in London in 1870 and has not been heard of since. Another prize in the collection is Velásquez's portrait of *Philip IV*, one of a series of ten the artist did of his patron. There are canvases by Juan de Sevilla, Valdes Leal, Juan de Borgoña, Francesco Gallego and six Goyas plus early first editions or trial proofs of all four sets of Goya's etching-aquatints: *The Caprichos, Disasters of War, Tauromaquia* and *Proverbios*. These edi-

tions were until 1953 in the library of the Dukes of Lerma. The group of Spanish 19th century paintings is the largest in America. The museum is also beginning to collect Latin American and Spanish 12th century works. Fine examples of Juan Gris and Joan Miró and Diego Rivera's Cubist portrait of *Ilya Ehrenburg* make a good starting point.

EL PASO

EL PASO MUSEUM OF ART

1211 Montana, El Paso, Texas

Hours: Tues.–Sat. 10–5; Sun. 1–5
Closed: Mon.

The El Paso Museum, long housed in the 1910 residence of Senator and Mrs. W. W. Turney, who gave it to the city in 1940, has become a focal point for the visual arts. Although one can no longer say it's a long time between museums in Texas, El Paso, situated on the Mexican border in the far western reaches of the state, and with more of its citizens speaking Spanish than English, has had to form its own cultural oasis. With the donation in 1959–1960 of an unusually magnanimous Kress gift, two wings were added. The architectural statement is precise: each wing is attached to the Turney house and each other by a glass corridor which leaves the many-pillared façade intact and manages to harmonize with it.

The west wing holds the Old Master collection, which runs from 1200 to about 1800. Some highlights: the oldest painting in the group, a large wood panel of *The Madonna and Child*, attributed to the school of Lucca; another panel painting, *St. Jerome and St. Francis*, by Jacopo del Sellaio; Anthony Van Dyck's *Portrait of a Lady*. As befits El Paso's heritage, the Spaniards—Jusepe de Ribera, Juan de Borgoña, Francisco de Zurbarán, Esteban Murillo—are well represented. The large galleries of the east wing are used for traveling exhibitions or for showing different facets of the museum's changing collection. The downstairs Heritage

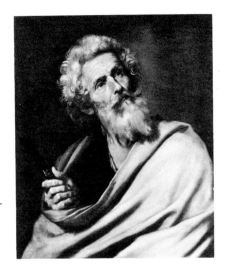

Jusepe de Ribera: Saint Bartholomew (El Paso Museum of Art, El Paso, Tex., Samuel H. Kress Collection. Bullaty-Lomeo photo)

Gallery is primarily of historical interest. Much of El Paso's collecting revolves around its heritage: Mexican Colonial paintings, Pre-Columbian artifacts, American Indian artifacts, art of the Louisiana Purchase and contemporary Rio Grande art.

FORT WORTH

AMON CARTER MUSEUM OF WESTERN ART

3501 Camp Bowie Boulevard, Fort Worth, Texas

Hours: Tues.–Sat. 10–5; Sun., holidays 1–5:30
Closed: Mon.
Library

The three museums, troikas of culture that form a triangle around Carter Square in Fort Worth, have wisely restricted their areas of collecting so that they complement each other rather than compete. The Amon Carter, established under the will of the late Amon G. Carter, publisher, pioneer oil producer and civic leader of Forth Worth, is a small, handsome museum which opened its

doors in 1961. It is dedicated to the study and documentation of western North America. Its scholarly publications, exhibitions and permanent collection are related to the many aspects of American culture which can be identified as "western."

The building is made of honey-colored shell stone quarried near Austin. The architect, Philip Johnson, has given the museum a two-storied glass façade segmented by tapering columns. All the galleries in the teakwood and bronze interior face out into the entrance court. The museum becomes a platform for viewing the city, with Fort Worth's skyline sweeping the distance. Set in alien grandeur, skimming the top of the flowering trees on a lower terrace, is Henry Moore's *Upright Motives No. 1–2–7*. The similarity of these forms and the totem poles of the North American Indians is striking. (Moore's piece and a charming portrait of Indians called *Peaux Rouges*, by Bonnard, done when Buffalo Bill Cody's "Wild West Show" was in Paris, are among the only non-American works in the museum.)

While this is a personal collection, brought together by a man

Amon Carter Museum, Henry Moore "Upright Motives No. 1–2–7" in Foreground (courtesy Amon Carter Museum, Fort Worth, Tex.)

who, through tradition and predilection, was involved in our fron-
tier in its romantic cowboy and Indian phase, the museum has
broadened the term "western" to include any work of art which
was executed in what at one time was considered West. After all,
Ohio was once western territory.

Built primarily on Remington and Russell, the collection has
been expanded by extensive additions of works of artists on the
early exploration survey of the West and the late, romantic paint-
ings of Thomas Moran, Albert Bierstadt and others. There is also
a growing collection of 20th century artists, such as Stuart Davis,
Marsden Hartley, Georgia O'Keeffe and John Marin, who visited
and recounted their impressions of the desert country. The 19th
century print collection of views of the American West, especially
city views, is one of the most extensive in the country, and an
archive of photographs on the same subject is being assembled.

THE FORT WORTH ART MUSEUM

1309 Montgomery Street, Fort Worth, Texas

Hours: Tues.–Sat. 10–5; Sun. 1–5
Closed: Mon., Thanksgiving, Dec. 24–25

In 1909 Mrs. Jennie Scheuber, librarian, hung on her library walls
the first exhibition that the American Federation of Arts sent
across the country. The federation, formed that same year in
Washington by Elihu Root, Robert Woods Bliss and Theodore
Roosevelt, had as its aim the circulation of works of art in areas
where there were no general museums. Today the AFA continues
this service to both large and small museums. After that showing,
"Miss Jennie" began begging, cajoling and driving to build a col-
lection. She wheedled $10 out of each of 70 women to buy Eak-
ins's *Swimming Hole*, and even so, payments had to be sent along
on the installment plan, since it took a long time to convince all
those women that one painting was worth all that money. Today it
is appraised at $300,000. An art association was established after
this venture and was housed in the library until 1954, when
Herbert Bayer designed the present museum on a rise of green in
Carter Square, which, together with the adjoining William Edring-
ton Scott Theater, makes this a focus for all the performing arts:

theater, opera, ballet and music, as well as visual arts. The theater's entire plan was conceived by Donald Oenslager, one of America's foremost scenic designers.

The art center's collection, mainly American, has recently begun to emphasize the 20th century and includes Picasso's bronze *Head of a Woman*, Kandinsky's *Above and Left*, Feininger's *Manhattan II*, Shahn's *Allegory*, Rothko's *Light Cloud—Dark Cloud* and Still's *Yellow—56*, as well as works by Sheeler, Marin, O'Keeffe, Tamayo, Graves, Cornell, Vasarely, Oldenburg, Judd, Kelly and Stella. Picasso's important *Femme Couchée Lisant* is the first picture to be acquired by an American museum through Telstar auction (a refinement of the salesroom which allows bidders to compete from different cities, even different continents, through satellite television). A new wing designed by Ford, Powell and Carson of San Antonio opened in mid-1974. It has doubled the exhibition space and gives more opportunity for the permanent collection to be viewed.

One cannot leave this spot without saying a word about the concentration of art and architecture on Amon Carter Square. Within sight and walking distance are the Amon Carter Museum of Western Art, Fort Worth Art Center Museum, the Kimbell Art Museum and the Children's Museum (parents, don't park your children here—stay with them, it's well worth it). The Fort Worth Museum of Science and History is just around the corner on Montgomery Street and contains, among treasures natural to it, beautiful North and Middle American Indian artifacts.

Thomas Eakins: Swimming Hole (Fort Worth Art Museum, Fort Worth Tex.)

KIMBELL ART MUSEUM

Carter Square, Fort Worth, Texas

Hours: Tues. 10–9; Wed.–Sat. 10–5; Sun. 1–5
Closed: Mon., major holidays

The Kimbell Art Museum is one of two in the United States, the other being Kansas City, that can almost be called "instant museum." For while donor Kay Kimbell had a collection of paintings, only those of top quality, about 40 in number, were delegated to the new collections. At his death Kimbell, whose fortune was made in such diverse enterprises as oil and grain, groceries and insurance, left the proceeds of the Kimbell Art Foundation to build and endow a museum. His widow completed the bequest by putting her share of the community property into the foundation.

In 1966 Richard F. Brown, former director of the Los Angeles County Museum, was appointed director and requested to simultaneously build a building and a collection. Avoiding the areas covered by its neighbors, the Amon Carter and the Fort Worth museums, the Kimbell begins with antiquities and ends roughly around 1920.

Louis Kahn, the architect chosen, formed the building with a series of parallel cycloid vaults. Occasional breaks allow for outdoor interludes of contained garden space. One such space holds Antoine Bourdelle's pensive *Penelope*. At the entrance to Penelope's bower stands an ancient Greek *Funerary Statue of a Young Female Attendant* of the late Classical period (340–330 B.C.). The two figures are so juxtaposed that, as Dr. Brown says, "One encounters the beginning and the end of Classicism in one glance." In another garden court Maillol's *L'Air* basks in the Texas sun.

The part of the museum that concerns the visitor is on one level and is larger than a standard football field. However, the arrangement of galleries allows for both intimacy and open flow— an ambience that creates a feeling of nearness to the work whether it is hung in the traditional manner or placed on an easel. Another factor is that where the halves of the vaults meet there is a long slit through which daylight spills. There is wizardry in the way the Texas sun is controlled, deflected, never glaring, gently washing the space with its warmth. The works of art seen through

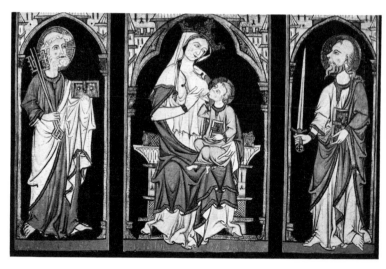

The Barnabas Altarpiece (Kimbell Art Museum, Fort Worth, Tex.)

changing lights and weathers take on many faces.

One of the rare objects is the frescoed apse from the small chapel of St. André de Bagalance near Avignon, dated mid-12th century. Found on a farm, much of the chapel still stands. During the period when religious institutions were closed in France, the building was used as a cattle barn, and its frescoes were whitewashed. The paintings and a thin layer of plaster were transferred to canvas and are presented here in their original dimension.

Another prime treasure, the *Barnabas Altarpiece*, rests on a sideboard. This triptych, long thought to be French, is now recorded as the earliest English painting on wood extant (about 1250). The famous *Westminster Retable* in Westminster Abbey is dated 20 years later.

It is a temptation to dwell on individual works here: the *Cycladic Figure*, the formidable bronze Cambodian *Buddha Enthroned*, J. M. W. Turner's *Glaucus and Scylla*, Boucher's *Four Classical Myths on the Theme of Fire*; the English Portrait School, including Romney, Raeburn, Lawrence and Gainsborough; Goya's *The Matador, Pedro Romero*. French 19th century painting is represented by Monet, Pissarro and Degas, and moves into the 20th

century with a 1905 Derain, *The River Seine at Chatou,* and Picasso's Cubist *Man with a Pipe,* 1911.

Iran, India, China and Japan are represented, again in concurrence with the museum's stated policy, with few but choice pieces. The same holds true for the African and Pre-Columbian sections.

The feat of finding such select pieces in a short period of time is impressive. Only the combination of eye, scholarship and Sherlock Holmesian bent made it possible. Almost every work has a story. The Bellini *Madonna and Child* had not been seen in public in over 160 years. The beautiful Pissarro painted in 1871 disappeared 70 years ago and turned up in a modest South American collection. The Vuillard seen long ago in an exhibition took a year of sleuthing to find. Obviously director Brown would be as much at home in Scotland Yard as he is in the museum world. One leaves this museum feeling that everything possible has been done to bring the viewer into close engagement with the works of art. At every turn, in every gallery, the visitor is subtly coerced into holding a dialogue with the individual piece. Panoramic views are blessedly few.

Aristide Maillol: L'Air (Kimbell Art Museum, Fort Worth, Tex.)

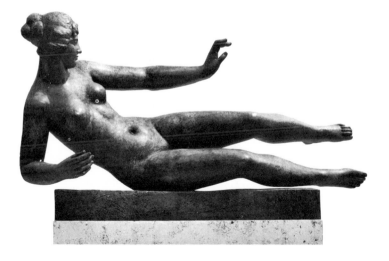

HOUSTON

BAYOU BEND COLLECTION OF THE MUSEUM OF FINE ARTS

1 Westcott Street, Houston, Texas

Hours: Mornings: Wed.–Sat. 2-hour tours every 15 mins. 10–11:15.
Afternoons: Tues.–Fri. 2-hour tours every 15 mins. 1:15–2:30.
Reservations required. Open second Sun. each month without
reservations except in March
Closed: Aug., major holidays

One of the great collections of Americana in the country rests in a sprawling house at the bend of the Buffalo Bayou in Houston. It is the former home of Miss Ima Hogg. About 1920 Miss Ima, as she is lovingly called around Houston, became intrigued with an antique American chair in the New York studio of painter Wayman Adams. Although she had collected American glass and some English furniture, the beauty and availability of early American furniture was not known to her.

Descended from a long line of public servants—her grandfather was a congressman in the Texas Republic, her father a governor—it was natural for her, when she started collecting seriously, to think in terms of a gift to the state. Her brother Will, after some initial reluctance that shortly transformed into enthusiasm, shared the project with her. In 1927, joined by another brother, Michael, they built the house in River Oaks that was to be the setting for the collection and their home until Miss Hogg gave it to the Museum of Fine Arts in 1958. Then began the slow process of turning the house into a house-museum, of gathering furniture, paintings and *objets d'art* into their proper province. The many-faceted Miss Hogg's other collection of Klee, Kandinsky, Picasso and Matisse moved with her to an apartment, and Bayou Bend opened as a public museum in 1966.

Starting with the Murphy Room, which contains the oldest pieces, the range is 1650–1870. There are 22 room settings.

In 1970 Miss Hogg added a Folk Art Room, and in 1971 the Belter Parlor moved the collection into the Rococo revival phase of the Victorian era. Don't miss the campaign china in the Texas room. It was made at Mercy Pottery in Burslem, Staffordshire,

England, to commemorate the war between the United States and Mexico. Lack of space does not allow for specifics, especially regarding the fine painting collection, which includes Smibert, Feke, Blackburn, Copley, Stuart, Peale and Cole. One corridor is full of Copley sketches; *Mrs. Paul Richard* is surely one of his American masterpieces. Another beauty is Robert Feke's *Portrait of Ann McCall*, from his less familiar Philadelphia period. This 1749 portrait was in the same family for which it was painted until 1960 and was long attributed to Copley. The painter's identity was established through the recent discovery of the McCall family ledger.

The 14 acres around Bayou Bend drip Spanish moss and glow with dogwood, azaleas and camelias in a woodland setting.

CONTEMPORARY ARTS ASSOCIATION

5216 Montrose, Houston, Texas

Hours: Tues.–Sat. 10–5; Sun. 12–6
Closed: Mon., major holidays

Since its founding in 1948 the Contemporary Arts Association has undergone many changes in policy as well as a change in name and address. In 1972 the museum moved into what may be presumed to be its permanent quarters. Built across the street from the older Fine Arts Museum, it is a handsome, stark statement, a parallelogram-shaped block covered by thin vertical stripes of finely serrated stainless steel. A wide sidewalk ramp leads one halfway along the building to a high, narrow slit of entrance. Entering, one feels one has slipped through the board fence into the ball park, for the unbroken space has the dimension of a good-sized playing field. It was designed for maximum flexibility. Since the program of the center is oriented in that direction, this seems to be a happy arrangement of form and function.

Always lively with film series, lectures and happenings, the museum was among the first to explore the relationship between art and industry and to stress design. "From Fountain Pen to Tractor" and "Contempora in Cotton" were but two of a long series of exhibitions presented with unique displays. The first exhibit in the new building emphasized its aims. Ten of the most

Exterior of the Museum (Contemporary
Arts Association, Houston, Tex.
Hickey & Robertson photo)

innovative artists from about the country were chosen to come to
the museum and create their own works, whether in video tech-
nology, light, optical imagery or experiments in ecology. "Exhibi-
tion Ten" startled Houston and set the pace it has been following
ever since, to reach out and involve the total community, the
public as well as the artist.

THE MUSEUM OF FINE ARTS

1001 Bissonnet Street, Houston, Texas

*Hours: Tues.–Sat. 9:30–5; Sun. 12–6; first Wed. each month Oct.–
 May 9–9*
Closed: Mon., major holidays
Restaurant, library

The recently opened Brown Pavilion at the Houston Museum of
Fine Arts is a stunning and provocative building, the last to be
designed by the internationally known architect Mies van der
Rohe. The wing, encased on three sides with glass panels joined
with black steel mullions, literally wraps its arms around the older,
1924, Classical structure. One is enticed through the museum's
broad low entrance gallery, where Duchamp-Villon's distinguished
bronze *Le Cheval Majeur* is centered, into the high sweep of Cul-
linan Hall. Mies van der Rohe's first step (it opened in 1958) of

he then already fully conceived project that has ended with the Brown Pavilion. Cullinan Hall holds major contemporary works from the permanent collection such as Peter Bradley, Helen Frankenthaler, Larry Poons, Friedel Dzubas, Dan Christiansen, Julio Gonzales, Anthony Caro and James Brooks's moving *J.F.K.* A large white Calder mobile undulates subtly against the Cullinan's white walls. One moves up another level to the Pavilion, a mammoth curving space compared correctly in size to a football field. The changing contemporary exhibitions will be held here. Conventional methods of installation must be discarded in this vast wall-less space. The lower level of the Pavilion contains the Pre-Columbian, American Indian (from the Ima Hogg collection –see Bayou Bend, Houston), African and Oceanic collections, a gallery of Frederic Remington, that recorder of the Plains and the Plains Indians, a print and drawing gallery, auditorium and a 15,000-volume library.

The Pavilion proper leads into the second-floor galleries of the older museum. The galleries on the second floor are more static, since many of the collections must be shown intact. The Robert Lee Blaffer memorial group holds a top Cézanne, *Portrait of Madame Cézanne;* important panels by Giovanni di Paolo; a retable, school of Avignon, 15th century, from the chapel of Notre Dame des Sceaux. Here also is one of the museum's most popular

Interior View, the Brown Pavilion, Museum of Fine Arts, Houston, Tex.)

paintings, Renoir's *Still Life with Bouquet,* an allegory of the art within which Renoir copied a sketch of Manet's which Manet die after a painting by Goya.

In the Kress collection of Old Masters are works by Tintoretto Magnasco, Sebastiano del Piombo and *Market Place in Pirna Saxony,* by Bernardo Bellotto. Bellotto did for Pirna on the Elbe what his uncle, Canaletto, did for Venice on the Adriatic —and with less to work with. The Edith A. and Percy S. Straus collection of Italian Renaissance paintings and sculpture encompasses bronzes by Cellini, Giovanni da Bologna and Verrocchio paintings by Hans Memling and Rogier van der Weyden. Fra Angelico is here at his endearing best in the predella *Temptation of St. Anthony, Abbot.*

One gallery holds a collection of Medieval works including a religious monstrance from the Guelph Treasure (see Cleveland). The galleries of French art run from the Classicism of Gérôme to the Post-Impressionists. Antiquities and Far Eastern material are shown in galleries at the south entrance to the museum, which is dominated by the 91-inch bronze sculpture *Ephebus,* one of the greatest Greek figures in existence. I would like to see him glory in the space of the Brown Pavilion.

The Houston Public School of Art League was founded in 1905 to purchase reproductions of Old Masters for school use. From these simple beginnings and motivated by many of the same movers, or their children, the museum, long classed as merely a good regional museum, has with the strengthening of its collections in almost every area and the opening of the Brown Pavilion moved into the category of major museums in the United States.

Mattia Preti: The Decollation of St. Paul (Museum of Fine Arts, Houston, Tex. Laurence H. Favrot Bequest Fund)

AN ANTONIO

MARION KOOGLER McNAY ART INSTITUTE

000 North New Braunfels, San Antonio, Texas

Tours: Tues.–Sat. 9–5; Sun. 2–5
Closed: Mon., major holidays
Library

Marion Koogler McNay contributed her name, her house and her works of art to form the San Antonio Art Institute. Even as the large Hispano-Moorish building went up in 1929, Mrs. McNay was thinking of it in terms of a public trust. Stirred by the Armory Show of 1913, she began to buy the work of those artists who deeply influenced 20th century painting. Perhaps because she was herself a watercolorist, Mrs. McNay concentrated on that difficult medium, and today the museum has a distinguished roster of such names as Cassatt, Boudin, Bonnard, De La Fresnaye and Klee. Pascin is spendidly represented by 218 drawings and water-colors that range from the erotic to the witty. Redon, in *Profile with Flowers*, displays his trademark—brilliant, wet-eyed anem-ones. Demuth's *From a Kitchen Garden* and Homer's *Scotch Mist* are two American beauties.

During the last 15 years of her life, Mrs. McNay focused on acquiring such important oils as *Portrait of the Artist with the Idol* by Gauguin, van Gogh's *Women Crossing the Fields,* Pissarro's *Haymakers Resting,* and Cézanne's *Portrait of Henri Gasquet.*

The second collection here is the Frederic Oppenheimer, pri-marily Gothic and Medieval material, unique in the Southwest. A new and charming Gallery of Folk Art of the Southwest illus-trates the art of the santero—both retablo paintings and bultos (see Santa Fe, Museum of International Folk Art).

While today the core of the McNay still maintains its delight-ful house-museum character, growth has lately been so prodigious that two wings have been built and another is in the planning stage. The Emily Wells Brown Wing opened in 1970. It includes a sculpture pavilion and large gallery that doubles as auditorium. On the lower floor is a splendid library, an aspect of the museum that has grown enormously.

In 1973 the Sylvan and Mary Lang Wing, consisting of four large galleries, opened. It houses the Lang Collection—important American paintings by Homer, Hopper, Shahn, Dove, Sheeler and so on and includes first-rate sculpture by Degas, Giacometti, Moore, Picasso, Alexander Calder and Archipenko, as well as paintings by Klee, Dufy, Dubuffet and Braque. Other gifts to the museum include three Hepworths, a beautiful large Ben Nicholson and Picasso's *Portrait of Sylvette*, which brings the museum's Picasso holdings to ten in various media.

The print cabinet's aim is to purchase editions of the highest quality. A proof impression of Redon's *Centaur Visant les Nues* is the only known example in sepia. Among recent additions are all of the Matisse etchings for Mallarmé's *Poesies*, some of the rare prints by Sheeler and Burchfield and several very early Marin etchings. Every print acquired is not only rare but a fine edition. Growing constantly, the print collection is probably the most important in the Southwest.

Contemporary changing exhibitions are shown on the second floor, and a purchase fund allows for constant surprises, such as fine examples of Barbara Hepworth's and Germaine Richier's sculpture and the five bronze studies for Rodin's *The Burghers of Calais*.

Pablo Picasso: Portrait of Sylvette (Marion Koogler McNay Art Institute, San Antonio, Tex. Gift of the Estate of Tom Slick)

SAN ANTONIO MUSEUM OF ART

801 Broadway, San Antonio, Texas

Tours: Mon.–Fri. 9–5; Sat., Sun., holidays 10–6

The San Antonio Museum Association governs three museums: the Witte Memorial Museum, the San Antonio Museum of Transportation and the San Antonio Museum of Art.

The art museum occupies its own building. With the purchase and complete restoration of the former Lone Star Brewery, another move is contemplated. The building is the largest and best example left in Texas of warehouse architecture, vintage 1880.

Constructed of cast iron, concrete vaulting and brick, and resting on 2½ acres along the San Antonio River, the building has recently been declared a historic monument. The interior design and architectural changes will be in the hands of the innovative firm, Cambridge Seven Association Inc., Boston.

Although the emphasis still will be on Texas, with the decorative arts, furniture and crafts set in period rooms, the plan is to evolve eventually into an encyclopedic museum. The American Indian group is extensive and fine. A small Pre-Columbian collection and some African and Oceanic pieces are here, as well as a Far Eastern crafts section. The holdings will be expanded to cover European painting and decorative arts. Periodic in-depth exhibitions will continue to be held.

Lighthouse Gallery and the *Ticonderoga* (Shelburne Museum, Shelburne, Vt.)

VERMONT

SHELBURNE MUSEUM
Shelburne, Vermont

Hours: Daily 9–5 May 15–Oct. 15

The museum enclave, Shelburne, was founded by Mr. and Mrs. J. Watson Webb in 1947 to preserve America's heritage, and New England's in particular. Some 35 buildings filled with examples of early craftsmanship have been reassembled in Vermont's green hills. The Stagecoach Inn shows early American folk art: ship figureheads, weather vanes, signs, carousel figures, the American eagles so popular with early carvers. The Lighthouse Gallery displays marine oils and historic prints of clipper ships. A bit large for inclusion, the 896-ton side wheeler *Ticonderoga* rests in the open. On either side of this staunch old boat stand the Webb Gallery and the Electra Havemeyer Memorial Building.

The Webb Gallery of American Art, starting with Pieter Vanderlyn and an anonymous portrait of George Washington, sans teeth, shows a collection of more than 200 paintings. It ranges through the 18th and 19th centuries with such painters as John Wollaston, John S. Copley, S. F. B. Morse, John Quidor and Winslow Homer. A ten-foot statue of Justice which formerly decorated the courthouse at Barnstable, Massachusetts, scales in hand and alarmingly realistic, stands in the entrance foyer.

The Webb Memorial, done in the Greek Revival style so popular in 19th century New England, houses the collection of European paintings inherited from Mrs. Webb's parents, the Henry O. Havemeyers. The interiors, six paneled rooms, are furnished as they were in the J. Watson Webbs' New York apartment. Artists represented by important works include Rembrandt, Goya, Cour-

bet, Corot, Degas, Manet, Monet and Cassatt. The main body of the Henry O. Havemeyer collection is a cornerstone of the Metropolitan Museum painting section, and it would be difficult to say who were the more indefatigable collectors—Mrs. Webb or her parents. There the likeness ceased. Electra Havemeyer's first purchase at the age of eighteen was a cigar store Indian, and from that moment she left her parents with their El Grecos and Japanese tea jars and marched firmly back into the world of Americana. The Shelburne Museum is unique testimonial to the heritage and accomplishment of this talented, charming and spirited woman.

Larry Rivers: Me (Chrysler Museum at Norfolk, Norfolk, Va. Gift of Walter P. Chrysler, Jr.)

VIRGINIA

CHRYSLER MUSEUM OF ART AT NORFOLK

Olney Road and Mowbray Arch, Norfolk, Virginia

Hours: Mon.–Sat. 10–5; Sun. 11–5
Library

With the accession of the Walter P. Chrysler Collection, the Norfolk Museum of Arts and Sciences not only acquired a large and varied collection but a new name as well. A gallery guide given to the visitor on entering is helpful in showing both the range and the placement of the various collections. The lobby gives us a rich fare of Early American paintings, including three Charles Willson Peale portraits to supplement his *George Washington: Mrs. Thomas Elliott;* a beguiling child's likeness, *Mary O'Donnell;* and *Mrs. John O'Donnell,* who holds in her hand a miniature, presumably of her husband, thus giving the museum yet another Peale portrait.

The galleries encircle a green courtyard with the large first-floor space, used for changing exhibitions, opening to yet another garden court. There is an Egyptian gallery and a Coptic corner. A small forest of Greek, Etruscan and Roman sculpture is shown in a stairwell, giving the visitor added perspective of the works on his ascent or descent.

The fine glass collection has examples of practically every known culture, with a large holding in American glass. Contemporary glass ends with some professionally executed and amusing pieces blown in the museum's own art school.

French art is well represented with an Old Master gallery. A 19th century French gallery tends toward the Academic. The Impressionists and Post-Impressionists have a room of their own,

highlighted by Gauguin's *La Perte du Pucelage*, Cézanne's *Le Baigneur au Rocher*, and Renoir's delightful portrait *Durand-Ruel's Daughter*. The French, with the exception of Picasso, command the contemporary European gallery: Léger, Laurens, Braque, Matisse and Soulages. El Greco's *Portrait of a Gentleman* stands out among the Spanish paintings. Practically every gallery, whether Dutch, Flemish or English, creates its own atmosphere with the use of furniture and decorative arts of the period.

Although the scene is slowly changing, most contemporary collections south of the Mason-Dixon line tend to be conservative. A George Bellows nude, yes; a Philip Pearlstein nude, no. Refreshingly, the Chrysler Museum owns fine examples of Tworkov, Frankenthaler, Krushenick, Rosenquist and many other leading American artists, including an outsized canvas by Larry Rivers entitled *Me*. It's autobiographical all the way from bare infant on the bear rug to Larry the saxaphone player. When collector Joseph Hirshhorn saw it his envy was such that he commissioned one for himself. It is titled *Me Too*.

A new wing will house one of the largest art reference libraries south of Washington.

RICHMOND

VIRGINIA MUSEUM OF FINE ARTS
Boulevard at Grove Avenue, Richmond, Virginia

Hours: Tues.–Sat. 11–5; Sun. 1–5; Sept.–May, Sat. 8 P.M.–10 P.M.
Closed: Mon., major holidays
Library, restaurant

Richmond burned for three days after it fell to Grant at the end of the Civil War. For decades thereafter the arts went by the board while the city concentrated on rebuilding. Not that Richmond was actually culturally deprived. Its state capitol building had been designed by Thomas Jefferson. For a period of time Richmond was the home of the Academy of Arts and Sciences of America, the first (1786) of its kind in the New World. In 1919

Judge John Barton Payne gave his collection of more than 50 paintings to the state of Virginia. But it wasn't until 1936 that the Old Dominion could gather together its rich cultural heritage and Payne's international art collection under the roof of a museum.

In 1933 construction of a museum under a WPA grant was begun. It followed the pattern of so many public buildings of the 1930s, a Neo-Classical structure with the usual fluted columns and portico. In well-ordered progression wings have been added. 1976 will see the opening of a final group of galleries and a sculpture garden. The last cast available of Maillol's *The River* has just been purchased from Maillol's model for the work and will reign in the garden.

No museum in the country sets an ambience for different periods in art history more thoroughly than Richmond. Egypt, ancient Greece and Rome, Byzantium, the Medieval or Renaissance worlds, each has a small orientation area adjacent to the gallery that holds the art and artifacts where one can push a button, sit quietly, and see a screening with commentary on the country and period of the cultures represented, whether it be 18th century England or the Oriental world.

The fine examples from temple and cave from various parts of India are from the distinguished Heeramaneck collection. Persian miniatures and a gallery of delectable small objects adjoin. Other

Robert Salmon: Boston Harbor from Castle Island (Ship "Charlotte") (Virginia Museum of Fine Arts, Richmond, Va.)

Francisco Goya: General
Nicolas Guye (Virginia
Museum of Fine Arts,
Richmond, Va.)

highlights: a small panel for an altar by Signorelli, *The Presenta-tion of the Virgin,* unmistakably recalls his great frescoes in the Cathedral of Orvieto; Francesco Guardi's *Piazza San Marco* is an especially fine example of Guardi's absorption with the Piazza; and Constable's *Pond at Hampstead Heath* is a felicitous picture with its sensitive use of light.

A series of portraits, Primitive and relatively sophisticated, evokes Colonial Virginia. The tobacco boats plying between Eng-land and America carried planters to London on business. While there, they often seized the opportunity to sit for portraits. Those who didn't make London might send detailed descriptions of how they looked, or wished to look, and in a matter of months "por-traits" were returned, presenting later historians with problems.

Richmond has three early canvases known as the Ambler por-traits, the coats of arms attesting that they were painted before 1775, when family escutcheons went out of style, at least for a while.

Newer acquisitions are *A River Landscape* by Salomon van Ruysdael, *Boston Harbor from Castle Island* by Robert Salmon, *General Nicolas Guye* by Goya, and the Ailsa Mellon Bruce Col-lection of Decorative Arts.

A long trip via Ireland has brought a stained glass window from Canterbury Cathedral to rest in Richmond. A few pieces of

glass have been replaced, but the original leading is intact. A scholarly treatise on the window by Madeline H. Caviness as well as an article by Hans Jucker on Richmond's impressive Roman sculpture of Caligula is in pamphlet form in the museum bookstore—and recommended reading.

In a setting reminiscent of the great days of czarist Russia, the Pratt Collection of Imperial Crown Jewels nestles in embrasures suggesting draped Rococo opera boxes. Carl Fabergé's unbelievable fantasies in crystal, gold and gems take the form of Easter eggs, icons, a whole garden of bejeweled potted plants, cigarette cases and snuffboxes. These priceless bibelots are exhibited with a lively sense of theater.

Four artmobiles—big motor coaches with humidity control and sound equipment—travel through the state with exhibits from the museum. The theater, one of the best equipped in America, offers plays, ballets and concerts. Visitors can phone for tickets. There is a members' lounge and restaurant, and the new wing will house an everyman's cafeteria. The five galleries in the wing will provide space for showing the ever expanding collection of contemporary art and for temporary exhibitions. If publications are a measure of an institution's stability, Virginia is a rock, for just 30 years after the museum's founding it published a major catalog on its European holdings. Its house publication, *Arts in Virginia*, published three times a year, is a scholarly, handsome journal.

WILLIAMSBURG

ABBY ALDRICH ROCKEFELLER FOLK ART COLLECTION
Williamsburg, Virginia

Hours: March 16–Oct. 31: Mon.–Sat. 10–9; Sun. 12–9. Nov. 1–
* March 15: daily 12–8*
Library

Any trip to Williamsburg should include this museum—and for this museum alone any student of nonacademic American art should go out of his way to Williamsburg. Because more than half of the collection dates from the 19th century and cannot be considered

Attributed to Corbin: Henry Ward Beecher (Abby Aldrich Rockefeller Folk Art Collection, Williamsburg, Va.)

a part of the 18th century colonial Williamsburg restoration, the stately brick repository sits on the edge of the Williamsburg enclave, between the Inn and the Lodge. The scale is that of a roomy private home, the intimate wainscotted galleries compatible with the unassuming painting, sculpture, decorated furniture and useful household wares displayed therein.

In the stairwell, a great ship's figurehead of Minnehaha is proudly and permanently anchored to one wall. It is believed to have been carved in 1856 in Boston for the ship named for our romanticized, victimized Indian maiden. A buxom, larger-than-life polychrome carved Columbia often greets visitors at the top of the stairs. Across the hall, the charming early 19th century room was taken from a house in Wagram, North Carolina. It was probably painted by an itinerant decorator. Over the mantel is a mural, *View of New York*, thought to have derived from a print or engraving. This room houses southern folk art. Folk art from Pennsylvania, the Northeast and the Midwest is also included in the collection. Among the identified artists whose work is represented are Edward Hicks, Erastus S. Field, John Brewster, Edbury Hatch and William Gleason. The collection rotates and annually sponsors a major cataloged exhibition of little-known American folk material borrowed from public and private collections.

WASHINGTON

THE CHARLES AND EMMA FRYE MUSEUM

704 Terry Avenue, Seattle, Washington

Hours: Mon.–Sat. 10–5; Sun., holidays 12–6
Closed: Dec. 25

The architecture of this small, pleasant building is clean-lined and understated. Charles Frye, a successful farmer turned merchant, was enamored of 19th century German and French Academic painting. His will stipulated that the installation (planned by him and far too crowded and weighed down with heavy 19th century frames) remain. However an occasional Childe Hassam or Mary Cassatt relieves the ponderousness. There are examples of the three generations of Wyeths, plus Grant Wood, Everett Shinn, George Luks and, to leap back in time, John Singleton Copley.

The front galleries hold changing exhibitions of primarily contemporary material.

THE HENRY GALLERY: UNIVERSITY OF WASHINGTON

15th Avenue N.E. at N.E. 41st Street, Seattle, Washington

Hours: Tues.–Sat. 10–5; Thurs. 10–10; Sun. 1–5
Closed: Mon., major holidays

Although the gallery has a permanent collection of 19th and 20th century painting including 39 works by Morris Graves and others by Homer, Innes and Blakelock, it is the lively theme shows that stimulate both students and community. Whether it's "Light, Motion and Sound" or an exhibition showing what conceptual artists

are doing, the exhibitions usually expand beyond the purely visual. For example, one views an exhibition of John Doe's painting, but in an adjacent conceptual center are slide projections of other works, and one hears a recording of John Doe's working techniques, philosophy of art or how he likes his shirts ironed.

An extensive archive of Northwest artists is being gathered here. Scattered about the campus are major sculptures by Bourdelle, Moore, Newman and Noguchi.

SEATTLE ART MUSEUM

Volunteer Park, Seattle, Washington

Hours: Tues.–Sat. 10–5; Sun., holidays 12–5; Thurs. 7 P.M.–10 P.M. Closed: Mon. Jan. 1, May 30, Thanksgiving, Dec. 25

MUSEUM PAVILION, SEATTLE CENTER

Hours: Tues.–Thurs. 10–5; Fri. 10–9; Sun. 12–5 Closed: Mon., Jan. 1, Thanksgiving, Dec. 25

Like other American cities at the turn of the century, Seattle had its struggling Art Society, but in 1933 the scene changed dramatically when Mrs. Eugene Fuller and her son Richard E. Fuller built and gave the present museum to the city. No other museum visitor in the country is put to the test that one is in Seattle; the matter rests on whether you want to have a visual experience outside or inside the museum, for across the broad park lawns one looks over Puget Sound to the pine-covered hills and on to snow-laced Mount Olympia. The view is now compounded by a monumental sculpture, a granite circle of Noguchi's, which, if one is on axis at the museum's door, allows for viewing all this splendor through the Noguchi.

Dr. Fuller was the museum's president and director until he resigned in 1972. Always on the prowl for treasures, he made a find in Gumps warehouse in San Francisco. For decades, huge marble animal figures, former guardians of princely tombs, had lain there wrapped in rope. Today these simple, monolithic sculptures of rams, lions and camels of 12th to 17th century China flank the

Haniwa Warrier (Seattle Art Museum, Seattle, Wash.
E. Fuller Memorial Collection, Earl Fields photo)

museum's entrance and emphasize the Fullers' penchant for the arts of the Far East.

Not all of the rich collection can be on view at once, but the jade collection (considered one of the finest in the country), the Kress, the East Indian and the Classical are more or less permanent installations.

The Chinese and Japanese galleries show nearly all facets of these cultures, with the Japanese being considered one of the most distinguished outside Japan. Gradually the collection was expanded to embrace almost every age and culture. East Indian sculpture ranges from a 2nd century Buddha to the later elegance of 11th century Udipur (Jain). A small tribal arts section has its main strength in African art. Romanesque moves into the Renaissance with an especially fine version of Lucas Cranach the Elder's *Judgment of Paris.*

The Kress collection includes Rubens's powerful little sketch of *The Last Supper.* This is all that is left of the artist's grand concept for the finished painting commissioned for an Antwerp church destroyed by fire. Also in the Kress collection is a delightful ceiling painting by Tiepolo plus the original sketch and a great Florentine bronze *Pietà* by Massimiliano Soldani.

Again, the European decorative arts section is small but highly selective.

The opening in 1965 of the Seattle Art Museum Pavilion in the remodeled United Kingdom Pavilion of the Seattle World's Fair has solved certain space problems. The museum's contemporary holdings are shown here along with annuals and theme exhibits. The collection, administered by the mother museum, contains such Europeans as Duchamp, Léger, Picabia, Klee, Kirchner, Nolde, and Beckmann. Some Americans shown are Frankenthaler, McCracken, Stamos, Marca-Relli, and of course Northwest artists Tobey, Callahan and Graves are shown in depth.

WISCONSIN

UNIVERSITY OF WISCONSIN: ELVEHJEM ART CENTER
Madison, Wisconsin

Hours: Mon.–Sat. 9–4:45; Sun. 1:4:45
Closed: Major holidays
Library

The University of Wisconsin was given its first painting in 1885; as the works of art trickled in through the years they were stored or strewn about on campus walls. In 1958 President Conrad E. Elvehjem instigated a study of campus needs, which resulted in the building by architect Harry Weise which holds an art school, museum, auditorium and the Kohler art library—one of the best in the Middle West.

The museum, accessible from both campus and street, is oriented around a two-storied court. All upstairs galleries open onto the wide balcony, giving a feeling of order and compactness. There is an elegance of understatement here. The philosophy of the museum, which is after all a teaching museum, seems to be to let the eye rest on one noble example rather than several lesser ones.

The Old Master collection is strongest in Italian and Netherlandish paintings. One important work is a marble tondo, *Madonna and Child,* by Florentine sculptor Benedetto da Maiano. Another, *Adoration of the Shepherds* by Giorgio Vasari, has been in the collection since 1923.

The very good collection of Indian sculpture and miniatures has been recently enhanced with late Gupta sculpture of Kubera and an early 6th century Northern Wei Dynasty *Bodhisattva*

Giorgio di Chirico: Metaphysical Interior with Biscuits
(University of Wisconsin, Elvehjem Art Center, Madison, Wisc.
Gift of Nathan Cummings. David M. Spradling photo)

from the Yün Kang caves. The print collection is large and varied, and stretches from works by Dürer and Rembrandt to four original engravings of William Hogarth, *The Election Series*, plus works by two rowdy compatriots—Rowlandson and Cruikshank—to prints by such current artists as Hayter, Peterdi and Lasansky. Wisconsin may seem an unlikely place for a collection of Russian paintings and icons, including an outstanding 15th century triptych. But there they are, a gift of His Excellency Joseph E. Davies, ambassador to Russia during the troubled years of World War II and an alumnus of the University of Wisconsin. The scholarly catalog is a textbook on Russian icons. In keeping with the museum policy, the contemporary collection, while not large, is selective.

MILWAUKEE

MILWAUKEE ART CENTER

750 N. Lincoln Memorial Drive, Milwaukee, Wisconsin

Hours: Mon.–Sat. 10–5; Thurs. 10–10; Sun. 1–5
Closed: Jan. 1, Dec. 25

Few museums in the country have expanded their holdings and their horizons as rapidly as has Milwaukee in the last few years. This is due in part to the gift of Mrs. Harry Lynde Bradley's large and eclectic collection of contemporary American and European painting and sculpture, and to the decision of the Milwaukee Art Center's trustees to add a wing of 127,000 feet of space. Although Milwaukee has had a museum since 1888, when civic-minded Frederick Layton gave his collection and a building to house it to the city, the dynamic force that operates today came with the opening in 1957 of the War Memorial Building and Art Center designed by Eero Saarinen. The new wing projects to the east and Lake Michigan, a small sculpture court being the link between old and new. Though the addition is three stories above ground level, because of the land's topography it is lower than much of the older structure. The stunning free-form Saarinen staircase leads to the roof of the addition, where such heroic sculpture as Rodin's *Striding Man* is silhouetted against Lake Michi-

gan's vast expanse. The simple poured-concrete building, designed by Milwaukee architect David Kohler, is understated. The broad entrance gallery and open mezzanine space is ideal for such pieces as Dewain Valentine's enormous and luminous *Concave Circle* of cast polyester resin. The visitor can move forward to examples of practically all the well-known contemporary artists —Gottlieb, Dubuffet, Rothko, Kelly, Stella, Segal. Gallery stoppers are Dwain Hanson's *The Janitor*, life-sized in polyester and fiberglass, too real for comfort, and Tom Wesselmann's *Still Life No. 51*, with its outsized but appropriate for Milwaukee Pabst Blue Ribbon Beer can. Op, Pop, hard edge, soft edge, photorealism—they're all represented.

One can only call the early European painting section spotty, but it offers some arresting canvases, such as Ferdinand Bol's *Portrait of an Oriental* and a school of Fontainebleau *Three Princes*. The Italian Pier Leone Ghezzi's *The Fertility of the Egg* is a Bosch-like canvas with slightly frivolous overtones.

There is a good section of small 19th century paintings—Delacroix, Lepine, Vuillard, Couture, Lautrec—and a collection of 19th century genre paintings, starting with the Primitive portraitists. The American historical section, though not large, is diverse, selective and growing, a recent addition being *Portrait of a Highlander* by the Pittsburgh Primitive John Kane. But it is the Bradley Collection of painting and sculpture that lifts Milwaukee into the higher echelons of the museum world. Early 20th century concentration is on the German Expressionists, followed by Kandinsky, Van Dongen, Villon, Léger, Miró, de Staël, Riopelle, Tobey, Rothko, O'Keeffe, Stuart Davis (one early Stuart Davis seems right out of the Ashcan School) and Picasso's large oil *The Cock of the Liberation*, memorializing France's freedom from German occupation. The sculpture collection is formidable, with important examples of European and American works. An innovative feature in the museum is a series of 89 telephones. Instead of being trapped by the set speech of an Accoustoguide, one goes to a telephone in the gallery and dials a number for information on a painting of particular interest.

A gift of a sumptuous private house, Villa Terrace, gives the Art Center a separate decorative arts museum. Strangely, there seems to be nothing incongruous about an Italian-style villa (this

one built by David Adler, one of the last of America's great Revival architects) housing American decorative arts, which even include a Shaker room. The museum features American and English period rooms, with emphasis on the strong 18th century Palladian influence in both countries. Built on a cliff with descending terraces downward, the museum also provides a delightful setting for its popular summer concerts.

Pierre Bonnard: Girl in Straw Hat (courtesy of Milwaukee Art Center, Milwaukee, Wisc. Gift of Harry Lynde Bradley)

Gertrude Vanderbilt Whitney: Buffalo Bill, the Scout (Buffalo Bill Historical Center, Whitney Gallery of Western Art, Cody, Wyo.)

WYOMING

BUFFALO BILL HISTORICAL CENTER: THE WHITNEY GALLERY OF WESTERN ART

720 Sheridan Avenue, Cody, Wyoming

Hours: May and Sept., daily 8–5; June, July, Aug.: 7 A.M.–*10* P.M.

It's a long time between museums out on the western plains, so don't miss this one. The simple building's entrance lounge frames a sandy mesa reaching to a spectacular mountain range and a heroic-sized bronze equestrian sculpture of *Buffalo Bill, the Scout,* done by Gertrude Vanderbilt Whitney. Mrs. Whitney was instrumental in acquiring this large tract of land for the historical center of which the gallery is a part. All the aspects that made up frontier life, the grandeur of the untouched landscape, the Indian, the buffalo, the frontiersmen, are recorded on canvas and in bronze. This testimony left to us by our artists becomes increasingly important as the old West fades into legend.

Some of the best paintings here were collected by William F. "Buffalo Bill" Cody and displayed at the Irma Hotel, which he built in Cody in 1902. The collection of 31 paintings, along with the hotel, were sold to Mr. and Mrs. Pearl C. Newell to settle the Cody estate. But 40 years later Mrs. Newell, who had refused all offers to purchase, bequeathed them to the museum. The equestrian portrait of Buffalo Bill by the French artist Rosa Bonheur was done in 1889 in Paris, where Cody had taken his "Wild West Show." A few years later, when Cody was notified that his home was burning, he called back, "Save the Bonheur picture, let the home burn."

Among the Albert Bierstadts are *Last of the Buffalo* and *Wind*

441

River, Wyoming, eloquent portrayals of our western saga. Seventy-two George Catlin paintings of his journey up the Missouri, from the Paul Mellon Collection, are on indefinite loan from the National Gallery. The Alfred Jacob Miller paintings are the earliest pictures of the territory that is now Wyoming. The museum has many works of Charles M. Russell, a self-taught painter, sculptor and cowhand, whose life centered on the prairies and the plains. Frederic Remington, who has left the most complete record of the Old West, was born in New York State but went west in 1882. He roamed the plains with cowboys and Indians and was a witness to many of the encounters he painted so vividly. One gallery displays the entire contents of Remington's studio at the time of his death in 1909, memorabilia from every facet of pioneer western life.

The museum is happily situated on routes 14 and 20—the eastern gateway to Yellowstone National Park.

ACKNOWLEDGMENTS

The acknowledgments listed in the brief bibliography represent but a fraction of my obligations, most of which are to the directors, curators and staff of every institution noted in this book. My gratitude goes out to them all for their unfailing patience, friendliness and helpfulness in allowing me to roam through their museums at will, often after closing hours and at times inconvenient to them, thus making an arduous cross- and crisscross-country schedule tolerable for me. I am grateful to them for making available to me catalogs and other material on the history of their institutions and collections.

BIBLIOGRAPHY

Brown, Milton. *American Painting from the Armory Show to the Depression.* Princeton, Princeton University, 1955.

Cahill, Holger. *American Painting and Sculpture.* Newark, Newark Museum.

Carter, Morris. *Isabella Stewart Gardner Museum and Fenway Court.* Boston, Houghton Mifflin, 1940.

Cartwright, W. Aubrey. *Guide to Art Museums in the U.S.* (Southeast Coast section). New York, Duell, Sloane & Pearce, 1957.

Coe, Ralph T. "Zurbaran and Mannerism," *Apollo,* Dec. 1972.

Coke, Van Deren. *Taos and Santa Fe.* Amon Carter Museum of Western Art publication.

Cooper, Douglas. *The Cubist Epoch.* New York, Phaidon, 1971.

Dana, John Cotton. *American Art.* Woodstock, Vt., privately printed.

Dockstader, Frederick J. *Indian Art of the Americas.* New York, Museum of the American Indian, Heye Foundation. 1973.

Eliot, Alexander, and Editors of *Time. Three Hundred Years of American Painting.* New York, Random House, 1957.

Faison, S. Lane, Jr. *Art Tours and Detours in New York State.*

————. *A Guide to the Art Museums of New England.* New York, Harcourt, Brace and Co., 1958.

Flexner, James T. *Short History of American Painting.* Boston, Houghton Mifflin. 1950.

Fryxell, Fritiof. *Thomas Moran.* East Hampton, N.Y., East Hampton Free Library, 1958.

Gilbert, Dorothy. *American Art Directory.* New York, Bowker, 1957.

Hendy, Philip. *Isabella Stewart Gardner Museum, Catalogue of the Collections.* Boston, Gardner Museum.

Hoving, Thomas P. F. *Guide to the Metropolitan Museum of Art.* New York, Metropolitan Museum of Art, 1972.

Howe, Winifred. *History of the Metropolitan Museum of Art.* 2 vols. New York, Columbia University Press, 1946.

Iglaurer, Edith. "Housekeeping at the Big Museum," *Harper's,* February, 1960.

Kubler, George. *Santos.* Fort Worth, Amon Carter Museum of Western Art, June, 1964.

Lansdale, Nelson. "Mrs. Jack Gardner's Palace," *Horizon*, July, 1959.

Larkin, Oliver. *Art and Life in America*. New York, Rinehart, 1949.

Lewis, Oscar. *Big Four*. New York, Knopf, 1946.

Lyon, Peter. "Adventurous Angels," *Horizon*, May, 1959.

McCleery, William. "Interview with Norton Simon," *Princeton University Quarterly*, Spring. 1974.

Maxon, John. *The Art Institute of Chicago*. New York, Harry N. Abrams, 1970.

Mooz, R. Peter. *Antiques Magazine*, November, 1968 and 1973.

Overmeyer, Grace. *Government in the Arts*. London, Norton & McLeod, 1939.

Pach, Walter. *The American Art Museum*. New York, Pantheon Books, Inc., 1948.

Pach, Walter, trans. *Journal of Eugene Delacroix*. New York, Crown, 1948.

Phillips, Duncan. *The Enchantment of Art*. New York, J. Lane, 1914.

———. *The Leadership of Giogione*. Washington, American Federation of Arts, Inc., 1937.

Rewald, John. "Degas," *Gazette des Beaux Arts*, August, 1946.

Richardson, E. P. *Painting in America*. New York, Crowell, 1956.

Roberts, George and Mary. *Triumph on Fairmount: Fiske Kimball and the Philadelphia Art Museum*. Philadelphia, Lippincott, 1959.

Rose, Barbara. *American Art since 1900*. New York, Frederick A. Praeger, 1967.

Saarinen, Aline B. *The Proud Possessors*. New York, Random House, 1958.

Sandberg, W. and Jaffe, H. L. C. *Pioneers of Modern Art*. New York, McGraw-Hill, 1961.

Taylor, Francis Henry. *Fifty Centuries of Art*. New York, Harper, 1954, 1960.

Tebbel, John. *The Life and Good Times of William Randolph Hearst*. New York, Dutton, 1952.

Watson, Forbes. *Art in Federal Buildings*. Washington, U.S. Treasury Dept., 1936.

Wittke, Carl. *The First Years: The Cleveland Museum 1916–1966*. Cleveland, The John Huntington Art & Polytechnic Trust and The Cleveland Museum of Art, 1966.

Wunder, Richard P. "The Smithsonian Institution's National Collection of Fine Arts," *Connoisseur*, May, 1968.

Zeri, Frederico. "The Italian Pictures: Discoveries and Problems," *Apollo*, Christmas, 1966.

Index

452 / Index